DREAMS AND

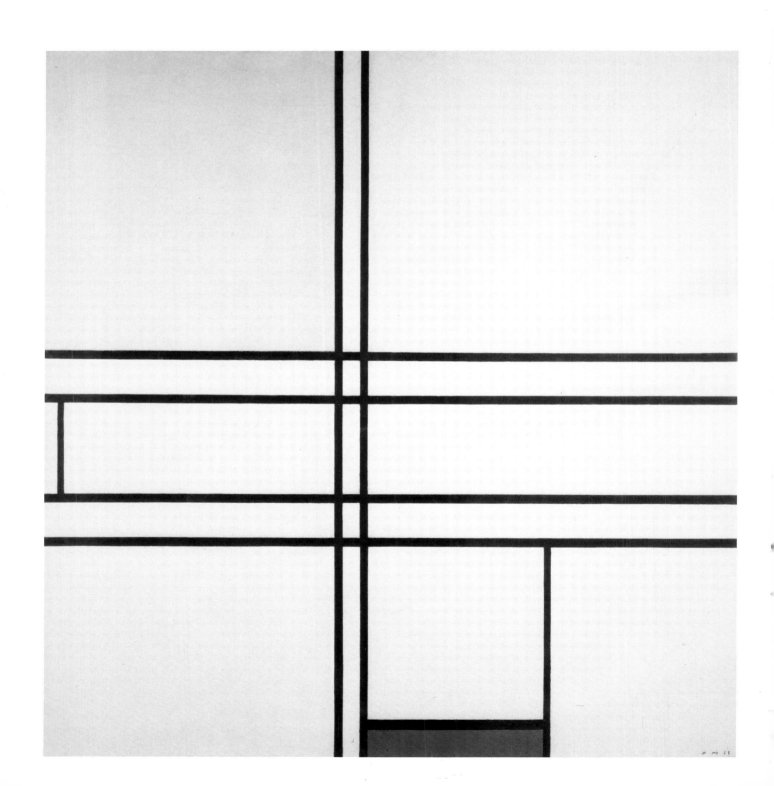

NIGHTMARES

Utopian Visions in Modern Art Valerie J. Fletcher

Smithsonian Institution Press

Washington, D.C., 1983

This book was edited by Virginia Wageman, designed by Alan Carter, typeset by Monotype Composition Company, and printed by Garamond/Pridemark Press.

The paper in this book meets the guidelines for permanence and durability of the Committee on Production Guidelines for Book Longevity of the Council on Library Resources.

Frontispiece: Piet Mondrian, *Composition with Blue and Yellow*, 1935 (58).

Library of Congress Cataloging-in-Publication Data:
Fletcher, Valerie J.
 Dreams and nightmares.

 Catalog accompanying an exhibition at the Hirshhorn Museum and Sculpture Garden.
 Bibliography: p.
 Includes index.
 1. Art, Modern—20th century—Exhibitions. 2. Utopias in art—Exhibitions. I. Hirshhorn Museum and Sculpture Garden. II. Title.
N6487.W3H573 1983 709'.04'00740153 83-16651
ISBN 0-87474-432-6

CONTENTS

Hirshhorn Museum and Sculpture Garden,
 Washington, D.C.
Indiana University Art Museum, Bloomington
Kunstsammlung Nordrhein-Westfalen, Düsseldorf,
 West Germany
Los Angeles County Museum of Art
Marion Koogler McNay Art Institute, San Antonio,
 Texas
Memorial Art Gallery of the University of Rochester
Metropolitan Museum of Art, New York
Munson-Williams-Proctor Institute, Utica, New York
Musée National d'Art Moderne, Paris
Museum of Fine Arts, Houston
Museum of Modern Art, New York
National Gallery of Art, Washington, D.C.
National Museum of American Art, Washington, D.C.
New Jersey State Museum, Trenton
Philadelphia Museum of Art
Portland Art Museum, Portland, Oregon
San Francisco Museum of Modern Art
Smith College Museum of Art, Northampton, Massa-
 chusetts
Solomon R. Guggenheim Museum, New York
Stedelijk Museum, Amsterdam
Tate Gallery, London
University of South Florida, Tampa
Whitney Museum of American Art, New York
Wichita Art Museum

André Emmerich Gallery, Zurich, Switzerland
Carl Solway Gallery, Cincinnati
Carus Gallery, New York
Cordier & Ekstrom, New York
Galerie Hilger, Vienna
Gimpel-Hanover Gallery, Zurich, Switzerland
Leo Castelli Gallery, New York
Leonard Hutton Galleries, New York
Max Protetch Gallery, New York
Pace Gallery, New York
Rachel Adler Gallery, New York
Ronald Feldman Fine Arts, New York
Rosa Esman Gallery, New York
Sidney Janis Gallery, New York
Sonnabend Gallery, New York
Twining Gallery, New York

FOREWORD

It is hard to think of 1984 without George Orwell coming to mind, his dire predictions blessedly tardy but threateningly real as each day reveals new perplexities of universal magnitude.

Indeed, it was the approach of the Orwellian year that sparked the idea for this exhibition, not in any direct sense or as a reflection of the book's message, but rather as an examination of the artists' role in shaping the utopias of the twentieth century and vice versa—in particular, the confluence of utopian ideals and Modernist art.

Western society currently is in an anti-utopian or dystopian mood, responding negatively to any social scheme or reform that posits a systematic reorganization of society. What a contrast this offers to the optimism prevalent at the beginning of this century, when social and individual renewal and rebirth were conceived of on the most audacious and hopeful utopian levels.

The movements discussed in the "dreams" section of this publication reflect the transcendent aspirations, the millennial vision of a society transformed, and of man recreated. The "nightmares" section treats the very opposite, the suspicion and hostility such utopian visions arouse today.

What seems remarkable now is the close affinity between utopian visionaries and the formalist aesthetic devices introduced in the early years of this century. As the heirs of an "art-for-art's-sake" doctrine, we tend to accept Modernist formal solutions as stemming from some innate and inevitable progression of aesthetic imperatives, free from outside influences or at the least limited to a minimum of such intrusions. How disconcerting to realize that so many pictorial inventions, now so acceptable, were the result of the most sanguine utopian aspirations. To impose such a limiting view on art history tends to assign emphasis in the wrong places, or at the least, to oversimplify its complexities.

It is interesting to realize that the ideals so ardently proclaimed by the Italian Futurists, who became the cultural allies of Mussolini's fascism, were embraced (to the extent of adapting Futurism's forms and dynamic philosophy) by the Russian Communists. Such is the leveling nature of utopia! Likewise, it seems of

singular interest that the utopian visions that obsessed the Italians, Russians, Germans, French, and Dutch ceased at approximately the same moment, with or without official government censure or pressure.

In any case, the connection between the utopian visionaries and the nature of twentieth-century Modernist art is undeniable and extensive, far more than is generally realized. Without question, the genesis of nonobjective art is to be found in the philosophical reflections and pronouncements of the utopianists prior to and immediately following the First World War. But it must be added that whatever its origins and no matter how interpreted, utopian art remains potent and influential in its other aspect as "pure" art.

While the language of utopian-inspired art has become the basic vocabulary for the art of this century, its genesis too often misinterpreted or neglected, dystopian art has yet to achieve the same universal endorsement. Perhaps its themes are too distressing for generations raised on the concept of pure art. Dystopian art is in general more earthbound and polemical, more pointed toward unveiling and reproaching than to visionary analogies. In consequence, it must convince us by its passion as much as by its polemic, by the power of its content as much as by the strength of its aesthetic.

It is our hope that this exhibition and catalog will serve to clarify this most fascinating aspect of Modernist art and relate it more closely to the now almost forgotten ideals, dreams, and aspirations that nurtured so much of the art of our century, dreams which in our own time have turned into nightmares.

ABRAM LERNER
Director

PREFACE

Early in the twentieth century, there was a widespread belief that a new era was beginning, that the dawn had arrived for the birth of a future world that was to be dramatically and beautifully different from the imperfect world heretofore known. This optimism was pervasive in European intellectual and artistic circles from the turn of the century through the 1920s and somewhat later in the United States. The flood of new movements in art in the period between 1910 and 1930 was characterized by a firm stand on the key issue of shaping the new era and on the central role of art in the formation of a new world/reality. The Modern Spirit was inextricably linked to an optimistic world view, and various artists in different countries were often surprisingly alike in their ideas. In general, they perceived science and technology positively, welcoming it as a foreshadowing of and the principal means toward achieving the better world. Many sought to comprehend and reveal the fundamental laws governing the universe, as if doing so would bring harmony to the world. This metaphysical concern incorporated for some an espousal of pure reason or rationalism, for others a more occult mysticism.

Utopian goals of early Modernists ranged from those primarily concerned with attaining a higher spiritual realm of consciousness, as was the case with Kasimir Malevich, Wassily Kandinsky, and Piet Mondrian, to those more concerned with the practical, physical aspects of an ideal world, such as the Russian Productivists and members of the Bauhaus. This exhibition cannot hope to demonstrate the full range and richness of the many utopian artists of the early twentieth century. I have tried to represent the major utopian artists and bring forward some who have been little known or rarely seen in the United States. In the final choices, somewhat greater preference was given to the dreamers over the pragmatists. In many ways the world in which we live is the heritage of the pragmatists, so it is the unfulfilled dreams that are allowed to have their day again in this exhibition.

The early twentieth century was paved with utopian schemes. Yet none succeeded as originally envisioned, despite the "fallout" effects they had on subsequent culture. Indeed, we have become so accustomed to

considering the ideas of utopian dreamers as naive, or, in the light of history, potentially dangerous, that we find it difficult to understand their commitment, their enthusiasm, their belief that their purpose was to succeed in propagating a new world. Though perhaps their spirit is one that cannot or possibly ought not be recaptured, it was nonetheless a remarkable phenomenon. In order to convey some of this élan, I have used as much as possible the artists' own words, of which there were many in that period of "spreading the word."

That the utopian spirit of early Modernism died has long been evident. It died quietly in the turmoil of the worldwide Depression, in the repressions of the new totalitarianism of Stalin, Hitler, and other dictators, in the horrors of World War II. It metamorphosed into an empty shell—often capable of great beauty and even power, but devoid of its early purpose. In its place a new spirit awoke. Not born of hope nor clothed in beauty, this new awareness arose from confrontation with, rather than escape from, the facts of painful reality, and its guise was fear—but a fear often engendered by a love of humanity. At times despairing and cynical, this new attitude subsumed an unspoken hope that the worst could yet be averted—and so in a way this new anti-utopian spirit has an inner core of utopian hope.

Anti-utopian, or dystopian, attitudes were first expressed and have become best known in literature, but they are also evident in the visual arts, particularly since the early 1960s. In marked contrast to the utopians, these artists have not for the most part been enshrined in the annals of art history. They have existed outside the formalist mainstream of modern art. It is only with the advent of Postmodernism, the "official" demise of the Modernist spirit in recent years, that their styles, as well as their meaning, have gained greater acceptance and attention. Some react explicitly against utopian ideas and styles, as Aldous Huxley and George Orwell did in their books. In *Nineteen Eighty-four,* Orwell summarized the contrast between utopian hopes and dystopian perversions:

In the early twentieth century, the vision of a future society unbelievably rich, leisured, orderly, and efficient—a glittering antiseptic world of glass and steel and snow-white concrete—was part of the consciousness of nearly every literate person. . . . The ideal set up by the Party was something huge, terrible, and glittering—a world of steel and concrete, of monstrous machines and terrifying weapons—a nation of warriors and fanatics, marching forward in perfect unity, all thinking the same thoughts and shouting the same slogans, perpetually working, fighting, triumphing, persecuting—300 million people all with the same face.[1]

Other artists have been inspired directly by events in contemporary society. In choosing artists and their works, I have eschewed those concerned with specific political events, such as the Sacco and Vanzetti trial or the massacre at My Lai. The intention here is to express a "Weltgeist," a spirit of concern for humanity without restrictions to nationalities or political parties. Thus, although a dystopian artist may have been originally motivated by the abuses of one government or credo, he would be moved to express his concern in universal images, comprehensible by and applicable to people everywhere.

Dystopian artists feel compelled to show us dangers, to warn us against the perils of *Brave New World* and *Nineteen Eighty-four.* However, as artists, their concern is with art, and not only with its import; they embrace art as something that can evoke rather than categorize, provoke thought rather than advocate a plan of action, move us to ideas and emotions and consciousness as no factual reality can. Perhaps they are a rearguard action, rather than the vanguard so continually sought in modern art, but their works, seen here half a century after Hitler took power in Germany and Stalin repressed utopian idealism in Russia, exert a call-to-arms as significant today as that of the utopians in the early years of our century.

ACKNOWLEDGMENTS

As a historical examination of twentieth-century art from a particular viewpoint, this exhibition perforce involved the efforts of a great many people. There were complex decisions and countless problems. To all those who assisted in bringing this project to fruition, I am profoundly grateful. I owe a special debt of gratitude to Abram Lerner, Director of the Hirshhorn Museum and Sculpture Garden, for his support of this project from the beginning, for his encouragement, and for his reassuring confidence in my abilities. To Stephen E. Weil, Deputy Director, I extend my warmest thanks for his ready advice and perceptive questions, which have extended to every aspect of the exhibition. To Charles Millard, Chief Curator, who has tolerated the inevitable disruptions caused by deadlines and crises with remarkable forbearance, goes my appreciation. Nancy Kirkpatrick, Executive Officer, has astutely guided this exhibition through the intricacies of budgetary and administrative requirements; for this I am grateful.

Many members of the Museum's staff worked expertly and cooperatively to realize this project in a very short time. Principal among these has been Jill Gollner, secretary to the curatorial department, who efficiently coordinated loan correspondence, typed and retyped the manuscript (including several major revisions that required exceptional dedication), and dispatched numerous other tasks with unfailing enthusiasm and good humor; her contributions have been crucial to the successful completion of this project. Deborah Geoffray, Exhibitions Assistant, handled a variety of loose ends, particularly pursuing elusive photographic materials, often on short notice. Meryl Klein, Assistant Registrar for Exhibitions, overcame innumerable difficulties in assembling works of art from many different sources. To her and to Registrar Doug Robinson I am profoundly grateful.

Joe Shannon, Chief of Exhibits and Design, devised the exhibition's layout through many alterations with true discernment. Ed Schiesser, production supervisor, assured the smooth progress of the installation with his customary humor and good nature. Producing this catalog entailed the efforts of various other professionals. Chief Photographer Lee Stalsworth made an exceptional number of illustrations for this catalog

with skill and speed. Anna Brooke, Librarian, carefully organized the bibliography. The editorial and design staff, particularly Ruth Spiegel and Alan Carter, at the Smithsonian Institution Press worked as effectively and cheerfully as always. Marian Burleigh-Motley reviewed the manuscript with thoughtful attention and insight. Special appreciation goes to Virginia Wageman, the Museum's editor, with whom it has been a pleasure to work. Editing the tremendously detailed manuscript while facing an imminent deadline, she attacked the various problems with patience, expertise, and extraordinary good will.

Penine Hart not only assisted with research and typing but offered well-timed encouragement. In addition to his customary responsibilities for publicizing the exhibition, Public Information Officer Sidney Lawrence supplied astute criticism on the catalog essay. In the Education Department, Victoria Lautman supervised docent training and Roni Polisar helped with catalog research and production. Other members of the Museum's staff who have been particularly helpful are Bob Allen, Denise Arnot, Charles Bobart, Jonnette Butts, Arthur Courtemanche, Mary Ann Gurley, Roy Johnsen, Brian Kavanagh, Jim Mahoney, Carol Parsons, and Francie Woltz.

A number of volunteers and student interns worked as research assistants and invaluable helpers throughout the project. Janet Coates, Ann Deutsch, Anne Fehr, Caroline Laccetti, and Patricia Waters gathered information in the early stages. Lynne Baer, Gisela Cooke, Janet Farber, and Barbara Woodward assisted in many, often laborious ways during the past year and a half. To these women and to my colleagues in the Department of Painting and Sculpture who furthered my work in various ways go my affectionate thanks.

I wish also to thank especially Tom Haueter and Pamela Fletcher for their warm personal support. Carla Panicali provided crucial intervention to obtain several difficult loans. Above all, the lenders to the exhibition have my sincere gratitude for graciously allowing us to borrow their fine works of art.

UTOPIAN DREAMS

INTRODUCTION

In the late nineteenth and early twentieth centuries, all of Europe simmered with expectations for the future. Many people felt that a new era was dawning in which a future world would be fashioned to be dramatically and beautifully different from the imperfect world heretofore known. This utopian attitude was pervasive in European intellectual and artistic circles from the turn of the century through the 1920s and somewhat later in the United States. With the end of the nineteenth century, millions of people felt that a millennium—that is, a period of great goodness and happiness, of perfect government and freedom from the imperfections of human existence—was at hand. Much more than the end of a decade, the transition to a new century carries a feeling of momentous significance, and this particular century had been one in which the physical world and man's perception of it and of his own place in it had been decisively altered.

The dramatic development of industrialization and the resultant urbanization in the nineteenth century had changed economic, political, and social structures more than in any period since the Renaissance or perhaps since antiquity. As Charles Péguy remarked in 1913, "The world has changed less since the time of Christ than it has in the last thirty years."[2] The period from 1875 to the outbreak of World War I was one of tremendous advances in science, technology, industry, and international socialism. This was seen as unprecedented progress, and it was widely believed that the twentieth century would reap the fruits of what the nineteenth century had so arduously sown. The earlier nineteenth-century feeling that the machine was a curse had metamorphosed into one of unqualified confidence, with little of the ambivalence and uncertainty of today. This period was marked by an astounding proliferation of inventions.[3] But it was not so much the specific inventions themselves, though they caused tremendous changes, as the sense of an accelerated rate of change in life, the feeling of being at the end of an older age and on the threshold of a new era, whose nature and laws had yet to be discovered.

From the 1890s, when feelings of anticipation began to grow, through the 1920s, when international

enthusiasm and commitment to the new cause reached their apogee, references to the new era and to coming fundamental changes recur in literature with amazing frequency. In an essay called "The New Age," published in *The New Age* (a socialist periodical edited in England by A. R. Orage in 1907–22), the poet Allen Upward wrote in 1911:

It is a sign of the times that so many of us should be busy in studying the signs of the times. In no other age since the birth of Christianity has there been manifested the same devouring curiosity about the future, and the same disposition to expect a new earth if not a new heaven.[4]

Creative and thinking individuals, especially artists, sought to proclaim the reality of this new age, to define it and to launch a purposeful program for the future. The writer Robert Musil later described this atmosphere of anticipation and participation:

Nobody knew exactly what was on the way; nobody was able to say whether it was to be a new art, a New Man, a new morality or perhaps a reshaping of society. . . . But people were standing up on all sides to fight against the old way of life. . . . The Superman was adored and the Subman was adored; one dreamed of . . . man and woman in the primeval Garden, and the destruction of society. Admittedly these were contradictions and very different battle cries, but they all breathed the same breath of life.[5]

All across Europe, many artists in the 1910s and '20s were convinced that the time was right for constructing an entirely new civilization based on a different, perfect order. The coming of a new age was imminent, as noted by the German Expressionist painter Franz Marc: "The world gives birth to a new age; there is only one question: has the time yet arrived today in which the old world will be dissolved? Are we ready for the *vita nuova?*"[6]

In sharp contrast to the *art pour l'art* aestheticism of the late nineteenth century, many artists came to feel, especially after World War I, that their task was to help forge an ordered and holistic new world to replace the chaos and fragmentation of extant civilization. The flood of new movements in art in the period between 1910 and 1930 was characterized by a firm commitment to the formation of a new

world and to the realization of an enlightened Modern Spirit. The architect Le Corbusier wrote in 1920: "There is a new spirit abroad: it is a spirit of construction and synthesis, moved by a clear conception of things. Whatever one may think of it, this spirit animates the greater part of human activity today. . . . A GREAT ERA WHICH HAS JUST BEGUN."[7]

Of the numerous artists committed to the creation of this new world can be counted the Italian Futurists, the Russian avant-garde (including the Suprematists, Constructivists, Productivists, and others), a few Expressionists and the Bauhaus in Germany, the international De Stijl group originating in Holland, the French Purists, and a few American artists, architects, and designers.

The impetus was clearly not to reconstruct the past but to build anew. It was an enormous responsibility to formulate the plans and lay the foundations of a new civilization. As the Bauhaus artist László Moholy-Nagy said, "We need Utopians of genius."[8] Though many artists and writers were filled with this desire to work toward an ideal future, the exact nature of this common goal was difficult to pin down in specific terms:

We lack a utopia! Utopia, that is the goal of all truly living men, that is the ideal for which one [longs] to die . . . this [so utopian] ideal, unity in belief, in love, in hope for humanity.[9]

In proclaiming their commitment to an ideal new world, optimistic artists and intellectuals of the early twentieth century drew less upon the traditions of art than upon centuries of utopian thought. Indeed, the plethora of idealistic art movements of that period represents the culmination of those visionary conceptions and social philosophies loosely known as utopias.

The word *utopia,* coined in 1516 by Thomas More to describe an ideal imaginary country, derives from the Greek roots *ou/eu* and *topos,* meaning both "no place" and "good place." Utopia may be succinctly defined as an ideal state in which all is ordered for the best for mankind as a whole, and social evils such as poverty and injustice have been eliminated—in short, "a society in which peace, abundance and

virtue permanently and universally obtain."[10] Concise definitions, however, do not do justice to a concept with many different meanings. Utopia represents centuries of ideas in the form of novellas, manifestoes, detailed blueprints, political tracts, philosophical discourses, economic treatises, actual communities, and pure fantasy. To some degree, these theoretical models are all speculative, imaginary, visionary, though they may range from carefully detailed pragmatism to nonspecific spiritual or metaphysical postulations. Many are futurist in the sense that they are based on a passage of time until technological, socioeconomic, ethical, or other conditions arrive that would make the project attainable.

Since its goal is to postulate expansions beyond the limitations of known life and society, utopia is a perpetually expanding conception, speculating on the nature of a better world and stimulating man to reshape reality to approximate more closely the ideal of his dreams. Yet to others the word means something not quite admirable: impractical escapism that avoids grappling with reality, or worse, a messianic attempt to impose arbitrary or simplistic solutions on nonhomogenous humanity—hence the derogatory use of the word *utopian*. Still, for many people through the centuries the word has meant a source of hope, a repository of humanitarian ideals, a plan of action, an eventual solution to perennial and seemingly unnecessary social problems.

Utopian writings have exerted an immense inspirational force in the history of Western cultural thought. Although many seminal concepts were introduced in Plato's *Republic* (ca. 384–370 B.C.), it was not until the Renaissance that attention shifted from emphasis on heavenly rewards to humanistic concerns with mankind's terrestrial well-being. Thomas More's *Utopia* (1516) reasserted many of the classical ideals of the *Republic* and laid the groundwork for subsequent proposals. Essential to the conceptions of both Plato and More was the recognition that an ideal, equitable society can exist only if a cooperative spirit prevails. Communal activities, such as work and athletics, or in some cases shared living and dining facilities, would encourage a sense of "belonging" and cooperation, replacing isolation and selfishness. Responsible, be-

nevolent rulers would administer the equitable development of the economy and property (socialism *avant la lettre*), as well as supervise universal education and justice.

After the tremendous social, economic, and cultural changes of the Renaissance and the Reformation, the early seventeenth century yielded unprecedented numbers of utopias which introduced additional concepts that eventually became equated with utopian thought. The city, or city-state, constructed according to a geometrically regular plan became a favored setting in many literary utopias and was often depicted in paintings. Johann Andreae's *Christianopolis* (1619) emphasized the central importance of religion and work to the creation and maintenance of an ideal society. An important characteristic of Renaissance and subsequent utopias is their comprehensive approach, with regard to not only social planning but human fulfillment in general. Tommaso Campanella's *City of the Sun* (1623) proposed an international commonwealth to replace the divisiveness caused by European nationalism and by Catholic and Protestant rivalry. A Dominican monk, Campanella tried to unite basic Christian theology with esoteric traditions like astrology and also with science and rationalism (ideas that earned him long imprisonment under the Inquisition). Francis Bacon's *New Atlantis* (1624, published 1627) is noteworthy for its wholehearted espousal of science as the means to universal abundance through application to industry. He described a future time when discoveries in medicine, biology, metallurgy, physics, and the other sciences would have yielded astounding inventions (foreshadowing the telephone, telegraph, aircraft, submarines, steam engines, even what we would call "alternative energy" sources).

In contrast to the outburst of utopias produced amid the upheaval and excitement of the Renaissance, the eighteenth-century Enlightenment produced few noteworthy utopias. Jean-Jacques Rousseau (1712–78) advocated a return to nature, without science or luxury, a supposedly ideal Edenesque state depicted in the Arcadian landscapes of the French painters Nicolas Poussin and Claude Lorrain. However, that period witnessed the dissemination of egalitarian ideals and the emphasis on reason and education in

the formation of new societies. The attempted implementation of these ideals in the late eighteenth century (particularly in the American and French revolutions) and the massive socioeconomic changes caused by the Industrial Revolution spurred the development of utopian socialism in the early nineteenth century.

In the immediate aftermath of industrialization, utopian socialists tried to moderate the detrimental impact of technology and urbanization on human life, while utilizing their potential benefits. Many reformers, like Robert Owen (1771–1877), tried to regroup society through restructuring industrial agglomerations into agricultural communities, which would avoid the problems of urban concentration. Owen hoped to inaugurate a "New Moral World," where mankind would be liberated from the "monstrous evils" of private property, "absurd or irrational systems of religion and other institutions like marriage."[11]

One of the most influential early utopian socialists was Henri de Saint-Simon (1760–1825). In his four-volume *Industry* (1816–18) and other writings, he advocated rational scientific progress as the means to a new social system based on industry and science. A progenitor of modern sociology and proponent of positivism, Saint-Simon sought the laws underlying human behavior and perceived science as developing in cycles to ever higher levels. He believed that a rational religion (a revised Christianity) and a socialist economy controlled by experts in technology and business could eliminate poverty. His ideas included an important role for the arts, which he felt could help create that future utopia, "when literature and the fine arts have . . . finally filled society with passion for its own well-being. . . . What a most beautiful destiny for the arts, that of exercising over society a positive power, a true priestly function . . . this is the duty of all artists, this their mission."[12] Saint-Simon's approach appealed to many people through the nineteenth century, including Karl Marx and a number of radical artists who strove for social import in the arts.

Another popular utopia was that proposed by Etienne Cabet in his novel *Voyage to Icaria* (1839), which described a prosperous and crimeless democracy divided into one hundred provinces, where everyone would be absolutely equal. Families would have identical individual houses with the same furniture, food, and clothing, because Cabet believed that only in a truly egalitarian environment could social-minded, harmonious individuals be developed. Though this concept had been expressed in More's *Utopia,* which has fifty-four identical cities, *Icaria* carried the concept further and engendered an immediate following.

In contrast to such ordered conformity, Charles Fourier (1772–1837) theorized that perfect harmony would result when everyone's natural urges were gratified. Satiating rather than trying futilely to overcome one's desires would allow individual happiness, while analytically applying these passionate needs would yield a harmonious collective order. All men would live like kings in luxurious communities, called phalanxes, housed in specially built communal palaces, called phalansteries. These would incorporate all kinds of resources, from workshops to ballrooms, residences, and banquet halls. People would work at a variety of jobs, which they would change frequently so as to avoid drudgery. Families would become unnecessary, and free love would prevail.

One form of utopian socialism that persisted through the nineteenth century rejected modern industrialization and urbanization in favor of a simpler life. In what was later to be labeled an anti-utopian view, many people felt that urban and technological development destroyed humanist values and lifestyles. This attitude dominated utopian practice in the United States, where hundreds of experimental communities were established in the nineteenth century, including over fifty Fourierist phalanxes and a number of religious utopian communities. In Europe, artist William Morris's *News from Nowhere* (1890) proposed returning to the methods and values of preindustrial times. Morris condemned the industrial division of labor because the mindless repetition reduced workers to stunted fragments, incapable of full development and fulfillment. Accordingly, Morris advocated decentralization and cottage industry, along the lines of medieval craft guilds.

A number of nineteenth-century political reformers, including Pierre-Joseph Proudhon in France, Henry

George in the United States, and Peter Kropotkin in Russia, advocated decentralist utopian structures. The most extreme form was idealistic anarchism, which attracted many individualists toward the end of the century, especially in France. Their goal, perhaps the utopian vision most reliant on the belief in the innate virtue of humanity, was a society entirely based on the free association of individuals without permanent structures or controls. The appeal of idealistic anarchism was so pervasive at the turn of the century that the aesthetics of some utopian artists in the 1910s reverberate with confidence in the formation of a new society based on the self-improvement of the individual, rather than on well-planned social structures.

Most other influential utopias, however, recognized the need for utilizing urban planning and technology to improve society in a populous age. The communitarian and decentralist approach of the early utopian socialists was supplanted in the late nineteenth century by political and economic theories that advocated the attainment of an ideal state through decisive, all-encompassing revolutionary action. The most influential of these theorists were, of course, Karl Marx and Friedrich Engels. In *Socialism: Utopian and Scientific* (1878) they contrasted traditional utopian proposals for isolated communities with their own "scientific" method, which emphasized the possibilities of full industrial development. By effecting complete industrialization, their utopia would attain material abundance, which in turn would eventually result in an egalitarian society. By the late nineteenth century, the precepts of utopian socialism concerning modest communities, as well as the more inclusive and revolutionary brands of Marxism had become so widespread that the term utopia became equated with socialist economics and leftist politics.

In the 1890s, popular literature promoted utopian ideals among many readers who would not normally consider such issues. Among the most widely read publications were those by Edward Bellamy and H. G. Wells, who brought traditional utopian definitions into the modern era. In *Looking Backward* (1888), Bellamy hypothesized that big business and big government in the United States would grow until they

would merge. By the year 2000, the United States would have become a prosperous, ordered socialist state, having universal education to age twenty-one followed by industrial work with equal pay. After forty-five (the age of retirement and suffrage), people would enjoy a cultivated life. The new environment, with its comforts and conveniences for all (housework would be minimal owing to labor-saving devices and shared laundry and dining facilities), would foster in turn the finer aspects of human nature. *Looking Backward* engendered enormous enthusiasm: by 1890 it had sold nearly two hundred thousand copies in several languages, and Bellamy societies were springing up in Europe and America.

Although widely known today as a founding father of science fiction, in the early twentieth century H. G. Wells (1866–1946) was considered to be the foremost proponent of utopianism. He inspired an enthusiastic following somewhat like that of R. Buckminster Fuller in the 1960s. Wells's compelling vision was so enormously influential in the first three decades of this century that George Orwell could write after his death:

Thinking people who were born about the beginning of this century are in some sense Wells' own creation. . . . I doubt whether anyone who was writing books between 1900 and 1920 . . . influenced the young so much. The minds of all of us and . . . the physical world would be perceptibly different if Wells never existed.[13]

Wells had such success in propagandizing his archetype of the future (through publications and lectures) that he came to be identified with it. The scientifically planned welfare state, technologically efficient, gleemingly hygienic, is often called "the Wellsian vision."

In his *Modern Utopia* (1905), which was widely read and reviewed, Wells summarized utopian prescriptions from Plato and More through Bellamy, and made several notable contributions to utopian thought. Unlike previous utopians, who proposed isolated communities, or even a unified Europe, Wells asserted that utopia could exist only on a worldwide scale. With modern communication and travel, Wells

forecast that no place could exist in isolation and, as Buckminster Fuller later demonstrated in his World Game strategy, full employment and equitable distribution of resources would require global cooperation. Such large-scale operations would entail coordination by a single government, which would lease out all resources to private development and would ensure the efficient functioning of the socialist welfare state. This World State would be administered by a class of rigorously trained rulers, called samurai, who would earn their positions through proven intellectual and moral merit and who would be required to live abstinently, even ascetically, in order to preclude corruption.

Besides the World State, the most outstanding central premise of Wells's utopian writings is the predilection for science and technology as the keys to societal progress. Not only do they allow full development of material resources, they provide the means to comprehensive planning on all levels of society. Wells's stories evoke captivating images of a shining new world created by beautiful machines, an image which so thoroughly permeated the consciousness of an entire generation that it dominated futurist conceptions in art, design, and film (e.g., Flash Gordon) up to World War II and still today in science fiction, which has become the refuge for such utopian dreams.

Another important premise of the Wellsian utopia was its far-reaching intentions. Unlike traditional utopian proposals, with their tendency toward static perfection, Wells's modern utopia was proposed "not as a permanent state but as a hopeful stage leading to a long ascent of stages."[14] This open-ended conception characterizes the ideas of many utopian artists of the early twentieth century. Rather than strictly defining a single, limited condition, many artists felt that the ultimate goal could not yet be known. The Italian Futurist painters felt that their utopian aspirations were only the first stage in attaining an as yet imperfectly perceived goal—"others will follow who . . . will conquer those summits of which we can only catch a glimpse."[15] Wells suggested that the ultimate purpose would be to shift the emphasis of human existence from the lower to the higher emotions, a supramaterialist goal remarkably similar to that of many utopian artists in the 1910s and '20s. He forecast that eventually the world would evolve beyond even the regulatory restraints of *A Modern Utopia* to a beautiful, visionary perfection, without politics, government, police, prisons, or insanity, because all humans would have transcended their baser natures:

Nearly all the greater evils of human life had been conquered. . . . The dreams of artists of perfected and lovely bodies and of a world transfigured to harmony and beauty had been realized; the spirits of order and organization ruled triumphant.[16]

Thus when artists in the early years of the twentieth century dedicated themselves and their art to the formation of a new ideal world, they had centuries of utopian thought to draw upon. Few utopian artists could be explicitly detailed about the specifics of the new world; rather, the character of the new era was discernible only in broad concepts. For some artists, particularly those who matured before World War I, the new age was to be one of increased or enhanced spiritual consciousness. Some occult religious philosophies in the late nineteenth and early twentieth centuries predicted the arrival of a new eon, radically different from past epochs. This anticipation of a mystical renewal underlay the aesthetics of some artists, notably Wassily Kandinsky and Piet Mondrian, both of whom were influenced by Theosophy. When Kandinsky referred to "our dawning epoch" and "the new world" in his aesthetic treatise *Concerning the Spiritual in Art* (1909, revised and published 1912), he understood it as a period of unprecedented spiritual enlightenment: "We see already before us an age of purposeful creation, and this spirit in painting stands in a direct, organic relationship to the creation of a new spiritual realm that is already beginning, for this spirit is the soul of the epoch of great spirituality."[17] Mondrian described the life of the new era as "directed neither toward the material for its own sake, nor toward the predominantly emotional: it is rather the autonomous life of the human spirit becoming conscious."[18]

Some artists perceived the new age as emerging in a distant future, while others saw it as already *in esse,* with World War I bringing it to the fore. Walter Gropius spoke for a number of German utopians when he wrote in 1919:

The old human spirit is overturned and is being recast into a new form. We . . . do not yet know the new order. We living will not experience it. Our work can only encompass the preparation of a coming unity of a later, harmonious time.[19]

World War I provided the catalyst for the international intensification of utopianism. By the time war broke out, a generation of young European artists was convinced that a revolution of values was necessary. Dreams of a new era for mankind not only survived the war, they were fueled by it. For many people it was the war to end all wars, creating a tabula rasa on which to build anew. The end of the war initiated a short-lived but exciting period of creative effort in the service of society.

Many intellectuals, artists, and writers believed that the power of science and technology could be harnessed for constructive purposes. They enthusiastically proclaimed that, above all, the new era was to be the machine age. Widely ranging scientific subjects attracted artists all across Europe. The French poet Blaise Cendrars recalled that artists in the 1910s and '20s "were much occupied with the latest theories about electro-chemistry, biology, experimental psychology and applied physics."[20] Utopian artists hoped to find in the astounding new scientific developments a legitimate model for social reconstruction, believing with Moholy-Nagy that "new tools and techniques cause social changes."[21] Science and technology epitomized for utopian artists the characteristics of their new world: dynamism, precision, order, abundance, cleanliness, and efficiency. They therefore tried to embody these qualities in their art, by employing industrial materials in the traditional arts of painting, sculpture, and architecture, by depicting subjects associated with technology, and by creating designs for the mass production of metal furniture and appliances. This "machine aesthetic" was perceived as signaling the new utopian culture and consciousness

that would transcend arbitrariness and inequity. Furthermore, most utopian artists in the 1920s and beyond looked to the scientific method as the ideal rational process that could liberate humanity from past irrationalities and individual capriciousness. They believed that the intellectual processes (especially logic and objective analysis) as well as the materials of modern science and technology (such as steel and glass) could serve as both inspirational ideals and practical models for restructuring the physical environment and building the future utopia.

Compounding this confidence in the technological potential for progress was the awareness that sweeping political changes were indeed possible and promised extensive social reconstruction. The Russian revolution had shown that even an ancient, entrenched status quo could be altered dramatically, if not obliterated. The founding of the Weimar Republic in 1918 reaffirmed the feeling that radical sociopolitical changes were "in the air" as part of the new era. This was powerfully felt even in countries that remained apart from political upheavals.

In keeping with nineteenth-century utopian theories, most early-twentieth-century European intellectuals viewed socialism and Communism as the next appropriate stage in the evolution of historical progress toward a perfected world. A number of utopian artists, especially in Germany and Russia, espoused socialist ideas, though few went beyond vague generalities concerning the aims and methods of political or economic ideology. Many avant-garde artists throughout Europe equated the Russian revolutionary regime with utopian ideals in general, as one German writer observed in 1920: "The key idea [or ultimate aim] of Bolshevism is the dissolution of the state, the opposition to every [system] for the good of an absolute humanity."[22]

In Russia, most avant-garde utopian artists supported the revolution. Some, like Tatlin, were active supporters of the Party and its ideology, while others, like Malevich, remained more aloof. Many put their art directly in the service of the Communist regime. Yet their writings rarely dealt with political ideology; the impression is that their eagerness to construct a new world left little room for a clear understanding

of Leninist or Stalinist ideology. For example, Lissitzky wrote:

If communism which set human labor on the throne and Suprematism which raised aloft the square of creativity now march forward together, then in the further stages of development it is communism which will have to remain behind because Suprematism—which embraces the totality of life's phenomena—will attract everyone away from the domination of work and from the domination of the intoxicated senses. It will liberate all those engaged in creative activity and make the world into a true model of perfection.[23]

In Germany, many artists and writers were attracted to socialism as a form of an international cooperative brotherhood, as the activist writer Kurt Hiller noted: "Socialism is no party doctrine but a way of thinking; it is the focussing of the soul on fraternity."[24] A number of artists used the term to describe a suprapolitical idealism derived from pacifism and egalitarianism. They believed that eventually, after a transitional period in which society would be reordered according to artistic criteria, traditional government per se would become superfluous. Bruno Taut wrote: "The states and the powers of the state will vanish: a new form of government will take their place . . . politics, war will . . . disappear."[25] Politically naive, the German architects dreamed of a nonmaterialist, pure form of socialism, as Carl Krayl wrote to Gropius in 1919:

We want to look into the distant future and show what is to come. . . . This time will come, for our own age of materialism in every form is tired, spent, devoid of ideas. . . . Nothing else can follow other than a release from the bonds of the materialist age, therefore *pure* socialism.[26]

The equation of socialism with transcending crass materialism was made by a number of utopians, like Hans Luckhardt who viewed socialism as proof of the evolution "toward a general spiritualization."[27]

At the Bauhaus, Gropius himself perceived Communism as a means of total transformation of the world, including personal attitudes and philosophies. Though his administration maintained an official policy of political nonalignment and there was a strict rule forbidding overt political activities on the part of both faculty and students, the school was widely perceived as a bastion of leftist sympathies. On the faculty, for example, Moholy-Nagy had tried unsuccessfully to join the Communist party after World War I, and he espoused the Russian-turned-international aesthetics of Constructivism in part because it was a classless art.

Although several De Stijl artists, including Theo van Doesburg, were sympathetic to socialism and Communism, the third manifesto of the De Stijl group, "Towards a Newly Shaped World" (1921), asserted their independence from any specific religious, political, or economic cause because the new era and its art would transcend these dogmas. They believed that the old Europe, with its religious sects, private property, materialism, and individualism, was dying, and in its place:

A new Europe already is arising thanks to us. The first, second and third Socialist Internationals constituted ridiculous nonsense. . . . The International of the Mind is an inner experience which cannot be translated into words. It . . . consist[s] of . . . creative acts and inner or intellectual force, which thus creates a newly shaped world.[28]

Thus van Doesburg defined the new world as internationalist and intellectual in character; its activating agents would be aesthetic and spiritual forces, rather than political or nationalistic activism.

Internationalism was one of the characteristics of the new era and its art. Although abruptly interrupted by World War I, the desire for international cooperation among artists re-emerged more strongly than ever. Many international exhibitions were held, and art journals were founded with contributors and subscribers from different countries.[29] Even in Russia, where war and the revolution had isolated artists from Europe after 1914, by 1922 Lissitzky could refer to "the internationalization of the new art" taking place throughout Europe: "The community of the tasks and aims of art in different countries is not something that exists by chance, nor is it inspired by dogma or fashion, but rather by an inherent quality of the mature human race."[30] In a similar vein, the De Stijl group believed that "the exponents of the new spirit . . . arise among all nations, among all

countries. . . . Theirs is the language of the mind, and in this manner they understand each other."[31]

Even without explicit associations with political ideology, the new era was envisioned by many artists as a time when universal precepts and collective cooperation would triumph over individualistic divisiveness, as Gropius affirmed at the Bauhaus:

The dominant spirit of our epoch is already recognizable although its form is not yet clearly defined. The old dualistic world-concept which envisaged the ego in opposition to the universe is rapidly losing ground. In its place is rising the idea of a universal unity in which all opposing forces exist in a state of absolute balance.[32]

These ideas were forcefully propounded by the De Stijl artists. In their first official manifesto (1918), they summarized what were to become internationally accepted attitudes concerning the nature of the new age:

1. There is an old and a new consciousness of the age. The old one is directed toward the individual. The new one is directed towards the universal. The conflict of the individual and the universal is reflected in the World War as well as in art today.
2. The war is destroying the old world with all that it contains: the pre-eminence of the individual in every field.
3. The new art has revealed the substance of the new consciousness of the age: an equal balance between the universal and the individual. . . .
7. Throughout the world the same consciousness has driven present-day artists to take part, on a spiritual level, in the world war against pre-eminence of individualism and idiosyncrasy. Therefore they sympathize with all who are waging a spiritual or material battle for the creation of international unity in life, art and culture.[33]

Thus, in a nutshell, the essentials of utopian attitudes: a new age, a new international consciousness, a new art, all aimed at creating a new world in which universal values would be recognized. The emphasis on *collective* effort and consciousness was widely perceived as one of the pre-eminent characteristics of the coming utopian world. Individualism was seen as limited and devisive.

Mondrian averred that in the new culture "the individual will be open to the universal and will tend more and more to unite with it."[34] Utopians throughout Europe perceived the merging of the individual with the universal as an expansion of human existence, not a restriction. Mondrian clearly defined the nature of the new era and the New Man as universal and transcendent, characterized by a new perception:

The mature universal *individual* emerges, who perceiving the universal more determinately, is capable of *pure plastic vision.* Thus the new era will differ from the old by its *conscious perception,* which will spontaneously realize itself everywhere as *universal.* . . . Our age forms the great turning point . . . for individuality becomes *real* only when it is transformed to universality.[35]

Even in the United States, this emphasis on collaborative, collective efforts emerged during the Depression, when individual efforts appeared fruitless in the face of overwhelming economic stagnation, as designer-architect Norman Bel Geddes noted in 1932:

As we progress, we will combine, which means we will work with the other person's interest in mind. Tomorrow, we will recognize that in many respects progress and combination are synonymous. Civilization is as much the product of cooperation as of individualism. Behind us are generations of rampant individualists; ahead, I believe, lies an era of rational cooperation.[36]

References to the New Man abound in utopian literature and art in the early twentieth century. In the late nineteenth century, Friedrich Nietzsche (1844–1900) had called for a glorious, idealistic new age, without materialist greed or petty nationalism, filled with free, creative souls. He advocated active struggle, rather than passive speculation and wishful thinking, to raise mankind to a divine level:

I bring you a goal. I preach to you the Superman. Man is something to be overcome. . . . All things before you have produced something beyond themselves, and would you be the ebb of this great flood? Would you rather go back to the animal than transcend man?[37]

The poet Guillaume Apollinaire summed up widespread sentiment when he wrote in 1915: "A new humanity is in the process of coming into being, more sensitive . . . more free, more loving, this new humanity is the spiral more heavenly than the bird, it is

the angel himself."[38] In *Men Like Gods* (1923), H. G. Wells forecast a distant future when people would have evolved into godlike beings (a concept popular around the start of this century in philosophy, mysticism, literature, and utopian art). This aspiration for a spiritualized new humanity underlies the aesthetics of Kandinsky's Expressionism, Malevich's Suprematism, and Mondrian's Neoplasticism. Mondrian defined the New Man, to whom he dedicated his new art in 1920, as entirely transcending the natural and technological environment to a new consciousness:

The new man should indeed be very different from the old type of man. . . . He lives amid material things, without enjoying them or suffering from them, as he once did: he uses his physical being as if it were a perfect machine, but without being a machine himself. And precisely there lies the difference: formerly man was himself a machine, now he utilizes the machine, be it his own physical being or the machine he constructs. To this last he relegates heavy work as much as possible, while he concentrates on spiritual inner things . . . while he himself becomes a *conscious mind.*[39]

In general, and especially at the Bauhaus, the New Man would be the whole man—intellectually, spiritually, and physically complete, capable of integrating natural needs with social concerns, instead of being a divided self, separated from fulfillment and from his fellow humans. After the mid-1920s, however, the holistic and spiritual conceptions of the New Man yielded increasingly to a mechanistic image of man. This idea of man-as-machine dates back at least to the eighteenth century and was intended as a positive analogy: if man would evolve and develop to be as logical, rational, and strong as machines, he would presumably be better off. Many artists from the 1910s to the 1930s depicted the New Man in a technological mold, emulating the appearances, precision, and objectivity of machines, as in Léger's *Figure of a Man* and *Man with Dog* (72, 73) and in Lissitzky's *Globetrotter* and *New Man* (29, 30). Especially after the early 1920s, the engineer, rather than the mystic or philosopher or teacher, became the ideal to be emulated, as asserted in a statement published with the *Machine Age Exposition* (1927) in New York:

There is a great new race of men in the world: the *Engineer.* He has created a new mechanical world . . . it is inevitable and important to the civilization of today that he make a union with the artist. This affiliation of [artist and engineer] will . . . become a new creative force.[40]

Many artists strove to emulate scientists and engineers by functioning objectively and consistently, as Lissitzky portrayed himself in *Constructor: Self-Portrait* (32).

In the new era, art and architecture were to play major roles in creating or attaining utopia. Although artists varied in defining the new utopian art, they were unanimous in their conviction that art and architecture were powerful activating agents that would serve humanity by working toward an ideal future. Artists placed themselves alongside the scientist and the engineer, the priest and the statesman as professionally engaged in forming the present and future world. Some believed their major task to be the formulation of ideals and goals, or models and prototypes of general rather than specific relevance. Of these, a few felt they should think far beyond practicality to fantasy, and leave the implementation to posterity; thus, even the most improbable possibilities could be postulated. Most utopians believed their role to be a didactic one, to educate humanity by means of art itself, art schools, lectures, and publications. Others wanted to become the physical builders of their future world, by laboring in workshops and factories. Whatever the individual shadings of the various definitions, it was agreed that the artist-architect would lead society toward its utopian goals.

In general, artists employed two approaches to effect their utopian goals. One was to encourage personal understanding and enlightenment, expanding human consciousness through the fine arts, particularly painting, and through education. The other was to ameliorate the environmental habitat, primarily through architecture and city planning, thereby diminishing some causes of destructive behavior, while simultaneously influencing social attitudes. The arts were expected to serve as indicators of the new world, reorienting mankind toward new values. At the Bauhaus, Moholy-Nagy summarized the utopian attitude toward the new art (regardless of the "ism"):

Art has an educational and formative ideological function, since not only the conscious, but also the unconscious mind absorbs the social atmosphere. . . . Despite the indirectness of his statement, [the artist's] work expresses allegiance to the few or many, to arrogance or humility, to the fixed or visionary. In this sense, he must take sides, must proclaim his stand.[41]

He believed that ideas concerning the improvement of society could be transformed into organized visual forms that could be intuited by the viewers: "This content can be generally grasped directly through the senses, on a subliminal level, without a conscious thinking process. Art may press for a socio-biological solution of problems just as energetically as social revolutionaries may press for political action."[42]

In ascribing such ambitious purposes to art and architecture, the means of expression—style—became a vital issue among utopian theoreticians. Since the messages that utopian artists hoped to convey were forward-looking and often concerned the alteration of mankind's *awareness,* rather than propaganda for specific social or political programs, the means of communication had to transcend the older representational styles. This included not only academic realism (which some utopian artists, like Kandinsky and Malevich, equated with empty materialism and unimaginative thinking), but also the doctrine of "art for art's sake." As Gropius observed at the Bauhaus, "All of us are fully aware that the old attitude of *l'art pour l'art* is obsolete and that things that concern us today cannot exist in isolation." Kandinsky's attitude was similar: "Beauty of color and form (despite the assertions of pure aesthetes or naturalists, whose principal aim is 'beauty') is not a sufficient aim by itself."[43]

Utopian artists embodied their beliefs in their subject matter, techniques, forms, and colors. Most, though not all, turned to abstraction. Some, like the Futurists and Precisionists, believed in the importance of recognizable subjects that connote an ideally organized, technological society, like machines, factories, and the city. Yet these utopians working in representational styles purified their subject matter in stylistic manners not far removed from abstraction. Compositions emphasize rectilinear structural elements, while forms are geometrically simplified, modeling is minimal, and colors are flat and pure. By selecting the "best" aspects of the world around them and eliminating the "bad," they project a timeless, idealized image, suspended in time and place.

Both representational and abstract artists favored pristine execution in their works. Brushwork in utopian painting is generally nonexpressive after World War I. Since an objective, collectivist society, purged of disruptive egos, was a widely desired utopian goal, anonymous execution became desirable. Nonmodulated brushwork and smooth, immaculate surfaces in all media were intended to express the artists' desires for an objective new reality and a collectivist new society in which individual efforts would merge into cooperative group efforts in the service of the new society. This manner of execution also bespeaks their espousal of the machine aesthetic. Technology and science, as the primary means to a better world, offered standards to be emulated by art: standardization, regularity, precision, anonymity, and objectivity. All these qualities were believed to exist in a crisp style of execution.

The media used in the creation of the new art and architecture also served as means of expressing utopian goals. The German architects of the Glass Chain group believed in the power of crystalline, colored glass to transform personal and social consciousness through spiritual and moral metamorphosis. Glass symbolized clearer awareness and determination, and provided a physical conduit for social harmony and spiritual enlightenment. The writer-architect Paul Scheerbart wrote, "Colored glass destroys hatred. . . . Glass opens up a new age."[44] What Scheerbart and others hoped for was no less than a new glass culture that would bring with it a new morality and a new consciousness: "A person who daily sets eyes on the splendors of glass *cannot* do wicked deeds."[45]

The most prevalent significance of materials in utopian art and architecture, however, was their association with modern industrial technology. The Russian Constructivists and the Bauhaus were most committed to this analogy, equating industrial materials with the new society. Vladimir Tatlin, leader of the Constructivists, promulgated the concept of a "culture of materials," where each material element would convey a

meaning while also fulfilling its function more efficiently than traditional materials. By respecting the inherent qualities of every material (e.g., the tensile strength of iron, the transparency of glass, the tautness of wire), the artist would respect and reveal the universal laws underlying nature. The use of ordinary materials, especially industrial ones, supposedly would establish a rapport between the proletarian working masses of the new industrial society and the new art, thereby cultivating a widespread new sensibility keyed to a modern industrial society. Thus the Russian architectural designs favored steel, wire, and glass over stone and wood because "iron is strong like the will of the proletariat; glass is clear like its conscience."[46] Some artists, like Lissitzky, turned to photography and photomontage (31, 32), which incorporated mechanical methods and could be reproduced in great numbers, like mass-production goods.

In a similar fashion, the Bauhaus focused on the importance of materials in every aspect of its curriculum, introducing materials not traditionally associated with the fine arts. Industrial metals, new kinds of glass, paper products, plastics, and so on became identified with the forthcoming technological utopia. Thus, Oskar Schlemmer made his sculptures from modern industrial metals (46), rather than stone or bronze, while fellow designers at the Bauhaus produced metal furniture and accessories for mass production. For nearly a decade, Josef Albers produced art using industrially manufactured glass and utilizing industrial techniques such as sandblasting (54, 55).

An outstanding characteristic of early-twentieth-century utopianism in the arts is its inclusiveness. Artists not only expanded the traditional parameters of artistic media, they broadened the definition of the artist's role to include all of the arts, the applied arts such as typography, poster design, architecture, furniture, clothing, and so on. As the Russian Alexander Blok proclaimed: "The artist's obligation is . . . to redo everything. To arrange things so that everything becomes new; so that the false, dirty, dull, ugly life which is ours becomes a just life, pure, gay, beautiful."[47]

The eventual union of all the arts in a *Gesamtkunstwerk* (total work of art) was anticipated as a logical step in the progress toward utopia. Architecture would effect the harmonious interrelationship of all other arts, each of which, though fully developed as an independent medium, would find ultimate fulfillment in working together, just as in the coming utopia independent elements would experience their apotheosis within the whole of a unified society. The concept of designing entirely coordinated environments in order to create powerful effects had gained international credence among architects and designers in the late nineteenth century, particularly among those involved in the Art Nouveau and Arts and Crafts movements. This commitment to transforming the entirety of the physical environment (in order to metamorphose mankind completely) characterizes virtually every utopian movement of our time.

An essential component of the new art was to be the active involvement of the viewer. Complacent aesthetic contemplation is no longer sufficient if utopia is to be attained. Ultimately, the new art and architecture would stimulate the viewer to act toward creating utopia, whether that be defined as enhanced spiritual consciousness or a new sociopolitical structure. As the Futurists proclaimed in 1912, the spectator "must be placed at the center of the picture. He shall not be present at, but participate in the action . . . so that he will in a manner be forced to struggle himself with the persons in the picture."[48] Similar sentiments were expressed by a number of artists, as when Lissitzky wrote that "now our design should make man *active.*"[49] According to Moholy-Nagy, in the new art, whatever the medium, "a dynamic constructive system of force is attained, whereby man, heretofore merely receptive in his observation of works of art, experiences a heightening of his own faculties and becomes an active partner with the forces unfolding themselves."[50] Ultimately, this participatory attitude would move the observer from an aesthetic dimension to a social one and would encourage the viewer to participate in such activities as theatrical performances, symposia, and political discussions, which, according to Moholy-Nagy, "would create the stimuli for a rejuvenation of creative citizenship, spontaneity, and an understanding of the needs of the community."[51]

Because early utopian artists were profoundly con-

cerned with communicating universalized messages of metaphysical, ontological, and sociopolitical import, there was much discussion of new styles, of the means with which the messages could be transmitted in the new art. Like music, particularly the atonal music being developed by Arnold Schönberg and others, abstract art was believed capable of effective, powerful communication with nonliteral components (indeed, the analogy between art and music was endemic during this period). Of all possible means to the spiritual liberation and social unification of mankind, a new expressive abstract art would play a key role. Kandinsky believed that such art possesses "an awakening prophetic power which can have a widespread and profound effect."[52] Moholy-Nagy asserted unequivocally the power of geometric abstract art to effect utopian social consciousness:

I believe that abstract art . . . projects a desirable future order, unhampered by any secondary meaning. . . . Abstract art . . . creates new types of spatial relationships, new inventions of forms, new visual laws—basic and simple—as the visual counterpart to a more purposeful, cooperative human society.[53]

He believed that the new art would eventually "penetrate through every phase of life" and "become part of civilization."[54] After that, another cycle of growth and change would begin.

There was much discussion of art as a universal visual language based on nonrepresentational forms. Semiotics, structural linguistics, and Gestalt perceptual psychology were emerging in the early twentieth century to show how sound and syntax, shapes and colors can possess some inherent meaning independent of the cultural context. The concept of a supranational language has long existed in the traditional sciences, as well as in esoteric fields like astrology, and awareness of other disciplines may have stimulated the aesthetic concept of a reductivist or symbolic universal language in the 1910s and '20s. Fields of knowledge often develop specialized languages, some of them comprehensible to an international audience because they use symbols rather than words. Thus, sciences like mathematics, chemistry, and physics can convey sophisticated meaning with formulae

consisting of only a few numbers, letters, and signs, like $E = mc^2$.

In their desire to educate humanity to an awareness of the new culture and to an elevated ontological and social consciousness, many utopian artists placed a high priority on developing a visual language comprehensible to everyone. They believed that only by means of a universal idiom could the message (the new way of seeing) directly reach people of all nations and classes, without the intervention of social customs, prejudices, or authority structures. From Moscow to Paris and virtually everywhere in between, the call arose for a universal language of art. Russian writer Velimir Khlebnikov issued a call "To the Painters of the World":

The goal is—to create a common written language, common to all peoples of the third planet from the sun, to construct written symbols that can be understood and accepted by the entire population of this star. . . . Painting has always spoken in a language accessible to all. . . . The mute geometric signs will reconcile to each other the multiplicity of languages. . . . The task of the artist of color is to offer geometric signs as the fundamental units of comprehension. . . . The alphabet already contains a world-wide network of sound pictures . . . now a second network should be created, from written characters.[55]

In formulating a new pictorial language for the new age, utopian artists were surprisingly consistent in their ideas, but the translation of aims into visualizations resulted at first in a variety of styles, particularly those developed before World War I. The unstable dynamism of Futurism with its shifting planes and the biomorphic forms of Kandinsky's Expressionism differ sharply from the more ordered and simplified style of Suprematism, while all three of these styles contrast with the contemplative and balanced stability of Neoplasticism. However, after the war, when utopian fervor reached its peak, the desire for a universal language accessible to viewers of differing national, cultural, and class backgrounds resulted in an international consensus about geometric abstraction as the new style.

Basic forms were considered essential to the new universal language, as Lissitzky noted: "Our time demands designs that have their origin in elementary

forms."[56] Many utopian abstract artists believed that elementary forms provided the common denominators of comprehensibility and could convey a subliminal message of universality and the essential unity of human existence. Van Doesburg noted that "as soon as the artist uses elementary forms as a means of expression, his work is not merely modern but universal."[57] Consequently, artists turned to the basic elements of art, to color, form, line, and space, to determine ways of redirecting human perceptions toward utopian goals.

In the years between 1910 and 1915 the pioneer abstractionists, particularly Wassily Kandinsky, Kasimir Malevich, Giacomo Balla, and Piet Mondrian (each in different countries), derived their styles from the study of the physical world in its various permutations, not only visible phenomena but also metaphysical and spiritual realities. To them, abstraction signified a metaphysical utopia of spiritual enlightenment and universal principles. However, this early period of heroic discovery, of analytical simplification and transformation, yielded after circa 1922–24 to a more conceptual and rationalist approach, in which their followers and younger contemporaries adapted their compositional elements and configurations to denote social significance.

Younger utopians like Moholy-Nagy at the Bauhaus and the Constructivists in Russia avoided the original transcendentalist connotations of abstraction for more socially oriented purposes. Moholy believed, like so many utopians after World War I, that "our age with its aspirations towards collective thought and action demands objective laws of creation."[58] By the mid-1920s, most utopian artists sought a universal language whose appropriately significant elements would propagate certain attitudes, such as scientific rationalism, objectivity, and a collectivist mentality, which in turn would lead ideally to the triumph of nonindividualist social cooperation over divisive egoism. Van Doesburg wrote: "As soon as the artists . . . have realized that they must speak a universal language, they will no longer cling to their individuality with such anxiety. They will serve a general principle far beyond the limitations of individuality."[59]

The paradigmatic source for the forms of the new

universal language was mathematics, especially geometry, which many artists perceived as a totally objective and precise discipline, theoretically complex yet visually clear. Geometry presents a codified system of mathematical principles, hypotheses, and proofs based on measurement and deduction—beautiful in their logic yet also practical. Geometric forms are clear and unarguable and therefore appear to resonate with a fundamental truth. They transcend cultural and historical circumstances, belonging to no single nation or era. As Lissitzky noted about Suprematism:

The form which is unequivocal, and that means immediately recognizable to everyone, is the geometric form. No one is going to confuse a square with a circle, or a circle with a triangle. . . . The result is not a personal affair concerning one individual artist; the intention is to create a system of universal validity.[60]

At the Bauhaus, Moholy-Nagy agreed, saying that he "chose simple geometrical forms as a step towards such objectivity."[61]

Geometry was widely perceived in the early twentieth century as connoting a new era of manmade, consciously reasoned order controlling the natural world. A widespread vogue for Neoplatonic philosophy between 1910 and 1920 reasserted the classical belief in geometry as embodying principles of harmony, reason, logic, and purity. Consequently, many utopian artists believed that geometric styles in the fine and applied arts would encourage the development of such values in people and would serve as paradigms for a harmonious and rational society. In van Doesburg's words, "Clarity . . . will serve as the basis for a new culture."[62] Geometric forms were understood as not only rational but ethical as well, implying values such as discipline, honesty, selflessness, and truth. Though few artists elucidated explicit values for individual forms and colors, geometry was pervasively considered a powerful means of actualizing mankind's reason, creativity, social and/or spiritual consciousness, and other productive faculties. Virtually all utopian artists who employed geometric abstraction assumed that direct contact with this new art would educate people to new ways of seeing and

thinking, which in turn would contribute substantially to the creation of a perfect future society.

Furthermore, geometric art styles were perceived as inevitably analogous to machine products because of the coincidence of visual and conceptual characteristics, e.g., forms reduced to simplicity and executed precisely, and the objective repetition of values through universally applicable shapes. Both geometry and machine technology were seen as contributing to the conquest of chaos by order, the ascendance of analysis and intellect over instincts and emotions, and the submission of the individual to universality and collectivity. The analogy between geometric forms and machine technology strengthened artists' assertions equating their abstraction with social progress. Fernand Léger noted with approval that "modern man lives more and more in a preponderately geometric order. All mechanical and industrial human creation is subject to geometric forces."[63] Since technology was viewed as the most powerful tool in the construction of the new world, utopian artists hoped analogous forms in art would have a similar impact and applicability.

There was much speculation on the affective powers and inherent meanings of forms and colors, and various theories were developed during this period. Many artists, especially in Russia and Germany, undertook thorough, often scientific investigations of the elemental means of art, including studies of sensory-physiological and psychological responses to specific stimuli. Most artists using geometric abstraction focused on the primacy of form to communicate their utopian intentions, with color occupying a secondary, though not negligible role. Since the coming utopia was widely postulated as being ever changing and full of movement, many utopian artists tried to convey this through vitalizing contrasts of colors. Drawing upon nineteenth-century color theories, artists such as the Futurist Balla and the Purist Léger relied on the contrast of bright colors to create optical dynamism suggestive of the power and bustle of the modern city. Color contrasts thus function as visual equivalents for motion and energy.

Before World War I, Kandinsky (and to a much lesser extent Malevich and the Futurists) viewed colors as equivalents for introspective emotions or spiritual states of enlightened awareness. Postwar artists, however, moved away from the subjectively expressive possibilities of color. Instead, color functioned as another element in the vocabulary of the new universal language aimed at inducing social harmony. Like geometric form, color would be, as Moholy-Nagy explained, a "composition of universal systems, independent of climate, race, temperament, education, rooted in biological laws."[64] In particular, the primary colors (red, yellow, blue) and the neutrals (black, white, gray) were most valued, both formally for their intensity and ideologically for their purity. As Lissitzky noted, "Our concern is with unmixed colors . . . aimed at direct physiological effect,"[65] such as red, which he equated with Communism, and white, which he associated with space and hygiene. Indeed, white, the traditional color of purity, was the most pervasive color among utopian abstractionists. In some paintings, like Malevich's Suprematist compositions, white suggests a nonspecific space, an ideal conceptual universe without scale or limit. In architecture, white was often considered the only acceptable color, particularly after 1925. Some architects, like Le Corbusier, associated it with hygiene, while others equated it with moral virtues like honesty and brotherhood.

While painting and sculpture could serve as indicators of utopia, architecture creates the actual physical environment conducive to the emergence of that new society. While actually ameliorating living conditions, architecture can also embody the ideals of the new era and visually influence consciousness. Thus, as the most practically effective and most socially involved art, architecture was embraced by twentieth-century utopians as the pre-eminent means of integrating the isolated individual into an ideal unity.

Throughout the history of utopian thought, architecture and urban planning have been recognized as playing significant roles in creating ideal societies, particularly since the Renaissance. The ideal of social transformation through architecture and comprehensive design became one of the driving forces of utopian modernism. Philip Johnson later recalled the attitudes of the twenties with somewhat cynical hind-

sight: "We were thoroughly of the opinion that if you had good architecture, the lives of people would be improved, that architecture would improve people, and people improve architecture until perfectibility would descend on us like the Holy Ghost, and we would be happy forever after."[66]

Utopian architects in the early twentieth century formulated an almost bewildering array of designs for the new world. Reflecting a wide variety of ideas, they range from metaphysical constructs and spiritualistic temples (literally architecture of the mind and soul) to technological and functionalist essays in absolute efficiency. Most utopian architects proposed generalized, conceptual models, leaving the specifics to be worked out later in actual practice by engineers and workers. Many of their grandiloquent proposals, some of them quite fantastic, remained purely hypothetical. This was a period of "paper architecture," when few projects had much chance of being built, especially between 1918 and 1924 in Germany and in the USSR, where the populaces were suffering from acute shortages of material and financial resources. Yet many of these designs were internationally known at the time and they effectively altered the language of architecture in a few short years.

Projects tended to be individual buildings, but some encompassed entire cities and even large geographic regions. Some designs perpetuated older building types like houses, while others introduced new formats considered appropriate for the new society (like skyscrapers, communal housing, community centers). There was a fascination, almost obsession, with heroic height and scale in buildings, and as a corollary, with aerial architecture per se. From Moscow to Paris and New York, plans were drawn for tremendously tall towers that would replace the existing disorder and filth of most cities. Beyond practical considerations, towers and aerial architecture reflect subliminal aspirations for a better world. They permit the psychological and physical sensation of being raised above worldly concerns, bringing man closer to the infinite vastness and divine cosmology of the heavens.

Many architectural designs of the years immediately before and after World War I owe a great deal to the aesthetics of abstract painting and sculpture. In De Stijl, both Mondrian and van Doesburg acknowledged that Neoplastic architecture arose from earlier developments on canvas: "In our time the leading art—painting—has ever indicated the way which architecture has to go in order to materialize what already exists imaginatively (aesthetically) in the other arts."[67] Similarly in Russia, architecture was expected to transpose the discoveries and new consciousness of abstraction from the fine arts to the social sphere:

We have just witnessed a time when painting stood at the spearhead of attack. And now we are reaching the transition from sculpture/painting to the unity of architecture. It is in architecture that we move today; it is the central issue of modern times.[68]

ITALIAN FUTURISM

Radical utopian aesthetics were first avowedly proclaimed and promulgated by the Futurist group of artists in Italy from early 1909 through the 1920s. Their leader, the poet F. T. Marinetti, an enthusiastic, almost fanatic purveyor of ideas, traveled all over Europe lecturing and arranging exhibitions on Futurist art. Although arising as a rebellion against the Italian culture entrenched in its past, Futurism addressed itself from the start to an international audience, primarily by means of widely disseminated manifestoes, which were published and translated from Italian and French into English, German, Spanish, and Russian and were read avidly from London to Moscow and even in San Francisco by 1915.

These manifestoes proclaimed the emergence of the new era and of artistic commitment to constructing a new world. The Italian Futurist painters, notably Giacomo Balla, Gino Severini, Umberto Boccioni, and Luigi Russolo, described themselves as "free moderns, who are confident in the radiant splendor of our future,"[69] and predicted that "political resurgence will be followed by a cultural resurgence. . . . Schools will be set up . . . millions of machines are already roaring . . . new flights of artistic inspiration are emerging and dazzling the world with their brilliance."[70] In "Geometric and Mechanical Splendour and the Numerical Sensibility" (1914), Marinetti wrote:

A new beauty is born today from the chaos of the new contradictory sensibilities. . . . [Its elements are many, e.g.,] speed, light, will-power, order, discipline, method, a feeling for the great city, aggressive optimism . . . imagination without strings.[71]

He envisioned a new mechanistic culture where "hunger and poverty disappear. . . . Ended now the need for wearisome and debasing labors. Intelligence finally reigns everywhere . . . every instinct brought to its greatest splendor. . . . An anarchy of perfections."[72]

The pre-eminent concern of the Futurists was the total renovation of the world, both in the physical domain and on the level of social and psychological values. Their rhetoric went beyond mere nihilistic re-

jection of the established order—that vehement scorn for past art and values that characterizes modern avant-gardism—to propose and define a new world order. The Futurist utopia would be essentially Dionysian in character. Theirs would not be an ascetic condition but one of unlimited abundance, with constant consumption of goods produced by modern technology. Their new world would furnish unending mental, physical, and sensory stimulation drawing upon all the resources of the new technological society. Though some utopian artists like Malevich, Kandinsky, and Mondrian disapproved of this kind of utopian vision, it had widespread appeal and is still many people's ideal of the good life.

A central tenet of Futurism was the importance of technology. Futurists believed that the speed and strength of the machine offered unlimited freedom from historical and physical constraints. Their well-advertised fantasies of technological modernity penetrated avant-garde aesthetics throughout Europe and in the United States, fostering a Promethean sense of technology as the solution for social ills and as the key stimulant to new modes of perception and states of mind. From the very first, in Marinetti's founding manifesto of February 1909, modern technology appeared as provocative and powerful, factually efficacious yet tantalizingly mysterious: "We will sing of the vibrant nightly fervor of arsenals and shipyards blazing with violent electric moons . . . bridges that stride the rivers like giant gymnasts flashing in the sun . . . and the sleek flight of planes whose propellors chatter in the wind."[73] Theirs was a romantic attitude characterized by hyperbolic flights of fancy, as described by Marinetti: "Oh! How I envy the men who will be born in the next century . . . when [the world] is wholly vivified, shaken, and bridled by the new electric forces! A haunting vision of the future carries my soul away."[74]

The desire for a radical changeover to a new technological society and an appropriate new art animated the entire Futurist utopian vision. As Balla, Boccioni, Carrà, Russolo, and Severini wrote:

Comrades, we tell you now that the triumphant progress of science makes profound changes in humanity inevitable. . . . Support and glory in our day-to-day world, which is

going to be continually and splendidly transformed by victorious Science.[75]

Marinetti was unequivocally enthralled by machines, urging "the enthusiastic imitation of electricity and the machine" and stating that "nothing is more beautiful than a great humming central electric station"[76] (12). He perceived technology as having permeated modern life and altered it intrinsically into something radically different, new, heroic:

Futurism is grounded in the complete renewal of human sensibility brought about by the great discoveries of science. Those people who today make use of the telegraph, the telephone, and phonograph, the train . . . the automobile . . . the dirigible, the airplane . . . do not realize that these . . . have a decisive influence on their psyches.[77]

Marinetti made the crucial comparison between man and machine, prophesying an inevitable merger: "Hence we must prepare for the imminent, inevitable identification of man with motor, facilitating and perfecting a constant interchange of intuition, rhythm, instinct and metallic discipline."[78]

It is this peculiar equation between mechanistic technology and human spiritual nature that distinguishes the art theories of the early period of the first machine age. The Futurists literally proposed to replace religion with technology: "Our forebears drew their artistic inspiration from a religious atmosphere which fed their souls; in the same way we must breathe in the tangible miracles of contemporary life."[79] The Futurists' mystical attitude toward technology persisted into the early 1920s, as summarized by Enrico Prampolini in his widely read "Aesthetic of the Machine and Mechanical Introspection in Art" (1922), where he expressed the romantic fervor that perceived technology as the new golden calf:

Is not the machine today the most exuberant of the mystery of human creation? Is it not the new mythical deity . . . of the contemporary human drama? The Machine . . . comes to have today in human concepts and thoughts the significance of an ideal and spiritual inspiration. . . .

We therefore Proclaim

1. The Machine to be the tutelary symbol of the universal

dynamism, potentially embodying in itself the essential elements of human creation. . . .

2. The aesthetic virtues of the machine and the metaphysical meaning of its motions and movements constitute the new font of inspiration for the arts.
3. [Do not merely represent machine forms but use it as analogy] with various spiritual realities. . . .
5. The machine marks the rhythm of human psychology and beats time for our spiritual exaltations.[80]

The Futurists' enthusiastic admiration of technology involved more than just superficial fascination with the appearance of machinery, with its polished metals, precise forms, rhythmic movement, and hypnotic speed. They perceived technology as a means of overcoming stasis and stagnation in society at large and in the individual; the effects of modern technology could thus provide essential means of inducing new states of mind.

This overriding obsession with technology produced Futurist proposals for radical innovations in life and art. Russolo believed that people would enjoy orchestrations of noises from "railways, iron foundries . . . electric power stations and underground railways."[81] He happily observed in 1913 that as machines multiply, they will introduce thousands of new and different noises, which will become part of the new life and music.[82] An entirely new canon of beauty based on machines would replace the classical traditions of over two millennia: "The racing automobile with its explosive breath . . . that whizzes like a volley from a machine gun is more beautiful than the Victory of Samothrace," wrote Marinetti.[83] Boccioni welcomed the wonders of science, noting that the movements of propellors, flywheels, valves, and other machines "create a rhythm which is just as beautiful . . . as the movements of an eyelid, and infinitely more modern."[84] And, as others were to do, he recommended that utopian reform should spring from science and scientific method: "Our constructive idealism has taken its laws from the new certainties given us by science."[85] In his preface to the catalog of the first exhibition of Futurist painting (1912), he confidently proclaimed, "The era of the great mechanized individuals has begun."[86]

In Futurist art, preferred themes included depictions of machines and related subjects representative of the emerging technological utopia, such as the products of structural engineering like the Eiffel Tower, suspension bridges, and the amazing power stations that would supply electricity for the new world. Of particular import were subjects that convey the perpetual movement and velocity of the anticipated utopia, such as speeding automobiles, buses, trains, subways, even weapons. The Futurist definition of the coming utopia centered on the concept of dynamism in every conceivable interpretation. The new technological environment, with high-speed transportation and instant communication, would allow for new sensations, new knowledge, and above all an unprecedented simultaneity of experience. Hence the Futurist preference for kinetic subjects and their depiction in styles suggestive of their speed and interpenetration were intended to show that life itself had become dynamic, not only in the physical sense of movement, but in the very perception of existence.

Dynamism became a fundamental theme in subsequent theories of utopian art between 1910 and 1930, ranging from literal interpretations, like Futurist images of speeding cars, to kinetic sculpture and architecture. A number of designs appeared in various countries that called for transformable architecture, with features like movable walls, changing light patterns, even rotating buildings. Movement of all kinds was intended by artists across Europe as a metaphor for evolutionary progress. The concept of diagonally placed lines and forms as indicators of dynamism became an entrenched tenet of much utopian art, from the Futurist "lines of speed and force" to the tilted forms and spirals of Russian abstraction and the smoothly flowing forms of American "streamline moderne."

In their works of art before World War I, the Futurists sought to convey the image and consciousness of their eagerly anticipated utopia. They posited that future world as a universally dynamic continuum, wherein every entity (individual persons, buildings, machines, lights, sounds, colors, and so on) would interrelate in a cosmic whole. This complete interpenetration of all elements of life would eliminate isolation and alienation. Futurist art was intended to pro-

mote an awareness of this essential interrelatedness; eventually mankind's abilities of perception would develop to the point where everyone would feel part of a unified whole. Thus, in early Futurist paintings such as *Dynamic Rhythm of a Head in a Bus* (1), *Paris Subway, Ferris Wheel, and Eiffel Tower* (2), and *Armored Train* (3) by Gino Severini (1883–1966), different elements were reordered and integrated into what Boccioni described as "an emotional architectural environment which creates sensation and completely involves the observer."[87] As Severini declared in 1913: "We want to enclose the universe in the work of art. . . . [The art works] will share the active intervention of the outside world, of which they represent the particular essence."[88]

In order to capture the total experience of the environment, the Futurist painters tried to create, in Carrà's words, "*total painting,* which requires the active cooperation of all the senses."[89] This utopian emphasis on the affective power of art, completely involving the spectator's perceptive faculties, draws upon the nineteenth-century concept of synaesthesia, which posited the interrelatedness of all sensory perceptions and their interaction with both the conscious intellect and the unconscious mind. Through these subtle influences, the new utopian art (whatever the particular style) would influence consciousness toward utopian viewpoints.

Because the Futurist universe was to be dynamic, joyful, and varied, Futurist art was not restricted to a single group style. It need only be evocative, powerful, gay, and shocking, so as to effect a vitalizing influence on its viewers. Borrowing some stylistic devices from Cubism, such as the analytical reduction of solid forms to two-dimensional planes, the Futurists developed visual analogies that effectively communicate the sensations of dynamism and simultaneity. Unlike the later utopian artists who sought a single, universal sign language of clearly defined geometric shapes, the Futurists solicited deliberate ambiguity of forms in order to elicit the viewers' wonderment. Paintings such as *Dynamic Rhythm of a Head in a Bus* (1), *Paris Subway, Ferris Wheel, and Eiffel Tower* (2), and *Speeding Automobile + Lights* (6) suggest unusual connections between seemingly incompatible

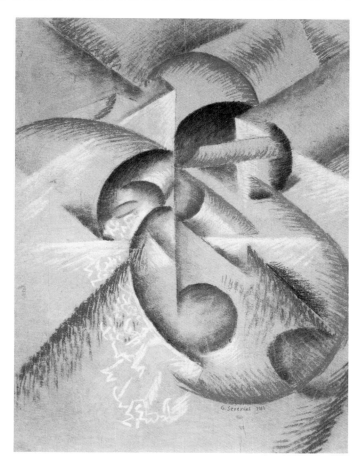

1 Gino Severini Italian, 1883–1966
Dynamic Rhythm of a Head in a Bus, 1912

realities. Such unprecedented combinations ideally would stimulate the viewer's intuition, ultimately developing mankind's perceptions to the point where the Futurist sensibility would become universal and utopia would result.

Visually, the Futurist painters used overlapping planes and dramatic contrasts of shapes and colors to suggest the effects of movement and the simultaneity of experience that would characterize the new world. To convey their fundamental belief in the interpenetration of all aspects of life, they abolished solid volumes in favor of openly structured compositions where mass and space interact. Perhaps their most significant contribution to later utopian aesthetic theories was the power of line. In their desire to create an affective visual tool that would convey the dynamism of the emerging epoch, the Futurists relied upon what they termed "lines of speed and force."

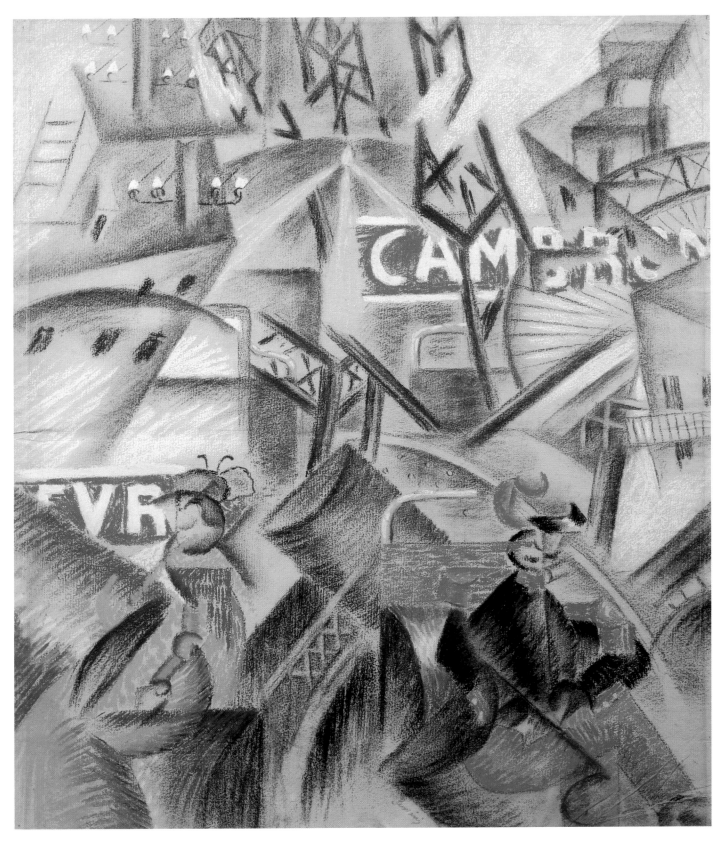

2 Gino Severini
Paris Subway, Ferris Wheel, and Eiffel Tower, c. 1912–13

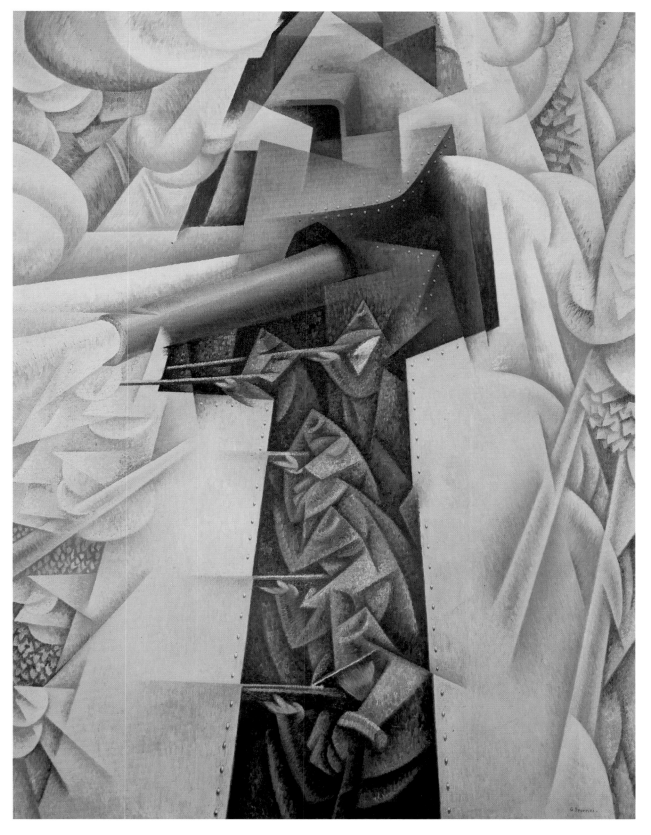

3 Gino Severini
Armored Train, 1915

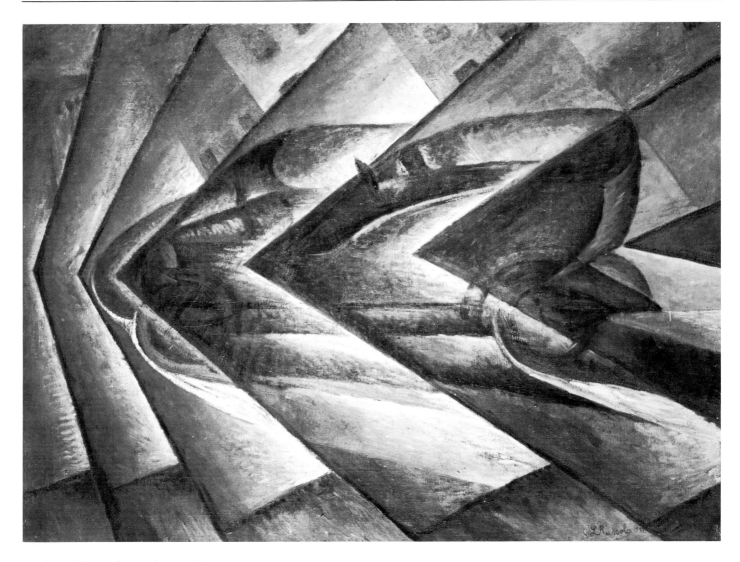

4 Luigi Russolo Italian, 1885–1947
Dynamism of an Automobile, 1913

Diagonally thrusting lines were felt to convey the sensation of rapid physical movement and, by implication, the metaphysical dynamism inherent in the Futurist sensibility. Boccioni believed that "the straight line will be living and palpitating . . . and its severe and fundamental bareness will be the symbol of the metallic severity of the lines of modern machinery."[90] In his velocity studies of speeding cars in 1912–13, Giacomo Balla (1871–1958) distilled the phenomena of the mechanized world into pictorial analogies of lines and the forms produced by those lines. He defined "lines of speed and force" as those invisible vectors produced by the movement of physical bodies, though without describing the shapes of those

bodies—rather like sound- and shock-waves and airflow patterns. In *Dynamism of an Automobile* (4) by Luigi Russolo (1885–1947), as well as in Balla's *Bridge of Velocity* (5) and *Speeding Automobile + Lights* (6), the diagonal play of lines and the resultant contrast of angular forms convey the rush and tumult of the modern dynamic world. Believing that a "profound analogy exists between the essential force-lines of speed" and the environment,[91] Balla soon dispensed with specific subject matter as too limiting, as in *Plastic Construction of Noise + Speed* (7). Thus lines and shapes transcend description to become metaphors that can be used abstractly, without the ostensible motif of a speeding car. "Everything be-

comes abstract by equivalents, which from their point of departure, lead to infinity," Balla wrote.[92] Ultimately, his abstract compositions signify a transcendent knowledge of the speed and creative force of the new human perceptual consciousness.

Among the essential contributions of the Futurists to utopian aesthetics before World War I was their willingness to embrace the emergence of mass society as a positive development. Years before the Communist revolution in Russia and the socialist movement in Germany, Futurism redefined art as functioning for the undifferentiated collective masses, rather than for a privileged elite—a democratic ideal fundamental to subsequent utopian artists. In keeping with this egalitarian approach, the Futurists contributed another crucial concept to the definition of the new utopian aesthetics: they expanded the domain of art to include virtually every aspect of life. Because attaining their goal of total transformation of the world depended primarily upon activating sensory experience, the Futurists availed themselves of every means at their disposal. They concerned themselves with the performing and decorative arts and indeed with life itself. Their numerous manifestoes written in the 1910s and '20s deal not only with painting, sculpture, and architecture, but with music, theater and cinema, sex, clothing, politics, dance, photography, language, and more—foreshadowing the multiplicity of interests and activities that later would characterize other utopian art movements, particularly the Russian avant-garde and the Bauhaus in Germany.

The Futurists recognized the power of the total physical environment to affect human thought and behavior: "The logical relationships which govern [the brain] are imposed on it by the environment in which it is formed. . . . If our world were different, we would reason differently."[93] Of the first generation Futurists, Balla was the most concerned with physically transforming the environment as a means of altering consciousness. In the manifesto "Futurist Reconstruction of the Universe" (1915), he dedicated himself "to realize this total fusion . . . to reconstruct the universe by making it more joyful."[94] The means to alter the environment would include all kinds of materials and devices, including transformable clothes, kinetic advertisements, and new toys to en-

courage imaginative impulses and expanding sensibilities, as described by Balla:

In . . . our great struggles for renewal . . . we must invent Futurist clothes, hap-hap-hap-hap-happy clothes, daring clothes with brilliant colors and dynamic lines. . . . The consequent merry dazzle produced by our clothes in the noisy streets, which we will have transformed with our Futurist architecture, will mean that everything will begin to sparkle like the glorious prism.[95]

Balla designed a number of interiors intended to function as total environments (8, 9). The walls and ceilings are covered with abstract murals of diagonal force lines and vivid colors. Completely designed by him down to the last detail, these interiors would have been completed with comparably designed furniture, a concept he implemented in his own home in the 1920s. The furnishings could be dismantled and rearranged at will (10), in keeping with the Futurist utopian goal of perpetual change and flux. By providing a comprehensive environment, Balla hoped that the Futurist sensibility would forcibly pervade the consciousness of anyone living in one of these interiors.

Also of interest to Balla was the creation of an artificial landscape to supersede the natural one. The Futurist utopia would thus include new types of abstract flora and fauna, including a robotic "metallic animal" and especially "the magical transformable"[96] *Futurist Flowers* (11), which would go outdoors as a Futurist garden or indoors as houseplants of a new order and sensibility.[97] The geometric shapes of these brightly painted flowers correspond to lines of force and can be assembled into a variety of compositions, implying an altogether new nature over which man can exercise total control, reshaping nature's organic forms into geometric terms.

The original Futurist group did not include any architects until Antonio Sant'Elia (1888–1916) became associated with them in 1914. In his designs for *The New City (La Città Nuova)* (12, 13), and in the accompanying statement (later manifesto), he crystallized the Futurist conception of the city:

[Architecture] must be new, just as our state of mind is new. . . . We must invent and build the Futurist city like an immense and tumultuous shipyard, agile, mobile, dy-

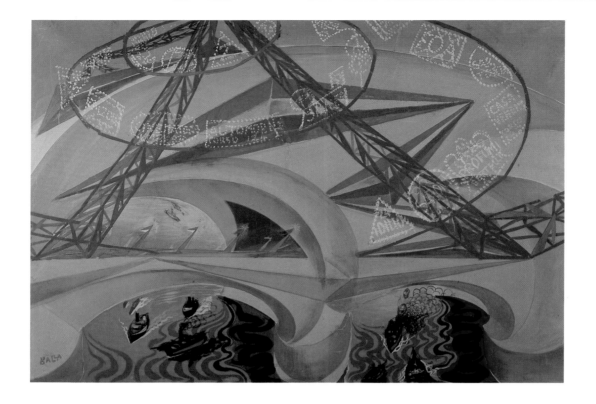

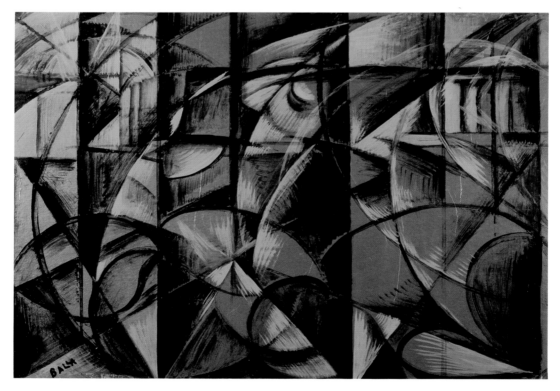

5 Giacomo Balla Italian, 1871–1958
Bridge of Velocity, 1913

6 Giacomo Balla
Speeding Automobile + Lights, 1913

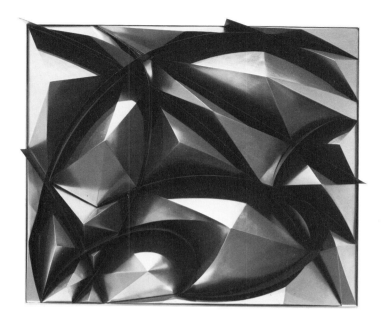

7 Giacomo Balla
Plastic Construction of Noise + Speed, 1914,
reconstructed 1968

8 Giacomo Balla
Study for Interior, 1918

9 Giacomo Balla
Study for Interior, 1920

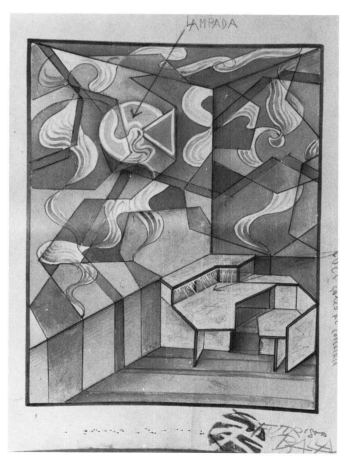

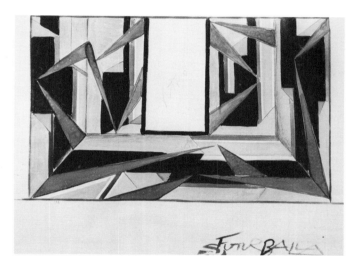

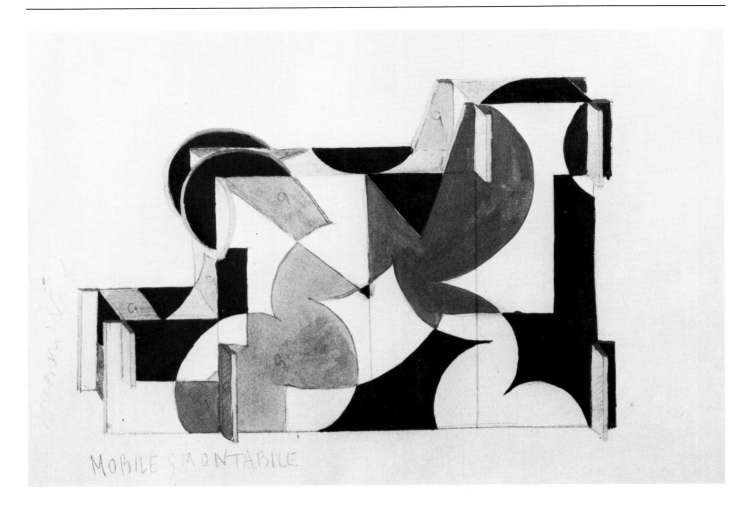

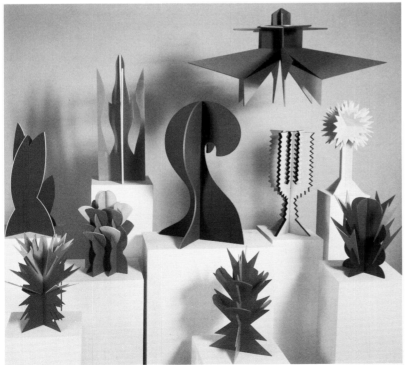

10 Giacomo Balla
Project for Disassembling Cabinet, 1920

11 Giacomo Balla
Futurist Flowers, 1918–25

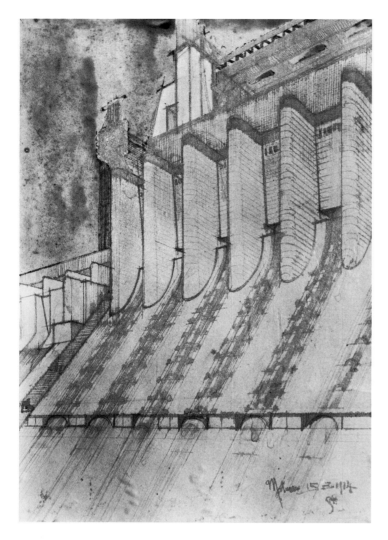

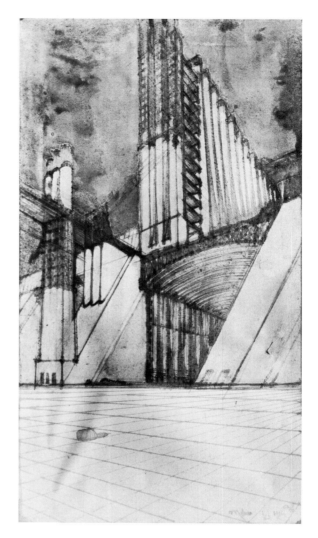

12 **Antonio Sant'Elia** Italian, 1888–1916
The New City: Design for an Electric Power Station,
1914

13 **Antonio Sant'Elia**
*The New City: Design for High-Rise Building
with External Elevators and Pedestrian Bridge,*
1914

namic in every detail; and the Futurist house must be like a gigantic machine. . . . [The Futurist city] must soar up on the brink of a tumultuous abyss: the street will no longer lie like a doormat at ground level, but will plunge many stories down into the earth . . . and will be linked . . . by metal gangways and swiftly moving pavements.[98]

In these few sentences, Sant'Elia established features that recur in many utopian designs: the analogy to machines, the fascination with dynamic movement and vertiginous height. He added, under Marinetti's influence, a purely Futurist characteristic of the city, its impermanence: "Every generation must build its own

city" so that the "constant renewal of architectonic environment" will contribute to the perpetual change of society.[99] He clearly defined architecture as a tool for utopia: "By the term architecture is meant the endeavor to harmonize the environment with Man, with freedom and great audacity, that is to transform the world of things into a direct projection of the world of the spirit."[100]

This scintillating dynamic vision reflects the ideas of H. G. Wells, who described the city of the future (London in A.D. 2100, population 33 million) in *When the Sleeper Awakes* (1897):

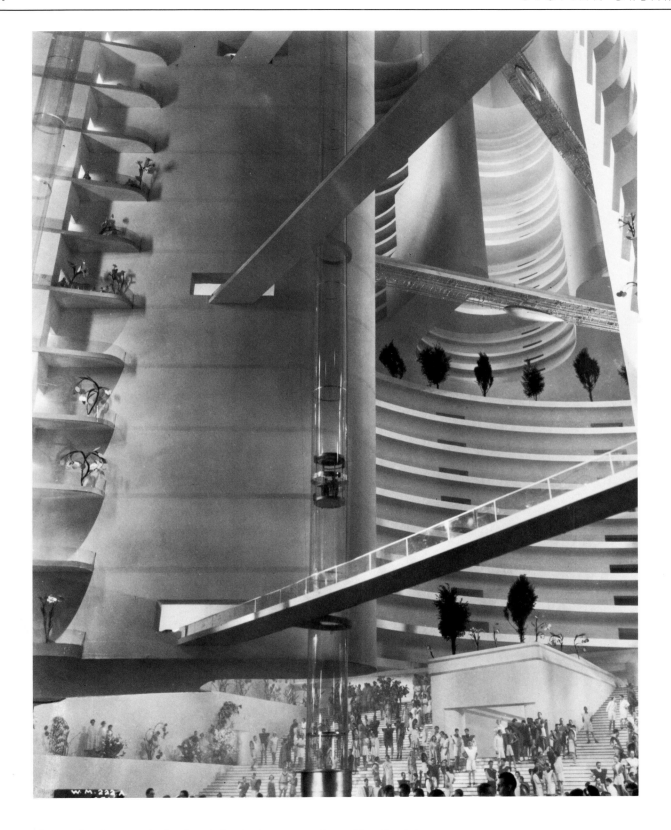

Figure 1 Portrayal of a futuristic city in a scene from Alex Korda's film *Things to Come* (1936), based on H. G. Wells's story *The Shape of Things to Come* (1934), with special effects by Bauhaus artist László Moholy-Nagy. Film Stills Archive, Museum of Modern Art, New York

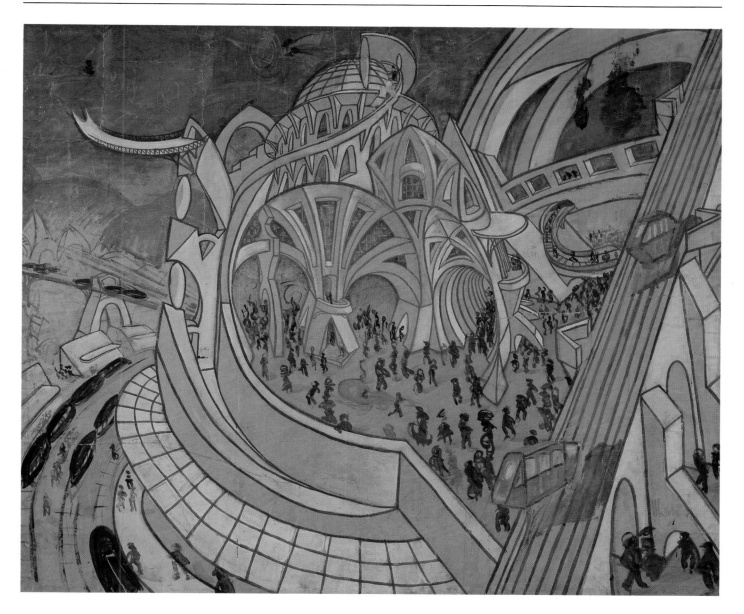

14 Virgilio Marchi Italian, 1895–1960
Futurist City: Building for a Piazza, 1919

15 Virgilio Marchi
Futurist City: Heliport and Buildings, 1919

His first impression was of overwhelming architecture . . . an aisle of Titanic buildings, curving spaciously in either direction. Overhead mighty cantilevers sprang together across the huge width of the place, and a tracery of translucent material shut out the sky. Gigantic globes of cool white light. . . . Here and there a gossamer suspension bridge dotted with foot passengers flung across the chasm and the air was webbed with slender cables.[101]

This image was given visual form in the 1936 film of Wells's *The Shape of Things to Come* (fig. 1), with special effects by Bauhaus artist Moholy-Nagy. Similar images of such a glistening, shimmering urban ideal echo through the 1930s and '40s, from Flash Gordon milieus to the Emerald City of Oz. The image of a self-contained, perfectly planned city of plastic, metal, and unbreakable glass, with a totally artificial environment, free from weather changes and human squalor, extends from Wells to Buckminster Fuller and was virtually equated with the modern vision of utopia.

After World War I, the Futurists devoted much attention to architecture. Virgilio Marchi (1895–1960) created a number of fantastic architectural designs quite different from those of Sant'Elia. Sant'Elia's buildings obey conventional requirements for actual constructions, while Marchi's visionary designs follow diagonal lines of force, with little concern for practical matters. His architecture is intended to express the bursting energy and dynamism of the new Futurist urban life, as in the wildly surging *Futurist City: Building for a Piazza* (14). Some conceptions were more stable and foreshadowed actual developments, as in *Heliport and Buildings* (15).

RUSSIAN
AVANT-GARDE

The hope for a new and better life had been intensifying in czarist Russia since the late nineteenth century. In overthrowing the centuries-old feudal social order, the Bolshevik revolution of 1917 provided a unique opportunity to construct a brand-new society. Not since the American and French revolutions of the late eighteenth century had large-scale utopia seemed so possible. Because the Russians had a tabula rasa on which to create a new order, the "reconstruction of the way of life" became a literal possibility and was undertaken on every level of society. Artists and architects saw their endeavors as an integral part of a wider movement involving the entire nation, from political leaders to scientists, writers, performers, filmmakers, and workers in every field.

Russian revolutionary thinkers displayed an awareness of Western utopian traditions. In his essay "Materialized Utopia" (1923), Boris Arnatov noted the importance of the *concept* of utopia as a first step toward achieving that perfect society. Citing Fourier and Marx, he wrote: "Taking root in the bosom of the historical process, such a utopia becomes a material force that organizes mankind. And that is when we can say with a capital letter: Utopia."[102] He urged the technological, urbanized utopia of the sort proposed by Marx and Wells, which would use "engineering as a universal method,"[103] rather than the romantic retreat into villages. Acknowledging the gap between their dreams and the material impossibility of immediately implementing them in a country essentially lacking in industry and other developed resources, Arnatov offered encouragement:

If a "materialized" utopia is at present only alliteratively similar to a "realized" utopia, then one conclusion must follow: *Help to realize the path indicated.* . . . Develop, continue further, reform, but do not turn aside. May this . . . leap across the abyss turn into a collective collaboration.[104]

The political revolution of 1917 was preceded by a period of feverish artistic innovation, as many artists and writers envisioned a new world view. Excited by new ideals, stimulated by Italian Futurism and metaphysical speculations, Kasimir Malevich (1878–1935)

emerged as a leading promulgator of the new spirit. By late 1915, he had formulated the theory and style of Suprematism, which he believed to be the next stage after Futurism in progressive evolutionary development. His essays on the new art are punctuated with references to "the new will," "the new life," and so on, asserting that:

Suprematism is the beginning of a new culture: the savage is conquered . . . a new form will be built. . . . These forms announce that man has attained his equilibrium; he has left the level of single reason and reached one of double reason.[105]

Malevich maintained that "Suprematism is attempting to set up a genuine world order, a new philosophy of life."[106] He felt that the radically new and different future would be attained through altered human awareness, rather than through specific political or sociological programs. Consequently, his new art of Suprematism was intended as a metaphysical and spiritual tool geared to expanding and raising human consciousness. It was an intellectual theory of art that would "build up a new world—the world of feeling."[107] By "feeling," Malevich meant a consciousness beyond physical sensations and ordinary emotions, an intuitional awareness of a new and unfamiliar order or state of being. Suprematist art would intimate the new subliminal world of fundamental feeling and perception, intuition and transrational comprehension which, Malevich believed, transcends superficial and customary appearances. For Malevich and his followers, such expansion of consciousness was the essential utopia—the condition of complete liberation when consciousness itself (i.e., the essential nature of humanity) would be revolutionized.

Some theories of early abstract art, such as Malevich's Suprematism in Russia, Kandinsky's Expressionism in Germany, and Mondrian's Neoplasticism in Holland and France, reflect a distrust of appearances and of material physicality as illusory. This attitude is an inherent component of some mystical and Neoplatonic philosophies that were popular in Europe in the late nineteenth and early twentieth centuries. Such philosophies posited that there is a hierarchic plurality of realms of being, the lowest of which comprises visible appearances. Only by penetrating the veil of illusion can man understand his existence and transcend his limitations to reach a higher plane of comprehension. Metaphysically inclined artists believed that such a condition of enlightenment is the utopia for which mankind should strive, both for its own sake and because once enlightenment is achieved, the evils of material existence will naturally cease. Consequently, artists like Malevich geared their new abstract art to express this "true" reality, the realm of ideated forms and universal laws. This often unspoken premise accounts for the frequent allusions among abstract artists to their nondescriptive styles as a form of New Realism. Malevich emphasized this aspect of Suprematism (which he originally called Supranaturalism to emphasize its transcendent purpose): "Everything which we call nature, in the last analysis, is a figment of the imagination, having no relation whatever to reality."[108] Malevich, like several other utopian geometric abstractionists, such as van Doesburg, referred to this new consciousness, this new approach to dealing with reality, as a fourth dimension.[109] Ilya Chasnik (1902–29), one of Malevich's many students, also pursued this aspect of Suprematism in his art, seeking ever higher levels of consciousness, as indicated by *The Seventh Dimension* (18).

The desired state of heightened consciousness would be attained through the new art of Suprematism, which would use colors and forms that, while not referring to any observable forms, suggest altered metaphysical perceptions. By employing abstract or nonobjective visual means not tied to the illusory world of observable appearances, Malevich and his followers hoped to make humanity aware of potential nonmaterialistic growth. Malevich believed that geometric abstraction could serve as a means of communication between one's limited physical self and a higher, suprapersonal, supranatural perception (or between individual and cosmic consciousness): "Structure is not composition for composition's sake; it is . . . a language composed of special words. It is something with the help of which one can talk about the universe or about the state of our inner animation."[110]

In early Suprematist compositions, Malevich used

titles such as *Soccer Match* (16), yet the simple geometric shapes of these pure abstract works reveal no vestigial representation. The associative titles simply emphasize Malevich's contention that Suprematism embodies a transformation, not just of the physical world but of human ontological consciousness. In order to kindle the cosmic intuitive "feeling" sought by Malevich and his followers, Suprematist compositions are generally self-contained, like a miniature cosmos with forms that do not extend out of the canvas (17). Size has no relevance; even the small compositions seem cosmic, like Chasnik's *Cosmos: Red Circle on Black Surface* (19). Such compositions can be construed as nonliteral diagrams of a supraphysical or subliminal universe of transrational comprehension, which can be entered by anyone through intuiting the pure feeling of this art.

Malevich's use of white ground (or black, in the works of Chasnik) suggests an infinite space, having no sense of scale, time, or other reference points. Associating geometric forms with intellectual efforts, Malevich viewed them as implying the triumph of enlightenment over material concerns. Brightly colored geometric forms float without regard to gravity in this cosmic space; their overlapping positions suggest spatiality, while their diagonal placement offers the illusion of continuous motion, without beginning or end (16, 17, 19). This is the state in which the artist (and viewer) attain cosmic consciousness, awareness of a higher dimension of existence—in short, the comprehension of, or feeling for, pure "nonobjectivity." Malevich hoped the spectator would feel liberated intellectually, aesthetically, physically, as if flying free without bounds (one of Malevich's favorite metaphors for Suprematism). No longer the mirror of the visible world or of ordinary perceptions, the Suprematist work of art serves as the catalyst for enlightened intellectual and spiritual consciousness. The new Suprematist art provides a means to a new awareness; and it is the actual *process* of struggling with its formal elements that causes this consciousness to emerge.

The seminal, symbolic form of Suprematism was the square and related rectilinear forms derived from it. As "the creation of intuitive reason,"[111] the square

was used to symbolize the higher nonobjective consciousness. The compositional arrangement of geometric forms would reflect the *system* according to which the new world order existed: "The Suprematist square and the forms proceeding out of it can be likened to the primitive marks (symbols) of aboriginal man. . . . The square changes and creates new forms, the elements of which can be classified in one way or another depending upon the feeling which gave rise to them."[112] Thus, abstract elements could represent abstract concepts, such as "the white square = pure movement; the black square = economy; the red square = revolution"[113]; and Malevich's post-revolutionary students wore symbolic squares on their sleeves, in keeping with their teacher's admonition to "bear the black square as a symbol of world revolution of art."[114] However, the metaphysical import far exceeded any social symbolism, and in the later 1920s Malevich vehemently dissociated the Suprematist visual vocabulary from literal meanings.

This new art is not an easy one to comprehend, and the Suprematist state of extraordinarily expanded consciousness could not, unfortunately, be fully or even adequately expressed in art, which remains inherently restricted to physical means. Nonetheless, the new art could at least intimate this "new world system," and Malevich's pupil Chasnik devoted his brief life to finding "more concrete and realistic answers" to the problems of expressing this new world more fully in art and architecture, so that Suprematism "will not long remain in the state in which it is now—that mankind will eventually understand that . . . Suprematism . . . is like all and nothing."[115]

El Lissitzky (1890–1941), one of Malevich's most innovative pupils, elucidated Suprematist aesthetics into a clearer analogy with the formation of the new world. In "Suprematism in World Reconstruction" (1920), he defined the new art as both a symbol and a system that continues to evolve. The Suprematist picture represents "a new world reality and in this way the foundation stone for a new representation of the shapes and forms of the material world" that is presently emerging.[116] As "a world floating in space," the Suprematist picture enables the viewer to venture "out beyond the confines of this sphere," to

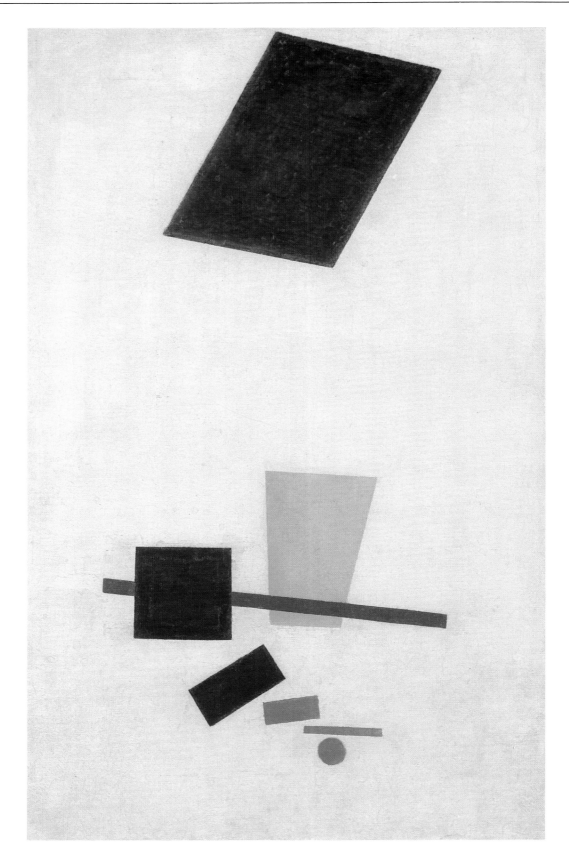

16 Kasimir Malevich Russian, 1878–1935
Soccer Match, 1915

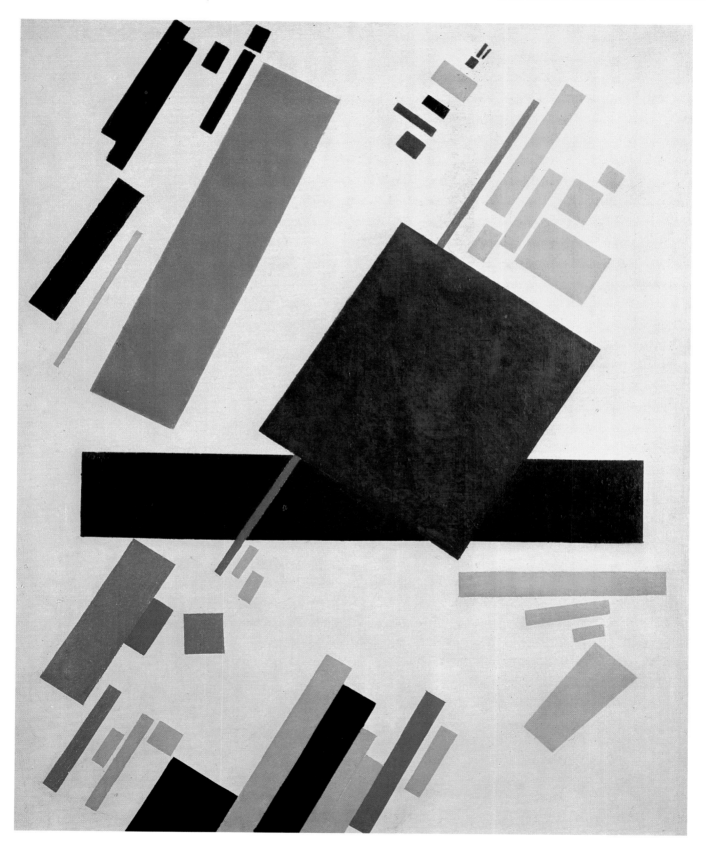

17 Kasimir Malevich
Suprematist Painting, 1916

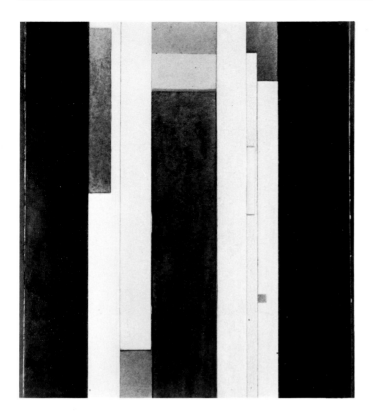

18 Ilya Chasnik Russian, 1902–29
The Seventh Dimension: Suprematist Stripe Relief,
1925

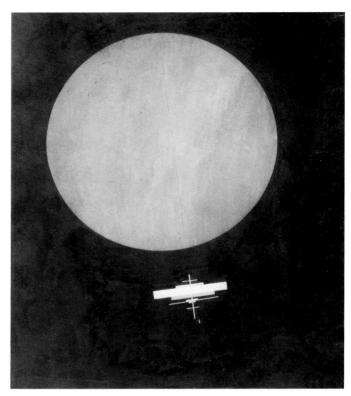

19 Ilya Chasnik
Cosmos: Red Circle on Black Surface, 1925

transcend outmoded thoughts and physical limitations to attain a cosmic consciousness.[117] Although this system has its utilitarian applications, the function of the new art is above all inspirational in order to liberate mankind completely: "Only a creative work which fills the whole world with its energy can join us together by means of its energy components to form collective unity like a circuit of electric current."[118]

Lissitzky believed in the coming of "a definite new world never before experienced—a world . . . which is now only in the first stage of its formation."[119] Building this new world would affect every human being and carry work "beyond the frontiers of comprehension," until the transformation from the old to the new would be complete: "We shall give a new face to this globe. We shall reshape it so thoroughly that the sun will no longer recognize its satellite."[120]

In 1919–20, Lissitzky developed his own Suprematist-inspired art, called *Proun* (an acronym for "Project for the Affirmation of the New Art"). In his essay

"PROUN: Not World Visions, BUT—World Reality" (1920) and other writings, Lissitzky described *Proun* as the pictorial equivalent of the ontological and societal movement toward perfection. The compositions of this new art were meant to be understood as emblems of the unending progress "from one stage to another on the chain of perfection."[121] His version of Suprematism moved away from transcendental philosophy to a more pragmatic, though still symbolic and idealistic, utopianism:

Every flat surface designed is a sign—not a mystical symbol but concrete sketch of reality. . . . A sign is designed, much later it is given its name, and later still its meaning becomes clear. So we do not understand the signs, the shapes, which the artist created, because man's brain has not yet reached the corresponding stage of development.[122]

Though he modified Malevich's Suprematist style to suit his own purposes, Lissitzky often retained the use

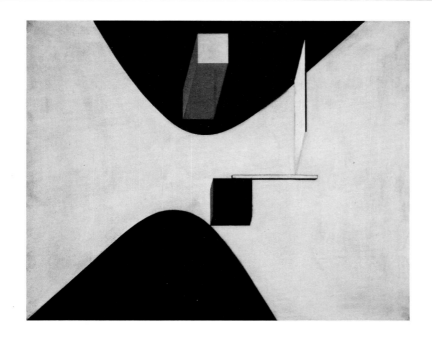

20 El Lissitzky
Russian, 1890–1941
Proun 23, No. 6, 1919

21 El Lissitzky
Proun, c. 1920

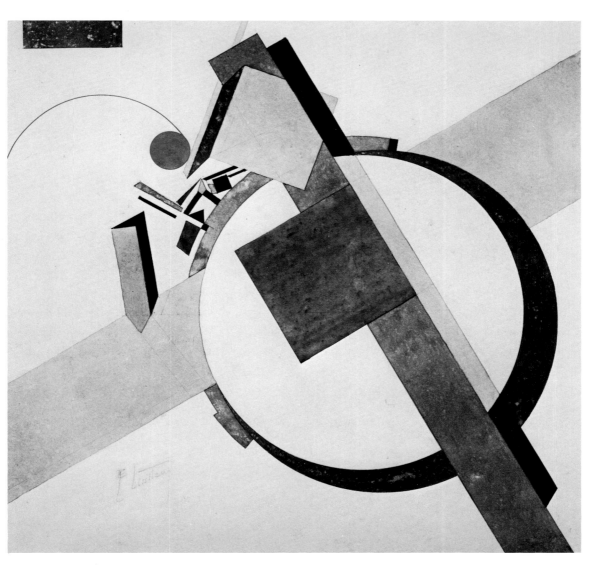

of a white plane to suggest infinite space, and he generally avoided literalist definitions of abstract forms. Rather, geometric forms acquired meaning only as components of an entirety. Compositionally they "convey to us the impression of movement, of powerful forces in motion."[123] Next to Malevich's paintings, Lissitzky's *Prouns* (20, 21) are clearly more architectonic in nature, with solidly volumetric forms that relate to each other in a spatially structured way, often along an axial system. The arrangement and overlap of forms suggest structures floating in an ideal infinite space, sometimes suggesting an isometric view of architectonic forms, seemingly weightless and in perpetual motion. The *Prouns* portrayed a new space intended to be perceived as a spatial environment having no specific time, location, or scale, into which the spectator could imaginatively project himself. "Proun begins as a level surface, [then] turns into a model of three-dimensional space," Lissitzky wrote.[124]

Intended as experiments embodying new conceptions, the *Prouns* were to have direct application to the social environment. Lissitzky's compositions of 1919–21 often functioned as pictorial two-dimensional equivalents for architecture and city planning. Some, like the two illustrated here (20, 21), suggest aerial views of town plans laid out according to the principles of geometric abstract art. Lissitzky wrote that "thanks to the Prouns, monolithic communist towns will be built, in which the inhabitants of the world will live."[125] The *Prouns* take the principles adumbrated in Suprematism and make them explicitly architectural: "I created the Proun as an interchange station between painting and architecture. I have treated canvas and wooden board as a building site. . . . In this manner it is possible to create reality which is clear to all."[126] Lissitzky's architectural goal is reflected in his use of colors, which he employed as if they were building materials:

The colors . . . in my Proun works are to be regarded as equivalent to materials. That is . . . the red, yellow or black parts . . . do not indicate colors these parts are to be painted, but rather the appropriate material they are to be made from, as for example shining copper, dull iron, and so forth.[127]

Eventually, the conceptions discovered in painting would be applied to the physical transformation of the world:

The new element of treatment which we have brought to the fore in our painting will be applied to the whole of this still-to-be-built world and will transform the roughness of concrete and the smoothness of metal and the reflection of glass into the outer membrane of the new life. This is the way in which the artist has set about the reconstruction of the world.[128]

This attitude of moving from theory, especially obscure metaphysical speculations, to the construction of the new society characterized the years immediately following the Bolshevik revolution. Under Malevich's leadership, the Unovis group (an acronym for "Affirmers of the New Art") laid plans in Vitebsk and elsewhere for injecting the Suprematist ethos into the world, as Malevich announced in the Unovis leaflet of 1920:

Our studios . . . build the forms of life—these are not pictures but projects which will become living beings. . . . We call to action . . . our comrades the . . . textile workers, tailors, dressmakers and all those who manufacture objects of the utilitarian world, so that all together . . . we can reclothe the earth in a new form and a new sense.[129]

Henceforth, as stated in a subsequent Unovis pamphlet, Suprematist works of art would be "blueprints for the building and assembling of forms of utilitarian organisms . . . in concert with astronomers, engineers and mechanics."[130]

Always more concerned with theories and ideal models than actual and immediate production, Malevich believed it was the artist's role to create formal syntheses to serve as nonfunctional models from which architects and engineers could derive inspiration and deduce practical adaptations. When he turned his attention from painting to architecture in the mid-1920s, he created, along with his colleague Chasnik, the *Architectons* (22, 23, 24, 25). These assemblages of rectangular solids and other elements could be rearranged into a variety of asymmetrical, yet balanced, vertical or horizontal compositions. Some *Architectons*, called *planits* (22) were intended by

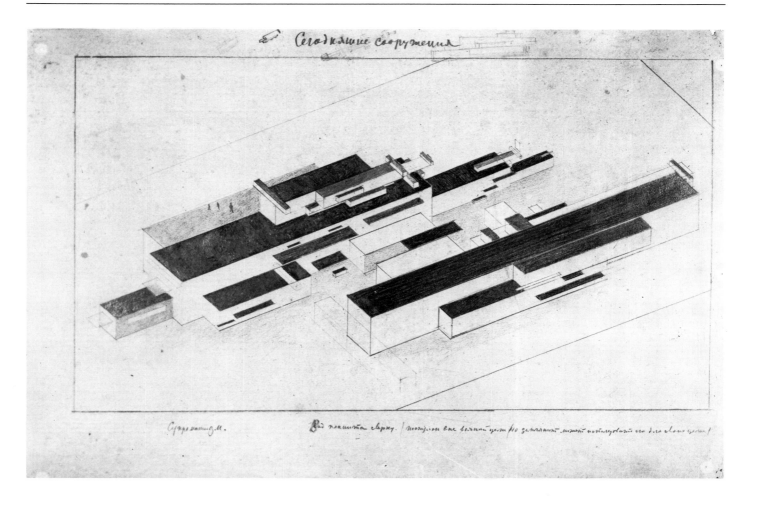

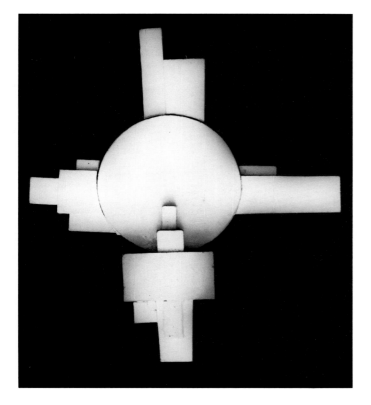

22 Kasimir Malevich
Design for Suprematist Architecton: Planit, 1923–24

23 Ilya Chasnik
Suprematist Architectonic Model: Cross and Circle,
1926

Malevich to float in the air or even in outer space:

The new dwellings of man lie in space. The Earth is
becoming for him an intermediate stage. . . . The new
man's provisional dwellings both in space and on earth
must be adapted to the airplane. A house built this way
will still be habitable tomorrow. Hence we Suprematists
propose the non-objective *planits* as a basis for the com-
mon creation of our existence.[131]

The tendency to conceive architectural designs that
embody abstract social ideals, rather than confront
specific and practical building tasks, was characteris-
tic of Russian utopianism. In a nation grievously lack-

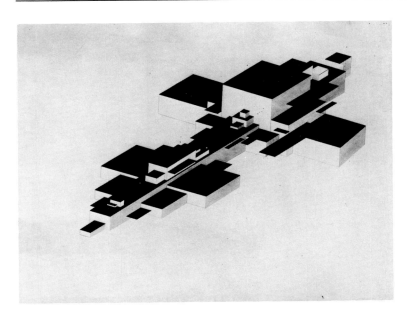

24 Ilya Chasnik
Design for Suprematist Architecton, 1928

25 Ilya Chasnik
*Design for Architectonic Model:
Cross and Circle,* 1928

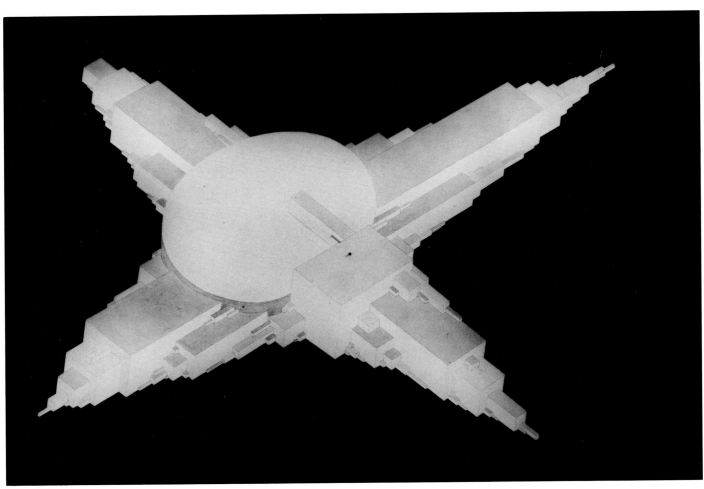

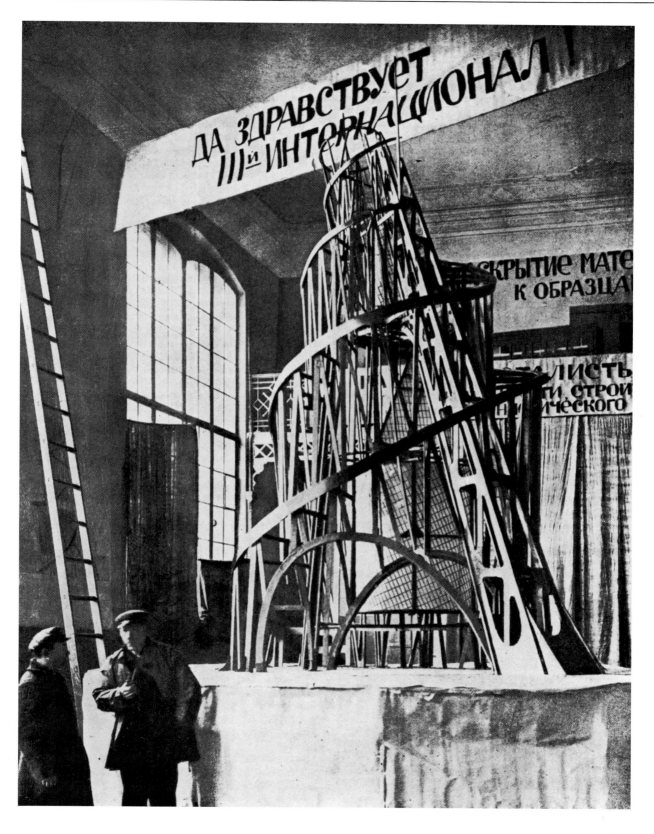

26 **Vladimir Tatlin** Russian, 1885–1953
Model of the Monument to the Third International:
Project for Petrograd, 1920; destroyed

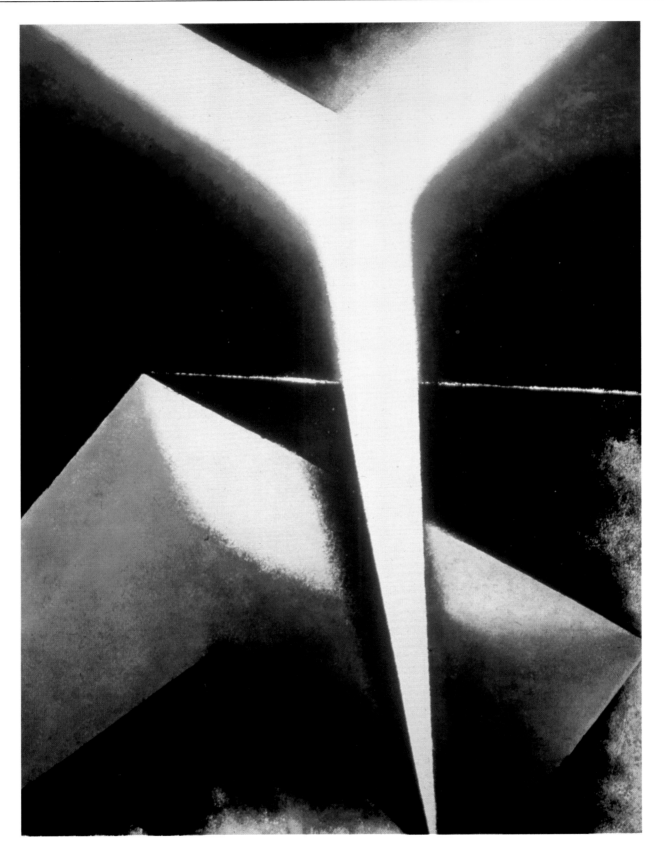

27 Alexander Rodchenko Russian, 1891–1956
Untitled, c. 1919

ing material and financial resources, utopians were free to imagine projects that might be realized in a distant, rather than immediate future. In contrast to unimaginative, academic architects who have "made so bold as to talk of Utopia,"[132] Lissitzky insisted that the new architecture should embody the ideals of the new era:

Our new architecture . . . is poised on the threshold of the future and committed to more than mere construction. Its task is to comprehend the new conditions of life, so that by the creation of responsive building design it can actively participate in the full realization of the new world.[133]

As late as 1929, utopians such as Lissitzky believed that futuristic architectural plans and proposals were fundamentally sound. He asserted that these "studio dreams" were needed as the first step and that they would gradually acquire a solid social basis, incorporating utilitarian concerns. This process of starting with ideal visions was deemed important by Lissitzky because "we are striving in our architecture as in our whole life to create a new social order, that is to say, to raise the instinctive to a conscious level."[134]

In the years immediately following the revolution, even the Constructivist artists, led by Vladimir Tatlin (1885–1953), who generally concerned themselves with designing for the imminent transformation of the physical world, were swept up in the idealism of pure abstraction in architecture and the arts. Tatlin's model for a tower to house the Third Communist International (26), the first major statement of Constructivist architecture, incorporated the symbolism of abstract geometric shapes: a cube, a pyramid, a cylinder, and a hemisphere set within a diagonally thrusting spiral framework. These forms were to provide the functional spaces (legislative, executive, and propagandist) for the Communist party headquarters in Moscow, but pragmatic concerns were subsumed into the symbolic implications of the geometric volumes. The manifesto issued when the model for the tower was exhibited urged artists to unite "purely artistic forms with utilitarian intentions" and to create "models which stimulate us to inventions in our work of creating the new world."[135]

Utopian artists and architects in revolutionary Russia held geometric forms in high esteem as conveyors of social ideals. The avant-garde art schools, founded to promote the construction of an entirely new world based on utopian principles, devoted much effort to studying the inherent meanings of geometric forms. The Asnova group (Association of New Architects), led by N. Ladovsky and N. Golosov, developed a precise doctrine of architectural forms in 1920–22. Having conducted laboratory investigations of spectators' reactions to scale, volume, mass, proportions, and so on, they identified specific forms with specific values. The cube was equated with honesty and integrity, the sphere with tranquility and equilibrium (many artists also perceived the sphere and the circle as cosmic symbols suggestive of the astronomical universe and the eternal cycle of existence and renewal, as well as inherent unity). The spiral (which combines the thrust of a diagonal line and the movement of a circle) was perceived by Lenin himself, as well as by many artists and intellectuals, as the emblem of the revolution, signifying dynamism and progress. The critic Nikolai Punin identified the spiral with "the creative will and the muscle straining with the hammer" of the proletariat, but further defined it as "a line of liberation for humanity. With one extremity resting on the ground, it flees the earth with the other; and thereby becomes a symbol of disinterestedness, and of the converse of earthly pettiness."[136]

Like the Suprematists, the Constructivists first used abstract geometric forms in painting (27), but quickly moved from the limited domain of canvas to direct involvement in constructing the new world. The inspirational power of Tatlin's tower was great, as attested by the number of photographs and art works referring to it, such as Lissitzky's photomontage (31). With few opportunities to build in the years following the revolution, the Constructivists produced conceptual and symbolic objects of a purely abstract nature. Works in the *Constructivist Spatial Apparatus (KPS)* series by Georgy Stenberg (1900–33) and his brother Vladimir in 1919–21 were designed, as the title implies, to suggest conceptual prototypes for a potentially utilitarian structure. In contrast to traditional

28 Georgy Stenberg Russian, 1900–33
KPS-11, 1919–20, reconstructed 1975

sculpture, *KPS-11* in this series (28) dematerializes solid mass for structured space and linear elements held in functional tension, like the skeletal structure of a modern high-rise building.

The Constructivists viewed their art as a means of "organizing life." Emphasizing the principles of construction as a philosophy of life, the Constructivists understood the active assembling of structural parts into a creative and dynamic whole as analogous to the building of a new world. The constructed work of art thus functioned as a symbol or metaphor for the order of the new society in which the individual elements function together to create an open, comprehensible collectivity. The new Constructivist art was thus seen as emblematic of the fusion of art with life to create a new reality.

Lissitzky's designs for a mechanical production of the symbolic opera-drama *Victory over the Sun* reflect his espousal of Constructivist principles, as well as several of the prevalent ideas concerning the new humanity. *Globetrotter* (29) refers to the ability of modern man to travel freely around the world. In this image, the new technological man is literally on top of the world, implying his conquest of the limitations of nature, including gravity and nationalistic divisions. In *New Man* (30), the figure consists of machinelike elements constructed so as to suggest the methods, strengths, and materials of industrial architecture and technological engineering. The composition of this New Man acts as a metaphor for the society of the future, which would be constructed according to a combination of aesthetic and scientific criteria and in which the individual members would retain their identity and character while together constituting a clear, rational entirety. The use of abstract shapes was intended to convey further meaning, with their crisp geometric forms as analogous to technology and objectivity in general, while the red square as the heart symbolized both the social philosophy of Communism and the transcendental metaphysics of Suprematism. The New Man thus rationally integrates the technology of his industrial environment with a suprasocietal awareness.[137]

The Constructivist aesthetic embraced science and technology as pre-eminent means to formulating the

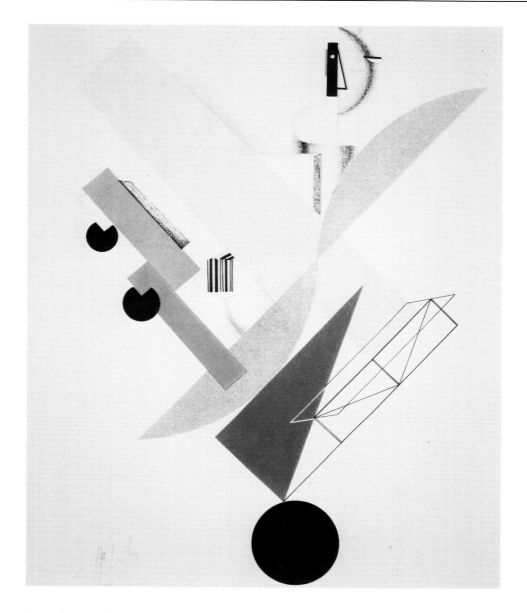

29 El Lissitzky
Victory over the Sun: Globetrotter, 1923

new world. In addition to adopting geometric forms in art and architecture, Constructivists endorsed precision and objectivity as paradigms for artistic and social efforts. Some artists used mathematical measuring instruments as they strove to equal the precision and validity of engineering. Lissitzky's image of *Tatlin Working on the Monument to the Third International* (31) portrays the sculptor-architect as a magnificent designer of an industrial world, incorporating mathematical precepts and the methods and materials of engineering. In Lissitzky's words, "The artist is turning . . . into a constructor of the new world."[138] The image of a builder or constructor was particularly popular among utopian artists in the 1920s in Russia, as well as elsewhere. The term *constructor* combined both the concept of designer or overall planner with the proletarian image of a worker who physically labors to build the new structure. Lissitzky described the utopian constructivist artist as "the omniscient, omnipotent, omnific constructor of the new world . . . promoter of a world which indeed already exists in man but which man has not yet been able to per-

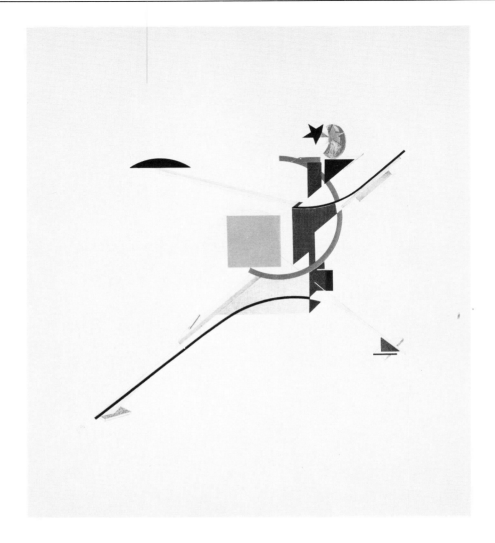

30 El Lissitzky
Victory over the Sun: New Man, 1923

ceive."[139] The image of the artist as constructor denoted objectivity, comparable to that of a scientist or engineer, as indicated in Lissitzky's *Constructor: Self-Portrait* (32). The artist's face is montaged onto a background of graph paper; his hand employs the architect's compass rather than paintbrush or chisel. Like Rodchenko and others, Lissitzky used the ruler and compass in art because he believed "ruler and compass and machine are only extensions of the finger which points the way."[140] The geometer's implements are bathed in light on the artist's right, as if to equate geometry with enlightened reason, which brings human nature out of darkness.

As in other matters, Lissitzky steered a conciliatory path between Suprematist avoidance of technological appearances and the Productivist obsession with equating art with industry. He agreed that "art belongs to the age of science; we employ the methods of our age—we analyze."[141] He believed that:

Technology has surely exerted its influence on the new artists. We have suddenly realized that the plastic art of our time is not created by the artist, but by the engineer. The vitality, the uniformity, the monumental quality, the accuracy, and perhaps the beauty of the machine were an exhortation to the artist.[142]

But he rejected outright "machine art" as erroneous. Instead of slavishly copying machine forms, Lissitzky believed in the inspirational possibilities of technology for art as a whole: "Like science, [modern art] has

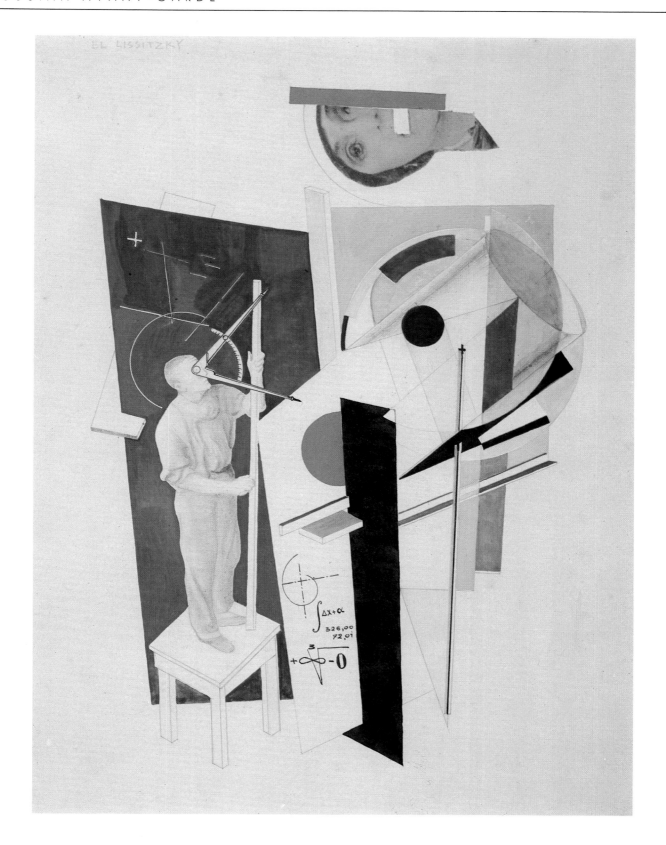

31 El Lissitzky
*Tatlin Working on the Monument to the Third
International, 1921–22*

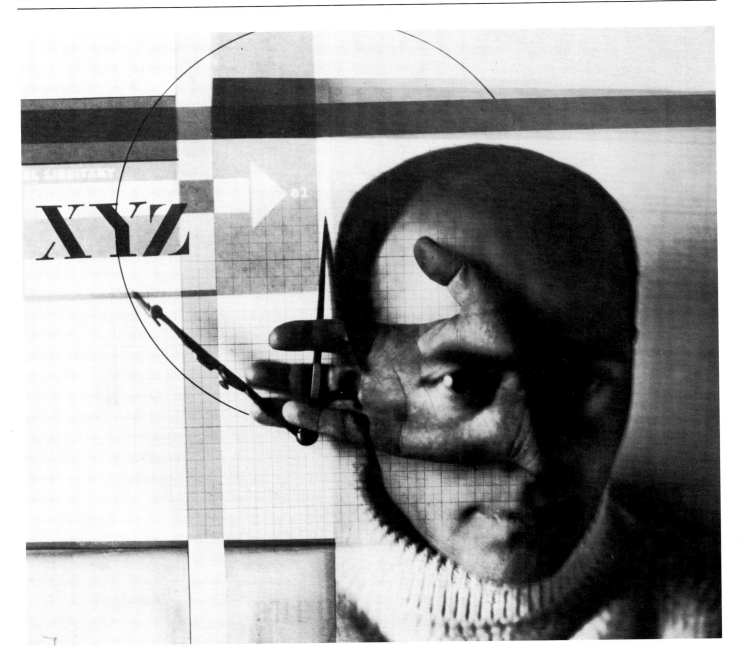

32 El Lissitzky
Constructor: Self-Portrait, 1924

reduced the form to its basic elements, in order to reconstruct it according to the universal laws of nature."[143] Unlike science, art has the "power to create aims [which] is the artist's freedom, denied to the scientist."[144]

The revolutionary fervor which insisted that art be incorporated into a new way of life led many Constructivists to adopt the Productivist attitude that easel painting was irrelevant and even prototype sculptures were insufficiently effective. After 1923, many artists turned to the applied arts of typography and poster design and to producing prototypes for the mass production of clothing, textiles, furniture, and other utilitarian objects. Thus the original utopian visions began to be translated into tangible reality. When art becomes the totality of life, one way or another, utopia will have been achieved.

GERMAN EXPRESSIONISM

Outside of Russia, Germany proved to be the most fertile breeding ground for utopian aspirations. Industrialization, urbanization, political power, and the attendant social changes came in a rush in the last quarter of the nineteenth century, ushering in an acute intellectual crisis. Before World War I, a number of artists and writers agitated for a revolution in values for the good of man. Periodicals such as *Die Aktion* published articles calling for new sociocultural values and radical changes in the world. The art and ideas of the Futurists were known from 1912 on, and there were calls for the "improvement of the world, the realization of the kingdom of God on earth."[145]

Paralleling developments in Russia, utopian conceptions in German art followed a similar development from metaphysical and spiritual ideals to more practical, industrial goals. In the years preceding World War I, Russian-born Wassily Kandinsky (1866–1944) developed a decidedly nonmaterialistic brand of utopian art. His personal aesthetic theory, which dominated the ideas of the Blaue Reiter group in Munich, was vitally concerned with the spiritual welfare of mankind. Along with the German painter Franz Marc and others, Kandinsky anticipated the coming of a new era of heightened consciousness. These artists were not concerned with political or economic renewal but with, in Kandinsky's words, "the spirit that will lead us into the realms of tomorrow"[146] when mankind would be concerned with "feelings," by which Kandinsky meant an intense spiritual awareness, rather than physical sensations or superficial emotions.

Although dealing with subjective concerns that spring from deep within the individual, the Expressionism of the Blaue Reiter group was intended to establish contact with the broad reaches of humanity. This aesthetic incorporated a strong belief that an artistic revolution could effect radical social change by purifying and transforming the individual. Abstraction, Kandinsky hoped, would create a new consciousness by affecting the viewer directly on a subliminal and primary level with its message of universal creativity. Rejecting the materialist world for a subjective inner reality unrestricted by logic, he hoped

to spread an awareness of deeper, universally valid values. Indeed, Kandinsky's Expressionism has much in common with Malevich's Suprematism, though the two theories were conceived independently. Both artists rebelled against the predominant materialism of modern society and proposed instead to revolutionize human existence onto an altogether different plane. They set their sights above and beyond the social problems of daily physical life to a more profound, and therefore abstruse and difficult to define (as well as attain), state of being. Theirs was an evolution of values, perceptions, and priorities—from the material to the spiritual, from the local to the cosmic, from the temporal to the eternal.

Kandinsky's ideals reflect the influence of the Theosophical Society founded in the late nineteenth century by Mme H. P. Blavatsky. One of the central aims of this international organization was to promote a universal brotherhood of mankind based on spiritual awareness. Having read Blavatsky's writings and those of Rudolf Steiner (founder of the related movement known as Anthroposophy), Kandinsky agreed with their belief that by focusing on spiritual concerns, humanity would attain new perspectives, and subsequently other matters would eventually follow in this evolution to a better existence. In addition to citing Blavatsky's concluding statement to her book *The Key to Theosophy* (1889, German translation 1907), where she predicted that "in the twenty-first century, this earth will be a paradise by comparison with what it is now," Kandinsky asserted that "the spirit progresses, and hence today's inner laws of harmony are tomorrow's external laws."[147] He elucidated this belief later, when he participated in Russian avant-garde utopianism (1914–21), in his essay "The Great Utopia" (1920): "Since from the nonmaterial is born the material, art, too, with time, freely and inevitably produces material values as well. What yesterday was a mad 'idea' today becomes a fact, from which, tomorrow will become material reality."[148]

As a first step, Kandinsky developed his Expressionist style of abstraction (33, 34, 35) as a means of preparing people to see and think in terms of immaterial values, eventually to penetrate through matter to the spirit. His paintings would reveal that a new

spiritual era and a new "higher man" were in the process of emerging. Reaching the spectator, including the uninitiated, was essential to Kandinsky's utopian aesthetics. He was determined to avoid a superficial art "having the appearance of geometrical ornament, which would—to put it crudely—be like a tie or carpet."[149] To this end, he carefully analyzed the elements of expression, principally forms and colors, in his treatise *Concerning the Spiritual in Art* (1909, published 1911, revised 1912), in order to define and clarify "that divine language which . . . is addressed by man to man."[150]

Kandinsky believed that effective use of forms and colors could powerfully affect the viewer by touching a responsive chord in his soul (in much the same way as music can), and in so doing, ultimately transcend habitual processes of thought and perception. He believed that "every form has inner content . . . there is no form that says nothing."[151] Because Kandinsky associated realistic forms with a materialistic frame of mind, he moved to abstract forms to express spiritual values and higher consciousness. However, he felt that utilizing purely abstract, geometrical forms would exclude the human factor and thereby impoverish potential expression. Consequently, he developed a style of amorphous forms that blends abstraction with referential shapes derived from such sources as mountainous landscapes (33, 35) and various human and animal themes. Kandinsky felt that there is an inherent spiritual accord between such "organic" forms and the nature of human consciousness, because, without being too descriptive or symbolic, the subjects from which these forms derived would exert a subliminal influence upon the viewer. This "concordance" of the real with the abstract into organic forms could be infinitely suggestive in an elusive way, implying a mysterious content that would elicit spectator involvement.

Indeed, Kandinsky's complex compositions of ambiguous forms require active exploration and interpretation. He believed that the appropriate arrangement of these suggestive shapes could be a powerful method of communicating universal and cosmological ideas. For example, sharp conflicts of symbolically colored organic forms (34) could express the

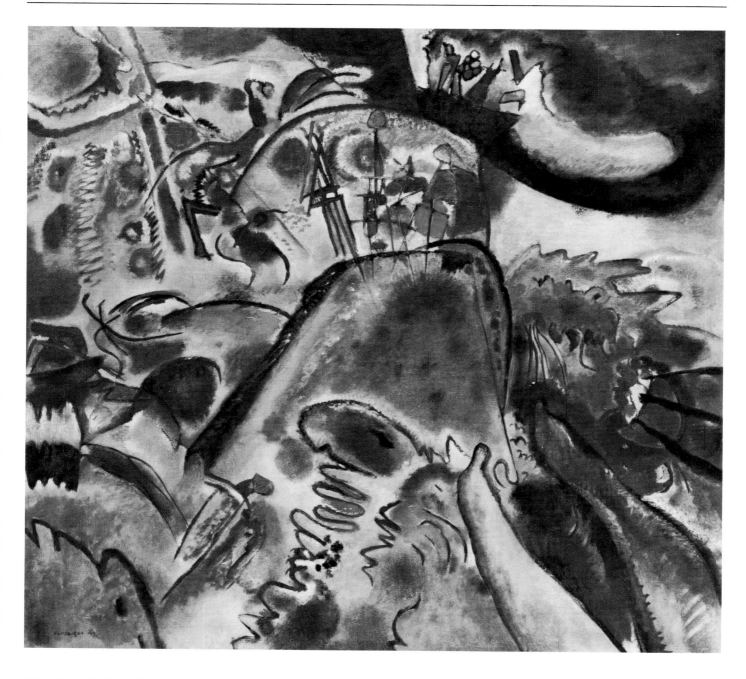

33 Wassily Kandinsky Russian, 1866–1944
Small Pleasures No. 174, 1913

apocalyptic struggle between cosmic forces of good and evil, material and spiritual, self and others. The position, direction, isolation, or repetition of individual elements relating to each other in a cosmic space without scale or time would create a powerful and dynamic subconscious effect, while the viewer's active involvement in and discovery of meaning would result in a new, heightened awareness. Furthermore, compositions seemingly unrestricted by recognizable subject matter and conventional aesthetic laws would elicit the spontaneous functioning of human faculties. Kandinsky believed that such spontaneity could upset the extant order of the world and ultimately reveal a different and fundamentally satisfying way of dealing with reality.

Color was the most powerful affective tool in Kan-

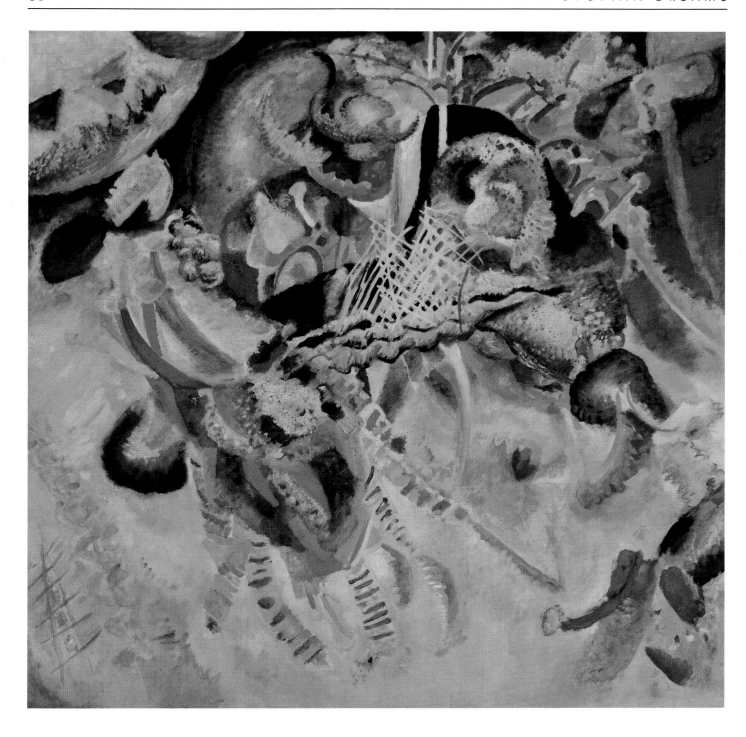

34 Wassily Kandinsky
Fugue, 1914

dinsky's vocabulary. Beyond its purely physical or optical effects, color has a psychological, emotional power, which "can give rise to other, deeper sensations and set off a whole chain of psychic experiences" that can "develop into a deeper form of experience."[152] Properly orchestrated, color "awak-

ens on the one hand a certain precise, and yet imprecise, representation having a purely internal, psychological sound."[153] Kandinsky drew upon his own observations and nineteenth-century color theories to assign associative and emotive values to varying shades of the basic colors. For example, because

yellow tends to glow outward from the canvas, certain shades of it can convey the manic and shrill aspects of humanity, and its use can upset people. Blue, on the other hand, is a heavenly or spiritual hue, which can create a feeling of tranquillity and profound contemplation. He defined other colors such as red (material beauty and warmth, powerful emotional intensity, capable of many effects depending upon the exact shade), violet (combining the spirituality of blue with the material warmth of red), and so on. Black portends nothingness, existence without future or hope. In a metaphysical interpretation remarkably similar to Malevich's, Kandinsky perceived white as "the symbol of a world where all colors as material qualities and substances have disappeared," akin to "a great silence . . . stretching away to infinity . . . white affects our psyche like a great silence . . . full of possibilities . . . the nothingness that exists before the beginning."[154]

Because he sought a spiritual consciousness fundamentally different from material reality and because spontaneity was deemed an essential means to this goal, Kandinsky refrained from defining a style based on absolute rules. Excessive systemization would inhibit spontaneity and freedom, so he tried to be flexible enough to allow for infinitely expanding possibilities and unforeseen responses in the subconscious and "superconscious." Thus, "even if overall construction can be arrived at purely by theory, nevertheless, there remains something extra which is the true spirit of creation . . . which can never be created or discovered, but only suddenly inspired by feeling."[155] Eventually, verbal explanations would no longer be needed, "as people develop greater and more refined sensitivity through the use of more and more abstract forms (which will receive no interpretation in physical terms)."[156]

As part of the progression toward a new world, many Expressionists believed that utter destruction of the old values was a necessary preparation for breaking through to a better existence. In the years preceding World War I, Expressionists envisioned a purifying cataclysm that would rid the world of the traditions and institutions that had hitherto restricted the full development of mankind. Thus, when war broke out in late 1918, it was actually welcomed by

a number of German artists and writers, as it was by the Italian Futurists. Franz Marc wrote from the front that war was "a preparation for a breakthrough to a higher spiritual existence," exactly what was needed for "sweeping dirt and decay away to give us the future today."[157] Marc foresaw that the essential good would "survive, refined and hardened by the purifying of war."[158]

After the war ended, this constructive vision gripped German artists, intellectuals, and writers. When the monarchy fell in November 1918, revolution was in the air and sometimes in the streets as leftists paraded, occupied buildings, took political power in Bavaria, and fought rightist militants in various cities. Coming almost exactly one year after the Russian revolution, the German transition from monarchy to democracy was expected to follow a similar path toward total socialist renovation. Socialist Gustav Landauer expressed the activist optimism of late 1918–early 1919: "There is a new and convulsive stirring abroad; spirits are awakening; souls are rising . . . to responsibility and hands to do great deeds; may the fruit of revolution be rebirth."[159] Just as workers and soldiers formed councils, artists quickly grouped together in the Novembergrüppe and Arbeitsrat für Kunst (AfK; Working Council for the Arts) in order to help shape policies for the new society.

The ideas of the AfK were formulated by its leaders, Bruno Taut (1880–1938) and Walter Gropius (1883–1969), both architects, who believed that "the aim must be a new culture . . . a long-term objective, gleaming magnificently in the distance."[160] Gropius wrote confidently of their hopes for a new world and emphasized the need to preserve pure utopian goals lest the future ideal world be despoiled:

But ideas die as soon as they become compromises. Hence there must be clear watersheds between dream and reality, between longing for the stars and everyday labor. Architects, sculptors, painters . . . *build in imagination,* unconcerned about technical difficulties. The boon of imagination is always more important than all technique, which always adapts itself to man's creative will.[161]

As in Russia, these architects and artists were willing to devote themselves to the unfettered conceptualization of utopia, a perfect, uncompromised era that

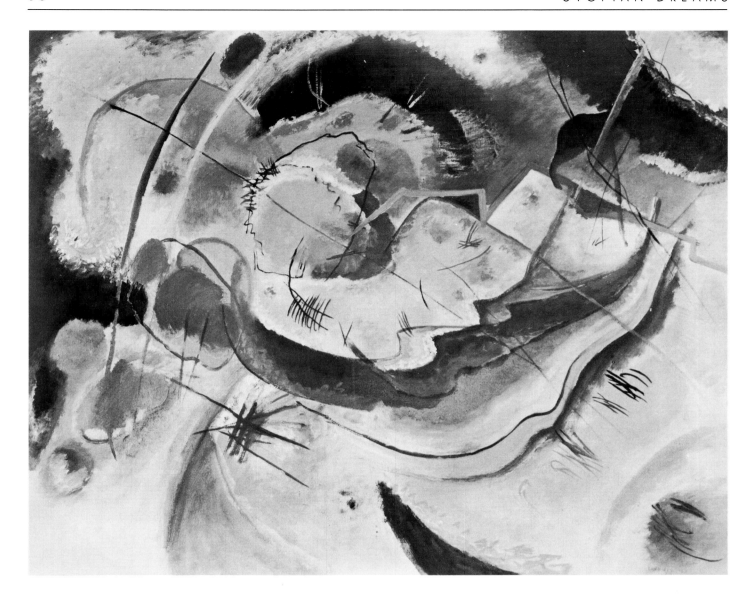

35 Wassily Kandinsky
Improvisation (Little Painting with Yellow), 1914

they would never see because of the lack of material support. Bruno Taut wrote:

We cannot be creators today, but we are seekers and callers. We shall not cease seeking for that which later may crystallize out . . . know[ing] in deep humility that everything today is nothing but the first light of dawn. . . . We call upon all those who believe in the future. . . . One day there will be a world view. . . . Then there will be no striving . . . [and the new] art will shine into every nook and cranny.[162]

From the outset, the AfK established the importance of architecture in building a new world, stressing that the process of building itself would bring people together in a collaborative effort:

The various disrupted tendencies can find their way back to a single unity only under the wings of a new architecture. . . . The direct carrier of spiritual forces, molder of the sensibilities of the general public, which today are slumbering and tomorrow will awake, is architecture . . . today's architects must prepare the way for tomorrow's buildings.[163]

Taut and Gropius exhorted architects to gather together and strive for "the symbol of the building belonging to a better future and which demonstrates

the cosmic character of the architecture, its religious foundations, so-called Utopias."[164] Taut urged: "We call upon all those who believe in the future. All strong longing for the future is architecture in the making. One day there will be a world-view and then there will also be its sign, its crystal—architecture."[165]

After the early optimism of 1918–early 1919, utopians realized that the government of the new republic was more committed to maintaining a bourgeois status quo than in effecting radical and total change. Yet this disappointment, combined with the economic horror of runaway inflation and unemployment, did not dampen their belief in creating a utopia. They simply modified their approach, turning instead to a more private and incremental approach to achieving utopia. In December 1919, Taut formed the Glass Chain (Die gläserne Kette), a small, informal alliance of visionary architects who exchanged ideas and designs by letter, in preparation for future implementation. Although their overall goals were the same as the AfK, members of the Glass Chain withdrew from activism to formulate theories and design prototypes. Instead of the earlier calls for public participation, political involvement, and exhibitions, they retreated to the quiet preparation of futuristic architectural designs until the time when society would finally be ready to accept them and cooperate in creating a new world.

That such a time would come was accepted as inevitable, as Taut wrote in the architectural journal Frühlicht:

How day will eventually break—who knows? But we can feel the morning. . . . We and all those striding with us see in the distance the early light of the awakening morning! . . . Glassy and bright, a new world shines out in the early light; it is sending out its first rays. A first gleam of jubilant dawn. . . . Today more than ever we believe in our will, which creates for us the only life value. And this value is: everlasting change.[166]

The architects of the Glass Chain, including Taut, Gropius, Hermann Finsterlin, Hans Scharoun, Wassily Luckhardt, Wenzel Hablik, and others, created visionary architectural designs (36–43). These were intended to alert the public to the radically different nature of the coming utopia. Gropius wrote that these fantastic drawings "really are extreme examples of what we want: utopia."[167]

The members of the Glass Chain believed in colored glass architecture as having the power to transform mankind spiritually. Bruno Taut was the most vociferous advocate of glass architecture, which he proselytized in three illustrated books of 1919–20 (The World Architect, The Dissolution of Cities, and Alpine Architecture), in which cities have been decentralized, so that people live amid natural settings all over the world. Entire mountain ranges have been transformed with glass structures having no utilitarian function other than to create a sense of spiritual and aesthetic wonder that will unite people with nature, the cosmos, and each other. Inscribed on The Crystal Mountain of 1919 (fig. 2), one of the illustrations in Alpine Architecture, is Taut's description of his future world: "The rock above the treeline is hewn away and smoothed into many-faceted crystalline forms. The snow-domes in the background are covered with an architecture of glass arches. In the foreground, pyramids of crystal shafts. Above the chasm, a bridge-like trellis of glass."

The fascination with glass architecture among these utopian architects derived largely from Taut's propagation of the ideas of the Expressionist Paul Scheerbart (1863–1915), whose Glass Architecture (1914) presented one hundred eleven paragraphs arguing for a total environment of glass:

Our culture is in a sense a product of our architecture. If we wish to raise our culture to a higher level, we are forced for better or for worse to transform our architecture. . . . This can be done only through the introduction of glass architecture that lets the sunlight and the light of the moon and stars into our rooms. . . . If glass architecture is everywhere . . . the splendour is absolutely unimaginable. . . . Then we should have a paradise on earth and would not need to gaze longingly at the paradise in the sky.[168]

The favorite use of glass among the architects of this group was in images suggestive of crystal. As a symbol long associated with esoteric religious beliefs and mystical philosophies, crystal implied the coming spiritualization of humanity.

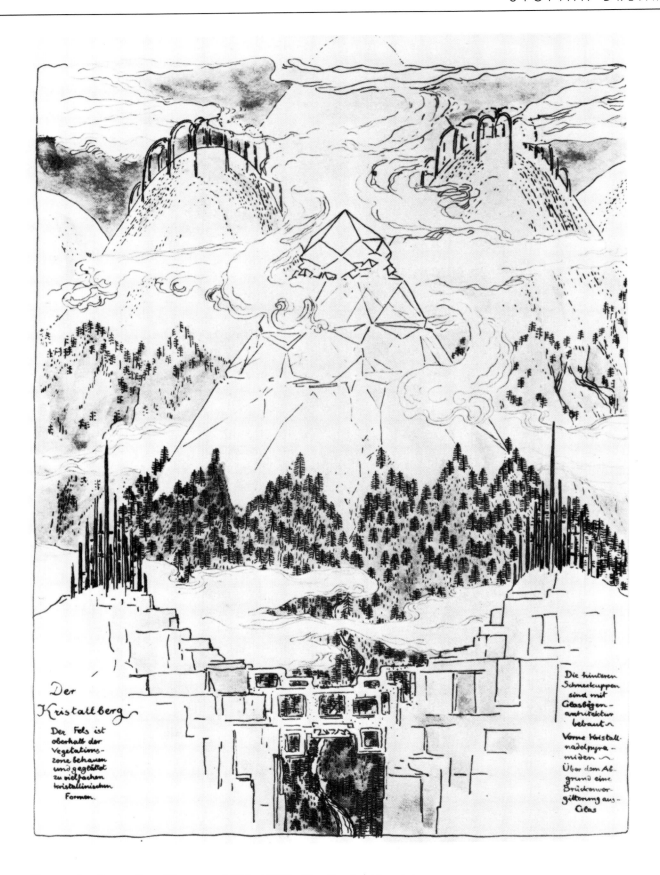

Figure 2 Bruno Taut (German, 1880–1938), *The Crystal Mountain,*
illustration in *Alpine Architecture* (Hagen, Germany, 1919)

One member of the Glass Chain, Hermann Finsterlin (1887–1973), was a painter rather than an architect. His delicately tinted polyplike buildings recall amoeba and other primeval biological forms (36–39). Over five hundred watercolor and ink sketches extend natural biomorphic forms into architecture, usually depicting single buildings. Many seem to surge and swell as if in the process of expansive organic growth. Finsterlin believed there was a biological creative urge in the universe, which manifested itself in art; he called these drawings "systems of the soul."[169]

Radically digressing from traditional building styles and methods, Expressionist utopian architectural designs generally ignore orthogonal plans and post and lintel systems in favor of more freely abstract and expressive forms. Rarely are walls vertical, and spe-

cific styles may vary from rounded organic softness (36–39) to hard-edged crystalline faceting (40, 43), because what mattered were the spiritual effects aroused in the spectator. Through its transparency, glass architecture embraces nature and induces its inhabitants to contemplative union with the cosmos. The ideas of nineteenth-century Romantic transcendentalism, which postulated the individual transcending his own insignificance through immersion in God's nature, are perpetuated in the manmade ambiance of glass architecture. Furthermore, constantly changing light, both natural and artifical, causes an infinite variety of visual patterns and variegated colors. Thus glass architecture is an architecture of dynamism and perpetual flux—a source of endless stimulation. Glass also creates spatial ambiguities and the suggestion of total openness and clarity; it dematerializes matter

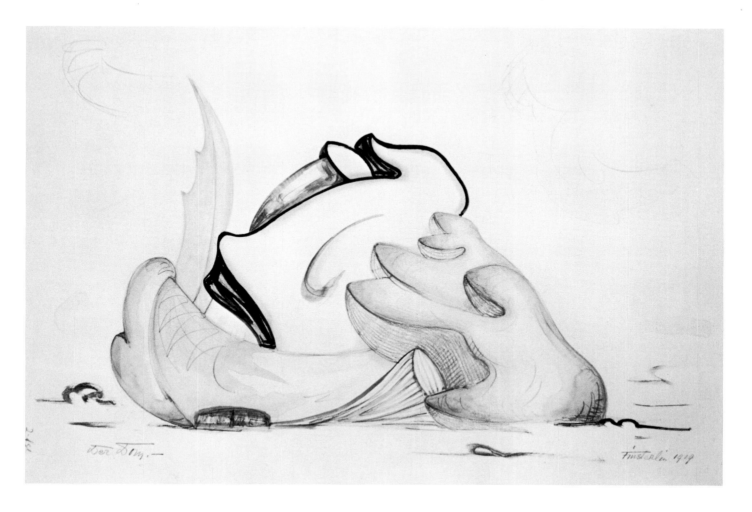

36 Hermann Finsterlin German, 1887–1973
Concert Hall, 1919

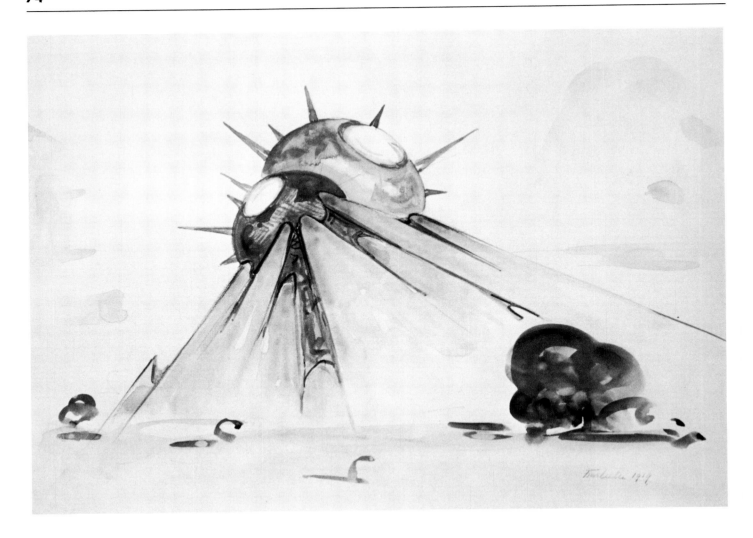

37 Hermann Finsterlin
Cathedral, 1919

into visual and spiritual concerns, just as Gothic stained-glass windows stimulated Christian souls toward union with God. The architects of the Glass Chain thus imbued glass architecture with powers far beyond its spectacular beauty. It would provide emotional and spiritual sustenance, serving the subjective needs of people, stimulating them to perceptions beyond materialistic concerns. The ultimate result would be the transformation of the world into a glittering jewel and humanity into a cooperative, spiritually enlightened union.

Wenzel August Hablik (1881–1934) was one of the most sincerely committed visionary architects of the Glass Chain. As early as 1903, he composed exquisite watercolor drawings of enormous crystalline structures surging upward from mountainous terrain.

Between 1907 and 1924, he conceived flying colonies and other physically mobile structures as part of his dedication to the creation of a new society. Some of his projects are clearly fantasies, while others address clear constructional concerns, as in *Cycle of Exhibition Buildings* (40) and *House and Studio* (41).

In 1924, Hablik assembled his *Utopian Architectural Cycle* (42, 43), a portfolio of etchings based on his compositions of the preceding decade, prefaced with his "Architectural Manifesto":

People of the World! Nations! Races! Generations! All of you represent humanity, one single, great family. . . . What have you now perceived? That mankind has arrived at a turning point. That experiments in founding monarchies, nations and other political, economic, religious organizations over thousands of years have failed. . . .

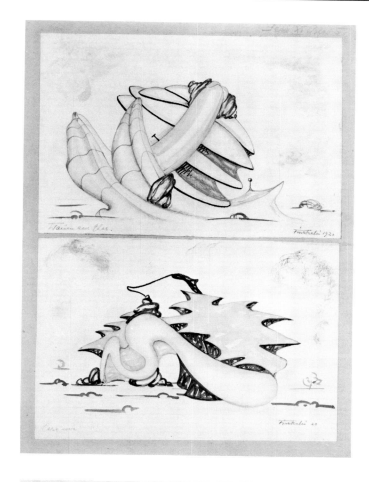

Are there any bridges to a better future out of this wasteland? Yes, the belief in eternal strength and the truth! The conscience of the world becomes stronger and stronger, the knowledge of paradise lost makes those who long for it come alive again. . . . May a new spirit in architecture mark the beginning.[170]

In "A New Architecture as the Basis for a New Religion and World View, a Connection to the People of the World," Hablik described his belief in the powers of utopian architecture:

Don't think of your environment as obligatory, don't think of your actions as restricted by money. . . . But do think about the time . . . when everyone flies, when trains and cars run without people, when war will become an inconceivably crazy notion. All of this and much more . . . we could do. . . . Wishes have an elementary power. . . . Well! We still need to wait awhile, but what are fifty years? What are 500 years? . . . But it is important to be prepared for that time.[171]

Hablik urged people to rise above their destructive ways by always keeping "a fairy-tale goal in sight."[172] Utopian visionary architecture thus served an essential motivational purpose as inspiration to a better world.

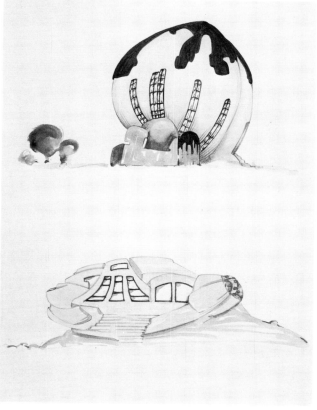

38 Hermann Finsterlin
Dream in Glass and *New House,* 1920

39 Hermann Finsterlin
House of Devotion and Museum, c. 1919–20

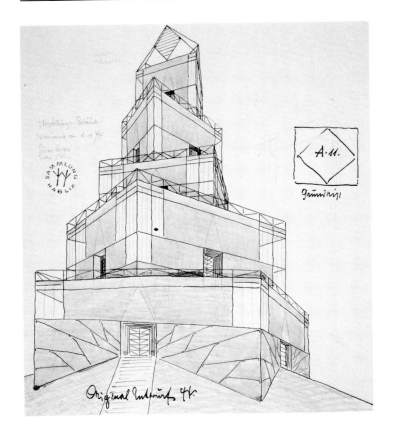

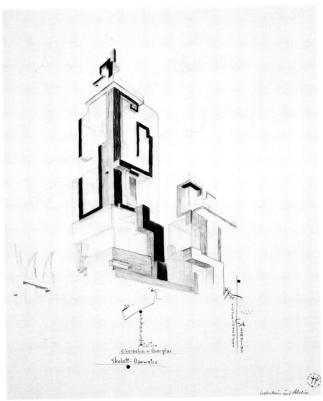

40 **Wenzel August Hablik** German, 1881–1934
Cycle of Exhibition Buildings: Cube, Calcite Spar,
1920

41 **Wenzel August Hablik**
House and Studio, 1921

42 **Wenzel August Hablik**
Utopian Architectural Cycle: Explorer's Settlement,
1914–24

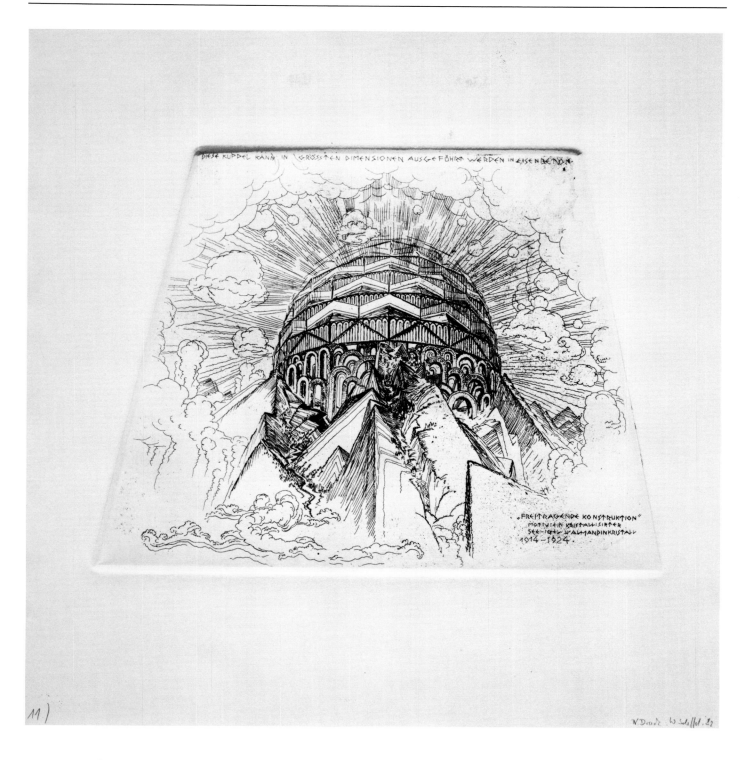

43 Wenzel August Hablik
*Utopian Architectural Cycle: Free-Standing Dome
Construction, 1914–24*

GERMAN BAUHAUS

The Expressionist concern with deep human spiritual values underlay the utopian attitude of the early years of the Bauhaus, founded in 1919 by architect Walter Gropius, who retreated from the AfK into this enclave in order to preserve his utopian goals against contamination by reality. Gropius wrote in December 1919:

If we want to achieve something great, then we must adhere to our programme in every respect and tolerate no compromises—particularly amongst ourselves. Initially we would rather achieve nothing, for any shifting of our position is the beginning of the end. We must have faith in our ability to wait patiently until the day comes when we step out in public—vehemently and fully prepared. I consider the close union amongst ourselves to be . . . much more important than external propaganda.[173]

The ultimate goal, symbolized by the "cathedral of the future" image (44), was the great *Gesamtkunstwerk,* the creation of a totally new environment constructed according to idealistic artistic principles, which would unite all the arts with architecture and all segments of society into a cooperative union. As Gropius proclaimed in the founding program of the Bauhaus in 1919:

Together let us desire, conceive, and create the new structure of the future, which will embrace architecture and sculpture and painting in one unity and which will one day rise toward heaven from the hands of a million workers like the crystal symbol of a new faith.[174]

The image of the cathedral acted as the symbol of utopian collectivist cooperation to be enacted at the Bauhaus. This inspiring collective building project (*Kultusbau*) was to be the means of uniting people into the new society. The cathedral image also recalled medieval times when a town united to build its church which embodied the ideals of its age. Gropius sought a similar goal:

A universally great, enduring, spiritual religious idea . . . which finally must find its crystalline expression in a great *Gesamtkunstwerk.* And this great total work of art, this cathedral of the future, will then shine with its abundance of light into the smallest objects of everyday life. . . . We will not live to see the day, but we are, and this I firmly believe, the precursors and first instruments of such a universal idea.[175]

This goal was to be achieved through the development and pervasive distribution of radically new design in all fields. Eventually the Bauhaus name (derived from the root "bau" meaning "building") became synonymous with industrial design, though at first (until 1922–24) the approach had emphasized handicrafts. But the Bauhaus founding faculty addressed itself to concerns other than mere vocational training. The curriculum was geared to the more immediately recognizable goals of educating future artists. To attain a better culture, people would first have to be trained to recognize the essential interrelatedness of all aspects of human life and experience.

Gropius founded the Bauhaus to nurture the current generation of utopians and to educate the next. Though utopian artists throughout Europe believed that their art was the primary means of educating people to understand the values of the new era, many utopians also lectured, published articles and books, and taught in art schools, as additional means of propagating utopia. In the years following the revolution, virtually every avant-garde artist in the USSR served on the faculty of one or more art schools, most of which had an open admissions policy. Education was a moral imperative since (in true utopian tradition) it was believed that once people understood, they would produce a better society.

To prepare for the future utopia in which the environment, society, and the self would be fully integrated, the Bauhaus teachers devised a program of holistic aesthetic education. The required preliminary course (*Vorkurs*) taught students to shed their conditioned perceptions and develop new ones, regarding both art and themselves. Through exercises with different materials and methods, as well as other studies (including meditation during the early years under the mystic artist Johannes Itten), the student would learn to perceive universal harmonies and to express them in new art forms.

In keeping with utopian projects through the centuries, the members of the Bauhaus tried to establish a model community of cooperation and shared social consciousness, with an international faculty and students working closely together. Though the members of the Bauhaus shared a common utopian commit-

44 Lionel Feininger American, 1871–1956
Cathedral of the Future, 1919

ment, there was at first no compulsion to formulate a single, dominant style governing all the arts. Since their long-term utopian goal encompassed true freedom as a central tenet, the Bauhaus aimed to be a working community of creative individuals functioning as complete human beings. As Paul Klee noted in 1921:

I welcome the fact that forces so differently oriented are working together in our Bauhaus. I also approve of the conflict between these forces if its effect is evidenced in the final accomplishment. To meet an obstacle is a good test of strength. . . . Our work lives and develops through the interplay of opposing forces, just as in nature the good and the bad work together productively in the long run.[176]

The history of the Bauhaus falls into three periods, the first dominated by Expressionism, the second by

45 Oskar Schlemmer German, 1888–1943
Utopia, 1921

Constructivism, and the third by Functionalism. The first two phases, from 1919 to 1928 under Gropius's directorship, were the most exciting years, illuminated by the glow of utopian enthusiasm for a new beginning. During these years, members of the Bauhaus were totally committed to their task. Projects included the private Utopia Press which published their almanac *Utopia: Documents of Reality* (1920–21), for which Oskar Schlemmer (1888–1943) designed the cover (45). Though the Bauhaus teachers and students remained firmly dedicated to creating a new world, after 1925 the idealist fervor began to subside, discouraged by lack of progress, as Schlemmer noted in 1925: "Utopia? It is indeed astonishing how little has been accomplished so far in this direction."[177]

Though from the start in 1919 the focus at the Bauhaus was on design in all fields, the best-known teachers were artists in the traditional media, and they pursued their own paths of development. Lionel Feininger (1871–1956) executed the *Cathedral of the Future* (44) in his Futurist-inspired Expressionist style. In contrast to the electrified lines and medieval symbolism of Feininger, most Bauhaus artists aimed at a more consciously "modern" look.

Like Itten, Klee, and Feininger, Kandinsky also brought prewar Expressionism to the Bauhaus. Influenced by the burgeoning international attitude favoring scientific methods and crisp forms, which he encountered both in Russia (1914–21) and at the Bauhaus (1921–33), Kandinsky modified his style from calligraphic and organic forms to increasingly geometric shapes. In the pedagogical treatise *Point and*

Line to Plane (1926), he exhaustively analyzed color, line, and austerely geometric form, yet still defined the goal of art as a step toward that synthesis of the human with the divine in an all-encompassing unity.

Around 1923, the Bauhaus reoriented its philosophy away from the mystical and spiritual attitudes and the emphasis on handicrafts to a greater interest in technology, science, and rationalism. As Gropius announced, "The Bauhaus believes the machine to be our modern medium of design and seeks to come to terms with it."[178] This reorientation was stimulated in part by the presence of the De Stijl artist Theo van Doesburg in Weimar in 1921–22, where his lectures on the "machine aesthetic" attracted many Bauhaus pupils. Vigorous debates ensued between the medieval, mystical advocates of crafts and the pro-technology faction. Oskar Schlemmer recorded this change with approval in his diary:

Turning one's back on utopia. We can and should concentrate only on what is most real, the realization of ideas. Instead of cathedrals, the "living machine." Repudiation of the Middle Ages and of the medieval concept of craftsmanship . . . [which] will be replaced by concrete objects which serve specific purposes.[179]

Members of the Bauhaus believed that the emergence of the machine age was an inevitable and extremely significant stage in historical evolution. The pervasiveness of technology signified a new world reality. After the mid-1920s, the earlier romantic attitude yielded to a cooler, ostensibly more rational approach. Instead of making technology into the new religion, as the Futurists did, later utopian artists thought that technology would allow modern man to *do without* traditional religion. For artists like Moholy-Nagy, technology "replaced the transcendental spiritualism of past eras" with rationalism and pragmatic humanism.[180] Technology would serve to liberate mankind from superstitious beliefs of all kinds because science reveals the workings of the universe as operating according to known laws. Yet, even among those artists most avidly devoted to technology for its own objectivity, there were some who unconsciously raised the machine to a position of godlike superiority over humanity.

In this struggle between utopian ideologies at the

Bauhaus, Schlemmer sided with the technologically inclined faculty because he believed that increasing mechanization served ultimately to place greater emphasis on man, to define him as unique, irreplaceable, and the center of all utopian concerns:

[The] emblem of our time is *mechanization,* the inexorable process which now lays claim to every sphere of life and art. Everything which can be mechanized *is* mechanized. The result: our recognition of that which can *not* be mechanized.[181]

From his arrival at the Bauhaus in 1920, Schlemmer focused on the human figure and its adaption to the new technological environment. He hoped through severe simplification of form and the use of numerical proportions to elevate the human figure from erratic and complex confusion to an ideal state. Regarding man as the alpha and omega of all values, Schlemmer rejected abstraction as inhumanly soulless and tried instead to create an ideal type as an emblem of the human focus of the coming utopia. "Man, the human figure . . . is the measure of all things," he wrote. "The elemental aspect of the figure is the type. Its creation is the ultimate and highest task."[182] Seeking the fundamental, universal nature of humanity, Schlemmer subsumes individual characteristics into a generalized ideal conception, as in the *Homo* relief (46).

Besides the fine arts, Bauhaus artists turned their attention to other art forms. The theater was particularly valued as a means of summarizing utopian conceptions. As head of the theater workshop, Schlemmer defined the theater as a microcosm in which an image of the future utopia, or aspects of it and its ideals, could be created:

The economic crisis may make building impossible for years to come. There are no noble tasks to which the utopian fantasies of the moderns might be applied. The illusionary world of the theater offers an outlet for these fantasies. We must be content with surrogates, create out of wood and cardboard what we cannot build in stone and steel.[183]

Synthesizing the various arts into a *Gesamtkunstwerk,* the theater allowed a creative blend of technology with the new aesthetics. In his *Abstract Review:*

46 Oskar Schlemmer
Homo, 1931, cast 1968

Design for a Mechanical Stage (47), Andrew Weininger (b. 1899) presented man as a finite, rational being with cool, precise forms. Costume designs conceal natural human forms in spherical, cubic, and cylindrical shapes, giving the actors an abstract ("universalized") appearance, subsuming individuals into an anonymous collective whole. Like many other utopians of the period, such as Lissitzky in his designs for *Victory over the Sun* (29, 30) and the De Stijl painter Vilmos Huszar in his *Figure Composition for a Mechanical Theater* (64), Weininger proposed a technological theater, in which not only the sets and lighting but even the performers could be mechanized.

In keeping with the Bauhaus's utopian goal of uniting all of life into a great *Gesamtkunstwerk,* students produced designs for architecture and industrial mass production, particularly after 1922. In his founding program for the Bauhaus, Gropius called for "mutual planning of extensive, Utopian structural designs . . . aimed at the future."[184] Geometric de-

signs for houses, like Weininger's *House Fantasia* (48), were devised for a projected Bauhaus settlement. While in Weimar, the Bauhaus occupied existing school buildings, which were transformed with the products of the workshops. Gropius's office by 1923 (fig. 3) epitomized the concept of a unified total environment, with every element, from light fixture to carpet, designed in the geometric abstract vocabulary equated with an ordered future world.

In the applied arts, everything from ashtrays to graphic design expressed the fundamental ideals of order and function through economical, usually abstract means, as seen in Joost Schmidt's (1893–1948) design for a Bauhaus poster (49). In his advertising designs, Herbert Bayer (b. 1900) exemplifies the Bauhaus ideals of a functional machine aesthetic and a *Gesamtkunstwerk* unifying the various arts into one structure. *Exhibition Tower Advertising Electrical Products* (50) combines industrial materials, including electric lights, with graphic design and the pure geometric forms and planar construction of Constructivist aesthetics. It creates the feeling of a model world, with a prototype building set in a white, infinite space without scale or limits.

The shift at the Bauhaus away from a medievalist utopia to a technological and production design approach owed much to the arrival of the Hungarian Constructivist artist, László Moholy-Nagy (1895–1946) in 1923. He introduced a more technical and scientific orientation to the *Vorkurs,* with controlled laboratory exercises in modern materials, especially metal and transparent plastics. In contrast to the original faculty members, Moholy was uninterested in metaphysical issues and higher consciousness. Instead, he was enthusiastically committed to the dynamic pace of the machine age and devoted his efforts to propagating its reality.

Moholy-Nagy believed that technology signified a further stage on the path to utopia, proclaiming, "We can no longer think of life without technical progress."[185] He believed that technology would allow total rejection of past cultures and the construction of a new one. To help promote this goal, the new art should be systematized along objective, rational, structural lines, in emulation of scientific method, which "is a builder of man's ability to perceive, to

47 Andrew Weininger American, b. Germany 1899
Abstract Review: Design for a Mechanical Stage,
1923, enlarged 1951

48 Andrew Weininger
House Fantasia, 1922, enlarged 1951

49 Joost Schmidt German, 1893–1948
Art of the Bauhaus, 1923

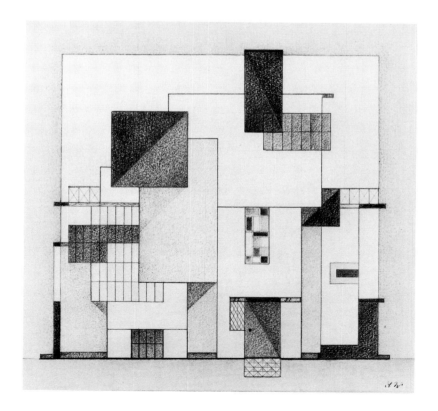

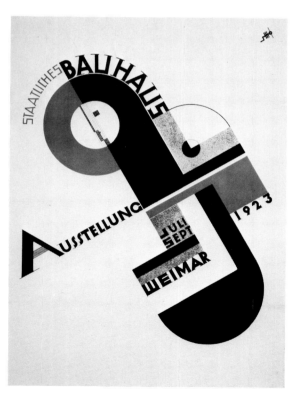

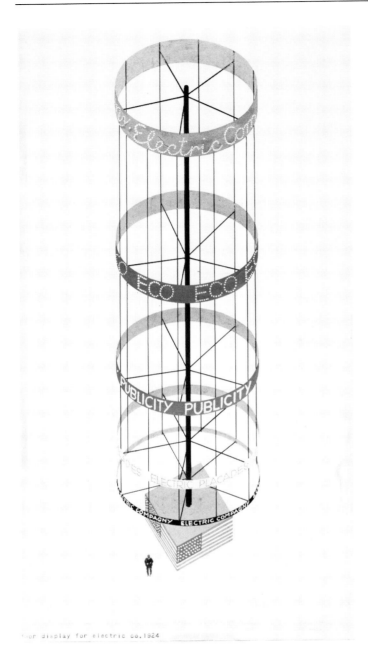

for display for electric co. 1924

50 Herbert Bayer American, b. Austria 1900
Exhibition Tower Advertising Electrical Products,
1924

which science, reason, and intellect would work to-
gether. The new art should therefore create new
means of communication and new signaling symbols
that would lead to improved and expanded human
development.

Moholy discussed the new art in his book *The New
Vision* (1928). He perceived the struggle to create
utopia not as a pipe dream; it simply required the
cooperative efforts of many individuals working over
a long period of time:

Utopia? Utopia? No, but a task for pioneers. We need
Utopians of genius, a new Jules Verne, not to sketch the
broad outlines of an easily imaginable technical Utopia
but to prophesy the existence of the man of the future,
who . . . will work in harmony with the basic laws of his
being. . . . Our time is one of transition, one of striving
toward a synthesis of all knowledge.[187]

Moholy thought that the new art should reorient
people away from overly dominant materialism to the
multifaceted existence that they really need: "The true
function of art is to be . . . an intuitive search for the
missing equilibrium among our emotional, intellectual,
and social lives. Art is . . . a direct linking of man to
man."[188] Consequently, Moholy viewed Neoplasti-
cism, Suprematism, and Constructivism as having
much in common, together constituting the new uto-
pian art. Regardless of the "ism," this new art stands
for "the value of seeing everything as related, [which]
has become the activating force in the construction of
a new life."[189] The new painting contributes by effect-
ing "a conformity between [the artists'] vision and the
subconscious aspirations of their times . . . painting is
the ultimate clarification of the principles of optical
communication."[190] Though he recognized that it
might take decades for people to comprehend the
new vision in art as a metaphor for the principles of
a new life, he firmly believed that the transition from
art to society would occur eventually. Shortly before
he died in 1946, he wrote optimistically that the time
had come to "translate Utopia into action."[191]

Moholy-Nagy's art was a variation on Constructiv-
ism, which he believed "is the embodiment of life and
the principle of all human and cosmic develop-
ment."[192] In 1920–22, he had been deeply influenced
by Russian Constructivism, especially the Suprematist-

. . . reason logically."[186] Because modern science
and technology tended to be international rather than
partisan in nature, Moholy espoused them as role
models for a democratic, open culture defined ac-
cording to universal laws. In Moholy's comprehensive
aesthetic theory, the new art, which would be based
on scientific knowledge of human abilities, would help
mankind to understand the nature of the new world in

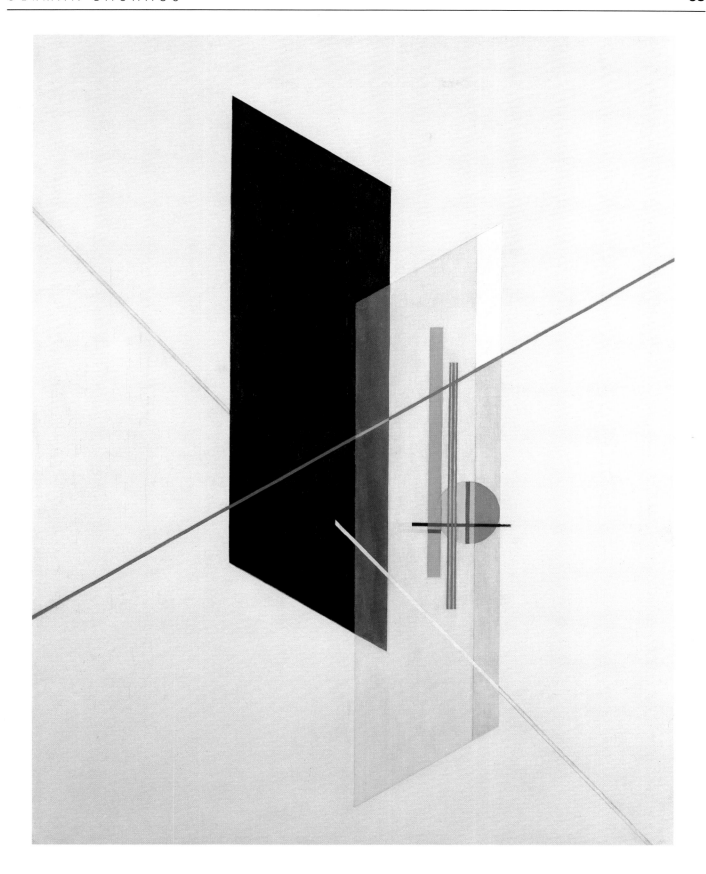

51 **László Moholy-Nagy** American, b. Hungary, 1895–1946
A-IX, 1923

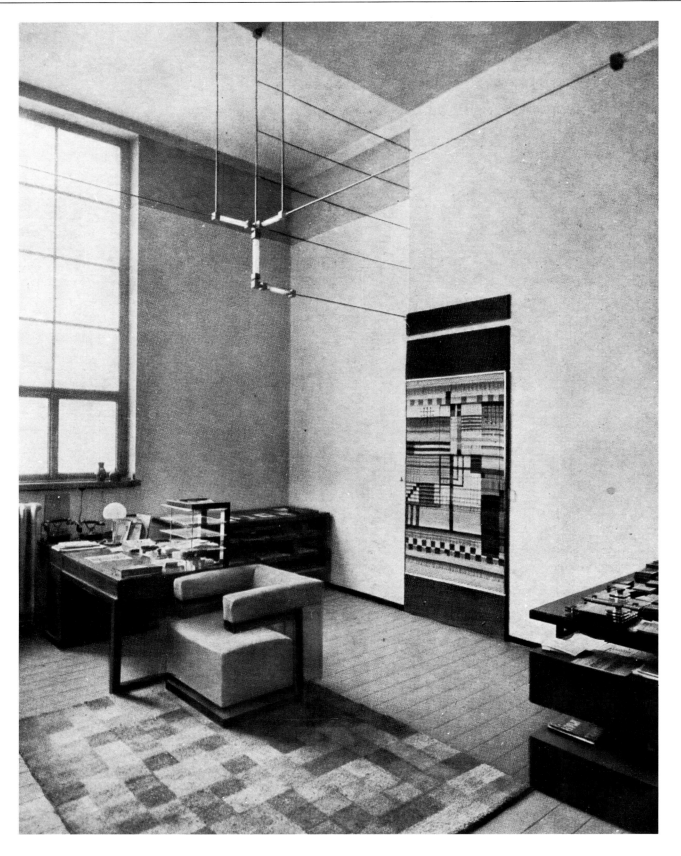

Figure 3 Director's office, the Bauhaus, Weimar, 1923.
Bauhaus Archiv, Berlin

influenced *Proun* works of Lissitzky. By 1922, the year of the major exhibition of Russian avant-garde art at the Galerie van Diemen in Berlin, the crossing diagonals and rectangles of Lissitzky's style were firmly entrenched in Moholy-Nagy's pictorial vocabulary, as was the use of an uncircumscribed, infinite space in which the geometric forms exist weightlessly. Works like *A-IX, Constructivist Composition,* and *Study for AM4* (51, 52, 53) depict transparent open volumes and planes in motion. Using geometrically definable and measurable forms, Moholy-Nagy wanted to reveal the relationships common to all mankind—not the metaphysical constructs of Kandinsky, Mondrian, or Malevich, but the psychophysical relationships of tension, relaxation, and harmonization of forces.

Moholy-Nagy defined his abstract style of painting in clearly utopian terms, summarizing ideas expressed by many artists of the period. He intended "to demonstrate . . . the [objective] standards of a new vision employing 'neutral' geometric forms."[193] His style of execution likewise emphasized objectivity and anonymity through the "smooth impersonal handling of pigment, renouncing all texture variations."[194] He sometimes used an airbrush and spray gun "in order to achieve machinelike perfection."[195] And because he wanted to "serve the public as an anonymous agent," he eliminated titles in favor of numbers and letters, "as if they were cars, airplanes, or other industrial products."[196]

His compositions depict forms and forces in motion, momentarily caught in a state of sensitive equilibrium that is both powerful and delicate. The structure is established by the intersection of ruler-straight lines varying in thickness from razor-sharp to solid beams, together with circles, triangles, and rectangles. Delicate hues, thinly applied, suggest the translucency of plastics or glass planes set in an indeterminate space. In keeping with his aesthetics of "vision in motion," most works favor dynamic diagonal relationships, rather than the stability of horizontal-vertical axes. With strictly economized means, Moholy created compositions having the exactitude of a formula, intimating a system of mathematical or scientific coordinates existing in balanced relations ad infinitum in

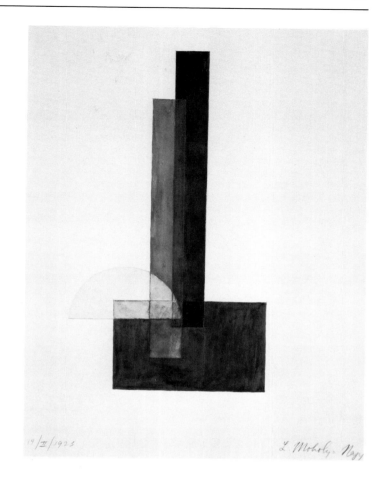

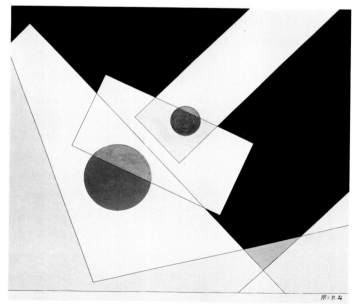

52 László Moholy-Nagy
Constructivist Composition, 1923

53 László Moholy-Nagy
Study for AM4, 1926

space. His message is of a future world, all space and mobility, a four-dimensional world of space-time without top or bottom, precisely articulated yet compellingly visionary.

Josef Albers (1888–1976) came to the Bauhaus as a student in 1919, became a teacher in 1925, and remained to the end in 1933. As teacher of the preliminary course, Albers exerted tremendous influence. In addition to the canonical importance of visual economy both as moral imperative and as equivalent to mechanistic efficiency, Albers stressed the sociological values of abstract forms in his teaching and art:

Discussion of the terms positive and active, negative and passive provides an opportunity to explain the sociological origins of our form language. . . . We no longer differentiate essentially between those elements which are "carrying" and those which are "carried," between those "serving" and those "served." Every element or component must be one that is "aiding" and "aided" at the same time.[197]

This last egalitarian statement may explain his preference in the 1920s for an architectonic style in which the rectangular elements build up a composition with equal values, no single element being more important than any other, as in *Skyscrapers B* and *Latticework* (54, 55). The clean clarity of this style embodies the rationalist qualities of harmony, proportion, and planned organization. The resolute use of rectangular planes in pure horizontal-vertical arrangements reflects the influence of De Stijl aesthetics on the Bauhaus in 1921–22, when van Doesburg lectured in Weimar. This influence is also clearly evident in Weininger's *House Fantasia* (48). Albers's style is totally democratic and impersonal—the perfect analogy for the future society of collective enterprise, where individuals are truly integrated as constructive components in an orderly, yet open-ended, unity. It is also an additive, repetitive idiom that everyone can use, and through the 1950s Albers worked in styles that could be mass produced.

The Bauhaus interest in the industrial production of art led many artists, including Albers, to work with modern technological materials. *Skyscraper B* and *Latticework* are both executed in flashed glass; that is,

thin layers of different colored glass are fused together into one plate and worked on with acids and sandblasting to reveal the underlying layers of color. Albers believed that working experimentally with different materials induces "a new way of seeing" and shows how formal qualities like harmony, balance, scale, and geometrical proportion are conjoined with other values, like "mysticism or hygiene . . . beauty or prudence."[198] This ethical approach to learning thus exceeds mere vocational training, "which inculcates manual skills"; instead, at the Bauhaus there is "no fiddling about but building."[199]

Eventually, the international machine aesthetic came to dominate the Bauhaus mentality: the severely geometric manner dedicated to pure functionalism forced out the individual artists, as attested by the resignations of Itten and Feininger and then of Schlemmer, Moholy-Nagy, and others after Hannes Meyer became the director in 1928. Meyer's uncompromising emphasis on functionalism and sleek industrial design, to the exclusion of all other concerns, effectively ended the holistic and idealistic utopian aspirations of the earlier period.

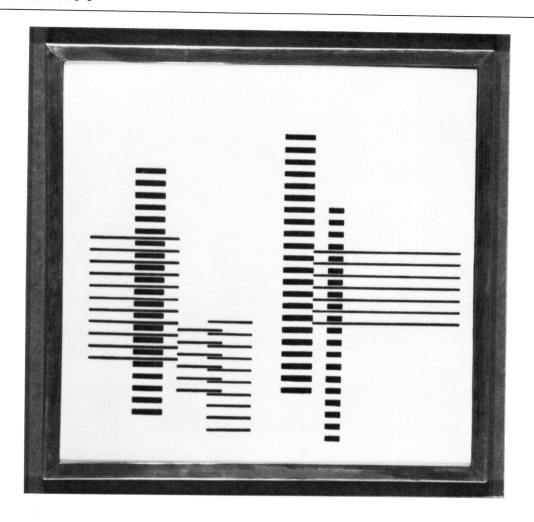

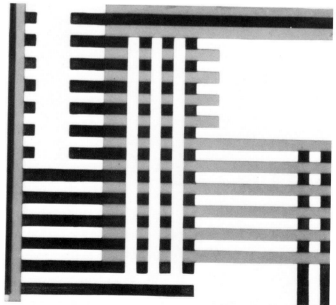

54 Josef Albers
American, b. Germany, 1888–1976
Skyscrapers B, 1925–29

55 Josef Albers
Latticework, c. 1926

DUTCH DE STIJL

The spirit of intellectual revolution and the quest for a new art expressive of the new era extended to the Netherlands in the 1910s and '20s. A group of artists and architects, called the De Stijl group from the name of their periodical (published 1917–31), succeeded to a greater degree than the Italians, Russians, or Germans in formulating a cohesive aesthetic theory and consistent stylistic features. The new Dutch art from its earliest development before and during World War I was neat, logical, orderly, and inclined toward geometric clarity and balanced stability. Though the group included architects and a sculptor, the aesthetics were formulated by painters, principally Piet Mondrian and Theo van Doesburg.

Since the early years of the century, Mondrian (1872–1944) had been concerned with discerning, defining, and expressing the fundamental universal laws governing all existence. Stimulated by the esoteric religious and metaphysical speculations of Theosophy, Mondrian attempted before World War I to perceive the basic relationships underlying and governing forms. Some of his terminology and ideas derive from *The New Image of the World* (1916) by the Dutch mystical writer M. J. H. Schoenmaekers. In the tradition of Neoplatonic philosophy, Schoenmaekers believed that despite its varied and capricious appearance, nature exists and functions according to absolute laws of geometric regularity, and true reality exists within or beyond visible appearances. Applying the principles of analytical Cubism to the landscape led Mondrian to the progressive simplification of the forms and rhythms of natural phenomena, as in *Pier and Ocean,* a charcoal drawing of 1914 (56).

Once the study of nature resulted in a systematic geometric structuring of ever-purer elements, Mondrian no longer needed to study motifs in nature. The fundamental patterns he had discovered in nature became to him the new reality of universal laws and rhythms. This new style, which he called Neoplasticism, summarized his metaphysical and artistic interests, as well as the utopian ideas in the air all across Europe. In his Neoplastic paintings (57, 58), Mondrian advocated the use of primary colors and the right angle and the complete avoidance of elements drawn from nature.

56 Piet Mondrian Dutch, 1872–1944
Pier and Ocean, 1914

Mondrian believed that the imbalance of dualistic opposites causes the tragedy of human life:

The struggle of one against the other forms the tragedy of life. . . . Although the greatest tragedy is due to the inherently unequal dualism of spirit and nature, there is tragedy also in outward life. Due to disequilibrated mutual relationships, the tragic exists between male and female, between society and individual.[200]

He defined these opposites in traditional dualistic terms, such as outwardness-inwardness, nature-spirit, individual-universal, male-female, active-passive, light-dark, yin-yang, good-evil, positive-negative, and so on. Mondrian believed that all forms and processes, indeed everything physical and conceptual, exist only in relation to each other and that "all relationship is governed by one relationship above all others: that of extreme opposites."[201] The new art therefore expressed this single, fundamental relationship—the opposition of two extremes, ideally in perfect equilibrium. The new art of Neoplasticism encompassed them all in a nonspecific, nonreferential mode, as described by Mondrian:

[Neoplasticism] expresses the relationship of extreme opposition in complete harmony and includes all other relationships. If we see these two extremes as manifestations of the inward and the outward . . . we see Neoplastic not

as denying the full life, but as the *conciliation* of the matter-mind duality.[202]

To resolve the tragic tenor of life caused by the imbalance of opposing forces, Mondrian believed that the new art should present the equilibrated harmony of these opposing elements, because "only the continual and repeated union of opposites can bring about the new progress. . . . Art can realize the union of opposites abstractly: that is why art precedes real life."[203] Mondrian felt that the new art would promote a holistic world view: "In this way the truly modern man sees things as a *whole* and accepts life *in its wholeness:* nature and spirit, world and faith, art and religion, man and God as *unity.*"[204] Eventually, mankind would begin to perceive this harmony everywhere, despite distracting particular appearances, and consequently would become aware of the unity and essential interrelatedness of all life. In this way, Neoplasticism serves as a mediator or interim step between the tragedy of life and the intellectual utopia of absolute harmony.

Like Malevich and Kandinsky, Mondrian anticipated a utopian state in which materialist concerns would lessen in importance as human consciousness reached an enlightened state of understanding. He equated such enlightenment with abstraction:

The life of modern cultured man is gradually turning away from the natural: it is becoming more and more abstract . . . we see life's interest centering more and more around the inward. The life of *truly modern* man is directed neither toward the material for its own sake, nor toward the predominantly emotional: it is rather the autonomous life of the human spirit becoming conscious. Modern man . . . *shows* a changed consciousness: all expressions of life assume a different appearance, a more *determinately abstract* appearance.[205]

Mondrian saw the elimination of all form and natural color as an expression of the human struggle for freedom from the tragic. The elements of opposition (the causes of tragedy in life) could never be eliminated (e.g., good cannot exist without bad), but their duality can exist in true equilibrium. This is expressed in the right-angle relationship of absolutely straight lines, because "the straight line tells the truth," said Mondrian.[206] Since the opposition is ab-

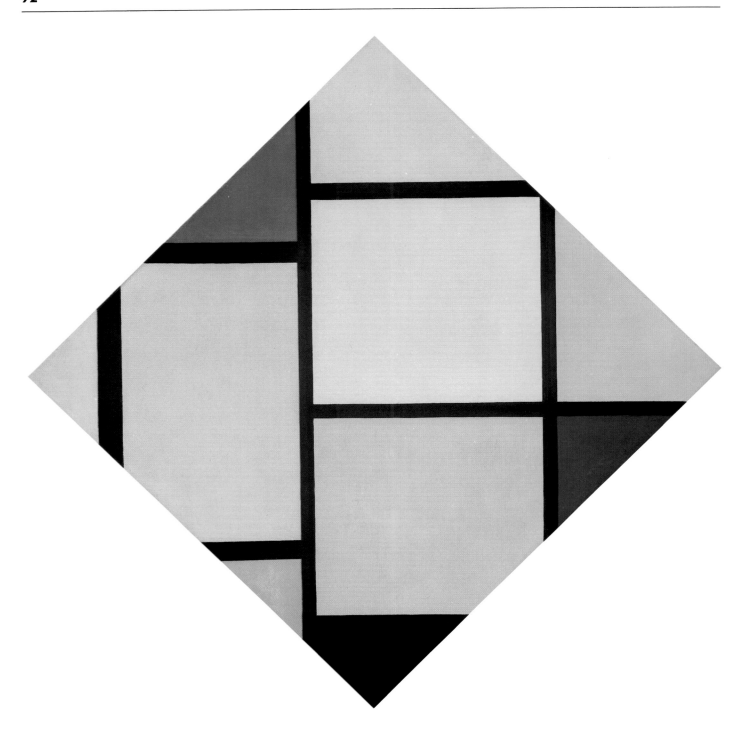

57 Piet Mondrian
Lozenge in Red, Yellow, and Blue, c. 1925

58 Piet Mondrian
Composition with Blue and Yellow, 1935

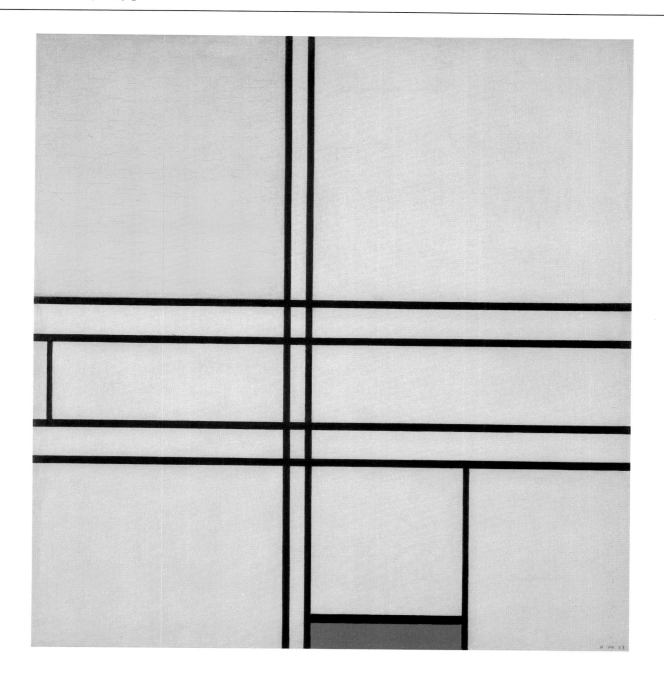

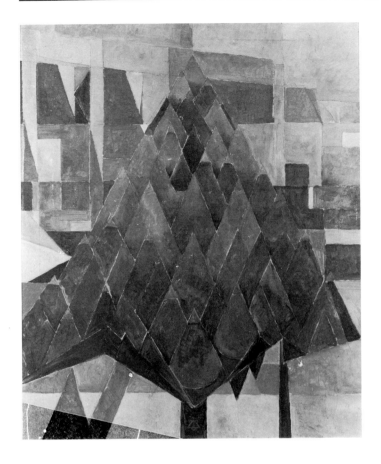

solute (no two elements or ideas can be more contrasted than when diametrically opposed), the effect of right-angle arrangements would be one of essential balance. Horizontal and vertical lines (as well as the opposition of black and white, yellow and blue) would represent the dualities of life in perfect balance. Their equilibrium would "bring to the fore the inner harmony of all life."[207] In their abstract compositions, the De Stijl painters presented an abstract constructive equivalent for the essential order, clarity, and harmony for which mankind should strive in order to attain utopia.

In Neoplastic compositions, there is no center, no focus, no conventional symmetry—the elements are arranged on the flat surface in subtle but inescapable relation to each other. Each component exists only as a part of a relationship, and the relationships in every composition are all parts of a larger unity. In many paintings, the lines and color areas run off the edge of the canvas, suggesting that what is visible is merely a diagram or fragment of a larger whole. Mondrian said: "Each thing is a miniature replica of the whole. . . . The microcosm is in every respect like the macrocosm."[208] Gradually, the viewer would perceive the fundamental interrelatedness of all existence. Then man could be at peace, as part of the whole, yet entire in himself.

The emergence of Mondrian's Neoplasticism coincided with the work of other painters in Holland during the war, notably Theo van Doesburg, Bart van der Leck, and Vilmos Huszar. In their own styles, they had been experimenting with balanced arrangements of simple geometric shapes and pure colors on neutral grids. The geometricizing compositions of their proto- and early abstract paintings were based on the progressive reduction of buildings, figures, the ocean, trees, still-lifes, and so forth, as in van

59 Theo van Doesburg Dutch, 1883–1931
Tree with Houses, 1916

60 Theo van Doesburg
Interior, 1919

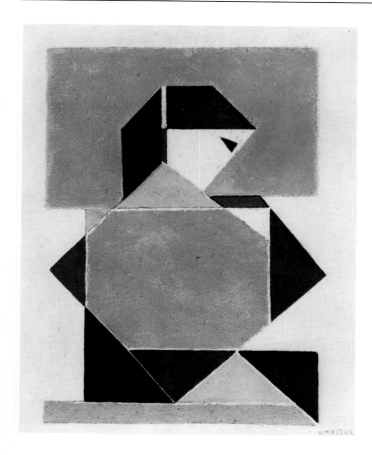

61 Vilmos Huszar Hungarian, 1884–1960
Figure of a Woman, c. 1918

Doesburg's (1883–1931) *Tree with Houses* (59) and *Interior* (60). For Vilmos Huszar (1884–1960), the balance between representation and abstraction was central to the communicative value of the new art. *Figure of a Woman* (61) clearly demonstrates the regularization of organic forms into a geometric construction.

The essential content and goal of De Stijl works was an all-embracing concept of harmony that unites art with life, physicality with spirituality. Van Doesburg asserted that "art and life are no longer separate domains. The idea that art is *an illusion divorced from real life* must therefore be abandoned."[209] This concept implied more than the application of artistic principles to the physical environment, though this was essential. It also signified an intellectual construct of the complete unity of all existence. The artificial duality that separates the world of the mind and imagina-

tion from the world of matter would, according to the precepts of De Stijl, be abandoned in favor of "an indivisible unity of the world."[210]

As did many utopian artists, De Stijl painters associated geometric abstraction with rationalism, objectivity, and technology, which they paradoxically equated with spiritual advancement. For Mondrian and van Doesburg, technology was significant as the means of transcending chaotic nature and overcoming individualism and emotionalism—thereby permitting access to universal laws or forces and hastening the spiritualization of life. In the "mechanistic aesthetic" of De Stijl, according to van Doesburg, "natural forms . . . have been converted into mechanical and impersonal forces."[211]

Though Mondrian maintained throughout his life the absolute need for the horizontal-vertical relationship, other De Stijl artists, particularly van Doesburg but also Huszar, César Domela, and others, incorporated the diagonal as an essential indicator of the nature of the anticipated utopia. Van Doesburg considered the stability of Neoplasticism to be a preliminary stage of development, which would lead to stasis if pursued for its own sake. Instead of the horizontal-vertical relationship, van Doesburg believed that the diagonally oriented placement of the right-angle relationship of elements expressed metaphorically a dynamic utopian condition with the potential for continual evolution. He used the term Elementarism to define this digression from Mondrian's Neoplasticism. Like H. G. Wells's open-ended conception of an ever-evolving utopia, van Doesburg asserted that the human spirit will always need to develop beyond what appears to be the final, harmonious solution. Often van Doesburg used a diamond-shaped canvas to orient the entire composition along diagonal lines, as in his *Contracompositions* (62, 63). Though Mondrian disapproved of the *Contracompositions*, he briefly recognized the power of diagonal arrangements in the 1920s when he used diamond-shaped canvases, as in *Lozenge in Red, Yellow, and Blue* (57).

The emphasis on the diagonal element in painting, and the heated debates over its meaning and importance reflect the seriousness with which the definition of utopia and how to depict it in art was taken in the

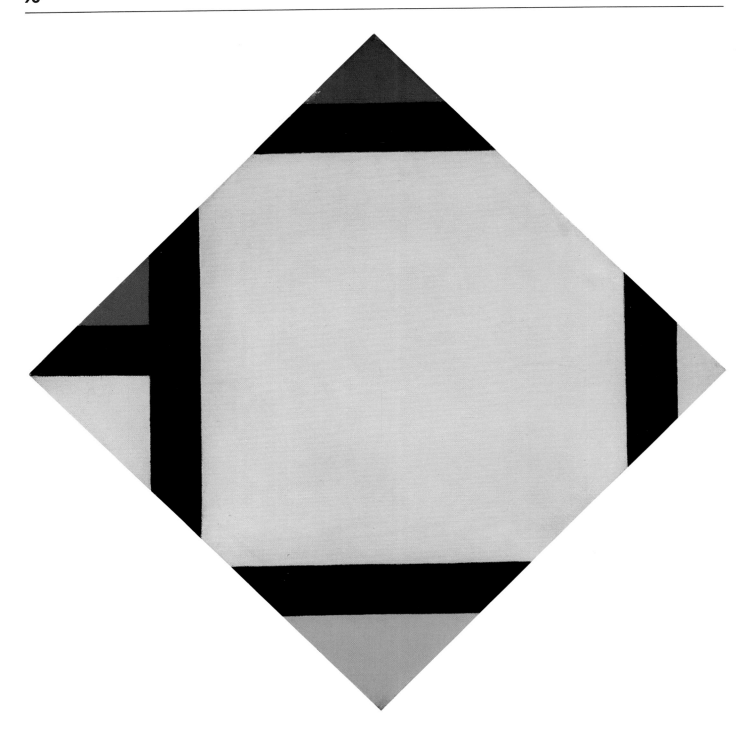

62 Theo van Doesburg
Contracomposition, 1924

1920s. For many artists, the coming ideal existence was to be based on perpetual change, rather than the traditionally static conception of utopia. The ideal state of existence as postulated by van Doesburg, Moholy-Nagy, Malevich, Lissitzky, and others incorporated the concept of a totally dynamic higher existence. This idea, though rooted in Futurism, owed much to other sources, such as Hegel's dialectics and Einstein's theory of relativity. With the popular acceptance after 1920 of Einstein's theory, the world view of many artists perceived life as a phenomenon of the space-time continuum. Life henceforth was perceived as having a fourth or higher dimension, which was a state of absolute dynamism, sometimes with spiritual overtones. The emblematic representation of the fourth dimension in art was intended to serve as a metaphor for the inner dynamic spirit of the new era. In painting, this concept was often expressed by means of diagonal lines and diagonally positioned forms, which many artists felt could signify the dynamism of the space-time continuum, as in Moholy-Nagy's art, and/or the spiritual dimension of human actuality, as in van Doesburg's Elementarist style. In Huszár's *Figure Composition for a Mechanical Theater* (64), right-angle forms are tipped to the diagonal, while in his *Composition* (65) some of the forms themselves incorporate the diagonal. In some works, the perceived equilibrium of Neoplasticism is literally upended at a 45–degree angle, as in Domela's relief construction (66), to suggest perpetual change and development.

The concept of extending Neoplastic precepts to embrace the entirety of life led van Doesburg and others into architectural design. More than easel paintings, architecture could surround people with the universal concepts of harmony and thereby assist them to strive toward the utopian goal. As Mondrian noted, "Certainly Neoplasticism's complete realization will have to be in a multiplicity of buildings."[212] De Stijl architecture was clearly viewed as an extension of painting. The relation between Neoplastic painting and architecture is evident in van Doesburg's designs for the Café Aubette (67). Only the title indicates that this composition is an architectural element rather than an independent painting. Entire interiors were de-

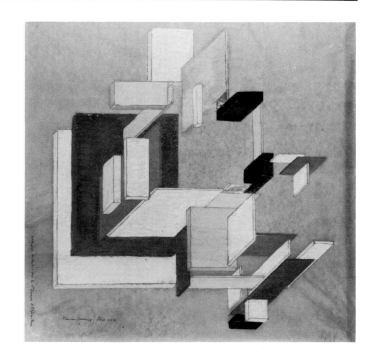

63 Theo van Doesburg
Contracomposition (Construction with Colors in the Fourth Dimension of Space and Time), 1924

signed according to the principles of painting, as in Félix del Marle's (1889–1952) *Neoplastic Studio* (68).

Van Doesburg explored the spatial ramifications of translating the basic forms of Elementarist painting into an architectural format, as in *Contracomposition (Construction with Colors in the Fourth Dimension of Space and Time)* (63). By juxtaposing planes (white and colored) at right angles, he defined, without entirely enclosing, abstract geometric space. This was intended as an exemplar of the essential interrelatedness and unity of the coming utopia.

In the mid-1920s, architects from Russia to Paris adopted an international ethos of elementary constructivism. After the early diversity of architectural forms in 1918–22, the principles of Russian Constructivism and Dutch De Stijl became internationally accepted as the appropriate vocabulary for utopian architecture and was epitomized in Frederick Kiesler's *City in Space* (fig. 4), which was exhibited at the 1925 International Exposition of Decorative Arts in Paris. Kiesler, who joined De Stijl in 1923, elaborated a completely open spatial construction on a

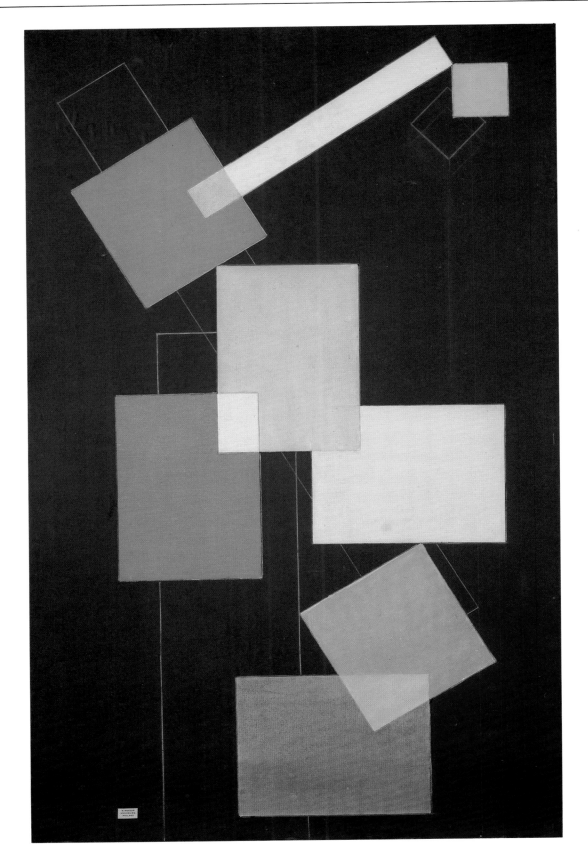

64 Vilmos Huszar
Figure Composition for a Mechanical Theater, c. 1920

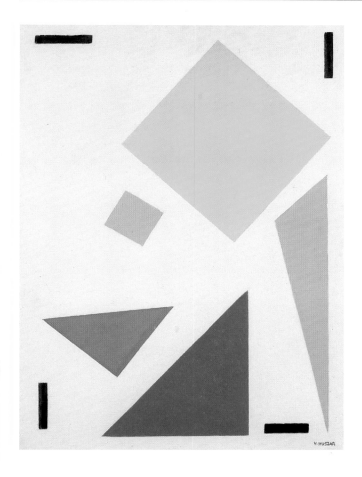

65 Vilmos Huszar
Composition, 1921

66 César Domela Dutch, b. 1900
Construction, 1929

67 Theo van Doesburg
Project for a Ceiling: Café Aubette, 1928

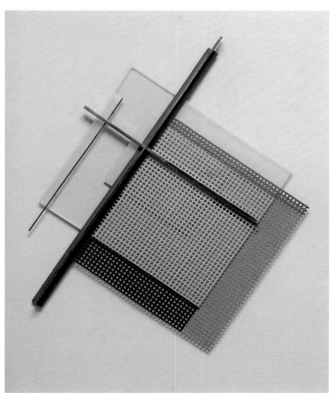

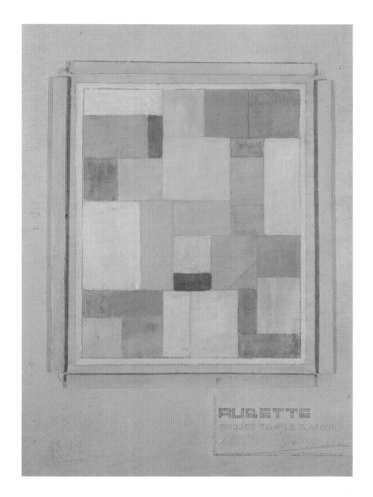

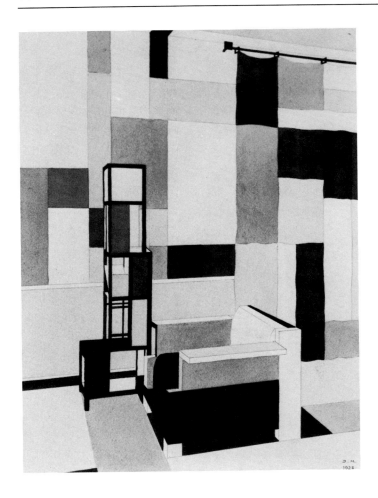

68 Félix del Marle French, 1889–1952
Neoplastic Studio, 1928

rectangular grid, which he called *architecture élémentarisée.* This suspended construction of trusses and flat planes was immediately recognized as a metaphor for the coming utopian world characterized by logical social relationships, rational structure, open freedom. Kiesler described it as "a city in space, decentralized and entirely suspended in space. A constellation without boundaries, floating dwellings, the habitat for the man of the future, where he can feel at home in anyone's place."[213] He intended it to express international utopian ideals:

A change of space into urbanism
No foundation, no walls
Detachment from the earth, suppression of the static axis
In creating new possibilities for living, it creates a new society.[214]

Essentially an ideal system of linear coordinates capable of infinite extension into space, *City in Space* renders visible the regular geometric grid generally accepted in the 1920s as the order of the new world. This was an idealistic architecture of metaphoric expression, not the pure functionalism of later years.

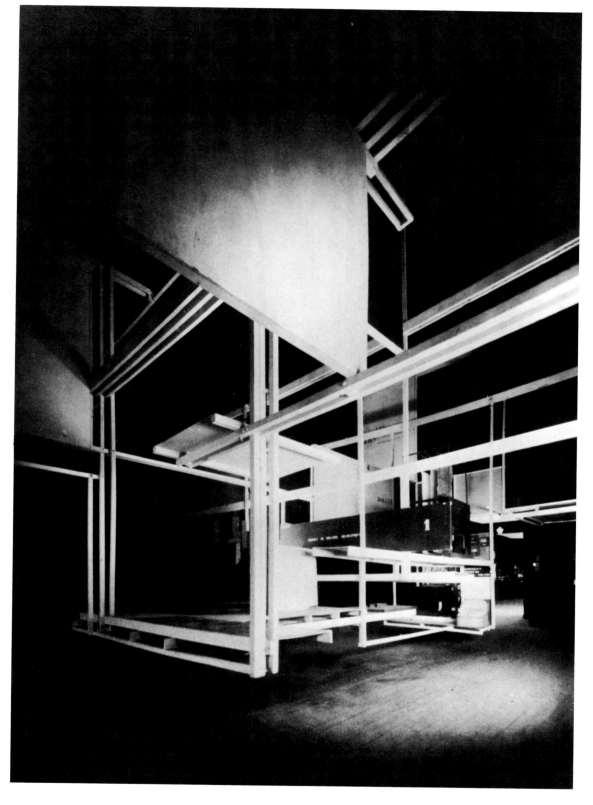

Figure 4

Frederick Kiesler (American, b. Austria, 1896–1965), *City in Space,* painted wood construction, in the Exposition of Decorative Arts, Paris, 1925; destroyed

FRENCH PURISM AND LÉGER

After World War I, the major De Stijl artists Mondrian and van Doesburg relocated to Paris, where they encountered a pervasive utopian spirit. Though generally known as *le rappel à l'ordre* (the return to order), the more overtly utopian reformers partook in what Guillaume Apollinaire called *l'esprit nouveau* (the new spirit):

The new spirit requires that we give ourselves to prophetic tasks. . . . The new spirit which is appearing claims above all . . . an overall view of the world and the human soul, and a sense of duty which conquers the emotions.[215]

Among the many artists in Paris concerned with reordering the world, or at least with imposing order in art, Fernand Léger (1881–1955) produced a style of painting that reconciled the Futurists' tremendous enthusiasm for the ambiance of the new technological world with the rationalism and controlled order of Purism. Immediately after the war, the utopian aesthetics of Purism had been elaborated by the painter Amédée Ozenfant (1886–1966) and the architect-painter Charles-Edouard Jeanneret (1887–1965, better known as Le Corbusier). Purism, as expounded in the periodical *L'Esprit Nouveau* (Paris, 1920–25), proposed that rational, logical order was the finest basis for the world of the new era. This compelling order was manifested in Le Corbusier's designs for utopian cities, notably the *Contemporary City for Three Million Inhabitants* of 1922 (fig. 5) and the *Voisin Plan* of 1925 (fig. 6). These designs are characterized by enormous scale, with absolute symmetry and pristine geometry (both for the ground plans and the towers). Though never implemented, these projects exerted tremendous influence on urban planning.

The Purists asserted the importance of intellect over emotion, and consequently favored geometric forms as conveyors of reason and functional efficiency. In their paintings, Le Corbusier and Ozenfant devised an aesthetic of elemental geometric shapes, which were believed to evoke in the viewer sensations of order. Subject matter was restricted to manufactured objects, and forms were rigorously arranged according to strict laws of numerical proportion, especially the ancient formula known as the Golden Section.

During the war, Léger had undergone a conversion

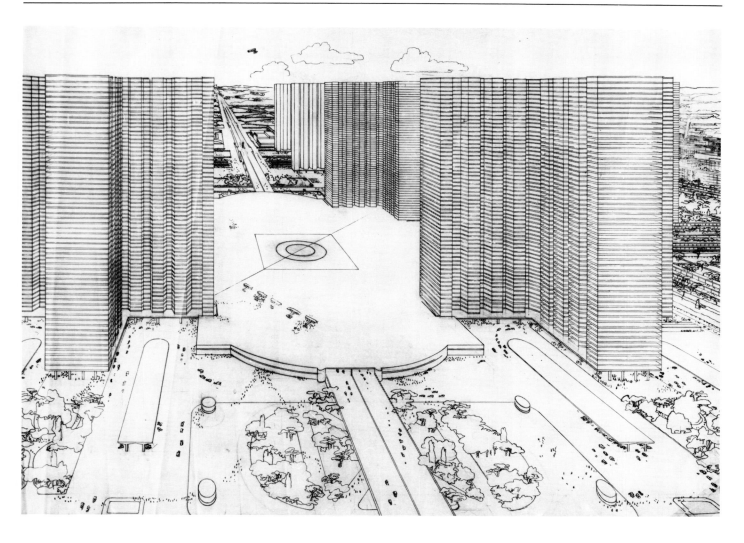

Figure 5

Le Corbusier (French, 1887–1965), view of the center of
the *Contemporary City for Three Million Inhabitants*,
1922, ink on paper. Fondation Le Corbusier, Paris

from Cubist formal concerns to a Futurist-like enthusiasm for the possibility of shaping a better world. Serving in an engineering unit, he had encountered advanced technology and the people who create and maintain it. Their optimistic view of the machine as a marvelous extension of human power and intellect led Léger to develop a heroic conception of a new world founded on technology. After the war, the theories of the Purists offered a timely and persuasive framework in which to recast his early style, bringing it from the isolation of the studio into a more socially oriented role. Although he never became a true Purist and

disagreed with several of its formal tenets (such as the adherence to a mathematically based composition), Léger absorbed its theories.

In formulating his own version of *l'esprit nouveau*, Léger—influenced also by De Stijl—expanded and enriched the rigid Purist doctrines to produce a visually bolder and more compelling style in the decade after the war. He incorporated his own preference for vivid contrasts of primary colors and expanded the range of subjects from still-lifes composed of geometric objects to include the larger context of the modern, machine-made environment whose precise

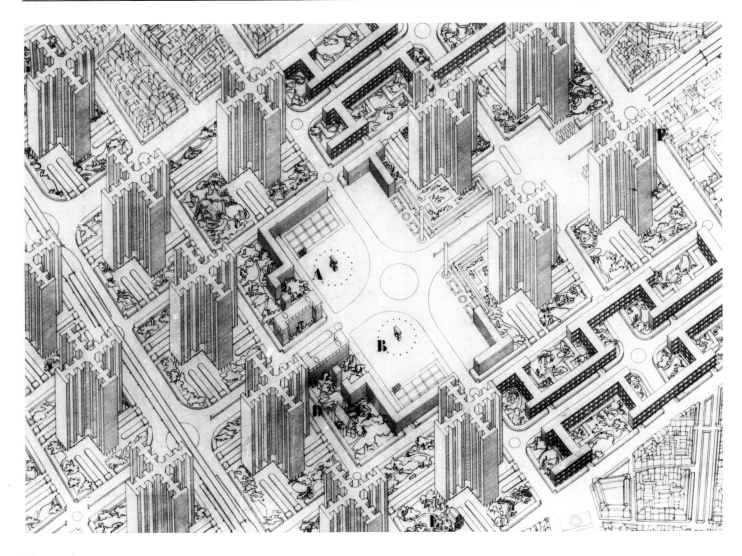

Figure 6
Le Corbusier, aerial view of the center of the *Voisin Plan*, 1925, ink on paper. Fondation Le Corbusier, Paris

organization would deepen the human need for order:

We are bound to our environment . . . [it is] the manufactured object which holds the secret of any renaissance we may have. A man living for a long time in the environment of these stern geometric forms will unconsciously find himself won over by them. . . . The contemporary environment is clearly [dominated by] the manufactured and "mechanical" object; this is slowly subjugating the breasts and curves of women, fruit, the soft landscape.[216]

In contrast to the Purists and other utopian painters who believed in the power of geometry alone to express utopian goals, Léger preferred an art more

directly concerned with life itself, with the rhythms of its environment and with people, whom he often placed at the center of his art.

The recurrent themes in Léger's postwar paintings are the modern city, its factories, and the people who live and work in this world. In one series of paintings, called *Disks* (69), he combined the structures of the urban environment with geometric abstraction—especially circular forms intended to suggest whirling wheels and cogs. He painted a number of works depicting man with machines and modern architecture. *Typographer* (70) makes the transition from the prewar analytical Cubism, with its disintegration of forms, to the postwar "machine aesthetic." Using

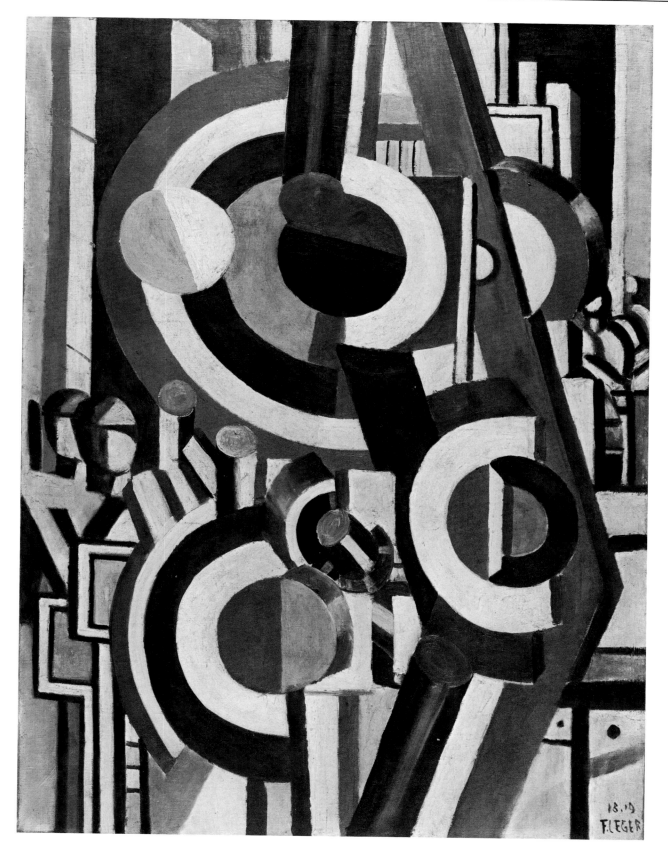

69 Fernand Léger French, 1881–1955
Disks, 1918–19

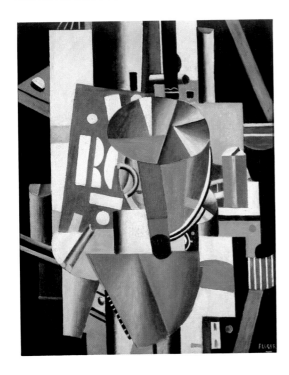

70 **Fernand Léger**
 Typographer, 1919

71 **Fernand Léger**
 The Mechanic, 1918

72 **Fernand Léger**
 Man with Dog, 1920

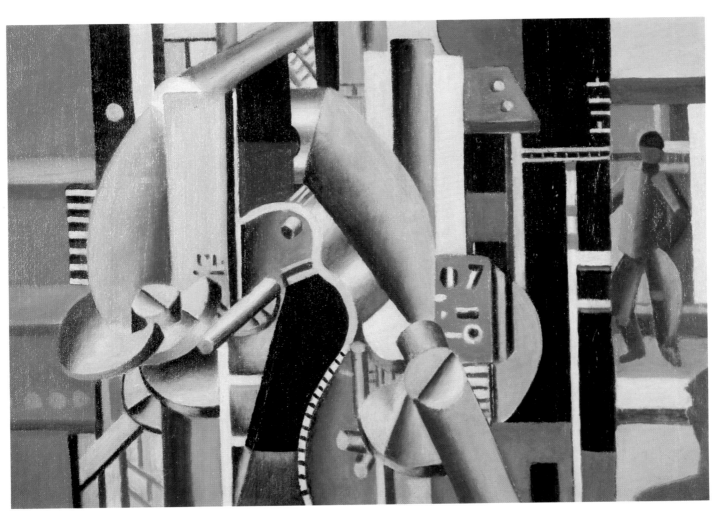

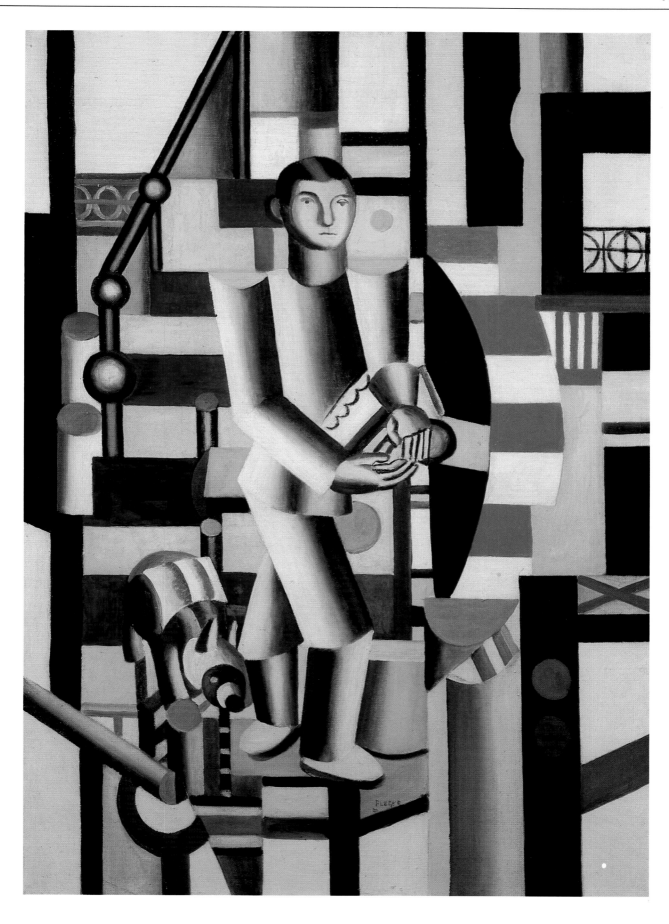

dissonant colors and clashing forms, Léger created an ensemble of evocative images that define the new world in general terms. Léger stressed that his new art did not merely depict machines; instead, it echoed their qualities of speed, strength, and precision in imaginative, pictorial forms. In *The Mechanic* (71), Léger organized planar areas of pure contrasting colors on an architectural framework of an underlying horizontal-vertical grid (derived partly from Purism) to produce a more straightforwardly legible image. The exciting sensation of dissonance and simultaneity centers on the machinery, while the human form has become more recognizable. The inference is that, despite his modest size, the human component controls the whirling power of modern industry.

The concept of the machinelike man dominating his rhythmic and powerful environment runs through Léger's art. Since he hoped that his art would influence people's attitudes concerning the technological future, he celebrated the new humanity within the context of that newly ordered world. Even at rest, the new man asserts his presence, as in *Man with Dog* (72) and *Figure of a Man* (73). Léger intended his art to be humanistic—to show man as an ordered, rational being, comparable yet superior to machines, fully in control of the power and complexities of his environment. Consequently, his figures are heroic in form and demeanor, with massive limbs, often confronting the spectator with a calmly impassive gaze. Posed frontally and in profile, they exude a sense of dignity and calm repose, their vigorous, sculpturally rounded forms in neutral tones completely at ease amid the vivid colors and sharp shapes of their world. The detachment with which the artist treats these figures and with which they view their environment is intended to convey a feeling of objectivity and reasoned control. These standardized figures resemble precisely engineered and polished machines assembled from interchangeable components. In the context of utopian aesthetics of the 1920s, this standardization asserted the commonality of all human beings and implied the desirability of their joining together in a collective unity.

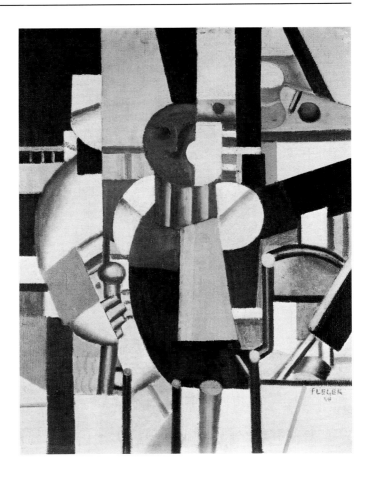

73 Fernand Léger
Figure of a Man (First State), 1920

AMERICAN PRECISIONISM AND ARCHITECTURE

In the United States optimistic expectations concerning the future were not so clearly or strongly linked to historic events like the arrival of a new century or the "war to end all wars," though such events played their part in stimulating utopian visions. Rather, the American outlook has always been tied to such confident expectations. Since its discovery nearly five hundred years ago, America has represented a fabled New World, the land of potential paradise with its virgin territories and unending opportunities. Indeed, its inception as a political entity in 1776 was a utopian experiment on an unprecedented scale. The premises of the new nation as stated in the Declaration of Independence and the Bill of Rights were (and are) quintessentially utopian: inalienable equality and the right to life, liberty, and the pursuit of happiness. The utopian fervor that swept Europe in the early twentieth century had long existed in the United States.

Indeed, the myth of the American dream contributed to the formation of utopian conceptions in Europe in the early years of the twentieth century. Europeans treasured the image of the United States as an urban and technological paradise. As Lissitzky noted in 1925, "The word America conjures up ideas of something ultra-perfect, rational, utilitarian, universal."[217] Much of this image was based on New York City with its skyscrapers, as described by H. G. Wells: "This New York so obsessed me with its limitless bigness. . . . One has a vision of bright electrical subways . . . spotless surfaces, and a shining order of everything wider, taller, cleaner, brighter."[218]

It was this vision that inspired the art of the Precisionist painters from the 1920s to the 1940s. Some artists like Louis Lozowick (1892–1973) and Charles Sheeler (1883–1965) felt that recognizable subjects would be more intelligible and acceptable to a mass audience than abstraction, and so they depicted urban and industrial scenes in a positive light. They represented the products of technology—urban architecture with its skyscrapers, machines, and related industrial images—and transmogrified them into adulatory symbols of the new culture. The subjects chosen served as inherent signifiers of the new world, while their portrayal in crisp, clean styles conveyed the

clarity and precision of the new machine world.

Lozowick was profoundly influenced by his contacts with utopian aesthetics in Europe. After visiting Paris in 1919, he spent three years in Berlin during the peak period of utopian hopes and activities. He associated with pre-eminent and articulate activists, including Lissitzky, Moholy-Nagy, and van Doesburg, and visited his native Russia, where he met Tatlin, Rodchenko, and Malevich. When he returned to the United States, Lozowick believed that the new art should reflect the industrialization and standardization that characterizes future development. In his essay "The Americanization of Art" (1927), Lozowick recommended subject matter taken from "the intriguing novelty, the crude virility, the stupendous magnitude of the new American environment," particularly the "gigantic engineering feats and colossal mechanical constructions" like skyscrapers and steel mills.[219] Furthermore, he advocated a style of "precise adjustment of structure" and "economic utilization of processes and materials."[220] This would "thereby foster in man a spirit of objectivity excluding all emotional aberration."[221] He recommended that the new art reveal to its mass audience the new geometrical order emerging in modern urban and industrial society:

The dominant trend . . . beneath all the apparent chaos and confusion is towards order and organization which find their outward sign and symbol in the rigid geometry of the American city: in the verticals of its smokestacks, in the parallels of its car tracks, the squares of its streets, the cubes of its factories, the arc of its bridges, the cylinders of its gas tanks.[222]

Through selective accentuation of the inherent geometrical features of these subjects, as in *Urban Geometry* (74), Lozowick made evident the beauty of this new rational order.

Besides his urban scenes, Lozowick made modern technology the subject of his *Machine Ornament* series (75). These ink compositions, originally called *Constructions,* had been started in Berlin under the influence of Lissitzky's *Prouns.* Using the forms and structures of actual machines, Lozowick composed them into semiabstract designs of pure black and white, beautiful mechanisms without scale or context,

in an unlimited space—images of pure potential and exemplars of the precision and beauty of machines. He hoped these drawings would "effect a greater coordination between modern art and modern industry."[223]

Charles Sheeler was personally enamored of the poetry and forms of industry, which he depicted from the 1930s to the end of his life. Of Sheeler's paintings of factories, Winslow Ames wrote, "It is not industry as it really exists but the industry of my dreams."[224] The restrained style suits the American attitude toward technology: an optimistic confidence so pervasive as to be virtually unnoticeable. Some of Sheeler's titles indicate this attitude toward industry as the prototypical image of the beautiful future society. In *Ballet Mécanique* (76), he delicately equates the forms of industrial architecture with the beauty of the dance. *Incantation* (77) hints at the magical nature or mysterious powers inherent in modern technology.

The pervasiveness and fervor of European utopian aesthetic theories, with their radically new styles in art and architecture, could not fail to affect the American scene. Increased contacts between European and American artists in the 1920s and '30s, along with publications and exhibitions of European utopian art,[225] gradually introduced the principles of Neoplasticism, Constructivism, and the Bauhaus into this country. With the closing of the Bauhaus (in 1933) and growing intolerance in Europe, prominent utopians immigrated to the United States, among them Gropius, Albers, Bayer, and Moholy-Nagy, all of whom continued to teach the Bauhaus ideas and styles. Moholy-Nagy founded the New Bauhaus, later the Institute of Design, in Chicago in 1936. Other artists, notably Mondrian, went to New York during World War II, where they exerted great influence on the art world.

The result was a wave of abstraction in the late 1930s and early '40s. But the times had changed; the mood was no longer the unbridled enthusiasm of the 1910s and '20s. Consequently, many American abstract artists did not espouse the utopian underpinnings of the styles they adopted, remaining generally unaffected by the involuted philosophies of contemporary European theoreticians. American abstract art

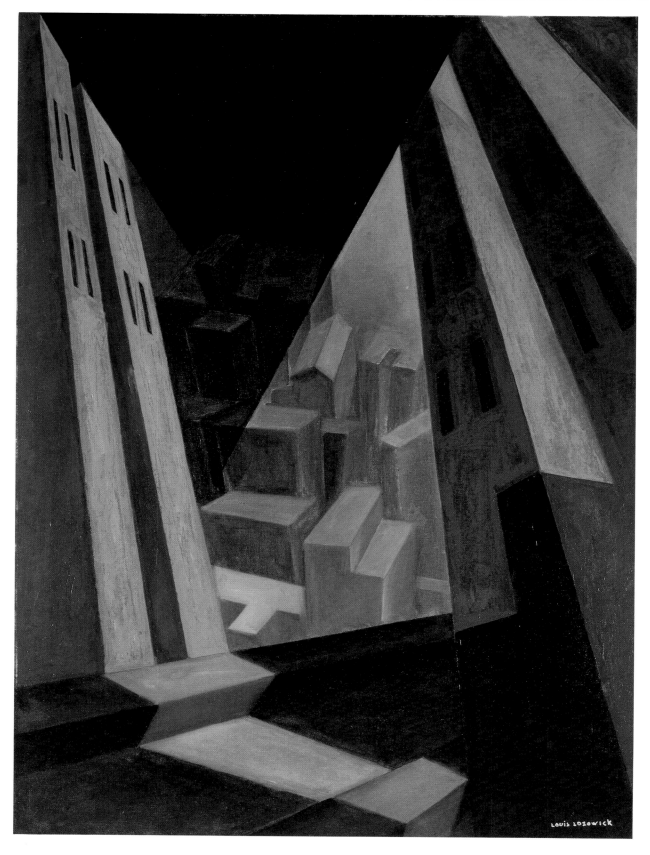

74 Louis Lozowick American, b. Russia, 1892–1973
Urban Geometry, 1925–27

75 Louis Lozowick
Machine Ornament #2, c. 1927

for the most part came into being after the turning point of circa 1930, when the second, nonutopian phase of Modernism began. As indicated by the change from De Stijl's utopian commitment to the formalism of Art Concret, European abstract art tended to lose or minimize its original utopian goals, escaping from the world into the self-referentiality of formal values. American abstract art expanded this tendency to focus on formal matters to the exclusion of socially reformist issues.

Some American abstract sculptors adopted the materials and techniques of modern technology in the 1930s in an attempt to create a machine-age art that augured the coming utopia. Influenced in part by his avid reading of science fiction, Theodore Roszak (1907–81) adopted the European machine aesthetic. Traveling in Europe in 1929–31 introduced him to Constructivist and Bauhaus principles, particularly those of Moholy-Nagy, which he used to create his

own style of nonobjective constructions (78). Acknowledging modern technology, industrial methods, and scientific discoveries as promises of a better life, Roszak felt in sympathy with the conditions of existence in the modern urban machine age and believed this art could contribute to an ordered technological environment, by offering exemplars of integration: "The constructivist position in modern art assumes a total interaction with life, theoretically and in direct engagement . . . implying a creative life beneficial to society."[226]

In the 1920s, the architectural renderer Hugh Ferriss (1889–1962) captured the romance of the visionary new city in his illustrated utopian book *The Metropolis of Tomorrow* (1929). Since before World War I, Americans had envisioned multileveled cities of enormous skyscrapers and bustling traffic, like William Leigh's *Visionary City* (fig. 7). The 1920s witnessed a sudden fascination with designs for future cities, such as Richard Neutra's ideally rational *Rush City Reformed* (1923) and Raymond Hood's huge skyscraper designs of the late 1920s and early '30s. A number of those designs were stimulated by Ferriss's drawings, which were well known in the mid-1920s through exhibitions and publications.

Ferriss's imaginary future city, *The Metropolis of Tomorrow* (79, 80), arose from his conviction that comprehensive idealistic planning was needed to shape a more civilized urban society. In *The Metropolis of Tomorrow,* Ferriss expounded themes similar to those being expressed in Europe. His belief in the affective power of architecture to influence people psychologically led him to call for a new, inspiring, urban architecture, dedicated to humanistic ideals:

Architecture influences the lives of human beings . . . specific consequences may be looked for in their thoughts, feelings and actions. . . . Our criterion for judging this self-conscious architecture will be its effect on human values; its net contribution to the harmonious development of man. We hope that eventually it will not only adequately meet the demands of our physical welfare, but will also serve in actualizing whatever may be man's potentialities of emotional and mental well-being.[227]

In *The Metropolis of Tomorrow,* an imaginary city is divided into zones, each representing an aspect of

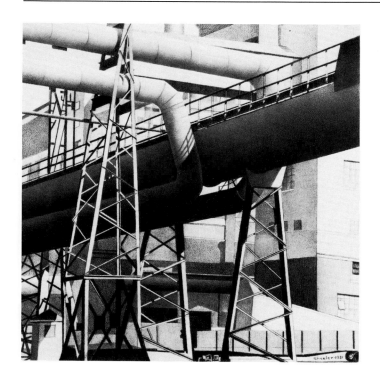

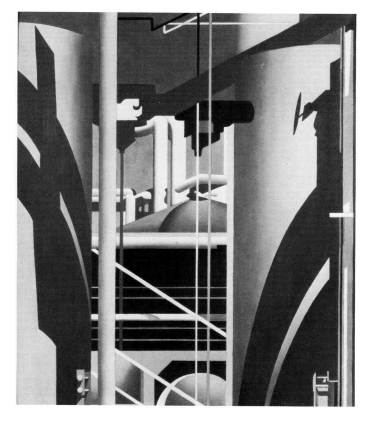

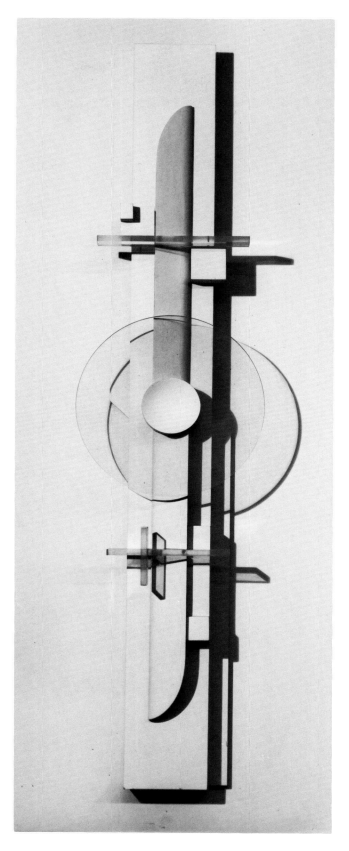

76 **Charles Sheeler** American, 1883–1965
Ballet Mécanique, 1931

77 **Charles Sheeler**
Incantation, 1946

78 **Theodore Roszak** American, b. Poland, 1907–81
Vertical Construction, 1943

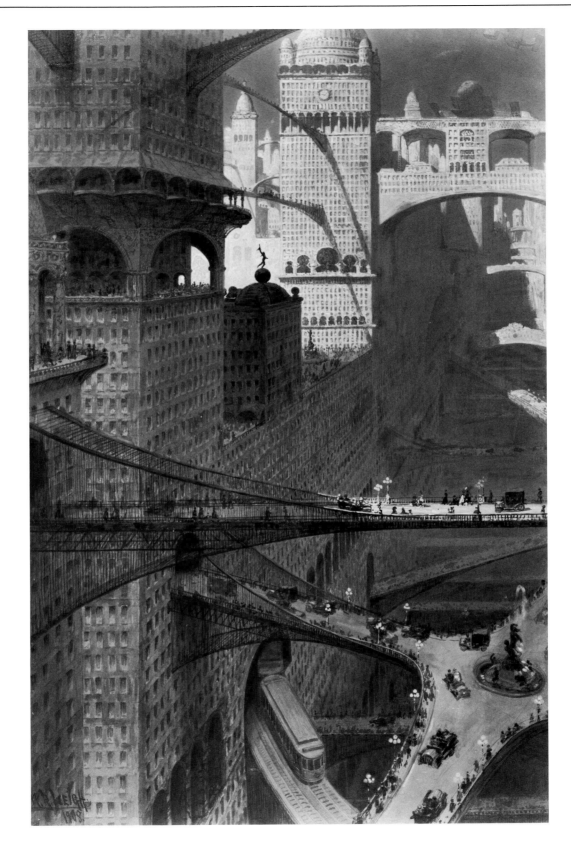

Figure 7 William R. Leigh (American, 1866–1955), *A Visionary City*, 1908, ink and Chinese white on tan board. Hirschl & Adler Galleries, New York

humanity (such as business, art, science), because Ferriss hoped that "the city could be made in the image of man."[228] Each zone would have as its center a huge tower, a thousand feet high and anywhere from three to eight city blocks wide. These skyscrapers would be set apart so they could be seen within ample vistas, thereby creating inspiring psychological and aesthetic effects, like looking at towering mountains. The Philosophy tower (79), standing where the art and science zones meet, is composed on a symbolic layout (its plan consists of three superimposed equilateral triangles to form a nine-pointed star) and proportions (a seven-stage elevation in the ratio of 3 to 1 to imply growth). Such forms were intended to convey the blend of science and esoteric fields, which constitutes the scope of human knowledge, as well as to symbolize the ideal society where "a number of separate parts aspire to be one."[229]

In the United States, the architectural and design style most clearly associated with a promising future was known as Streamline Moderne, an indigenous American version of a machine aesthetic. Largely created and championed by the industrial designers of the 1920s to '40s, this style was applied to the creation of everything from skyscrapers to household furnishings—the closest American approximation of a utopian *Gesamtkunstwerk*. Partly derived from Art Deco, the streamlined style emulated the look of modern technical design, specifically the forms of trains, planes, cars, and ocean liners engineered for maximum efficiency through minimal wind resistance. The resultant style of fluid horizontal lines, smooth surfaces, and rounded contours suitable for high-speed travel made little functional sense on a toaster or radio, but it rapidly came to be understood as a metaphor for the creation of a better world through technology and design. Ferriss used this style in many sections of his imaginary metropolis, as seen in the *Aerial View* (80), which presciently anticipated the look of the 1939 World's Fair in New York, where Streamline Moderne was used to create a total environment of visionary optimism.

In a nation that had rarely had cause to question the inevitability of its rosy future, the Great Depression profoundly shook the long-standing optimism.

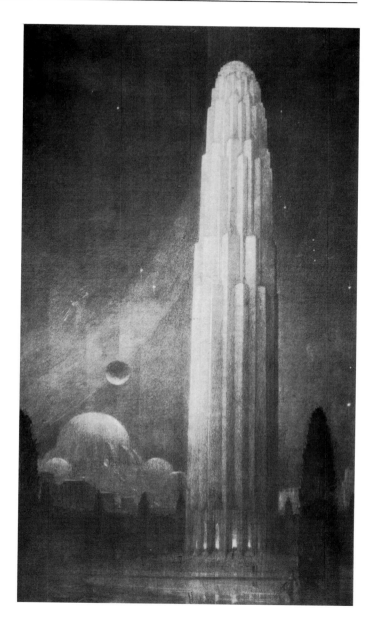

79 Hugh Ferriss American, 1889–1962
The Metropolis of Tomorrow: Philosophy at Night, 1928

Like World War I in Europe, the crash of 1929 and the ensuing economic collapse served as a catalyst to utopian ideas in America. The 1933 World's Fair in Chicago stimulated utopian dreams, as designer-architect Norman Bel Geddes wrote:

In the midst of a worldwide melancholy owing to an economic depression, a new age dawned with invigorating conceptions. . . . Complacency has vanished. A new horizon appears . . . that will inspire the next phase in the evolution of the age.[230]

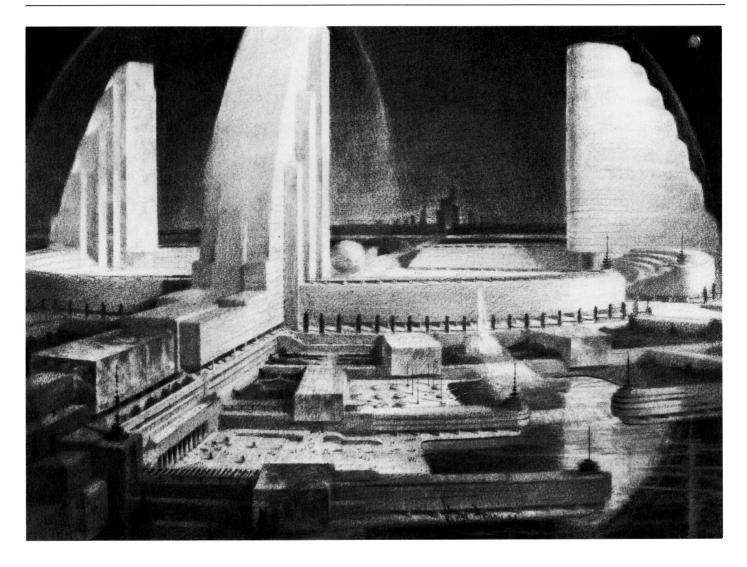

80 Hugh Ferriss
The Metropolis of Tomorrow: Aerial View, 1925

The New York World's Fair of 1939 was deliber-
ately planned to point the way to a better future. Its
organizing committee looked to Lewis Mumford, au-
thority on utopian thought, architectural and art his-
tory, and sociology, who believed that "if we allow
ourselves . . . to think for the world at large, we
may lay the foundation for a pattern of life which
would have an enormous impact in times to come."[231]
The leading planner, industrial designer and architect
Walter D. Teague, wrote that, despite the dishearten-
ing condition of society, "we see a new spirit of
order emerging. . . . We are beginning to agree on
certain details and preliminary drafts of our plans of
Utopia."[232] He felt that utopia should be pursued on

a practical basis, avoiding as much as possible preset
ideologies:

We have in our hands and in our minds the means to
build Utopia tomorrow. We can at once set about the job
of creating that race of fair, godlike men who have been
dreamed about and talked about for ages. . . . Condi-
tions would seem to be all set for the dawn of the well-
known new day.[233]

In addition to presenting a microcosmic image of
the "World of Tomorrow" in its own layout and
architecture, the 1939 World's Fair presented several
utopian conceptions of the urban civilization of the
future. Inside the General Motors building, the exhibit

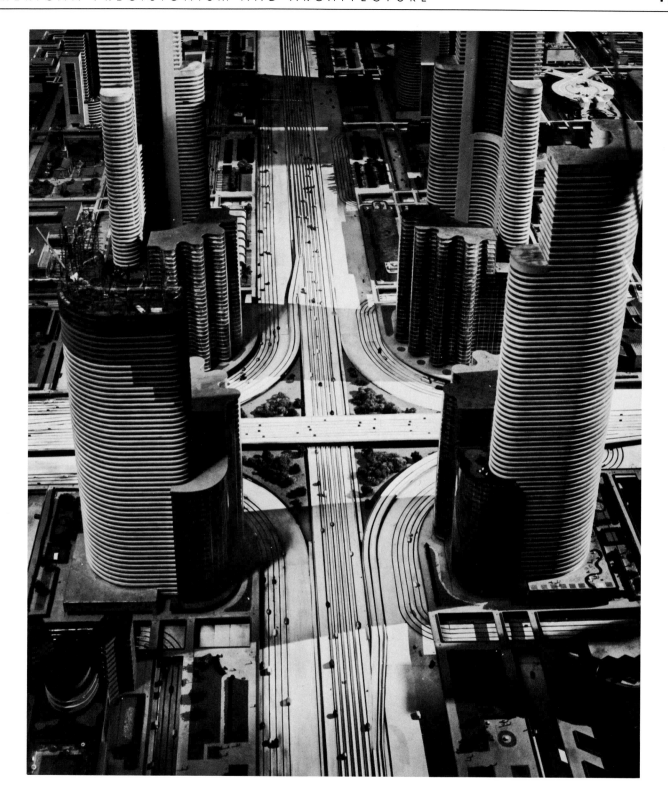

Figure 8 Norman Bel Geddes (American, 1893–1958), Futurama, exhibit in the General Motors building at the New York World's Fair, 1939. Norman Bel Geddes Collection, Hoblitzelle Theater of Arts Library, Humanities Research Center, University of Texas, Austin, by permission of Mrs. Edith Lutyens Bel Geddes, executrix

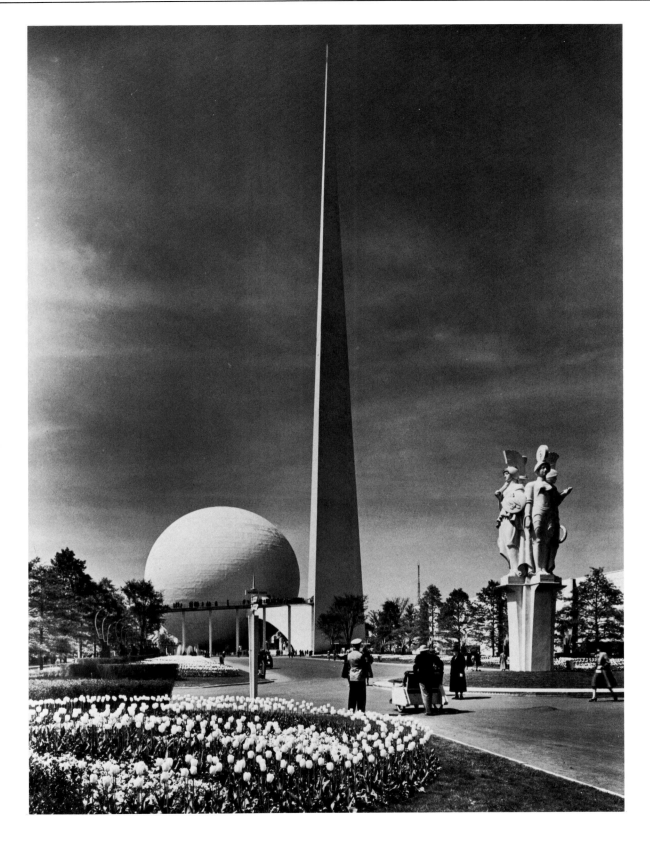

Figure 9 View of Theme Center (Trylon and Perisphere) at the New
York World's Fair, 1939, Wallace Harrison and J. André
Foulihoux architects. Museum of the City of New York

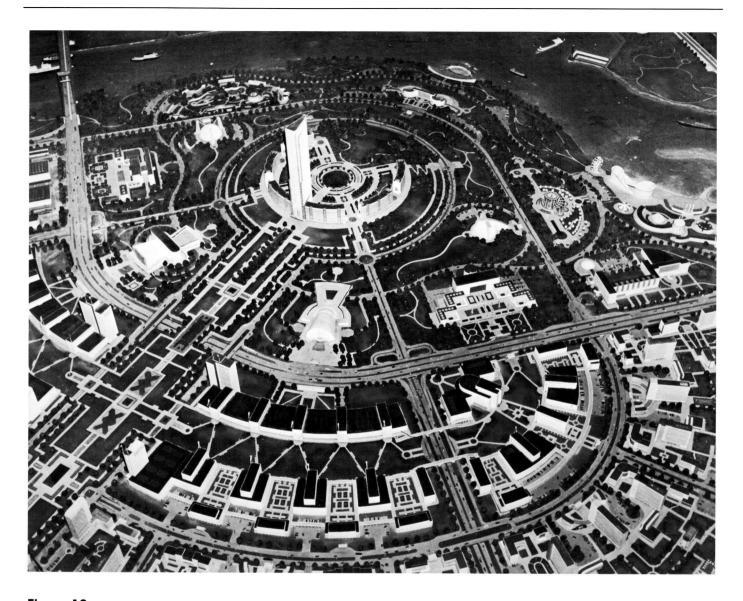

Figure 10

Henry Dreyfuss (American, 1904–72), Democracity, exhibit inside the Perisphere at the New York World's Fair, 1939. Records of the New York World's Fair, 1939–40, Rare Books and Manuscripts Division, New York Public Library, Astor, Lenox and Tilden Foundations

Futurama (fig. 8) by Bel Geddes envisioned in explicit detail the future American society. It would be characterized by major urban areas with access roads linked in a massive, multilaned interstate highway system. Bel Geddes confidently believed that the new era would be characterized by speed and mobility, which would provide the key to progress. Clearly the American utopia resembled the Italian Futurists' conceptions of a high-speed, technologically oriented, rabidly consumerist society, having little to do with the metaphysical utopias of higher spiritual awareness outlined by Mondrian, Malevich, and the German Expressionists.

The focus of the entire World's Fair was the Theme Center, whose pure white, geometric architecture, called the Trylon and Perisphere (fig. 9), powerfully

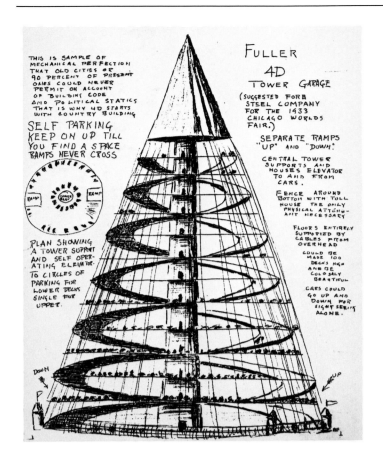

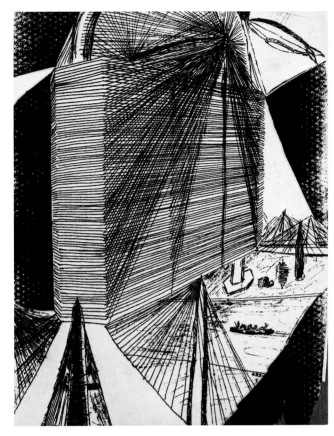

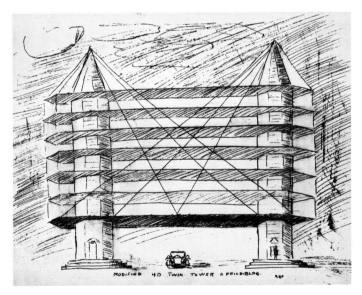

81 **R. Buckminster Fuller** American, 1895–1983
 4D Time Lock: Tower Garage, 1927

82 **R. Buckminster Fuller**
 *4D Time Lock: 100-Deck Office Building with
 Bridge A-1-9*, 1927

83 **R. Buckminster Fuller**
 *4D Time Lock: Modified 4D Twin Tower Office
 Building, A-1-13*, 1927

symbolized a world of perfect order, cleansed of all superfluity. In the American context defined by the Fair's planners, the Theme Center symbolized aspirations for global democracy and the free enterprise system. In the words of one planner:

These buildings are themselves a glimpse into the future, a sort of foretaste of that better world of tomorrow, of which we hope in some part to be the harbingers. We feel that simplicity must be the keynote of a perfectly ordered mechanical civilization.[234]

The Perisphere, an enormous sphere eighteen stories tall containing more interior space than Radio City Music Hall, housed the central exhibit, the Democracity (fig. 10), designed by Henry Dreyfuss. Democracity was a detailed, fully planned prototype for an ideal, "perfectly integrated futuristic metropolis" of a million people, with five residential satellite towns (suburbs).[235] It incorporated the various social and technical ideas seen elsewhere in the Fair's exhibits into a complete microcosm intended to convey the interdependence of people with each other and with technology in modern society. Unlike the abstract or fantastic designs of some European visionaries, Democracity was a sober, explicit proposal similar to the rationalism of Le Corbusier or late Bauhaus. Visitors observed a typical day in the life of Democracity, and as night fell, the interior dome of the Perisphere became a giant screen for the projection of propagandistic images. People, mostly workers of all kinds, marched together in united harmony, representing "the various groups in modern society—all the elements which must work together to make possible the better life which would flourish in such a city as lies below."[236]

Aside from the 1939 World's Fair, the single most persuasive proponent of utopia in the United States has been R. Buckminster Fuller (1895–1983). By 1927, Fuller had resolved that an ideal future world could be attained through comprehensive planning. He felt that "by competently reforming only the environment instead of trying to reform man," it would be possible to develop "the economic and technological capability of all humanity to enjoy freely all of its world . . . without any individual being advantaged

at the expense of another."[237] Fuller attacked this issue on many fronts, particularly through science, ultimately formulating a comprehensive system over a period of several decades.

A recurrent concern for Fuller was the need for a functional architecture for a world with an ever-increasing population, much of it ill-housed. In 1927, he made a World Town plan showing the placement of identical mass-produced housing towers all over the global village, from the United States to the North Pole and central Africa. The accompanying designs in the *4D Time Lock* series of mimeo drawings (81, 82, 83) proposed buildings revolutionary in design. Intended as structures to be mass produced using technological materials like steel cables and shatterproof glass, these buildings were conceived according to the principles of engineering, rather than traditional architecture. Fuller observed, "I am not interested in the old world of architecture . . . the new architecture has the task of making man a success."[238] The 4D buildings were intended to be self-sufficient, using wind generators to provide clean energy independent of government utilities. Though many European architects spoke of the machine aesthetic and the possibilities of mass-produced architecture, Fuller in his typically pragmatic and radically visionary way, totally redesigned architecture to suit real assembly-line techniques, all at an affordable cost. Though his various designs have been widely exhibited, they were never manufactured, partly because of hostility from industry and partly because the technology was lacking.

POST—WORLD WAR II

The Depression era and especially the years after World War II were not particularly favorable to utopian dreams. Yet the utopian tradition did not entirely die out. After the nuclear end to World War II, some perceived the need for betterment as more urgent than ever. Among the published utopias, B. F. Skinner's *Walden Two* (1948) was much noted. He advocated the systematic social use of behavioral psychology to engineer social reform by eliminating aggressiveness. Traditonal utopian concepts, notably decentralist and nontechnological proposals, also re-emerged, particularly in the 1960s. These tendencies were perceived not as retrograde but as true utopian progress, as Martin Buber noted in 1960:

The Utopian socialists have aspired more and more to a restructuring of society; not . . . in any romantic attempt to revive the stages of development that are over and done with, but rather in alliance with the decentralist counter-tendencies . . . and in alliance with something that is slowly evolving in the human soul: the most intimate of all resistances—resistance to mass or collective loneliness.[239]

In 1947, working with his newly defined principles of synergetics, Buckminster Fuller designed the geodesic dome (84). Since the 1920s, he had not ceased looking for what he called Universal Architecture, in which an ideal is given visual form, while being maximally efficient. He wrote: "Intellect is the sole

84 R. Buckminster Fuller
Geodesic Dome, 1952

guide to 'Universal Architecture,' which is humanity's supreme survival gesture. Universal Architecture [is the] scientific antidote for war."[240] Fuller's geodesic domes utilize the minimal arrangement of force lines (vectors) mirroring the complex yet fundamental structural system of energy in the universe. The linear trusses follow geodesic paths (a term used in mathematics and physics to define the shortest distance between points on a curved surface). As postulated in Fuller's synergetics, the tetrahedron represents the basic configuration of energy and structure on all levels of existence, from subatomic to cosmic, including both organic biology and mathematical absolutes. In addition to giving visual form to a dynamic coordinate system devised by Fuller to accommodate many complex physical laws, the geodesic dome (which exists in a variety of designs) embodies maximum efficiency. Using minimal materials, its structural soundness resists great internal and external forces. This means it can withstand all kinds of adverse conditions, and can therefore be used nearly anywhere for nearly anything. Using inexpensive materials, it can be enlarged indefinitely, growing stronger as it expands. Though its primary purpose remains the low-cost housing of individual families, domes have been calculated to enclose enormous spaces, even entire cities (the larger the dome, the thinner the structure, until it becomes a membrane)—a truly universal architecture.

The architecture of Frederick Kiesler (1896–1965) provides a link between the utopianism of the 1920s and that of the 1960s. Kiesler remained faithful to the earlier ideal of using an architectural environment to stimulate and enrich human life and consciousness. But he felt that the original utopian aesthetics had been diverted into "an architectural straight jacket" of functionalism and rectilinearity.[241] After the 1925 *City in Space* (fig. 4), Kiesler departed from international De Stijl and Constructivist precepts. He formulated an organic, biomorphic concept of architecture, which he called "endless." Starting with the early egg-shaped Endless Theater of 1926 and continuing in the 1933 Space House, he explored ways of devising flexible, flowing living space. He experimented with using new materials and structural techniques, from steel and

85 Frederick Kiesler American, b. Austria, 1896–1965
Space Division in Endless House, 1959

concrete to silk, colored glass, and soundproof cloth.

After World War II, Kiesler conceived the design for the *Endless House,* first in drawings and then in models (85, 86). Unlike the 1920s' emphasis on collective unity, Kiesler's keyword was "continuity." His definition of reality, quite unlike the equilibrium of opposites in Neoplasticism, is fluid—an infinite chain of possibilities without beginning or end. Continuity connotes a consciousness of being "correlated" with life and the cosmos, extending "far beyond the grasp of our five senses."[242] Eventually, "this reawakened sense of continuity will grow and grow and finally become the most positive, the most important new sense human beings will develop," wrote Kiesler.[243]

Like some anti-utopians of the 1950s and '60s, Kiesler felt that the emphasis on technology and materialism had gone too far and that architecture could help restore equilibrium and multidimensional satisfaction. His *Endless House* was intended to answer these needs: to create an environment conducive to "peace within." It provides radically different planning, "based on our inner needs and processes rather than on the dictates of mechanics."[244] In it the walls, floor, and ceiling flow into one another without interruption. Each section inside can be closed off for seclusion or opened up into one continuous space. Post and lintel construction is replaced by a tensional shell of concrete. Kiesler felt that this organic, holistic architecture

86 Frederick Kiesler
Endless House, 1959–61

Figure 11 Constant (Dutch, b. 1920), *The New Babylon: Spatio-vore,* 1959, perspex and aluminum. Rijksmuseum Kröller-Müller, Otterlo, Holland

would lead man to integration and fuller creativity. He called it the *Endless House* "because all ends meet, and meet continuously—there is no beginning and no end to it."[245]

The 1960s and '70s witnessed a resurgence of utopian thought, with a marked increase of theoretical and practical proposals, which were sometimes referred to as New Utopianism because they took into account the errors of early utopian philosophies. It was the period of the New Frontier, the New Left, the Great Society, Futurology (Futurologists study current trends and amplify them into projections about the future; it is a statistical field rather than visionary social utopianism), and the sudden proliferation of communes founded along decentralist, nonexploitive, often nonindustrial principles. After years of eclipse, Buckminster Fuller became a cult figure, electrifying students on campuses across the country with his lectures and publications, such as *Utopia or Oblivion* (1969). A new activist generation had come of age, impatient with the complacency of the fifteen postwar years, rebelling against the political and materialist values of their elders.

With the upsurge in utopian optimism came a new generation of visionary architects, generally called Megastructuralists. Many of them worked in collaborative groups, such as Archigram in England, Superstudio in Italy, and the Metabolists in Japan. A number of consciously utopian designs expand upon earlier conceptions, like Yona Friedman's rectilinear *Spatial City* that would hover in the air like Kiesler's *City in Space.* As earlier in the century, Europe produced more utopians than did the United States. One of the best known is Constant Nieuwenhuys (Dutch, b. 1920), who devised a new architectural environment for the new man of leisure, the *homo ludens* whose life will be freed from work by technology. The structures of his *New Babylon* (fig. 11), which he began in the late 1950s, were intended to provide settings that would encourage man's creativity and spontaneity in a shared society. Money, permanent residences, and material possessions would no longer matter, and regimentation would have faded away. The new city would consist of giant, multilevel spatial frames in a variety of materials and configurations. Most would be raised above the ground and

connected so as to form a labyrinthine metropolis network girding the earth. The elements of these "sectors" would be technologically sophisticated and movable to respond to myriad creative wishes, so that every space would offer fresh discoveries.

In the United States, the one utopian architect of continuing vision has been Italian-born Paolo Soleri (b. 1919), who has conceived a comprehensive renovation of human life. His philosophy of arcology (architecture + ecology) encompasses a holistic concern for man's basic needs and motivations. Rejecting the earlier ideal of the megalopolis surrounded by suburbs as wasteful and contrary to human needs, but recognizing the cultural need for cities, Soleri proposes instead greater density and concentration, leaving the countryside free. Each arcology would consist of multilevel complexes, primarily geometric megastructures that would house populations comparable to those now living in modern cities. Through miniaturization and thoughtful use of technology, large communities could become much more compact, occupying only a few square miles of land. This concentration within one complex would eliminate all vehicular traffic and keep urbanites in immediate proximity to open countryside. The individual arcologies would be linked together in a web, eventually circumscribing the earth.

Unlike most utopians who remain theoreticians of a reordered future, Soleri is constructing his utopia, called Arcosanti (87 and fig. 12), on 860 acres in Arizona. His is an organic architecture, built as much as possible from the resources at the site, including the earth itself and solar energy. The location was deliberately chosen to use marginal land, both to demonstrate the potential viability of such land and to affirm the beauty of such a site. Soleri's approach to future civilization combines practicality (active concern with ecology and natural energy) with metaphysical and aesthetic concerns. To avoid the trauma of standardization in mass society, Soleri encourages a more intense individual spiritual consciousness ("interiorization"), shifting emphasis away from material possessiveness to intellectual acquisitiveness and resulting in powerful creativity.

In the 1970s, some artists turned to visionary architectural designs as metaphors for and activating

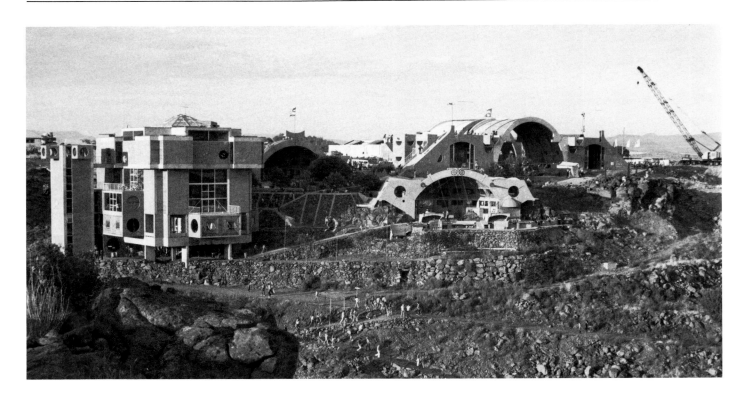

Figure 12 Paolo Soleri (American, b. Italy 1919), Arcosanti site
(in progress), Scottsdale, Arizona

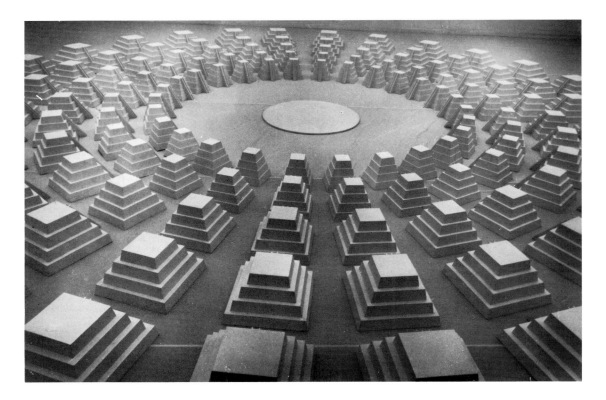

Figure 13 Anne and Patrick Poirier (French, both b. 1942), *A
Circular Utopia*, 1979, plaster. Collection of the artists,
Paris

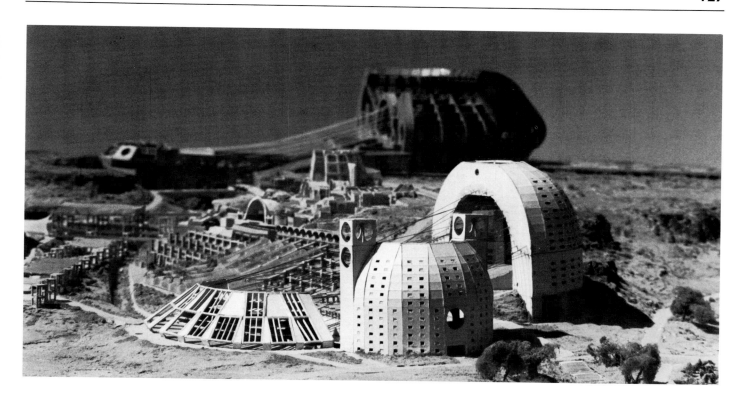

87 Paolo Soleri American, b. Italy 1919
Arcosanti (Critical Mass), 1979, detail of model

agents in the expansion of human faculties of aware-
ness. The French artists Anne and Patrick Poirier have
recently created the model for *A Circular Utopia* (fig.
13), in which the building type recalls ancient ziggur-
ats and the stepped pyramids of the Incas, Mayas,
and Egyptians.

Since 1967, Will Insley (b. 1929) has designed a
theoretical future civilization called *One City* (88, 89).
These exquisitely deliniated blueprints for utopia,
which are only parts of a larger whole, focus on
ceremonial buildings, in which space is the principal
factor. At an unspecified time in the future, the popu-
lation of the United States will have become affluent,
classless, and completely mobile. To avoid chaos
resulting from too much movement without purpose or
focus, the people choose to build a new city (the old
ones having long since fallen into ruins) as the symbol
of and focus for civilization. Intended to house the
entire population of 400 million people, *One City* is
laid out as one enormous squared spiral covering
675 square miles in the western plains between the
Rockies and the Mississippi.

The character of this utopia is clearly not utilitar-
ian. Like ancient civilizations whose forms resulted
from their religious beliefs, *One City* would serve
ceremonial and spiritual functions. In Insley's words:

This structure of virtually unfathomable complexity and
mystery . . . slips away from normal expectations of our
worldly understanding. *One City* has very little to do with
advanced planning theories of the present or with the
projected golden utopias of the future, but rather with the
dark cities of mythology which exist outside of normal time
in some strange location or extremity. *One City* hides itself
in mystery and plays games in the tunnels of our imagina-
tion.[246]

The spaces consist of large rooms and access
ways, and stairways climb all over the buildings as
they spread over hills and into valleys. The public
spaces between the Over and Under Buildings (the
private residences and the functional places) provide
an intricate network that would lead people through
labyrinths, up and down inclined passages and
through concealed spaces, through darkness into light
and back again. Conceptually *One City* would pro-

vide an unbroken environmental continuum, which, because of its totality, would powerfully influence perceptions. The ritualistic, ceremonial, and enigmatic are essential ingredients—they would induce evocative forces of perception, memory, and fantasy. People would move through the corridors and rooms in a physical process intended as analogous to a journey through the channels of the mind—a voyage of inner discovery.

88 **Will Insley** American, b. 1929
One City: Channel Space Reverse, 1968

89 **Will Insley**
One City: Volume Space Interior Wave, Isometric X-Ray View through the Ground, 1980–81 (project 1973)

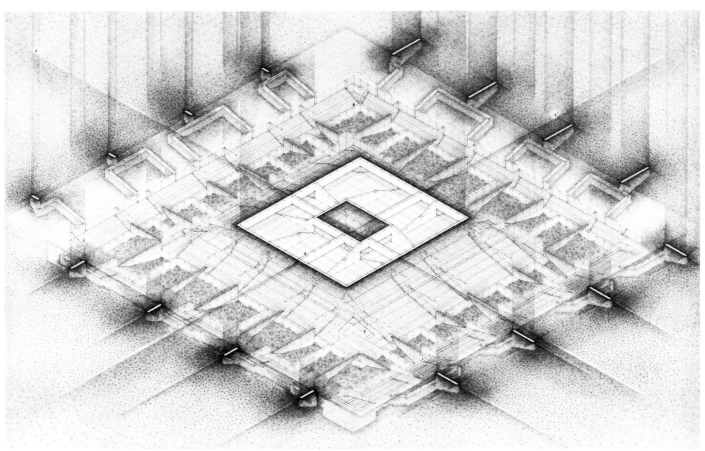

DYSTOPIAN NIGHTMARES

INTRODUCTION

While the nineteenth and early twentieth centuries witnessed the rise of utopianism, events of the mid-twentieth century brought disillusionment and reaction. As a literary genre and a world view concerning the future, the nightmares called dystopias, anti-utopias, or inverted utopias have seriously existed for less than a century; they are a phenomenon of our time. Arising as a reaction to both international utopian fervor and historical events in the early twentieth century, dystopia has displaced utopia with surprising speed since the 1930s. The old hope of steady progress, though still alive and trimmed with many real achievements, has yielded to doubts and fears.

People have come to ask: Do we really want utopia? Is the utopian dream really a nightmare? Nicholas Berdyaev wrote early in the century:

Utopias appear much more realizable than anyone used to believe. And we now find ourselves facing a most anguishing question: How to avoid their definitive actualization? . . . Perhaps now a new age is beginning, in which the intellectuals and cultivated class will dream of ways to avoid utopias and return to a non-utopian society, less "perfect" and freer.[247]

The term *dystopia* derives from the Greek roots *dys* plus *topos*, meaning "bad place," literally the opposite of utopia. Like utopia, dystopia is manifested primarily as a literary genre, but it has been powerful in other arts, particularly film. Dystopias describe imaginary future societies in which conditions are worse than the present civilization. As do utopias, dystopias blend fantasy with extrapolations from current trends into a compelling new reality. Generally, the nightmare visions tend to achieve their effect through their horrifying plausibility rather than through pure fantasy; they therefore draw upon present circumstances to a greater extent than do utopias. Anti-utopias often express opposition to utopian ideals by focusing on and attacking the imagery most frequently associated with utopianism, such as socialist economics, collectivist or communitarian ideology, powerful government, behavioral modification through education, the concept of the improved new man, the primacy of science and technology, and so on. Anti-utopians seek to avert these goals by reveal-

ing their inherent dangers and debunking the hard-core expectation that evolution leads inevitably to a nobler race of man and a better society.

Anti-utopian criticism has been raised by a wide range of people, sometimes even those with radically opposing views, including members of both the political Left and the Right. Every dream or vision invariably has its opponents, but modern anti-utopianism encompasses more than that. Anti-utopians believe that there are dangers inherent in the very idea of a society organized to achieve long-lasting utopian goals on a worldwide scale. They oppose the social and political arrangements needed to secure the ends, as well as the end results themselves. As one anti-utopian has written, "No Utopia has ever been described in which any sane man would on any conditions consent to live, if he could possibly escape."[248] One generation's dream has become the nightmare of the next.

Why did the utopian vision fade away, to be supplanted so thoroughly by dystopian nightmares? For the most part, historical events in the 1930s and 1940s cruelly disappointed the expectations of the nineteenth and early twentieth centuries, and subsequent developments in the past several decades have confirmed this disillusionment. The gradual march of progress from poverty and tyranny toward abundance and democratic freedom, which had proceeded slowly forward for several centuries at least, was perceived in mid-century as having been arrested or even substantially set back. The dreams became inexplicably perverted.

After the optimism of the roaring '20s, when international utopianism reached its peak, political and economic circumstances around the world altered drastically. By the early '30s, the Great Depression was in full global swing, profoundly shaking confidence in inevitable progress, even in the United States where optimism had always dominated. The most important disappointments occurred in the political sphere. In the two most overtly utopian countries in Europe, Germany and the USSR, high hopes for new social perfection were supplanted by two of the most inhumane totalitarian dictatorships of recorded history. With Hitler's accession to full power in 1933

and his ultrarightist Nazi ideology, the Weimar Republic became the Third Reich. Paralleling Hitler's rise to power in Germany, Stalin triumphed over all opposition, and the great experiment with utopian Communism in the USSR, in which so many intellectuals around the world had placed their confidence, metamorphosed into a repressive gulag society. Though the full extent of Stalin's savagery was not known until years later, the similarity between his regime and Hitler's could not be overlooked for long.

Meanwhile, the Spanish Civil War of 1937–39, which for many political utopians was to be the proving ground for their beliefs, resulted in resounding defeat for their idealistic hopes. The Moscow purge trials of 1936–38 painfully disenchanted many adherents of leftist politics, especially Communism, and the final blow was struck by the Nazi-Soviet Nonaggression Pact of August 1939. Then the outbreak of World War II in 1939 effectively ended utopian hopes for international cooperation. After the war, vestigial confidence in Communism was gradually destroyed by Stalin's renewed cultural purges of 1946 and the cold war of the late 1940s to '50s. Communist politics, and by association some socialist movements, were thoroughly discredited. Both the possibility and the desirability of utopia became problematical.

Because a well-ordered ideal society seems to necessitate government by a cadre of specially qualified experts, true democracy would conflict with utopian planning and implementation. As evidenced by history, rule by an elite inevitably becomes oppressive tyranny. Consequently, anti-utopians urge abandoning utopian visions, because to achieve and maintain any ideal state would require either an oppressive political regime or at the very least an overly dominant bureaucracy enforcing the implementation of the utopian blueprint for perfection. Instead of a single, total organizing vision, anti-utopians argue that it is preferable to pursue many paths, often unrelated and contradictory, toward the future. Rather than establishing all-encompassing, abstract ideals, many dystopians attack specific evils, in the hope that such threats to human well-being can be avoided or eradicated. In that sense, their nightmares represent an-

other form of idealism. Except for those who have taken refuge in passive cynicism, dystopians fight to improve the lot of mankind, both pragmatically and philosophically. By combating utopian plans that pose potential threats to individual well-being, by trying to prevent certain social developments, they yearn for a better future world and try to amplify man's awareness of the world and of humanity—essentially similar ideals to those underlying utopian visions. The specific approaches to these goals differ radically, but the desire for ameliorating the human condition inspires both utopians and dystopians.

The warnings came as early as the 1920s, but it was not until after World War II that scores of political utopians recognized and admitted their disillusionment with leftist politics. Arthur Koestler's novel *Darkness at Noon* (1940) was one of the first to declare that the utopia dreamt of by so many leftist intellectuals had turned into a nightmare. Koestler expressed his reversal from his beliefs of 1919–38, when he had supported the "general cause, the world revolution, the last of capitalism, the end of man's exploitation of man and so on. These ideals, which I focussed on the Soviet Union, were betrayed by the Stalinist dictatorships and I went into the opposition camp."[249] He was joined by many others, including André Gide, in subsequent publications like *The God That Failed* (1949), in which prominent intellectuals explained their renunciation.

War did much to destroy the utopian vision. The twentieth century produced two of the most devastating wars of all history. After the "war to end all wars" had claimed thirty-five million dead, World War II killed nearly fifty-five million, ending only with the production of a weapon capable of destroying the human race. The idea of peace, though more necessary than ever before, seems to have retreated into a chimera. In this respect, utopia has failed.

In other ways, utopian ideas have to some extent succeeded, but the result is not utopia. The twentieth century has finally provided the means with which to transform these ideas into social realities. Utopian concepts like socialism and collective societies, the global village and the megacity, abundance through technology, mass communication and universal educa-

tion have become an integral part of the fabric of modern life. Ranging from undeniable improvements to horrendous failures, the results have been so mixed that their "success" is hotly debated. Even in minor respects, real utopian advances exact a price. Increased literacy, suffrage, and communications can mean that more people are reached by political manipulation, as Hitler proved in the 1930s and McCarthy in the '50s.

Even without the realities of such historical events, however, the inherent weaknesses and perils of utopian theoretical assumptions were increasingly recognized as the 1930s and '40s progressed. For example, the traditional utopian emphasis and reliance on the cooperative benevolence and reason of humanity came to be perceived as failing to account for the fullness of human nature. Man's biological and psychological drives can resist rational analysis, let alone intellectual control, and can motivate human behavior as powerfully as conscious, intellectual incentives. Moreover, were completely rational thought and social structures possible, they could exact a high price by repressing those passions, emotions, and nonlogical modes of being and perception. The results might be conclusions in which logic excludes other, equally valid considerations, with a resultant reduction in the complexity of human nature and life.

Anti-utopians point out that the very process of creating a utopia may subvert the goal through necessarily coercive means, as many post–World War II sociologists and thinkers elucidated, notably Karl Popper in "Utopia and Violence" (1947–48) and *The Open Society and Its Enemies* (1950), and Karl Mannheim in *Ideology and Utopia* (1955).

Though widespread dystopian attitudes emerged strongly in society and the arts after World War II, they had appeared earlier in literature. Anti-utopian criticism can be traced to Aristophanes's satirical gibes against Platonic idealism, and some sporadic examples followed the surge of utopianism in the Renaissance, such as Joseph Hall's *Another World and Yet the Same* (1600). Serious anti-utopian literature emerged only in the late nineteenth century, however, with Samuel Butler's *Erewhon* ("nowhere" spelled backward) of 1871 and several refutations of

Bellamy's popular utopia, such as J. W. Roberts's *Looking Within: The Misleading Tendencies of Looking Backward Made Manifest* (1893).

It was not until the period of rampant utopianism after the First World War that the basic ideas, themes, and images in anti-utopian literature were established. Between 1920 and 1950, major dystopian novels achieved global fame: Evgeny Zamyatin's *We* (written in Russia 1920–21, published outside Russia 1924), Aldous Huxley's *Brave New World* (1932), Ayn Rand's *Anthem* (written 1937, published 1946), and George Orwell's *Nineteen Eighty-four* (1948, published 1949). In these works, the prototypical images of dystopia, which would echo through subsequent literature and art of the 1950s to '80s, were created. Frighteningly similar, these novels describe nightmare states where men are conditioned to obedience, individuality is subjugated to the state and collective anonymity, freedom is eliminated, knowledge is limited and manipulated, and science and technology are used to reinforce the state's authority and control of its citizens. Though the vast majority of anti-utopian writings appeared later, these seminal works provided a requiem for the centuries-old dream of an ideal, organized society, and signaled their replacement in the modern era by the nightmare of bureaucratic welfare states and tyrannical dictatorships.

The theme of an omnipotent government controlling and oppressing the individual is one of the central concerns of dystopian literature and art. The control of the individual can be insidiously benevolent, as in *Brave New World,* where the government ensures that its citizens have every kind of comfort and physical indulgence. Or it can be harshly dogmatic and oppressive, as typified by *Nineteen Eighty-four*. Even before Stalin and Hitler, concern over the threat of totalitarianism and the loss of individual freedom appeared in Condé Pallen's little-known *Crucible Island* (1919), in which protest is treason, and children learn their socialist catechism in school:

Q: By whom were you begotten?
A: By the Sovereign State.
Q: Why were you begotten?

A: That I might know and love and serve the sovereign State always. . . .
Q: What is the individual?
A: The individual is only part of the whole . . . and finds his complete and perfect expression in the Sovereign State.[250]

In *We,* as early as 1920, Zamyatin attacked the emerging signs of totalitarian control in the USSR when he described a seemingly perfect and beautiful society constructed as Russian utopians hoped, with the One State to regulate the actions of all citizens and to ensure the well-being of society by enforcing absolute equality. In *We,* Zamyatin presented a particularly compelling anti-utopia, demonstrating the seductive beauty of utopian ideals. Until very late in the novel, descriptions abound concerning the sheer beauty of a rational and technological civilization. Only in the end does tyranny shine through when the state enforces the surgical removal of the imagination of every citizen (a refined lobotomy):

They'll cure you, they'll stuff you full of rich, fat happiness, and sated, you will doze off peacefully, snoring in perfect unison. . . . They want to free you of every squirming, torturing, nagging question mark. . . . Remember: those in paradise no longer know desires, no longer know pity or love. They are only the blessed, with their imaginations excised.[251]

In *Brave New World,* Huxley presented these ideas with new force and explicitness. The first anti-utopian novel to make an international impact, this satire depicts one of the classic dystopias of our century, along with Orwell's *Nineteen Eighty-four*. The titles of both works have become synonymous with the nightmare vision of the future, largely because their forecasts were surprisingly apposite. With its combination of satire and serious discussion, *Brave New World* vividly depicts a world of universal affluence and physical comfort, where everyone is happy. The catch is that there is no choice—the citizens have been controlled since conception by the World State, which decides what is good and necessary for social stability and universal happiness. The state controls education to condition children to think alike, to believe the same "truths" in order to ensure uniform behavior:

"That is the secret of happiness and virtue—liking what you've got to do. All conditioning aims at that: making people like their inescapable destiny."[252] As part of this destiny, conditioning teaches people to be unendingly happy, indulging freely in amusements, sex, and drugs. People are content because they can't be otherwise.

George Orwell envisioned an equally frightening but much less enjoyable future world in *Nineteen Eighty-four*. Again, in the struggle between individual freedom and a powerful government, the state triumphs. Unlike *Brave New World,* the Inner Party rulers of *Nineteen Eighty-four* are not concerned with people's happiness. They seek power for its own sake, for the pleasure of controlling others. Orwell viewed totalitarianism as a new phenomenon in history, a higher stage in the evolution of tyranny and despotism. Unlike older authoritarian regimes, totalitarian rule pervades every area of life (not merely the political sphere) with state control. The phrase "Big Brother is watching you" sums up the concept of the enforced loss of all individual liberty to the omniscient, omnipotent state. History and language are controlled to manipulate the populace's beliefs. Language is progressively reduced and channeled ("Newspeak") until it becomes impossible to express certain ideas, because there are no words for them.

Another principal theme in dystopian literature and art is the loss of uniqueness, the subjugation of the individual to the anonymity of mass conformity. Anti-utopians believe that any preconceived, comprehensive plan for a global society would extract a terrible loss of variety, reducing complexity to conformity. Regional, cultural, and personal differences would be leveled, repressed, or stultified. Often in literature, as in *We* and *Anthem,* this loss of separate identity is conveyed by the use of numbers instead of names for people. W. H. Auden's poem "*The Unknown Citizen:* To JS/07/M/378 This Marble Monument Is Erected by the State" extolls the perfect citizen:

He was found by the Bureau of Statistics to be
One against whom there was no official complaint
. . . He was a saint,
For in everything he did he served the Greater Community.[253]

Ayn Rand's *Anthem* (1937) depicts a society where the collective mentality has succeeded in eliminating the age-old cause of strife: the sense of the individual self as distinct from others. Names do not exist, only generic labels embodying abstract and communal ideals, like Fraternity, Solidarity, Similarity, International Collective, and so on. The narrator, Equality 7-2521, opens his tale with the words: "It is a sin to write this . . . to think words no others think . . . there is no transgression blacker than to do or think alone."[254] The narrator refers to himself as "we" because the concept as well as the word "I" have been suppressed. The motto of the world state is: "We are one in all and all in one. There are no men but only the great WE. One, indivisible, and forever."[255]

Aside from the pre-eminent concerns with the loss of individuality and social freedom, the most pervasive target of attack in dystopian literature and art is scientific technology as a destroyer of human values, worth, and dignity. Anti-utopians rarely suggest outright rejection of science and modern technology. That would be not only impossible but undesirable, since technology has brought so many improvements in living conditions. Most anti-utopians argue against the elevation of science and machines to a position of extreme pre-eminence, overshadowing humanist values.

In E. M. Forster's *The Machine Stops* (1909), the Machine satisfies every human need and desire. People never visit or go out because telephones and other communications media keep them in touch. People depend so much on technology that when the machine stops, life itself is threatened. Forster voiced the humanist fears concerning mechanization: that it will control life and dwarf humans, depriving them of creativity, self-respect, and uniqueness. He also expressed the fear that reliance on technology will damage mankind psychologically and even physically by undermining certain qualities, such as self-reliance, energy, independence, and muscular strength. At worst the machine can dehumanize; at best it brings such luxurious ease as to incite decay.

In *We*, Zamyatin reacted against the Russian post-revolutionary passion for scientific methods and crite-

ria as absolute arbiters of social values, including aesthetics. The hero, an engineer and mathematician, savors the beauty of the precision of machines:

. . . the cranks flashing . . . the bit of the slotting machine dancing up and down in time to unheard music. Suddenly I saw the whole beauty of this grandiose mechanical ballet, flooded with pale blue sunlight. . . . Why is this beautiful? . . . Answer: because it is *unfree* motion.[256]

Aldous Huxley distrusted the concept of progress through technology and vociferously warned against it in his writings, both fiction and nonfiction. He wrote:

Because we use 110 times more coal than our ancestors, we believe ourselves 110 times better intellectually, morally, and spiritually. . . . Progress has genuinely taken place in the realm of science and technology. . . . But the greater part of what is called moral progress consists merely in changes that are entirely without ameliorative direction.[257]

Huxley believed that the machine dehumanizes people by demanding mechanical efficency of them— a concept central to the art of Anzo half a century later; see, for example, Anzo's *Isolation 15* (117). Furthermore, Huxley feared its debilitating effects on human creativity. Long before television or video games, but in the era when movies and radio were rapidly displacing theater, he wrote that the total involvement of the spectator may cause passivity, rather than the activity hoped for by Lissitzky, Moholy-Nagy, and other utopian artists. In the late 1920s, he wrote: "Men no longer amuse themselves creatively, but sit and are passively amused by mechanical devices. Machinery condemns one of the most vital needs of humanity to a frustration which the progress of invention can only render more and more complete."[258] The travesty of life in *Brave New World* was made possible by advanced scientific techniques that permitted mass production of people and total mind manipulation.

The question of subliminal mind coercion or manipulation has pervaded modern anti-utopian nightmares, especially since the 1920s when many advances were made in this field, notably Pavlov's *Conditioned Reflexes* (1928). Utopians rely on education to teach

values such as enlightened virtue and cooperation— but at what point does this become indoctrination? In *Brave New World,* hypnopaedia (sleep teaching) is used: "62,400 repetitions make one truth."[259] Brainwashing and behavior modification have become all too easy with modern scientific techniques and chemicals, from truth serum to the subliminal messages transmittable at frequencies too rapid for the conscious eye or ear to detect. Science now allows true control of mass humanity, more complete than tyrannical force because, properly indoctrinated, no one rebels.

After the uncritical optimism of the early twentieth century, disillusionment with science and technology as unmitigated boons grew in the period from 1950 to the present. The principal trigger for this change was obviously the atomic bomb. With its first explosions in 1945, the new physics had succeeded in producing the new Armaggedon. The tremendous hopes residing in technology were so great that it took many years to shake them seriously. As the 1970s progressed, every month seemed to bring new revelations of the threats posed to human life and the ecology by industrial and other products. Perhaps the most disturbing realization was that sometimes the very inventions intended to improve life may end up destroying it as effectively as nuclear warfare, as in the case of thalidomide, the sedative responsible for thousands of deformed babies. Gradually attitudes toward science as the font of all progress have been shifting to uncertainty, doubt, and disbelief.

Some dystopians view even the utopian yearning for enhanced nonphysical spirituality as not entirely wholesome. When carried to an extreme, utopian emphasis on intellect and spiritual concerns can lead to neglect of the physical, thus furthering the dissolution of human wholeness into separate and unequal compartments. In many utopias, physical nature is discredited as base or a wrong model for emulation. Humans refine themselves away from all resemblance to animal nature out of a desire to be like the angels (angelism). H. G. Wells and some utopian artists like Mondrian and Malevich proposed to clean up the world to the point of sterility and ultimately to transcend physicality. Emotions are de-emphasized; colors

yield to white; solids dematerialize. This distancing from the realm of animal nature is equated with human progress to a "purer," more civilized level of existence. Implicit in this attitude is the denial or diminution of physical reality, or at least aspects of it, as inferior or unimportant. In Franz Werfel's dystopian novel, *Star of the Unborn* (1946), mankind has become so exquisitely refined that physical contact is distasteful and nature is avoided. While the desire for enhanced spiritual consciousness remains one of the finest utopian goals, as an absolute imperative it can lead to a perversion of humanity.

The early-twentieth-century utopian desire for creating a pristine artificial living environment is criticized in Zamyatin's *We*, where civilization exists only in huge geometric cities separated from nature by a wall. Even the weather is controlled, as H. G. Wells and others had hoped. There was no use for anything beyond the enclosed city: "Man ceased to be a savage only when we had built the Green Wall, when we had isolated our perfect mechanical world from the irrational, hideous world of trees, birds and animals."[260] The image of the Wellsian city of gleaming modern materials and the pristine geometric forms of utopian architecture and abstract art recur in many dystopias. *We* contains repeated references to the Russian avant-garde passion for mathematically precise images and their frightening absolutism:

If they fail to understand that we bring them mathematically infallible happiness, it will be our duty to compel them to be happy. . . . Yes, to unbend the wild, primitive curve and straighten it to a tangent—an asymptote—a straight line. For the line of the One State is the straight line. The great, divine, exact wise straight line—the wisest of all lines . . . the mathematically perfect life of the One State.[261]

Throughout the novel, "the beauty of the square, the cube, the straight line"[262] represents the absolute order imposed by the all-powerful government.

In the visual arts, anti-utopianism emerged gradually in the twentieth century, mostly after World War II, though there were earlier examples. More than in the fine arts, film proved to be the most effective and popular medium for expressing the dystopian fears of

our time. As early as 1926, Fritz Lang's *Metropolis* depicted what at first appears to be a marvelous, gleaming technological society, but turns out to be a world of totalitarian force founded on human slaves in a subterranean factory system. In *Modern Times* (1936), Charlie Chaplin falls prey to the forces of inhuman machinery. The 1960s and '70s produced hundreds of dystopian movies, from the dozens that deal with nuclear disasters and technology run wild to *THX-1138*, a view of society in A.D. 2400, when computers monitor and regulate humanity in an emotionless, white, subterranean culture.

In the traditional arts of painting and sculpture, the anti-utopian reaction has been expressed in many and varied ways, some overtly humanist, but sometimes consisting only of the negation or rejection of utopian styles. Since most utopian aesthetics were associated with leftist politics and the socialist-collectivist ethos, the historical events of the 1930s and '40s brought discredit on utopian ideas and art, or at least posed the problem of guilt by association. As seen in the novels of Zamyatin and other dystopians, geometric abstraction was clearly and critically identified with utopianism and with its failures. Disillusioned and discouraged, many utopian artists began dissociating themselves and their abstract art from all connections with society and real life, save the most generalized concepts of universality and order. As in Gilbert and Sullivan's operetta *Utopia Limited* (1893), in which a king in the tropics orders his subjects to wear European-style clothes, with disastrous results, many utopians between 1910 and 1935 gradually discovered that their ideas were mistaken.

The assumptions of utopian aesthetics, like other branches of utopian thought, contain inherent fallacies, or at least weaknesses. Artists who espoused geometric abstraction in art and architecture believed that if people could learn to perceive logical relationships and appreciate the beauty of those reasoned forms, they would apply these qualities to life and recreate the world on a logical foundation. Besides the general fallacy of believing that humanity can become benevolently rational, and the doubtful desirability of a purely rational world, these utopian artists ignored the subtler implications of their art and its

potential to affect human actions. A geometric language creates a fantasy of clarity and logic, a psychology of planning against chaos for ordered growth. Geometrically abstract utopian art aimed at inducing ordered thinking. Prior to 1930, this was universally perceived as an avenue toward growth, and in the hands of the early utopians, particularly those who emphasized the spiritual dimensions of geometric art, the expansive effects remained uppermost. But the rigid translation of intuition into dogma by later artists made geometric abstraction into a form of psychological manipulation, resembling a totalitarian doctrine.

Compounding these weaknesses, their styles of art were based on the questionable concept of geometric abstraction as a universal language. Geometric abstractionists accepted as axiomatic that geometric styles not only embodied reason and logic, but also conveyed transcendental and specific meanings, like the desirability of collective collaboration. But simply because geometric forms have been endowed since antiquity with certain qualities, such as reason, does not make it *true*—it only makes it an arbitrarily accepted convention. That the utopian abstractionists succeeded to some extent in creating a universal language comprehensible to rational, spiritual people cannot be denied in view of the effect their art has had, yet this language tends to affect precisely those people who have the key, who understand those geometric forms as signifiers of larger, rational constructs and metaphors of consciousness. Far from creating a universally accessible optical vocabulary, they produced a rarefied symbolic language that requires much training to be understood. Rather than having meaning to all humanity, utopian geometric abstraction lacks a workable syntactic guide and therefore remains somewhat incomprehensible to viewers without some familiarity with Platonic traditions, esoteric symbolic language, semiotics, or modern aesthetic theory.

The gradual disassociation of abstraction from utopian ideals and goals intensified as the events of history brought increasing discredit on utopianism in general. Utopian artists who had turned to geometric abstraction as a universal language had done so with great hopes, but by 1930 their utopian ideals appeared to have failed. A number of artists increasingly focused on internal, formal problems, abandoning the ideological aspects, and geometric abstraction increasingly lost its utopian character.[263] Younger abstract artists in Europe and especially America borrowed the exterior stylistic forms of abstraction without accepting or even acknowledging the implicit utopian aesthetics. By the late 1950s, formalist, or art-for-art's sake, aesthetics had obliterated the earlier associations. Though formalism constituted a retreat from utopianism to the isolation of "pure" art, where the artist need not confront difficult issues concerning human and social relationships, it may also be seen as tacit acceptance of the status quo, supporting the pattern of social development by affirming the styles, such as geometric abstraction, that were originally conceived as expressing confidence in a technologically oriented, collectivist, ordered society.

Many artists have rejected the ideals promoted by utopianism, participating in what Herbert Marcuse calls the "Great Refusal"—an opposition to the dominant cultural forces set in motion through utopian aspirations. These artists assign to art an important role in creating social values opposing the subjugation of human values to technology and other powerful forces. These countercultural artists have often been scarcely noticed in the art world's worship of Modernism. Humanism is perhaps a better term for much anti-utopian art, because it emphasizes its purposeful nature, in contrast to mere nihilism or pessimism.

Though humanism in art did not disappear in the wave of utopian abstraction between 1910 and 1930, it had been thoroughly eclipsed, re-emerging after the Second World War and continuing through today. Rejecting the prevalent retreat into formalism, increasing numbers of artists have protested the dehumanization of mankind. Humanist artists attempt to establish the primacy of human existence and quality over other questions of politics, economics, and society. By discrediting myths like the dominance of scientific and technological values, and de-emphasizing material consumption, dystopian art asserts the need for a new social value system that offers greater attention to human needs and perceptions—ultimately

leading to social changes and a saner, more just and satisfying life. The humanist believes that "the apocalyptic contingency must be recognized as *conceivable*, yet shown to be *avoidable*."[264]

Many dystopian artists depict the unacceptable and express the desperation and horror of the human situation. Through foreboding images, these artists hope to shock people and stimulate them to sensitivity, awareness, and action, much as the utopians hoped to do with their then-novel abstraction. Though negative in appearance, dystopian art affirms the possibility of a different and better existence. This art ranges from broad attitudes to specific issues and often arises from or is rooted in observations of conditions in the real world. Attitudes range from those who despair utterly (as expressed in the late works of George Grosz) to those who believe disaster can be averted through conscientious efforts (a few of these border on a kind of humanist utopianism). Some artists consciously direct their art to specific goals; others simply express personal reactions to the crisis of modern life. Some artists may even deny any intention of expressing dystopian or humanist content, but their images speak louder. Nearly all these artists are individualists—unlike the utopians, they avoid collectivist group ethics. Since their art expresses the importance of the individual over any organization, it seems appropriate that these artists are disinclined to accept group aesthetics.

Because dystopians seek to warn against what might happen, their art aims at making an immediately comprehensible impact—to communicate with people. This has generally led to the use of representational styles, in contrast to the utopian preference for geometric abstraction. While a few artists used vehemently gestural, expressionistic styles of abstraction after World War II to express angst, fear, and rejection of the earlier utopian styles of pristine geometric abstraction, most artists concerned with expressing these ideas exploit the symbolic and associational powers of representational forms. The human form offers the most universal and immediate vehicle for humanistic concerns, inasmuch as it is the subject with which everyone can most easily identify and understand. Dystopian artists utilize the human subject in all its permutations, from tangible physicality as warm, vulnerable flesh (the aspect utopians most tended to overlook or transmogrify), to its roles within a societal context. More than utopians who dream of a totally different ideal world, dystopian artists draw upon contemporary reality, with its politics, its architecture, its history. This may take the form of fairly literal descriptions of dystopian-tending situations or, at the opposite extreme, allegories without allusions to specific context. Some draw upon traditional classical symbolism of mythic proportions; others rely on formal tools of visual contrasts and textures. Not to be confused with social realism, dystopian and anti-utopian art transcends political, economic, national, and ideological limitations. Though many artists have been motivated by political events or beliefs (either to combat or support certain regimes), dystopian art does not serve as a political tool, except in the very broadest sense of fighting against political oppression of individual freedom.

EARLY PREMONITIONS

In Germany, industrialization and urbanization had started later than in France and the United States but then developed so precipitously after mid-century that Germans had a shorter period in which to adjust. That abruptness produced a profound intellectual crisis, possibly more intense than anywhere else. Pronounced anxiety about the future developed alongside utopian expectations in the early years of the twentieth century and was manifested in the early art of Ludwig Meidner and subsequently in the works of George Grosz and others.

Hypersensitive and emotional, Berlin artist Ludwig Meidner (1884–1966) was obsessed with tragic images of suffering, disaster, and death. As early as 1908, Meidner envisioned apocalyptic crowds, landscapes, and cities, which he drew and painted for nearly a decade. An eccentric artist, Meidner knew and was influenced by the Expressionists of the Brücke group in Berlin, notably Erich Heckel and Ernst Kirchner. Meidner's own style, with its disintegration of forms in a furious whirl of lines, combined Expressionism and Futurism. In most works, the Futurist element of feverish tumult predominates, but it is characterized by an ominous sense of disaster, which is reinforced in the paintings by the use of thick impasto and muted or muddied colors, particularly opaque browns, dark ocher, and blackish blues, as in *Apocalyptic City* (90).

Meidner was not alone among Expressionists in his focus on sinister and catastrophic scenes. His art epitomized the fear of impending universal destruction that was widespread in Europe in the half-dozen years before the outbreak of World War I. Whereas other Expressionists, notably Wassily Kandinsky and Franz Marc, envisioned an apocalypse as a step needed to cleanse the world of the institutions, traditions, and other structures that had inhibited or perverted the full development of mankind, Meidner and a few others were oppressed by a sense of doom. This was particularly apparent in literature. One of the most widely read poems of the period was "Weltende" (End of the World), published in January 1911 by Meidner's friend Jakob von Hoddis. George Heym, another friend of Meidner, wrote poems envisioning the modern city collapsing in clouds of smoke

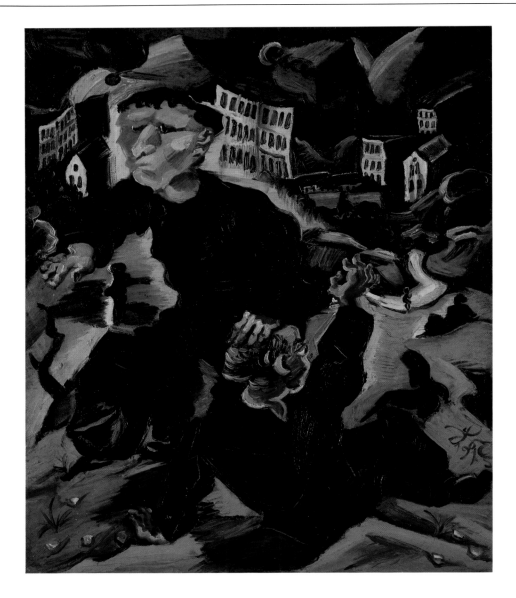

90　Ludwig Meidner　German, 1884–1966
Apocalyptic City, 1913

and consumed by fire, with hordes of dying people streaming through the darkened streets.

Though in retrospect Meidner's apocalyptic scenes clearly reflect European anxieties on the eve of World War I, they also transcend the specifics of war to convey cosmic chaos, a global sense of trauma. Many of Meidner's scenes are set in the modern city, with explosive lights, toppling buildings, ominous shadows, and frightened people, as in *The Uncertainty of Visions* (91). The figure staring out at us, though unidentified, may represent the artist (who appears in many apocalyptic scenes), or perhaps Everyman who continues through the midst of disaster.

The title suggests the dubiousness of trusting too much in visions, as the Futurists and other utopians were in the process of doing, because such visions may lead to disaster. *Apocalyptic Scene* of 1915 (92) depicts the fear and despair that bring people to the edge of chaos. Figures gaze upward, horrified, as buildings burn and topple in the background. Hands reach up in hopeless gestures of petition and fear; two figures in the center collapse in terror and death.

A number of other German artists, such as George Grosz and Otto Dix, later visualized the modern city as a place of violence and cruelty. Meidner, a prolific writer of poems and prose, often described the

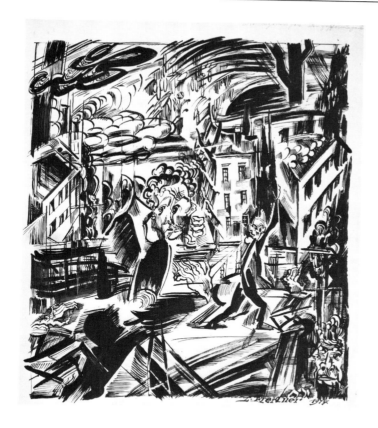

91 **Ludwig Meidner**
The Uncertainty of Visions, 1914

92 **Ludwig Meidner**
Apocalyptic Scene, 1915

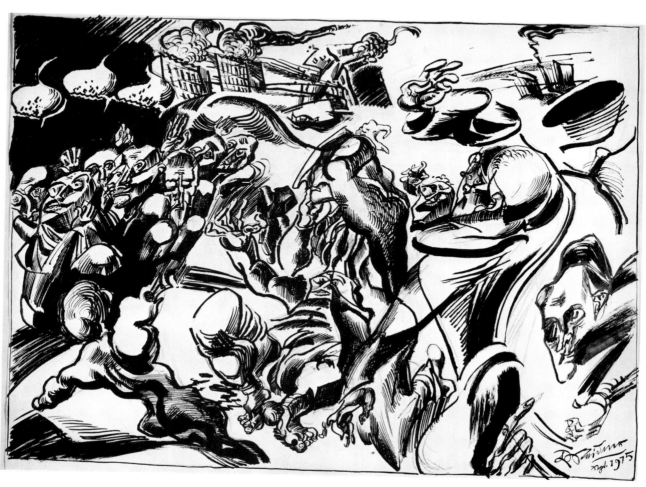

modern city in horrific terms: "The city nears. . . . There catastrophes explode from their windows, stairways silently collapse. People laugh beneath the ruins."[265] He condemned geometry in art as being too removed from reality, too remote from the world: "Artists strove like madmen for abstractions and non-objectivity. All you painters eager for heaven, you'd like to forget the earth and squeeze the spirit straight from your tubes—immaculate and utterly transcendent. But stop a moment and study the marvelous reality of things."[266]

Although Meidner turned away from his apocalyptic scenes after 1916, Expressionist depictions of dystopian fears continued in the prints of Frans Masereel (1889–1972). This Belgian-born artist worked primarily in Paris until World War II, but he felt greater affinities with German art. The First World War convinced him of the importance of pacifism and of the need to use art as a means of warning against potential disasters. He wrote: "The artist's place is in the first ranks of those who fight for the creation of a new system that excludes war and the exploitation of man by man. . . . His creations can become that engine of excitement that can stir human souls."[267] From the 1920s through the 1950s, Masereel composed powerful black and white images concerning the destructive forces of mass society and the perils of the city, industrialization, materialist values, and political demagoguery. *The Prophet* (93) warns of the rising threats to humanity in the late 1930s.

The end of World War I signaled the beginnings of incipient anti-utopianism in art as in literature. In this early phase, dystopian art was a subculture running against, yet touched by, the dominant utopian tenor of its time. Dada artists, particularly those in Berlin, enunciated contempt for and refused to participate in the utopian illusions of progress, unlimited technology, the perfectibility of man, and so on. Rejecting the myth of technology, Dada artists often used machine imagery in satirical ways, deriding the machine's superior position in society. In *The Spirit of Our Time (Mechanical Object)* of 1919–20 (fig. 14), Raoul Hausmann tacked onto an ideal human head the measuring tape and mass-produced objects so dear to many utopians. The result is a mockery of the New Man and his new era.

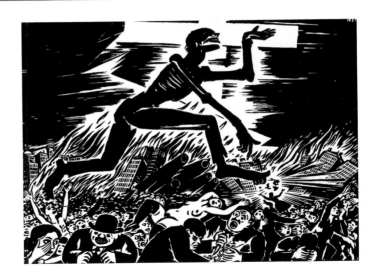

93 Frans Masereel Belgian, 1889–1972
The Prophet, 1937

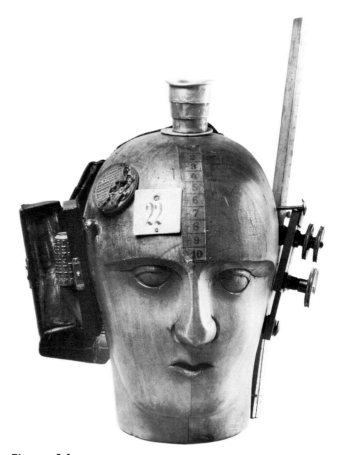

Figure 14

Raoul Hausmann (French, b. Austria, 1886–1971), *The Spirit of Our Time (Mechanical Object),* 1919–20, assemblage of wood head and found objects. Musée National d'Art Moderne, Paris

Yet even Dadaists were touched with utopian idealism inasmuch as their attacks on institutions and systems implied belief in something better. Dada destructiveness was meant as a stage in the quest for complete freedom from cultural indoctrination, in order to liberate stifled human values. Subsequent dystopians share this dualism: their criticism is often underlaid by a belief that there *can* be something better. The Dada ideal was absolute freedom of thought and action, but Dada offered no true alternative to existing cultural values. The concept of the transformation of man got lost in the process of destruction, and only nihilism remained.

When the German revolution broke out after World War I, George Grosz (1893–1959), a leading Berlin Dadaist, was caught up in the dream of a dawning new society and the brotherhood of man. He joined the Communist party and espoused a utopian style. As an expression of his political commitment, he turned to painting in a Constructivist representational style in 1920. He effaced all individuality from the figures as a tribute to the anonymous collective citizen, as in *Untitled* (94). He used a rubber stamp to sign these works: *Grosz-constructivist.* Grosz explained these works in typical utopian terms: "Man is represented no longer individually . . . but as a collectivist, almost mechanical concept. The fate of the individual is no longer important."[268] However, he was fundamentally an individualist, and his subliminal feelings transformed this painting into a quiet nightmare. The regular rectangular geometry of the architecture is hard, coldly impersonal, empty, even darkly menacing. The precisely constructed geometric figure has become a stereotype, truncated, without hands or expression; its torso is firmly rooted in a cube, unable to move. The New Man does not offer hope for the future; rather, the featureless head conveys the soullessness of an automaton.

The theme of the human-as-machine or machine-as-human recurs in dystopian literature and art. Though the concept of automatons has existed for centuries, Karel Căpek's drama *R.U.R.* (1921) introduced the word and image of the robot as symbol of technology run amok. In this play, Rossum's Universal Robots were manufactured to relieve men of onerous labor and to improve production efficiency, raising quality and quantity while lowering prices all over the world. Instead, people used robots for selfish and destructive purposes, remaining indifferent to the growing dangers until it was too late for humanity. Căpek's characters finally realize that scientific progress should have moved more slowly and responsibly:

Good Lord, we just rode along on this avalanche of demand and kept chattering . . . about engineering, the social problem, about progress, about lots of interesting things. As if that kind of gossip would somehow guide us aright in our rolling course. . . . History is not made by great dreams but by the petty needs of all honest . . . and self-seeking folk, that is, of everybody in general.[269]

Heinrich Hoerle (1895–1936) was one of the co-founders of the Progressive Artists Group in Cologne. Espousing left-wing revolutionary causes, this group was essentially utopian in nature: it sought a classless, rulerless society and, familiar with the theories of Suprematism and De Stijl, pursued as its ultimate goal a more vigorous revolution of society. However, while his colleagues Franz Seiwert and Gerdt Arntz attempted to portray social conditions in the coming collectivist society, in a stylized pictorial language of elemental geometric shapes, Hoerle was concerned with the personal aspects and the psychological effects of the world he saw evolving around him. *Mechanical Men* (95) expresses the physical and psychological alienation of those who live and work in the machine age. The mannikinlike figures (derived from the *pittura metaphysica* of Carrà and de Chirico) stand in regimented formation, their torsos schematized, hardened, and polished like metal casings, their faces devoid of expression and the warmth of human flesh. The limbs of these mutants have metamorphosed into appendages that are frighteningly less than human. These half-human, half-mechanized figures act as a metaphor for the industrial factory workers enslaved by the machines they handle, dominated by the exigencies of the machine age. Archetypes of depersonalized modern man, Hoerle's and Grosz's paintings are early images of robot men existing in the cold, modern environment. Instead of exalting the new world of industry and geometry, their pictures reveal its cold emptiness, with the individual frozen in a quiet nightmare of isolation.

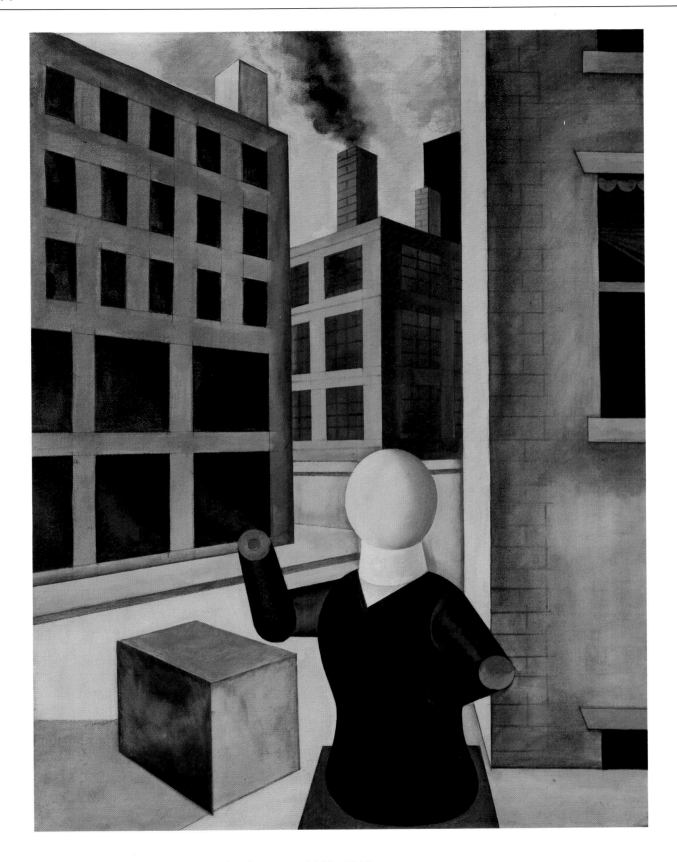

94 George Grosz American, b. Germany, 1893–1959
Untitled, 1920

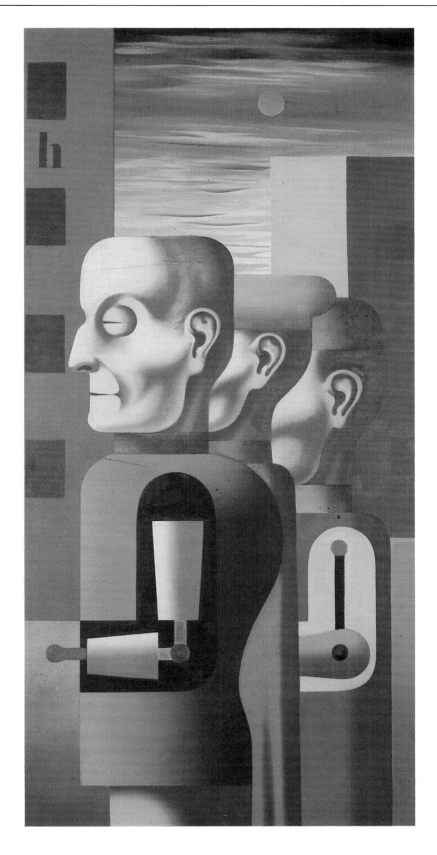

95 **Heinrich Hoerle** German, 1895–1936
Mechanical Men, 1930

Grosz soon abandoned his Constructivist style and firmly rejected the utopian theories of abstraction: "You pretend to create for man—where is man? What else is . . . your abstract muttering of timelessness, but a ridiculous, useless speculation on eternity."[270] Moreover, he never entirely believed in the inherent goodness of man. As early as 1922, he said, "Man is not good, but a beast."[271]

Grosz had espoused Communism because he hated the authoritarianism and militarism of the German government. After the mid-1920s, he realized that the Communist party was beginning to exhibit similar characteristics, and he grew disillusioned, rejecting Communism, along with the underlying desire for an industrial society dominated by the machine. "Finally my doubts became so strong, I had to quit," he wrote, "I just faded out."[272] By 1930–31, he was filled with despair for the future of society: "Perhaps what lies ahead of us is the new Middle Ages. . . . At least to me humanist ideas seem to be dying out . . . human rights are no longer greatly valued. Rather it would appear that hand in hand with the progress of civilization goes a sound contempt for human life."[273]

With Hitler's rise to power, Grosz immigrated to the United States in 1933. His disillusionment was complete: "The horrible, so-called scientific communism has made me what I am today—a scornful sceptic."[274] He confessed to "unbelief in any form of progress. . . . I have no more illusions."[275] His paintings from the late 1930s and 1940s depict a devastated world, populated by lost souls wandering without hope. He tried to create beauty, "but every time the beautiful world collapses into rubble and horrifying human ruins,"[276] as in *The Pit* (96). Grosz's largest painting, *The Pit* is a fantastic vision of a nightmare world. From the burning city in the pit, evil swarms up in the form of thousands of rats. The scene includes symbols of a world gone mad: a fanatic manipulates puppets, bodies hang from the gallows, a figure rots in prison while overhead hover allegorical figures of war and death. It is a world without scale, restless and complicated, utterly without focus or reason.

Grosz's stickman figure emerges in works immedi-

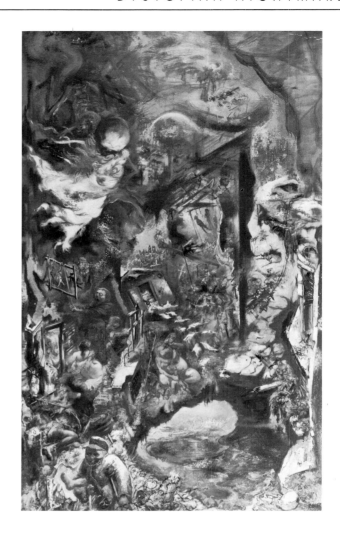

96 George Grosz
The Pit, 1946

ately after World War II. Bristling with rage, severely emaciated, this fanatic of the modern era inhabits a gray, colorless country wreathed in barbed wire. In *Enemy of the Rainbow* (97), a stick-soldier has slashed a rainbow canvas as he guards a desolate concentration camp surrounded by tall wire fences. The prismatic hues of the rainbow, symbolic of human hopes, ideals, beauty, and happiness, are outlawed in this imaginary country, destroyed by the stickman's cruel hate.

While anti-utopianism was most marked in German art, the stock market crash of 1929 and the resultant depression had a profound psychological and sociological impact on Americans. A confident, self-reliant, progressive nation suddenly had to face unprece-

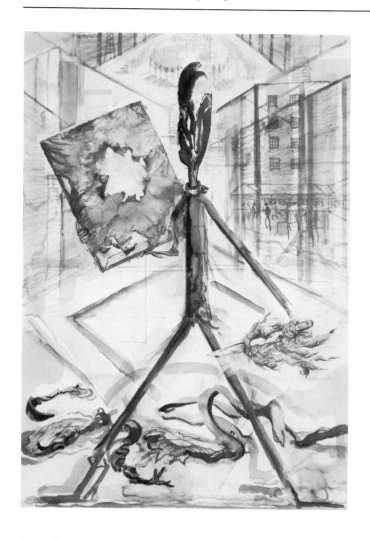

97 George Grosz
Enemy of the Rainbow, 1946–48

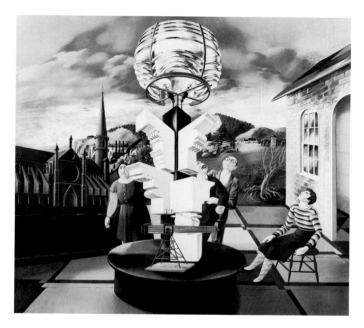

98 Peter Blume American, b. Russia 1906
Light of the World, 1932

dented doubts and questions. Social Realists, Region-alists, and others tried to re-establish a sense of human values founded not on remote idealities but on the real nature of mankind. While few works are overtly dystopian, Peter Blume's *Light of the World* (98) expresses the suspicious and mixed emotions emerging even in technocratic America concerning the burgeoning intrusion of machines into traditional ways of life. Four figures stare worriedly up at an elabo-rate electrical light terminal. Set in the context of hometown U.S.A., the crystalline beacon, raised on a pedestal like a religious icon or artwork, symbol-izes modern technology. On the right, a family farm represents traditional values of work and agrarian economics, while the Gothic church stands for reli-

gious beliefs based on faith rather than reason. The phrase used as the painting's title has always referred to Christ, but here has been transferred to a product of scientific engineering. As the Futurists and other utopians wished, science has supplanted older spiri-tual values as the pre-eminent focus of interest and awe, even worship in the new era. The machine age, however, brought some bad along with the good, as one writer noted in 1930: "We know that from the machine's need to expand has grown our ideology of persuasion, our hideous myths of progress as an external matter: that man's life is becoming more and more the pitiful rationale of the machine."[277]

POST—WORLD WAR II

The effects of the events of the 1930s and of World War II on international aesthetics were profound and took many forms, though often not obvious or even conscious responses to the atrocities and political events of history. After the war, the intellectual and artistic climate was substantially altered. The prevailing socialist, Communist, and utopian ideologies and the styles identified with them—principally geometric abstraction—had lost credibility. The aesthetics of the 1920s appeared as woefully inadequate schemas that did not account for man's whole nature and behavior. The events of history in the 1930s and 1940s made the irrational, emotional, and evil aspects of mankind so evident that they could no longer be considered as mere trifles to be overcome.

In Europe and America after World War II, artists in growing numbers rejected the formulaic dogmas of Neoplasticism, Constructivism, and the Bauhaus. The after effects of the war—the cold war, McCarthyism, the threat of nuclear holocaust—made the cosmic constructs and rational conceptions of man and society seem irrelevant, unrealistic, even dangerous. Many artists turned to vehemently expressive styles of abstraction and representation. There was a need to acknowledge the individualistic, the emotional, the irrational factors inherent in human nature. Many postwar works of art concern feelings of anxiety, despair, uncertainty, and pessimism. The utopian conception of man's perfectibility and rational nature was replaced by a tragic view of life. Some expressed total cynicism, while others consciously or unconsciously asserted anti-utopian attitudes.

Postwar gestural abstraction rejected all vocabulary connoting the machine-made object. The cool, clean look was supplanted by distasteful, messy materials—the heavy pigments of Dubuffet and the corroded surfaces of welded metal sculptures. American Abstract Expressionists and European gestural painters embraced the personal, the subjective, the irrational, the tragic. Like the earlier Surrealists, the Abstract Expressionists sought refuge from the ravages of systemic destruction in the private realm of the emotions and the subconscious. Motivated by humanist concerns, though without explicit dystopianism, they

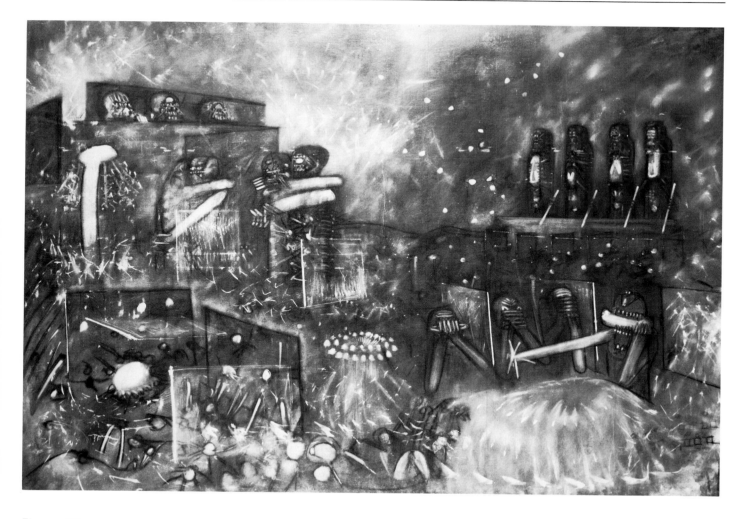

Figure 15

Matta (Chilean, b. 1912), *Dream No More of Escape,*
1953, oil on canvas. Collection of the artist, Paris

promoted values opposed to utopian geometric abstraction and its myths.

In the early 1950s, many artists like Francis Bacon, Asger Jorn, Graham Sutherland, Antonio Saura, and others created desolate images of haunting, semihuman monsters—iconographic indications of a pervasive angst. In *Dream No More of Escape* (fig. 15), the Surrealist Matta depicted screaming robotlike figures, with hands convulsed, at the mercy of their rectilinear environment, filled with glass labyrinths and torturous gadgets, a cosmic world that has been compartmentalized, bristling with horror. Such images break with, if not consciously deny, the affirmative utopian styles of pre—World War II in a spirit of revulsed negation resulting from wartime horrors. Un-

like the flood of utopian hopes that arose after the devastation of the First World War, the second evoked the opposite reaction. Gestural abstraction, Art Brut, the CoBrA group, l'art informel, tachisme, and many independent artists created new styles whose iconography and techniques express the spiritual condition of an epoch, not only their own personal angst. There was a widespread need to create a new picture of human and social reality, bringing into balance the ideal with the grotesque. Personal anxieties joined forces with fear about the present and future of society. The postwar styles were thus not simply self-revelatory, but portraiture of mankind in general. Artists stressed the sufferings, the breakable quality, the helplessness in the face of uncontrol-

lable forces, as well as the ability to wreak horrible actions. Though postwar artists in Europe and America did not generally create art directly based on the war, their work reflects the emotional and intellectual responses of a generation aghast at the enormity of real events.

One notable attempt was made to bring postwar art into contact with historical events and to acknowledge the changed consciousness of the times: the international sculpture competition in 1951–53 for a proposed *Monument to the Unknown Political Prisoner*. The subject cogently modifies the earlier tradition of the tomb of the unknown soldier (which had been widespread in the wake of the First World War) into recognition of the new victim of our totalitarian era. The organizers at the Institute of Contemporary Art in London chose the theme because they desired "to commemorate all those unknown men and women who in our time have been deprived of their lives or their liberty in the cause of human freedom."[278] Herbert Read noted that this monument offered "an opportunity . . . to free our age from the accusation of moral and aesthetic indifference."[279] Each nation held exhibitions and selected entries for the international show in London. Of the thirty-five hundred entries, however, only a few showed that modern art could express the suffering of the new dystopian societies. The monument, intended to be erected in several countries, including the south of England and West Berlin, was never executed.

The winning entry by Reg Butler (b. 1913) depicts three women and an abstract skeletal tower (99). Originally, there was a figure of a prisoner, but the artist replaced him with the women in whose memories the victim is remembered. One woman stands alone, with two others to one side, recalling Mary and her companions standing at the foot of Christ's cross and again outside his tomb (though this similarity apparently was not deliberate on the artist's part). The tower form suggests a number of associations, such as a cage, a gallows, a guillotine, or the watch tower of a prison camp. Butler has said that although his concept was to place a figure "in relation to a harmful metal structure not unlike an instrument of torture,"[280] he did not learn until later from survivors

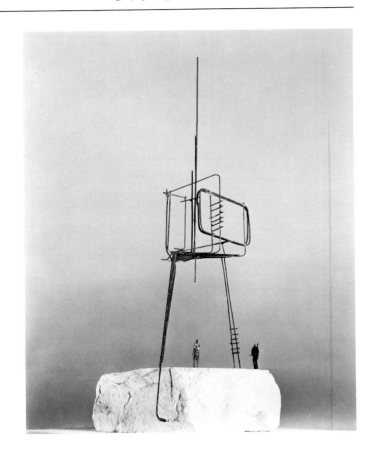

99 Reg Butler British, b. 1913
Monument to the Unknown Political Prisoner,
1951–53

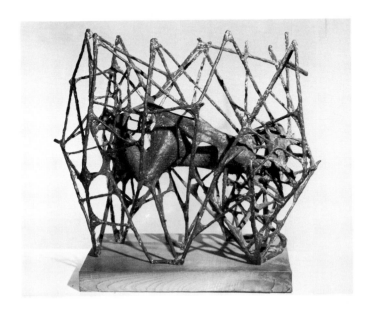

100 Luciano Minguzzi Italian, b. 1911
Monument to the Unknown Political Prisoner: Figure within Barbed Wire, 1952

of Buchenwald of the striking similarity between his sculptural form and the watch towers of the concentration camps. Butler's composition conveys the forced enclosure and torment of a human being and the triumph of his moral and spiritual strength over imprisonment and death. The steeply projecting rise of the linear forms also suggests the rise of freedom of thought, despite physical constraints.

For his entry, Luciano Minguzzi (b. 1911) depicted a recumbent figure helpless within the meshed confines of barbed wire (100). His aim was "to render homage to the prisoners who have suffered in all concentration camps."[281] Theodore Roszak (1907–81) wrote of his entry:

I was strongly motivated by the moral and social values implicit in the subject. . . . I envisioned the individual as politically committed either by accident or design against tyranny and oppression. While we have history to attest to the endless forms of human incarceration as a reward for "sinning" against the state, we have, nevertheless, witnessed the slow and hard won gains of those beliefs that have been sustained. . . . This clearly indicates to me not only the vindication of an individual morality, but the force with which ideas break through, however belatedly, and triumphantly assert themselves on society as a whole.[282]

With World War II, Roszak had grown disenchanted with his Constructivist aesthetics and in 1945 changed his style completely. He rejected the machine aesthetic and utopian visions as inappropriate to the spirit of the times, as well as false and limited. He became aware of Constructivism's "denial of a large area of human experience," and he recognized that its tenets were "largely motivated by the power principle,"[283] which he now considered pernicious. He said in 1952, "If the Constructivist sculptor chooses to pay homage to a technological duty, he does so at the risk of compromising the fullness of his vision and at the peril of surrendering man's spirit to a brittle and fragmentary existence."[284]

He consciously dropped the vocabulary of Constructivism because of its outlook and developed a roughly textured, darkly colored style of sculpture that gives anxiety shape. He wanted to express human experience and so turned to organic forms intended as visual metaphors of strife and subconscious emotions of despair and violence. Drawn from the biomorphic vocabulary of Surrealism, Roszak's menacing forms constitute a style that he described as:

an almost complete reversal of ideas and feelings from my earlier work. Instead of looking at densely populated man-made cities, it now contemplates the clearing. Instead of sharp and confident edges, its lines and shapes are now gnarled. . . . Instead of serving up slick chromism, its surfaces are scorched and coarsely pitted.[285]

Roszak believed that "the modern artist, acutely aware of the human predicament . . . mirrors the eternal spirit of man, despite technocracy's chronic indifference to his intuitive life, and [he] wars against the current reduction of man's personality to a docile and convenient cipher."[286] He hoped that by confronting the grim, even gruesome, aspects of human nature, mankind may overcome its compulsion toward destruction.

In the late 1940s and the 1950s, Roszak turned to mythic themes for subjects to express his angst and concern for human sensibility. The end of the war had prompted an outbreak of symbolic iconography, as if the horror of it all could only be expressed allegorically. A number of artists in the decade after Hiroshima revived some of the myths of classical culture that express the unchanging drives and repeated errors of humanity. Myriad images appeared depicting the fall of Icarus, the wrathful Furies, Prometheus, Odysseus, and similar subjects associated with the fall and suffering of man. In *The Furies* (101), Roszak depicted the classical agents of retribution (even the gods were subject to them) who secured vengeance for those who have died by violence. *Skylark* (102) represents Icarus, the winged man of classical mythology who flew too close to the sun, here falling in flames to his death. Inspired by a poem about the "chained skylark," Roszak felt that this piece "reflects the plight of man descended from his Promethean heights, caught within the bonds of civilization, and reduced to the ashes of his own bones."[287]

By the 1950s, a new image of man came to the fore in art, radically different from the utopian image of the rational being always objective and in control.

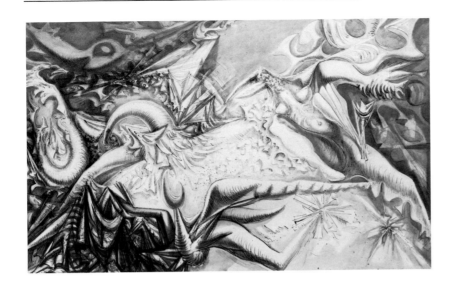

101 **Theodore Roszak**
Study for the Furies, 1950

102 **Theodore Roszak**
Skylark, 1950–51

103 **Leonard Baskin** American, b. 1922
Hydrogen Man, 1954

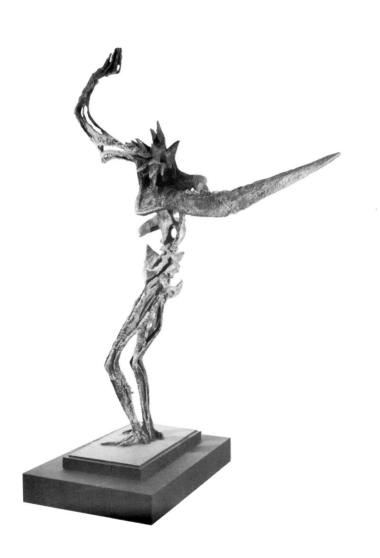

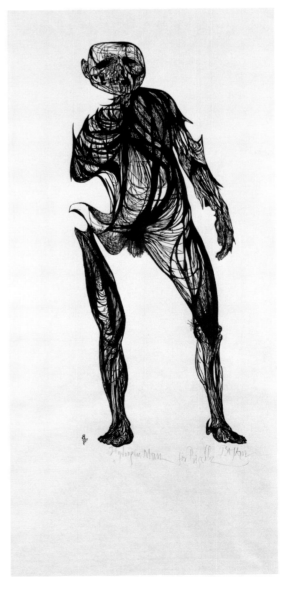

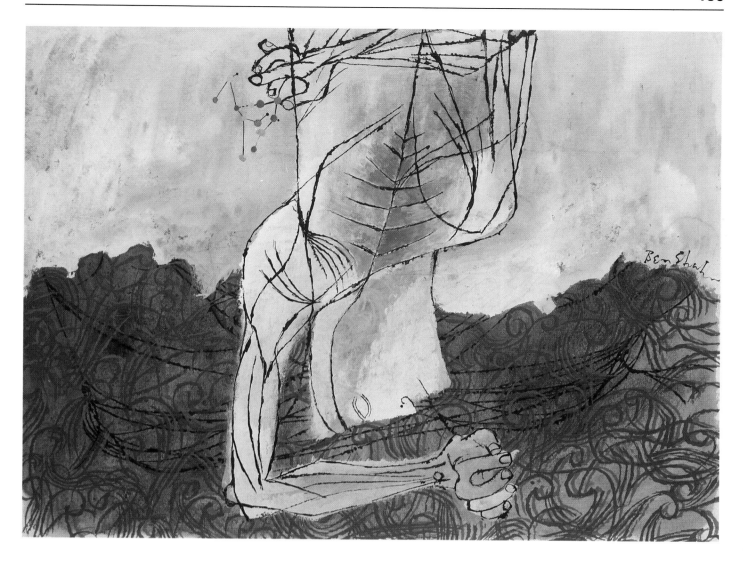

104 Ben Shahn
The Fall, 1957

Artists turned to depicting man as being destroyed by his environment and himself. A recurrent image in the 1950s and '60s was the theme of the fallen or destroyed man, the victim of his social context and circumstances. These are often dark visions in which the last vestiges of optimism are forsaken. At the end of the decade this tendency was so widespread that it was recognized as a significant development. In the exhibition *New Images of Man* (1959) at New York's Museum of Modern Art, works by many different artists were assembled—but not as a school or group or even a conscious movement. The artists were simply "individuals affirming their personal identity . . . in a time of stereotypes and standardization."[288] *New Images of Man* was significant because it forthrightly identified the pessimistic turn that art had taken since the end of World War II. Curator Peter Selz and theologian Paul Tillich noted that despite the widely different styles of the artists in the exhibition, who ranged from Bacon and Baskin to Roszak and Paolozzi, they shared a humanistic sensibility. As Tillich asked in the exhibition's catalog, "When in abstract or non-objective paintings and sculpture, the figure disappears completely . . . what has happened to man?"[289]

Leonard Baskin (b. 1922) created a number of works in the early 1950s depicting fallen or victimized men. In addition to the classical theme of Icarus

and generalized images like *Tormented Man,* he addressed the specific issue of atomic warfare in *Hydrogen Man* (103). Using a single image without environment, Baskin devastates the utopian concepts of the New Man, reason, and international cooperation. Flayed alive, the life-size *Hydrogen Man* confronts the viewer with a specter of himself, a stark, apocalyptic warning to all humanity, a dark portent of the possible future of warring mankind. Baskin's entire career has been devoted to a humanistic social and ethical philosophy. Like his friend Ben Shahn, Baskin vigorously opposes abstraction and believes figurative art should focus on the dilemmas and reactions of people in a hostile social environment. His graphics illustrate the life-negating forces that dominate modern life: war, including the threat of nuclear destruction, persecution, and personal angst. Baskin has described himself as a "moral realist" concerned with the human condition through figurative art:

The human figure is the image of all man and of one man. . . . In our time that image is despoiled and debauched. . . . Man has been incapable of love, wanting in charity and despairing of hope. He has not molded a life of abundance and peace, and he has charred the earth and befouled the heavens more wantonly than ever before. He has made of Eden a landscape of death. In this garden I dwell, and in limning the horror, the degradation and filth, I hold the cracked mirror up to man.[290]

Known primarily for his Social Realism of the 1930s, Ben Shahn (1898–1969) moved away from specific political concerns after World War II toward broader statements concerning societal ills and man's inhumanity to man, often using symbolism and allegory. In 1949 he wrote: "I believe that there is, at this point in history, a desperate need for a resurgence of humanism, a reawakening of values. I believe that art . . . can play a significant part in the reaffirming of man."[291] He later recounted how his philosophy changed from political to humanist concerns: "I was not the only artist who had been entranced by the social dream, and who could no longer reconcile that view with . . . art. . . . The change . . . was accomplished during World War II. . . . Theories melted before such experience."[292]

A theme of major interest to Shahn was that of the paradox of modern science: it elevates man yet may be his downfall as well, as seen in *The Fall* (104). Recalling the classical subject of Icarus, this figure, fallen from the heights, is identified as a scientist by the helix he holds in one hand. Shahn described this subject as the "intensity of delving into science in its purity and the possible painful and contradictory results—the abuse and thwarting of the original goals. . . . The paradox of man's goals."[293]

A recurrent image in Shahn's work is the firebeast, which he borrowed from an ancient legend to symbolize chaos. Shahn felt that some chaos is necessary for a fully experienced life, though too much wreaks disaster:

I love Chaos; it is the mysterious, unknown road. It's the unexpected, the way out; it is freedom; it is man's only hope. It is the poetic element in a dull and ordered world. . . . I am certainly not condemning order as such. . . . I don't propose to release Chaos and just turn her loose upon the human race—we still must have banks and plane schedules. But I think it would be nice if we . . . let her go free from time to time to . . . romp around a little among the Planned Society.[294]

In the *Lucky Dragon* series of 1960–61 (105), however, the firebeast symbolizes the atomic bomb. The eleven paintings in this series were inspired by illustrations Shahn did for an article in *Harper's* magazine in 1957–58 describing the catastrophe that befell the Japanese fishing boat *Lucky Dragon* in 1954. Trawling eighty-five miles from Bikini atoll, where the United States was testing its new H-bombs, the boat was covered with radioactive ashes. Not realizing the danger, the fishermen did not understand why they became ill. Though all but one of the twenty-five men recovered, they were sterile for life. Shahn depicted the terror and helplessness of these men, indeed of all humanity, in the face of such powerful destruction. The figures raise their hands in supplication to the monster of death and disaster, as the artist questions the morality and justice of unrelenting scientific development. Shahn was not simplistically negative in his attitude toward modern technology; on the contrary, he esteemed science. He believed, however, that human values supersede all others:

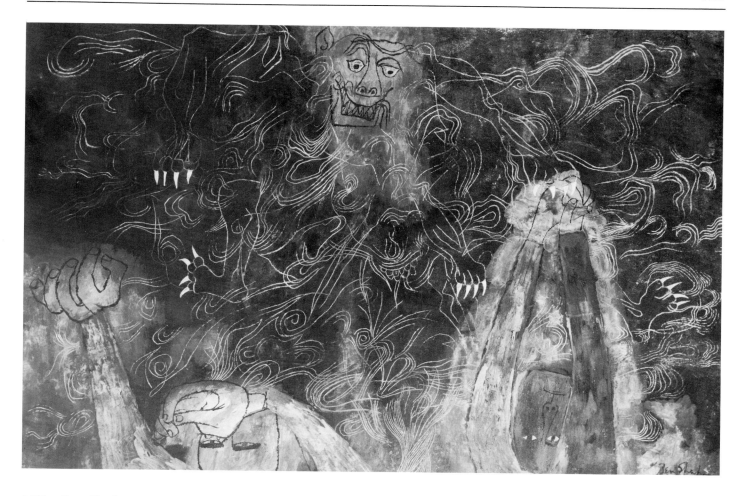

105 Ben Shahn

Lucky Dragon: We Did Not Know What Happened to Us, 1960

I have no quarrel with scientific skepticism as an attitude. I am sure that it provides a healthy antidote to fanaticism of all kinds, probably including the totalitarian kind. But as a philosophy or a way of life it is only negative. It is suspicious of belief. It negates positive values. . . . Society cannot grow on negatives. If man has lost his Jehovah, his Buddha, his Holy Family, he must have new . . . beliefs, to which he may attach his affections. Perhaps Humanism and Individualism are the logical heirs to our earlier, more mystical beliefs.[295]

Another artist who had worked in a Social Realist mode in the 1930s and 1940s and moved to more universal statements in the 1950s and 1960s was Joseph Hirsch (1910–81). After reportorial work in the Second World War, he turned to more open-ended interpretations of the world he saw developing around him. Whereas Grosz, Roszak, and Shahn used symbolic images, Hirsch adhered to a more narrative style so as to be easily understood by a general audience. Like the work of Shahn, Hirsch's work in the 1950s and '60s differed from the social commentary of the 1930s and '40s in that he avoided specific topical subjects for more universal commentary on the human condition.

Hirsch often depicted the modern individual in ambiguous situations, tinged with a sense of oppression (political and otherwise), isolation, or injustice. *The Watcher* (106) shows an anonymous man in a narrow opening in a wall. His eyes and hand, those parts of the body used for effective personal expression, are half hidden in the dark and tightly circumscribed by the bars, deliberately suggesting, as the artist once stated, that the figure is a prisoner. In *The Room* (107), Hirsch used ambiguity to create a sense of

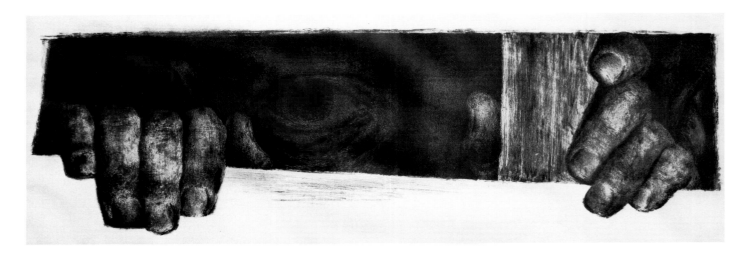

106 Joseph Hirsch American, 1910–81
The Watcher, 1950

107 Joseph Hirsch
The Room, 1958

disquiet. Though the painting seems to depict the interrogation of a prisoner, the inconclusive title and the inaction in the image leave the viewer without a clear indication of which political regime is responsible for the bloodied head of this anonymous prisoner—it could be anyone, anywhere. This oblique interpretation of a seemingly real event transforms both *The Watcher* and *The Room* into frightening scenes of social injustice, indictments of what have become commonplace events.

Like Shahn, Baskin, and Hirsch, George Tooker (American, b. 1920) was politically active in his youth, proselytizing for social change in the late 1930s. After briefly being involved with radical leftist causes, he found doctrinaire political ideas inadequate and turned to art as a means for effecting changes in attitudes. By the 1950s, Tooker had developed an elegant style of realism that he uses to depict metaphorically the conditions of modern society. Of particular concern to him is the fate of the individual in mass civilization, a theme that emerged with force in the 1950s, often appearing in satirical cartoons, like those of Herblock. Saul Steinberg's (b. 1914) *Passport Photos* (108) ironically comments on the loss of individual identity in mass society. The use of fingerprints to depict identical figures alludes to the

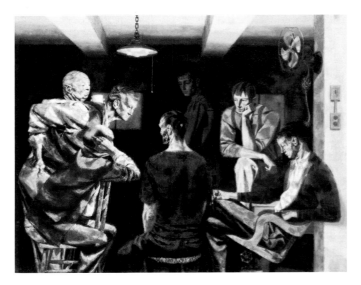

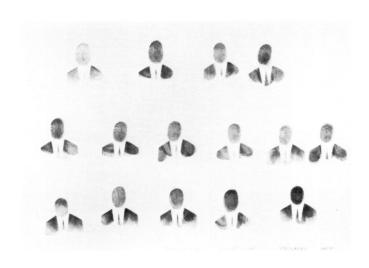

108 Saul Steinberg American, b. Rumania 1914
Passport Photos, 1955

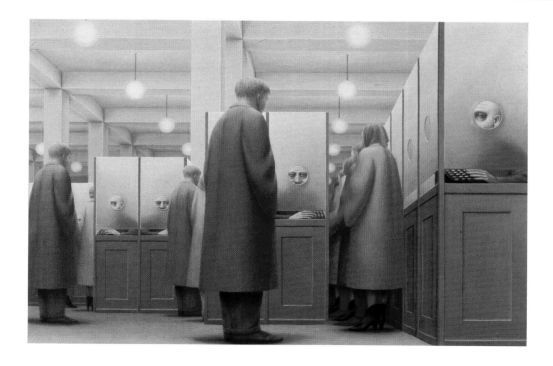

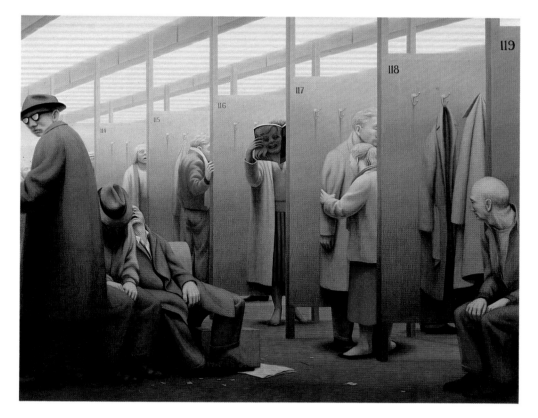

109 **George Tooker** American, b. 1920
Government Bureau, 1956

110 **George Tooker**
The Waiting Room, 1959

prevalent use of fingerprints as the means for government authorities to process, identify, document, and thereby control their citizens.

In paintings executed in the 1950s and 1960s, notably *Government Bureau* (1956), *The Waiting Room* (1959), and *Landscape with Figures* (1965–66), Tooker addressed the nature of the human condition in an urban environment. *Government Bureau* (109) depicts the dull feeling, the resigned turpitude, the sense of being an anonymous cipher in a crowd of equally indistinguishable people—in short, the psychological effects of dealing with the dreary bureaucracy of all modern governments, especially in the so-called advanced welfare states. In similar fashion, *The Waiting Room* (110) conveys the portentious terror of ordinary people being processed in an anonymous human assembly line that functions beyond the control or understanding of those involved. In both paintings, each figure appears to be literally the same person, repeated without end, as in *Brave New World* where the citizens are produced in identical batches of dozens or even hundreds. In both pictures, the people wait dully for commands from unseen authority. In *The Waiting Room,* the reason for all these people to wait is unclear—is it for some punishment or merely routine? There is no activity, no sound, no movement—only blank, empty existence.

In *The Waiting Room, Government Bureau,* and *Landscape with Figures,* the settings are precisely, geometrically ordered. This environment creates the feeling of absolute control by an unseen power and reinforces the impression of anonymity. In *Landscape with Figures* (111), Tooker drops all semblance of a descriptive situation for a more purely metaphorical composition. The individual figures are trapped within their private cells. Absolute rectilinear geometry prescribes their environment, separating each person from the others. Tooker powerfully suggests the all-embracing physical, emotional, and psychic isolation created by anonymous urban architecture and rigid social structures. The beauty of the geometry recalls the aspirations of the utopian artists of the early twentieth century; it clarifies, orders, and controls. But Tooker makes it quite clear that excessive order leads to overcontrol, ultimately stifling the human element. And despite the clear regularity of the settings, the

viewer also senses their mazelike entrapment. Thus, the architecture contributes to the numbing sense of unending sameness, creating a truly Kafkaesque vision. The effect of Tooker's paintings is amplified by his use of a sharply focused style and delicate hues. The atmosphere of *Government Bureau,* for example, is conveyed by the overall grayness, while the psychological dread of *Landscape with Figures* is furthered by the use of a shrill orange tonality.

In the 1960s, more artists consciously turned to art that conveys the social texture of modern times in all its grimness. The decade was characterized by activism of all kinds, inspired by a new surge of idealism after the quiet fifties. While some of the new generation embraced modified forms of utopianism, most were more concerned with combating perceived evils in society. Increasing numbers of artists turned to figuration, some concerning themselves with specific political causes, while others used subjects from history to provoke awareness of potential nightmares for the future.

The similarity of real events to anti-utopian fiction has lent additional credence to the warnings of Huxley, Orwell, and others. Dutch artist Jaap Mooy (b. 1915) equated Senator Joseph McCarthy with Orwell's nightmare in *Big Brother Is Watching You*

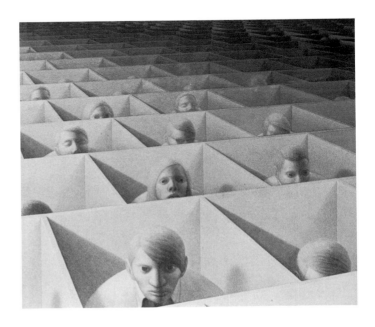

111 **George Tooker**
Landscape with Figures, 1965–66

(112). Executed a decade after McCarthy's witch hunt, this photomontage asserts the continued topicality of the problem. As the artist observed, "There are faces which can never be forgotten, because they have become symbols for what has influenced our lives so much."[296] Mooy uses illustrations from magazines in such a way as to transcend specifics to create timeless meanings. In *Think, Think, Think* (113), he combined photographs of POWs with other elements:

I added the giant brain (Big Brother again), plus the blueprint for the planned deprivation of freedom and of murder. I cut off the legs, so that no, or very little freedom of movement was left. I cut off the heads, since thinking is superfluous for such cadavers. The dehumanization is in full swing. To look at pictures in magazines in our times is often a gruesome task. "Think-think-think" when you look at them![297]

An expression of dystopian revulsion of the 1960s was the appearance of destructive art. The artist best known for his self-destructing art works is Jean Tinguely. A number of his mechanical assemblages of the 1960s self-destructed in a deliberate analogy to our mechanized civilization helplessly devouring itself through its own processes. It should be remembered that in the early 1960s, before the consumer and ecological movements really got under way, relatively few people questioned the predominance of technological development. Tinguely's machines mocked viewers, sometimes in amusing, sometimes in disturbing, ways. In 1961 he created the large mechanical sculpture called *Study for an End of the World (Dynamic Autodestructive Aggressive Monster Sculpture)*, which blew up and burned into rubble in front of an audience in Copenhagen. A second one (fig. 16) was created and destroyed in a Nevada desert, not far from nuclear testing sites, in order to make the message abundantly clear.

The international political events of the 1960s acted upon many artists as motivation to turn to humanistic and/or politically engaged art. The proliferation of nuclear weapons, the Cuban missile crisis, the assassinations of liberal leaders like the Kennedys and Martin Luther King, the escalating war in Vietnam, the rise in urban crime, the decay of the inner cities as the middle class fled to the suburbs, the race riots,

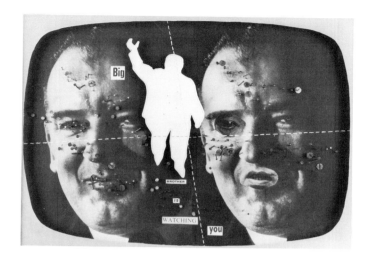

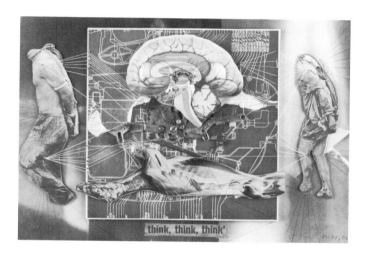

112 Jaap Mooy Dutch, b. 1915
Big Brother Is Watching You (McCarthy), 1963

113 Jaap Mooy
Think, Think, Think, 1963

the invasion of Czechoslovakia, the rise of international terrorism, and many other tumultuous events profoundly altered the general complacency of the 1950s. The global scale of political events and the ever-present awareness of the threat of nuclear holocaust produced a pervasive and powerful sense of the impotence of the individual. Many films presented, in truly frightening images, the ways in which nuclear war could erupt and what its aftermath might be, while other films suggested other possible means of destruction through the irresponsible development and use of supertechnology. There was a morbid fascina-

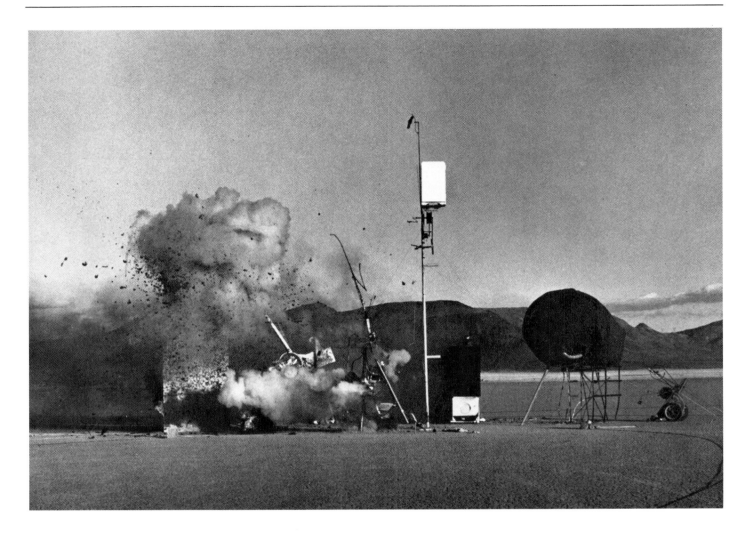

Figure 16

Jean Tinguely (Swiss, b. 1925), *Study for the End of the World No. 2,* 1962; destroyed

tion with the future as disaster, as Edward Kienholz suggests in *The Future as an Afterthought,* 1962 (fig. 17).

In Europe in the late 1960s and '70s, there were a number of exhibitions acknowledging and promoting "involved" or "engaged" art.[298] Though many of the exhibited art works were overtly political and even propagandistic, it became apparent that there were also many artists concerned with broader social concerns. Not linked by fixed ideology, hundreds of individual artists in Europe and increasingly in the United States believed that art should be socially activated.

In Spain, political turmoil characterized the 1960s.

After nearly thirty years of Franco's dictatorial rule, the populace was hungry for tolerance and political and individual liberties. Artists like Juan Genovés, Rafael Canogar, and Anzo created images of individuals at the mercy of powerful societal forces. This second wave of postwar artists moved beyond the gestural abstraction of the immediate postwar artists to realistic images criticizing political and social injustices. While their inspiration came from events and tensions in Spain, their art transcends specific times and places and so applies with equal relevance to the human condition internationally.

Genovés (b. 1930) depicts crowd scenes in which fleeing, frightened people, pitifully anonymous, are

at the mercy of equally anonymous powers, both judicial-political and military (114, 115). Gray and gray-brown tonalities convey the drabness of their constricted existence, much as Orwell described life in *Nineteen Eighty-four.* The people depicted have no individual identities and seem to exist only as part of the masses of unhappy citizens. The events he depicts are phenomena of large magnitude: the fate of one man is seen as the fate of many. His people are wraiths unable to escape from the psychological cemetery of insidious totalitarianism.

Apolitical in nature, the art of Anzo (José Iranzo

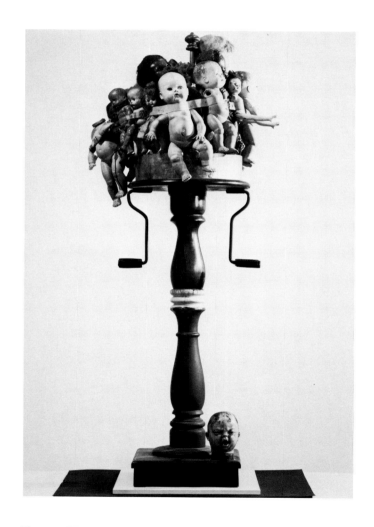

Figure 17

Edward Kienholz (American, b. 1927), *The Future as an Afterthought,* 1962, assemblage. Reinhard Onnasch Collection, Berlin, on loan to the Bayerische Staatsgemälde-sammlungen, Munich

Almonacid, b. 1931) has focused on the theme of the individual's isolation in the urban, technological environment of modern society. In a sense, his work is concerned with the *success* of the early-twentieth-century utopian dream. In *Isolation 12* (116), the lone figure is dwarfed by the scale of today's skyscrapers. The pristine environment of this well-ordered hygienic city, with gleaming rows of identical glass buildings, has eradicated all traces of nature; this city is beautiful and ordered, but so coldly impersonal as to be destructive to human individuality. It is very much like the city described by Zamyatin in *We:* "Around me, a glass desert"; "I wandered for two hours along the glass deserts of our precise, straight avenues"; "the city seemed built entirely of blue blocks of ice."[299]

The most recurrent theme in Anzo's oeuvre is the subtle control or influence of technology on human existence. In *Isolation 15* (117), the individual stands alone amid the machines of a large business office. The setting itself is not distressing, yet the final result is a sense of alienation from human warmth and companionship. Presenting a situation familiar to millions of office workers today, the artist does so not in a harshly critical way but gently, as if to ask, "Is this what we really want?"

A similar approach is used by Ernest Trova (b. 1927) in his *Falling Man* series, which projects an image of contemporary and future man in the context of modern scientific technology. A number of Trova's smaller sculptures from the 1960s interpret modern man as inextricably involved in the context of his technological environment, often pitted against the anonymous forces of industrial society. In some works he is dominated, even deformed by the technological world, as in *Nickel-Wedge Landscape* (118), where machinery engulfs the head of the man, obscuring his individual visage and overwhelming his thought processes. Similarly, in *Two-Story Plexiglas Box* (119) the complex and mysterious device applied to the figure implies a threat to his freedom and perhaps his very existence. Prostrate and vacuum-sealed, as if under laboratory conditions, the Fallen Man is prey to his shiningly pristine and advanced environment.

Trova's Falling Man is a truncated humanoid without arms, thus inhibiting his power to act, and without

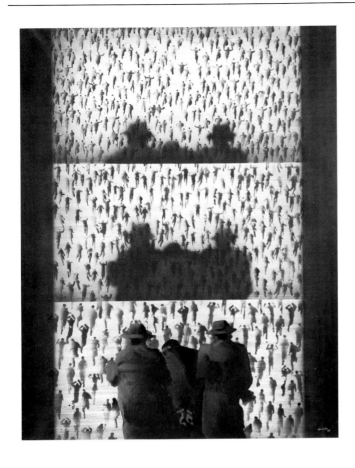

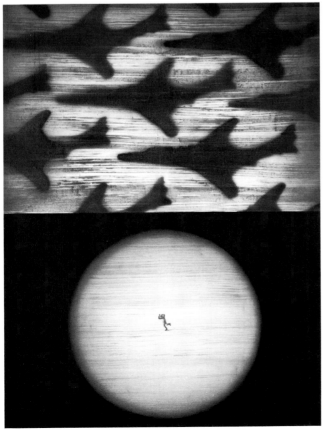

114 Juan Genovés Spanish, b. 1930
The Prisoner, 1968

115 Juan Genovés
Man, 1968

facial features, depriving him of individuality. Statically posed, *Falling Man* seems remote-controlled, lacking either the will or the ability to rebel. The generic title itself seems to denote the fallen state of humanity, rather than any physical action. In *Three-Box Landscape* (120), the clean, machined forms of the architectural environment immobilize the human figure, preventing free physical movement by strictly circumscribing or prescribing his actions. The effect is as much psychological as physical: the robotlike figure seems conditioned by the constancy of the situation.

However, the artist's outlook is not thoroughly pessimistic. In some works, man faces the circumstances of modern life with dignity and stoic strength, and in a few cases is equal to or even masters his environment. Trova has written:

The image of the figure in my works is fundamentally a graphic symbol of the "individual" . . . whose posture is neutrally-serene. . . . Placed in various . . . predicaments, placid and perilous, philosophically the Falling Man accepts and meets his environment with rational detachment and non-hysteria. . . . Being a pragmatic realist I see man, particularly certain individuals, rising above his nature, his environment, his socio-political entanglements, his time.[300]

Trova has noted that: "My man, if he's trying to tell a story at all, is saying we ought not to go berserk. The choice is between dignity and hysteria. I choose dignity."[301] The *Falling Man* works are not illustrations of a solution; they are tools of humanist survival. Trova says: "I am not a reformer . . . not part of any social or political group. My interest is man as he is now on the verge of entering the twenty-first century. My concern is in how to cope with our times."[302]

Jacob Landau (b. 1917) has long devoted his art to humanist concerns. His composite images powerfully communicate the tragedy of the individual caught in

116 Anzo (José Iranzo Almonacid) Spanish,
 b. 1931
 Isolation 12, 1967

117 Anzo
 Isolation 15, 1968

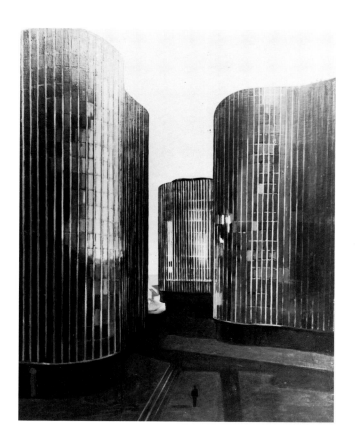

the grip of societal forces beyond his control. Most of his works deal with conflict, struggle, and violence. His pictures tell no story in the narrative sense, but depict visions of man impelled by external forces, physically and psychologically threatened by a hostile environment. His images are always compellingly active, as figures rush, fall, explode. Distrusting doctrinaire and radical politics, Landau prefers the power of art to communicate a belief system. A consciously anti-utopian artist, he believes "that the crisis of our time is a crisis of consciousness and meaning. We have failed to produce the earthly paradise. We are prisoners of our own inventions; we feel powerless and corrupted."[303]

Humanist art is essential, Landau believes, because the reawakening of humanist sensibilities is desperately needed in this dystopian age: "Without it we are an endangered and endangering species."[304] Art can stimulate individual consciousness, which is the springboard of social consciousness, says Landau: "A society that has been willing to sanction the slaughter of 75 million people in less than a century, and that prepares for even greater slaughters, is a society at the edge of history. The apocalypse we face collectively begins within each of us as we undergo private apocalypses of transformation."[305] In his many essays, Landau refuses to accept the apathy and fatalism so prevalent today. Offering art and humanism as alternatives to scientific rationalism as criteria for life, his philosophy clearly incorporates a core of utopian hope within the dystopian nightmare:

How often have we heard the word "idealist" uttered with a mixture of nostalgia and contempt? In a pragmatic world, the idealist is at best to be pitied, at worst to be scorned. The nostalgia is a remembrance of things lost, of wonder, love, hope, imagination, and the sheer possibility of it all. The scorn . . . is a function of the prevailing tendency within our technological and consumerist society to reward the acquisitive, aggressive, competitive . . . or wrathful personality traits. . . . We are drowning in the tide of side-effects and unintended consequences of narrow practicality. And the "science" side of human personality is overwhelming the "art" side. . . . The strategy of idealism [is] our only survival kit as we walk a tightrope over the abyss of social transformation. . . . When the rational scientific strategy for posing and solving problems

118 **Ernest Trova** American, b. 1927
Falling Man: Nickel-Wedge Landscape, c. 1966

119 **Ernest Trova**
Falling Man: Two-Story Plexiglas Box, 1966

120 **Ernest Trova**
Falling Man: Three-Box Landscape, 1966

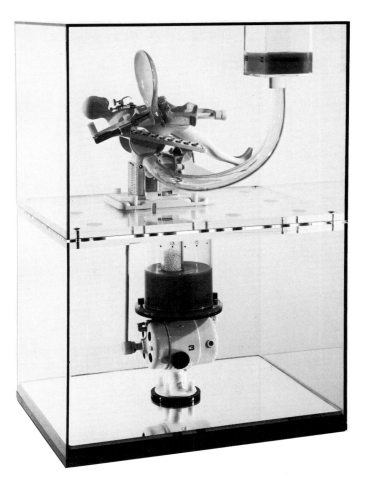

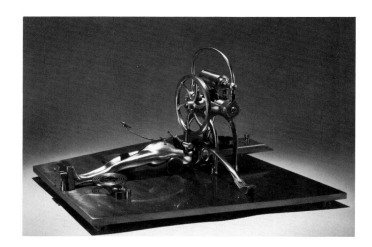

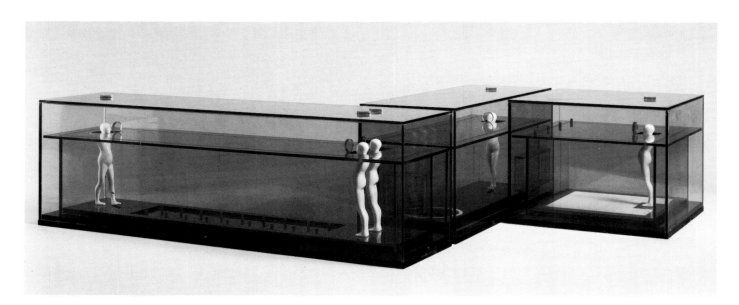

POST—WORLD WAR II 165

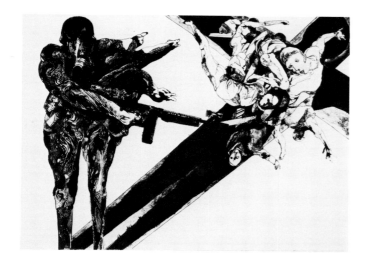

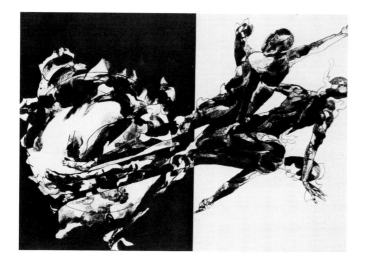

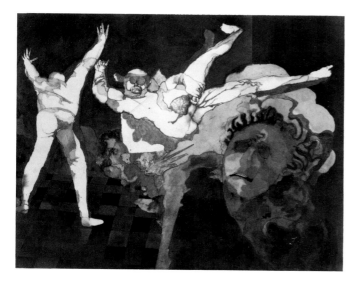

121 Jacob Landau American, b. 1917
Holocaust: The Question, 1967

122 Jacob Landau
Holocaust: Man's End, 1967

123 Jacob Landau
Great Society, 1967

itself begins to threaten our very survival, the time for
dreaming has come, and for a strategy of discovery . . .
of what may yet be.[306]

Landau, like many artists, drew upon the holocaust
for images in works produced in the 1960s, two
decades after the horrendous events. In his *Holocaust*
portfolio, *The Question* (121) depicts a figure repre-
sentative of all militants and totalitarians who domi-
nate others by violence. His victims writhe in fear and
pain against a shadowy background shaped like a
cross. In *Man's End* (122), from the same portfolio,
figures hurtle explosively from the earth, posing the
ominous question: despite all the warnings from past
errors, particularly World War II, will mankind ulti-
mately destroy itself in a nuclear holocaust?

In *Great Society* (123), Landau questions the virtues
of the social programs of the 1960s, when liberal
utopianism re-emerged. Alluding to the "Great Soci-
ety" of the Johnson years, this image contrasts human
vulnerability with powerful structures. *Urbanology
Triptych* (124) conveys the tremendous destructive
powers existing in our modern urban civilization. In
the center panel, figures hurtle through their strictly
delineated geometric environment in a paroxysm of
force. In the left panel, more contorted figures and
faces burst apart in another geometric, industrial set-
ting. In the right panel appears a terrorist scene with
bomb explosions and innocent victims.

Since the late 1960s, Nancy Grossman (b. 1940)
has explored the theme of human bondage in her art.
Expressed in physical terms, her bound and tethered
figures suggest their psychological domination by un-
seen manipulative forces; the unknown nature of these
powers suggests a more sinister evil than physical
brutality. The promethean *Figure* (125) twists in im-
passioned pain, screaming a silent cry for release
from his shackles. Faceless, stripped of individuality,

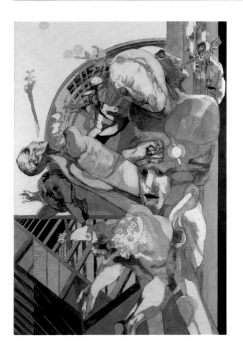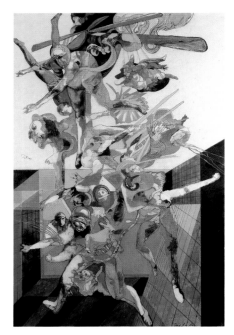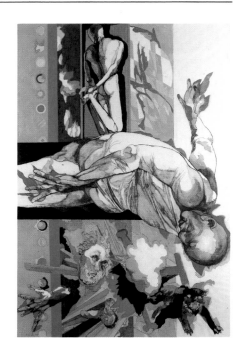

124 Jacob Landau
Urbanology Triptych, 1969

he rages and struggles against his imprisonment. The restraints are so complete, however, as to imply the near impossibility of escape despite all the man's physical strength. In *Double-Tethered Figure* (126), the strength has ebbed, revealing the delicate frailty of the human spirit. Resigned to his fate, this anonymous individual makes no effort to escape. Not protest art in the usual programmatic sense, these metaphors for the human condition communicate the horror of the peculiarly modern spiritual malignancy that corrupts and subjugates men in our century.

Like Tooker and Anzo, Gerhardt Liebmann (b. 1928) laments the anonymity of the individual within the modern urban environment. Even though that environment might be pristinely executed, as in *The City* (127), its geometric order becomes irrevocably impersonal, almost stark, as it stretches away in endless monotony. By implication, the unseen citizens of this imaginary city may well be as regularly ordered and identical as the millions of bricks depicted in this painting. Liebmann recently said of his work:

My art, on the whole, is involved with twentieth-century life; that is, the crowding with its attendant loneliness, the overbuilding with its accompanying emptiness of soul. I often use the common building brick to express these comments because the brick is of recognizable size which permits a sense of scale. . . . The horror we create is of a huge magnitude . . . and has been patiently reared. Man seems to delight—certainly, in America—in laboriously creating his frightening environment. Although such a process gives man a lengthy time to reflect on (and so to repair) his creation, he seems not to take advantage of that time. . . . Perhaps if an artist shows man the ultimate horror of it all, he might, hopefully, fight back. The economics of . . . city development are such that man, unlike in past ages, is growingly unable to express his individuality. That, to me, is the ultimate horror.[307]

In the mid-1970s Liebmann executed a series of drawings and paintings of dolls lined up in rows extending endlessly. In *America, Monday, October 22, 1973* (128), the repetitive uniformity of the dolls makes their mindless, puppetlike nature self-evident as they march to their doom.

A similar preoccupation with anonymity in modern mass society animates the art of German artist Thomas Bayrle (b. 1937). Bayrle has written: "The basic theme in all my pictures and graphic work is mass society and its organizational forms. The masses

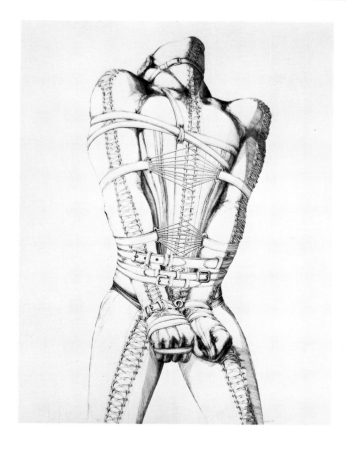

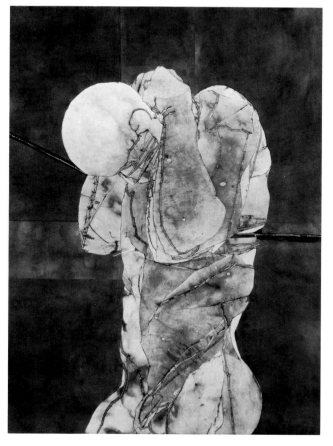

125 Nancy Grossman American, b. 1940
Figure, 1970

126 Nancy Grossman
Double-Tethered Figure, 1976

consist of millions of individuals who are dependent upon each other."[308] In *Two Halls* (129) the sheer numbers of people in contemporary urban society, with the concomitant loss of individuality, is made apparent. Within such a crowd, one's sense of uniqueness can be difficult to maintain.

In Bayrle's images, movement is a constant factor, especially regimented masses in motion. In *Call Me Jim* (130), he mocks the possibility of personal contacts within technological mass society and criticizes the dominance that automobiles have attained in our society:

Look around you. They have put all movement in concrete or behind glass—and we have let them. Now I see the facades of glass shoot up high and the concrete spread through the city. Highways are laid out throughout the town, prefabricated high-rise buildings follow jerkingly upwards; the flow of traffic is the basis. . . . It always looks like a catastrophe. . . . Always at right angles . . . the brutal right angles are only seen by the designers on blueprint plans. . . . [My works] are arbitrary fragments and yet everything is there: the complete idiocy![309]

Although the return to socially involved art has been an international phenomenon since the late 1960s and early 1970s, it has been particularly pronounced in Germany. After years of living literally on the firing line of international tensions, West German artists who came of age in the 1960s have bitterly criticized the darker side of human nature and the conditions of life in our age of anxiety. Karl Hermann Kraus (b. 1941) is one of the many German artists who have tried to come to terms with the social questions of our day. Using elements, images, and techniques from the mass media (such as video, repetition, collage), Kraus seeks to expose the issues, to make the viewer conscious of them, and to entice him or her into becoming actively involved with the problems of our time.

In *Freedom Object* (131), Kraus comments on the

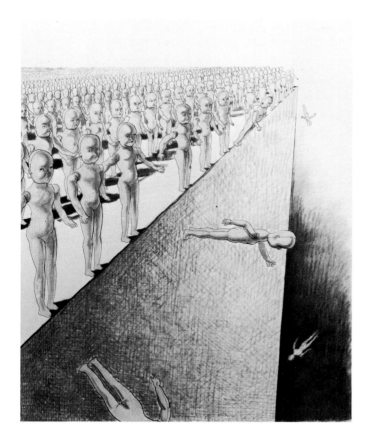

127 Gerhardt Liebmann American, b. 1928
The City, 1968

128 Gerhardt Liebmann
America, Monday, October 22, 1973, 1973

129 Thomas Bayrle German, b. 1937
Two Halls, 1982

near-obsession with material comforts that has characterized industrial nations in the mid-twentieth century. This orientation toward compulsive consumption of goods constitutes a form of cultural manipulation, subliminally controlling individuals, as indicated here by the sealed box that causes a sequence of commercials to rotate through the mind of the blank-eyed figure, as martial music softly plays. Underlying Kraus's work is a utopian hope of freeing people from societal imprints and cultural constraints of all kinds. By honestly confronting the issues, the viewer may realize that his freedom is jeopardized. For Kraus, art can remind us that:

Man is free. . . . In a society which degrades man so ruthlessly and robs him of all emotion, most people are forced either to vegetate as cripples without souls or to adapt themselves in such a way that they cannot recognize themselves anymore. . . . People should not be content to satisfy only their natural needs; one should not forget that

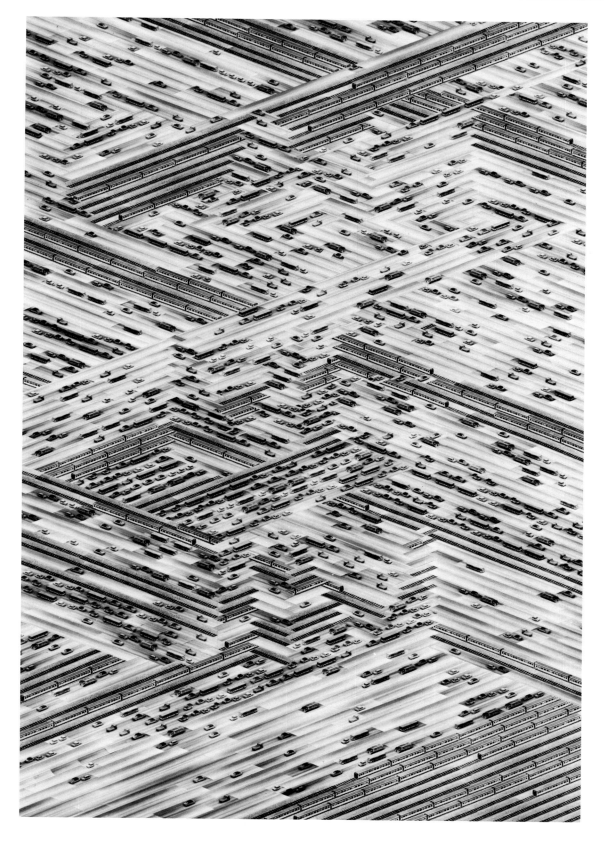

130 **Thomas Bayrle**
Call Me Jim, 1976

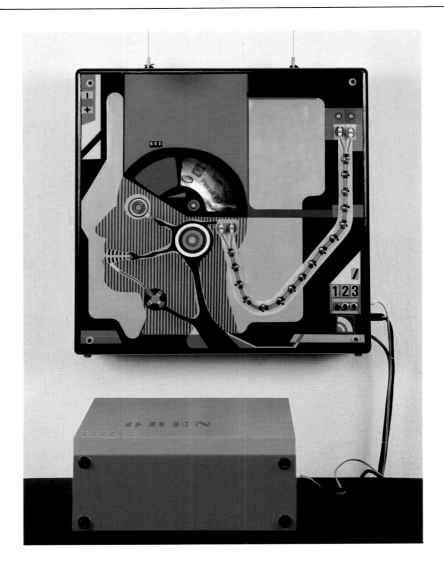

131 Karl Hermann Kraus German, b. 1941
Freedom Object, 1971

man still has a soul. With [material] substitutes people . . . [seek] some kind of security at a time which . . . is likely to be totally uncertain, thanks to a science devoid of all spiritual responsibility. The artist . . . is obliged to become aware . . . that all his actions, even the smallest, must be filled with this freedom. . . . Demonstrate your readiness to go recklessly this way before you forfeit your soul, before you yourselves become the machine man.[310]

Although computers and other hi-tech instruments fascinate him as means of bringing order to the world, Kraus also views technology critically as having adverse effects on man's psychological being. Hence, in *The Economy: They Ought to Do What They Have to Do* (132), he suggests that in today's

meganomics the individual has little say and less choice. Newspapers with statistics (*Die Wirtschaft* is a German equivalent of the *Wall Street Journal*) create the impression of the inevitability of economic conditions. Criticism of any one economic system, capitalist or socialist, is not the crucial issue here; rather, confrontation with and conscious awareness of the elements underlying all systems is the purpose. Kraus is concerned with the broadest kinds of mind manipulation, which exist within social structures and which cause the individual to accept without question the conditions and values of modern life. The repeated videolike image of the human brain overlaid with a computer circuit conveys the subtle control that mass

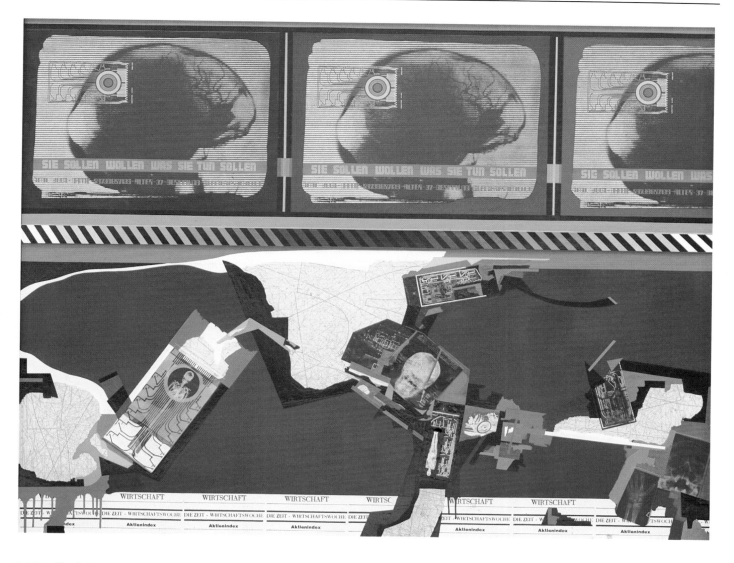

132 Karl Hermann Kraus
The Economy: They Ought to Do What They Have to Do, 1973

media can exercise over the conscious and unconscious decision-making process.

The issue of the manipulation of personal and social knowledge through modern mass media and sophisticated surveillance is the subject of another German artist, Hans-Jürgen Diehl (b. 1940). Using the bold forms and sharp contours of Pop Art (borrowed from commercial advertising techniques), *Manipulation* (133) evokes the specter of "Big Brother Is Watching." Diehl, like Kraus, belongs to a generation of artists painfully aware of the evils that can result from the successful manipulation of public consciousness.

Austrian artist Alfred Hrdlicka (b. 1928) overtly refers in his graphics to the perversion of early-twentieth-century utopian ideals into Nazi abuses. One of his expressionist etchings, ironically called *The New Man,* depicts a scene of Nazi torture, as commentary on how the aspiration toward a better humanity was so easily twisted into the idea of the Aryan "master race" in whose name so many monstrous deeds were committed. In his *Roll over Mondrian* series, Hrdlicka uses a De Stijl grid as the basis for the composition, but fills the open spaces with scenes of human life, particularly its baser aspects. Hrdlicka asserts the physical nature of man as a reality that cannot be fit into any systemic straightjacket. In *Roll over Mondrian: The All-New Testament*

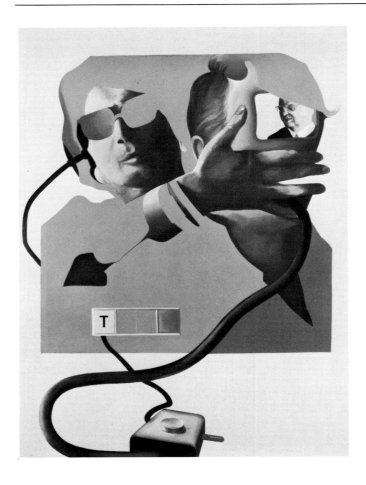

133 Hans-Jürgen Diehl German, b. 1940
Manipulation, 1968

134 Alfred Hrdlicka Austrian, b. 1928
Roll over Mondrian: The All-New Testament, 1966

(134), he criticizes both the rigidity of Mondrian's conceptions and the bestiality of human behavior. The juxtaposition of the geometric grid with these distasteful images not only recalls the perversion of the original utopian precepts but also suggests that neither extreme in itself is desirable. Together they may balance and offset each other.

In the last half dozen years the international art world has evidenced an increasing awareness of the dystopian dangers threatening our future existence. The fear of nuclear annihilation has mobilized citizens in many Western countries, notably Germany, France, Great Britain, and the United States. In art a number of works have appeared recently on the theme of nuclear holocaust and general doomsday subjects. Robert Morris (b. 1931) turned to this subject with an intensity that is truly frightening in works like *Restless Sleepers/Atomic Shroud* of 1981 (fig. 18), a

kind of sleeping bag imprinted with the skeletons of humans burnt by nuclear explosion.

Morris's transformation from a leading Minimalist sculptor in the 1960s to the maker of these disturbing images of doom epitomizes the changed atmosphere from formalism as the dominant mode in the art world to subject-oriented Postmodernism. *Prelude (A.B.): A Tomb-Garden outside the City* (135) presents an ominous intimation of the impending destruction of the human species. Beneath the skull perched atop the eerily glowing memorial tablet is inscribed a text that evokes the image of a devastated future world, in which enormous numbers of dead bodies have to be carted outside the city for disposition. Morris's text describes the gruesome situation:

It is a large machine, heavily built with welded steel gussets to reinforce the angles. . . . Because of the vibra-

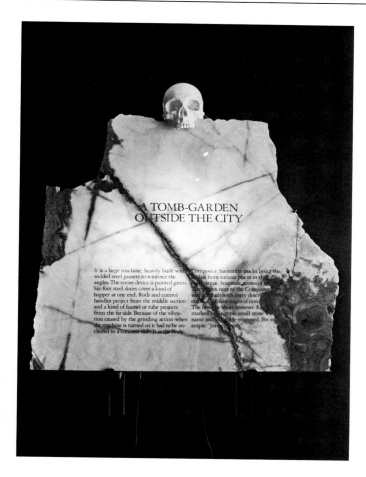

135 Robert Morris American, b. 1931
Prelude (A.B.): A Tomb Garden outside the City,
1979–80

tion caused by the grinding action when the machine is turned on it had to be anchored to a concrete slab. It is the Body Composter. Sanitation trucks bring the bodies from various places in the city. . . .

The impression of tremendous destruction is reinforced by the cracked and broken appearance of the cenotaph itself, while the large black cross on which the relief is displayed enhances the lugubrious effect of the entire composition. The theatricality and literary approach of this work is geared to engage the viewer's emotional involvement on an instinctive, almost visceral level. Morris is profoundly concerned about the continued drift of many nations toward self-destruction of all kinds, ecological and psychological, but especially nuclear. Consequently he creates works that eschew passive observation for a more active response from the audience, mentally, physically, ethically, and politically.

Some artists create works that are not intended to convey any specific anti-utopian fears, yet they do. A video *Portrait* (136) by the German artists Hartmut Lerch and Klaus Holtz records thousands of individual faces at varying speeds. Lerch has described their aim:

By consecutively presenting the thousands of portraits in such a fast way as to see over 20,000 different faces per

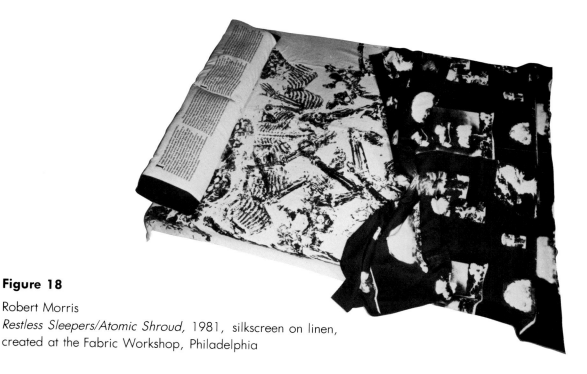

Figure 18

Robert Morris
Restless Sleepers/Atomic Shroud, 1981, silkscreen on linen, created at the Fabric Workshop, Philadelphia

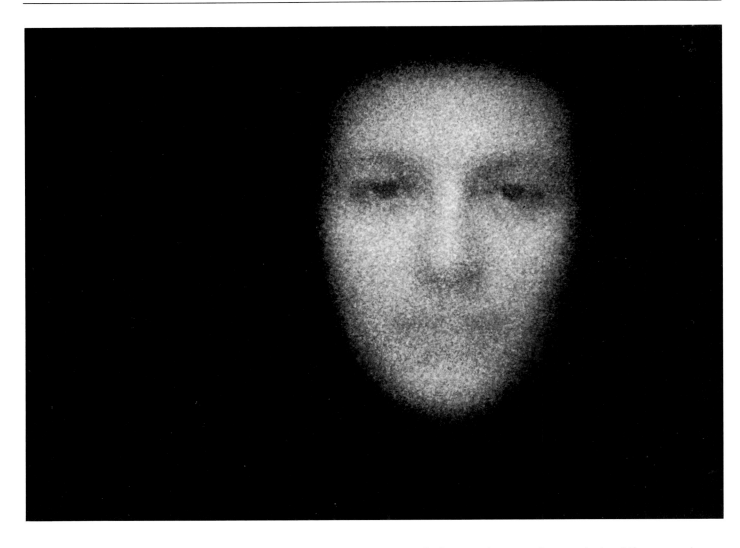

136 Hartmut Lerch German, b. 1949
Klaus Holtz German, b. 1946
Portrait, 1980–82, videotape

second, the eye does not distinguish the different attributes individually anymore, but forms one universal expression. . . . The faster the process works, the more the resulting face gains its beauty. Once the universality of this portrait is achieved, it slowly falls apart again into the multitude of different faces it is made of. The resulting face . . . the most representative human, looks like we all together would.[311]

Yet the effect is paradoxically disturbing. This progressive loss of individual personality into an ideal type suggests the psychological dehumanization feared by many anti-utopians. And the technique used, that of visual images projected at a speed so fast that it deceives the conscious mind's eye, is one of the techniques used in modern brainwashing and mind manipulation. Thus *Portrait* demonstrates within one work both the beauty of utopian ideals and their inherently disturbing ramifications.

EPILOGUE

In the history of human thought, utopian visions have prodded the imagination and the conscience of mankind, presenting dreams of a better existence in a world that so often seems purposeless and beyond help or endurance. As life has become more complex and difficult in the past few centuries, utopian visions have played increasingly important roles in offering paths for improvement. The discredit into which utopianism has fallen in the mid-twentieth century and the oft-repeated criticism that utopias are too romantically idealistic to be effected in the realistic world are surely justified, yet they miss the point. No perfect social order has been devised, and given the fallibility of the human species, none is apt to be. But the continuous striving for perfection has not been fruitless. On the contrary, utopianism has contributed new ideas and a spirit of perpetual renewal to the history of humanity. As Oscar Wilde wrote in the 1890s, "A map of the world that does not include Utopia is not worth even glancing at, for it leaves out the one country at which Humanity is always landing."[312]

The artists of the early twentieth century who embraced utopianism generally did so out of a desire to expand the parameters of human life. Though some concentrated on specific aspects of physical existence, from sociopolitical concerns to reshaping the urban environment, the essential impulse was to manifest their visions of extraordinary breadth and beauty for humanity. From the Futurist desire for a fully realized life characterized by "imagination without strings"[313] to Mondrian's conception of a life of completely equilibrated harmony, utopian art advertises a situation without limits, a state of being that was previously unrecognized. That the fundamental goal of utopian artists was transcendent is indicated by the heroic development of abstract styles and theories of tremendous power, rather than propagandistic imagery (as was devised to implement the "ideals" of Hitler and Stalin in the 1930s and '40s). Their art demonstrated that utopia can successfully serve as an object of inspiration and contemplation, rather than as a narrow prescription or literal blueprint for social change. As a constellation of hopes and beliefs, of aspirations and values, rather than as a doctrinaire credo, utopia can contribute to the progressive expansion of culture and the human experience.

Because they view the human condition holistically, utopias and dystopias can help us set new goals, reorder our priorities, and raise important questions encompassing human welfare rather than immediate necessity. Between them, utopians and dystopians make us cognizant of both sides of complex and profound issues, such as to what extent should values based on technology, ideology, materialism, or other beliefs determine future developments and efforts? If they served no other purpose and had no other impact than to stimulate serious discussion about long-range aspirations for our societies, utopias and dystopias will have been of inestimable value in the twentieth century. While utopians can offer inspiration with their unfettered dreams, dystopians perform the crucial function of criticizing and playing watchdog. Many of the horrifying visions portrayed in twentieth-century art and literature are not, for the most part, imperatives to abandon utopia but signals to dream *better,* more intelligently and profoundly. Nightmares make us examine our dreams more closely, so we can take into account new factors, new subtleties of spirit and human nature. In literature, Huxley, Orwell, and the others tried to alert mankind to imminent potential perversions of ideals into destructive fanaticism. In art, dystopian painters and sculptors have resisted the imposition of dogmatic formalist aesthetics and reasserted the importance of humanistic values.

Neither utopian nor dystopian ideals are sufficient in themselves. Both are extremes, potentially destructive in themselves, since any idealism pushed to an absolute runs the risk of fanaticism. There needs to be a complementary relationship between visionary anticipation and retrospection. A dialectic between them can yield a creative progression—perhaps having no final synthesis but producing ever better definitions and approaches in the search for an improved world and fuller human development. Utopias and dystopias can be shallow or profound, but both must continue. We cannot let the dialectic of visions die. Visions have ever been our guide; without them our world would be a poorer place.

UTOPIAN DREAMS

ITALIAN FUTURISM

1 **Gino Severini** Italian, 1883–1966
Dynamic Rhythm of a Head in a Bus, 1912, pastel, charcoal, and pencil on paper, 25⅛ × 19⁵⁄₁₆ inches (63.8 × 49.0 cm)
Estate of Joseph H. Hirshhorn, Washington, D.C.

2 **Gino Severini**
Paris Subway, Ferris Wheel, and Eiffel Tower, c. 1912–13, pastel and charcoal on paper, 23½ × 19 inches (59.6 × 48.2 cm)
Cleveland Museum of Art; gift of Mrs. Malcolm L. McBride

3 **Gino Severini**
Armored Train, 1915, oil on canvas, 46 × 34½ inches (116.8 × 87.6 cm)
Richard S. Zeisler Collection, New York

4 **Luigi Russolo** Italian, 1885–1947
Dynamism of an Automobile, 1913, oil on canvas, 40 × 55¼ inches (104 × 140 cm)
Musée National d'Art Moderne, Centre National d'Art et de Culture Georges Pompidou, Paris

5 **Giacomo Balla** Italian, 1871–1958
Bridge of Velocity, 1913, tempera and collage on cardboard, 36⅝ × 52 inches (93 × 132 cm)
Luce Balla and Elica Balla, Rome

6 **Giacomo Balla**
Speeding Automobile + Lights, 1913, oil on canvas, 19 × 26¾ inches (48.3 × 67.9 cm)
Mr. and Mrs. Morton G. Neumann, Chicago

7 **Giacomo Balla**
Plastic Construction of Noise + Speed, 1914, reconstructed 1968, aluminum and steel on painted wooden mount, 40⅛ × 46⅛ × 8 inches (101.7 × 117.8 × 20.2 cm)
Hirshhorn Museum and Sculpture Garden, Washington, D.C.; gift of Joseph H. Hirshhorn, 1972

8 Giacomo Balla

Study for Interior, 1918, tempera on paper,
10⅜ × 8¾ inches (27 × 22 cm)
Luce Balla and Elica Balla, Rome

9 Giacomo Balla

Study for Interior, 1920, watercolor on paper,
11⅞ × 16½ inches (30 × 42 cm)
Luce Balla and Elica Balla, Rome

10 Giacomo Balla

Project for Disassembling Cabinet, 1920, tempera on paper, 8¼ × 12¼ inches (21 × 31 cm)
Luce Balla and Elica Balla, Rome

11 Giacomo Balla

Futurist Flowers, 1918–25, ten painted wood constructions, various sizes ranging from 16½ × 35¾ × 35¾ inches (41.8 × 90.7 × 90.7 cm) to 12⅞ × 7⅞ × 7⅞ inches (32.6 × 20.0 × 19.3 cm)
Estate of Joseph H. Hirshhorn, Washington,

12 Antonio Sant'Elia Italian, 1888–1916

The New City: Design for an Electric Power Station, 1914, red and blue ink on paper, 11⅞ × 7⅞ inches (30 × 20 cm)
Paride Accetti, Milan

13 Antonio Sant'Elia

The New City: Design for High-Rise Building with External Elevators and Pedestrian Bridge, 1914, black, green, and red ink on paper, 11¹³⁄₁₆ × 6¹¹⁄₁₆ inches (30 × 17 cm)
Paride Accetti, Milan

14 Virgilio Marchi Italian, 1895–1960

Futurist City: Building for a Piazza, 1919, tempera on paper, 63 × 50 inches (160 × 125 cm)
Marchi Collection, Rome

15 Virgilio Marchi

Futurist City: Heliport and Buildings, 1919, ink on paper, 23¼ × 19 inches (59 × 48 cm)
Marchi Collection, Rome

RUSSIAN AVANT-GARDE

16 Kasimir Malevich Russian, 1878–1935

Soccer Match, 1915, oil on canvas, 27½ × 17¼ inches (70 × 44 cm)
Stedelijk Museum, Amsterdam

17 Kasimir Malevich

Suprematist Painting, 1916, oil on canvas, 34⅝ × 27¾ inches (88.0 × 70.5 cm)
Stedelijk Museum, Amsterdam

18 Ilya Chasnik Russian, 1902–29

The Seventh Dimension: Suprematist Stripe Relief, 1925, painted wood, paper, cardboard, and glass, 10¼ × 8⅞ inches (26.0 × 22.5 cm)
Leonard Hutton Galleries, New York

19 Ilya Chasnik

Cosmos: Red Circle on Black Surface, 1925, watercolor and ink on paper, 14⅝ × 12⅞ inches (37.2 × 32.8 cm)
Thomas P. Whitney Collection, Washington, Connecticut

20 El Lissitzky Russian, 1890–1941

Proun 23, No. 6, 1919, oil on canvas, 20½ × 30¼ inches (52 × 77 cm)
Mr. and Mrs. Eric Estorick, London

21 El Lissitzky

Proun, c. 1920, gouache and watercolor on paper, 15⅜ × 15⅞ inches (38.8 × 40.5 cm)
Indiana University Art Museum, Bloomington; Jane and Roger Wolcott Memorial

22 Kasimir Malevich

Design for Suprematist Architecton: Planit, 1923–24, pencil on paper, 14¼ × 21 inches (36.0 × 53.5 cm)
Stedelijk Museum, Amsterdam

23 Ilya Chasnik

Suprematist Architectonic Model: Cross and Circle, 1926, plaster, 7⅜ × 6½ × 1⅛ inches (18.7 × 16.4 × 2.7 cm)
Leonard Hutton Galleries, New York

24 Ilya Chasnik
Design for Suprematist Architecton, 1928, ink and pencil on paper, 24⅜ × 30¾ inches (62.0 × 78.2 cm)
Leonard Hutton Galleries, New York

25 Ilya Chasnik
Design for Architectonic Model: Cross and Circle, 1928, ink and pencil on paper, 24⅝ × 33¼ inches (62.4 × 84.6 cm)
Leonard Hutton Galleries, New York

26 Vladimir Tatlin Russian, 1885–1953
Model of the Monument to the Third International: Project for Petrograd, 1920, reconstructed 1983, fiberglas, metal, and plexiglas, 96 × 72 × 78 inches (243.8 × 182.9 × 198.1 cm)
Hirshhorn Museum and Sculpture Garden, Washington, D.C.

27 Alexander Rodchenko Russian, 1891–1956
Untitled, c. 1919, oil on cardboard, 18¼ × 14⅜ inches (46.5 × 36.5 cm)
Rachel Adler Gallery and Rosa Esman Gallery, New York

28 Georgy Stenberg Russian, 1900–33
KPS-11, 1919–20, reconstructed 1975, painted wood, iron, and glass, 61 × 18½ × 33½ inches (154.9 × 47.0 × 85.0 cm)
Los Angeles County Museum of Art; gift of Jean Chauvelin

29 El Lissitzky
Victory over the Sun: Globetrotter, 1923, color lithograph, 20¼ × 16¼ inches (51.2 × 41.2 cm)
Steinitz Family Collection, Alhambra, California

30 El Lissitzky
Victory over the Sun: New Man, 1923, color lithograph, 21 × 17¾ inches (53.3 × 45.1 cm)
Indiana University Art Museum, Bloomington; Jane and Roger Wolcott Memorial

31 El Lissitzky
Tatlin Working on the Monument to the Third

International, 1921–22, watercolor and photomontage, 11½ × 9 inches (29.2 × 22.9 cm)
Mr. and Mrs. Eric Estorick, London

32 El Lissitzky
Constructor: Self-Portrait, 1924, photomontage, 9¾ × 11½ inches (24.8 × 29.1 cm)
Steinitz Family Collection, Alhambra, California

GERMAN EXPRESSIONISM

33 Wassily Kandinsky Russian, 1866–1944
Small Pleasures No. 174, 1913, oil on canvas, 43¼ × 47⅛ inches (109.8 × 119.7 cm)
Solomon R. Guggenheim Museum, New York

34 Wassily Kandinsky
Fugue, 1914, oil on canvas, 51 × 51 inches (129.5 × 129.5 cm)
Solomon R. Guggenheim Museum, New York

35 Wassily Kandinsky
Improvisation (Little Painting with Yellow), 1914, oil on canvas, 30¾ × 39¾ inches (78.1 × 101.1 cm)
Philadelphia Museum of Art; Louise and Walter Arensberg Collection

36 Hermann Finsterlin German, 1887–1973
Concert Hall, 1919, colored pencil and watercolor on paper, 10 × 14⅛ inches (25.4 × 36.0 cm)
Rosemarie Haag Bletter, New York

37 Hermann Finsterlin
Cathedral, 1919, colored pencil and watercolor on paper, 10 × 14⅛ inches (25.4 × 36.0 cm)
Rosemarie Haag Bletter, New York

38 Hermann Finsterlin
Dream in Glass and *New House,* 1920, two sheets, watercolor on paper, 8⅝ × 12¼ inches (21.8 × 31.2 cm) each
Graphische Sammlung, Staatsgalerie, Stuttgart, West Germany

39 Hermann Finsterlin
House of Devotion and Museum, c. 1919–20,
watercolor and pencil on paper, 14⅞ × 11⅛
inches (37.8 × 28.2 cm)
Graphische Sammlung, Staatsgalerie, Stutt-
gart, West Germany

40 Wenzel August Hablik German, 1881–
1934
*Cycle of Exhibition Buildings: Cube, Calcite
Spar,* 1920, ink, watercolor, and pencil on
cardboard, 11 7/8 x 9 7/8 inches (30 × 25
cm)
Hablik Collection, Itzehoe, West Germany

41 Wenzel August Hablik
House and Studio, 1921, colored pencil and
pencil on cardboard, 25¾ × 19¾ inches
(65.1 × 50.0 cm)
Hablik Collection, Itzehoe, West Germany

42 Wenzel August Hablik
*Utopian Architectural Cycle: Explorer's Settle-
ment,* 1914–24, etching, 7¾ × 10⅛ inches
(19.8 × 25.6 cm)
Hablik Collection, Itzehoe, West Germany

43 Wenzel August Hablik
*Utopian Architectural Cycle: Free-Standing
Dome Construction,* 1914–24, etching, 7¾ ×
10 inches (19.8 × 25.6 cm)
Hablik Collection, Itzehoe, West Germany

GERMAN BAUHAUS

44 Lionel Feininger American, 1871–1956
Cathedral of the Future, 1919, woodcut, 7 ×
4¾ inches (17.8 × 12.1 cm)
Marion Koogler McNay Art Institute, San Anto-
nio, Texas; Museum purchase

45 Oskar Schlemmer German, 1888–1943
Utopia, 1921, cover design, colored litho-
graph on parchment paper, 6¾ × 9½ inches
(17 × 24 cm)
Gimpel-Hanover and André Emmerich Gallery,
Zurich, Switzerland

46 Oskar Schlemmer
Homo, 1931, cast 1968, nickel-plated steel
wire and zinc mounted on painted canvas over
board, 121¾ × 101⅞ × 6¼ inches (309.2
× 256.5 × 15.9 cm)
National Gallery of Art, Washington, D.C.;
gift of Enid A. Haupt, 1977

47 Andrew Weininger American, b. Germany
1899
*Abstract Review: Design for a Mechanical
Stage,* 1923, enlarged 1951, gouache on pa-
per, 8 × 12 inches (20.0 × 30.5 cm)
Andrew Weininger, New York

48 Andrew Weininger
House Fantasia, 1922, enlarged 1951,
gouache on paper, 10¼ × 11 inches (26 ×
27.9 cm)
Andrew Weininger, New York

49 Joost Schmidt German, 1893–1948
Art of the Bauhaus, 1923, color lithograph,
26¾ × 18⅞ inches (68 × 48 cm)
Private collection

50 Herbert Bayer American, b. Austria 1900
*Exhibition Tower Advertising Electrical Prod-
ucts,* 1924, gouache on paper, 26 × 15
inches (66 × 38.0 cm)
Herbert Bayer, Montecito, California

51 László Moholy-Nagy American, b. Hun-
gary, 1895–1946
A-IX, 1923, oil and pencil on canvas, 50½ ×
38¾ inches (128.3 × 98.4 cm)
San Francisco Museum of Modern Art; gift of
Sybil Moholy-Nagy

52 László Moholy-Nagy
Constructivist Composition, 1923, watercolor
and pencil on paper, 17⅛ × 13⅞ inches
(43.5 × 35.2 cm)
Estate of Joseph H. Hirshhorn, Washington,
D.C.

53 László Moholy-Nagy
Study for AM4, 1926, gouache and ink on
paper, 12½ × 14½ inches (31.8 × 36.8
cm)
Mr. and Mrs. Paul M. Hirschland

54 Josef Albers American, b. Germany, 1888–1976
Skyscrapers B, 1925–29, sandblasted flashed glass, 13 × 13 inches (33 × 33 cm)
Hirshhorn Museum and Sculpture Garden, Washington, D.C.; gift of the Joseph H. Hirshhorn Foundation, 1974

55 Josef Albers
Latticework, c. 1926, sandblasted and painted flashed glass, 10½ × 11½ inches (26.7 × 29.2 cm)
Hirshhorn Museum and Sculpture Garden, Washington, D.C.; gift of the Joseph H. Hirshhorn Foundation, 1974

DUTCH DE STIJL

56 Piet Mondrian Dutch, 1872–1944
Pier and Ocean, 1914, charcoal on paper, 20¾ × 26 inches (52.7 × 66.0 cm)
Sidney Janis Gallery, New York

57 Piet Mondrian
Lozenge in Red, Yellow, and Blue, c. 1925, oil on canvas, 56¼ × 56 inches (142.9 × 142.2 cm) diagonal
National Gallery of Art, Washington, D.C.; gift of Herbert and Nannette Rothschild, 1971

58 Piet Mondrian
Composition with Blue and Yellow, 1935, oil on canvas, 28¾ × 27¼ inches (73.0 × 69.2 cm)
Hirshhorn Museum and Sculpure Garden, Washington, D.C.

59 Theo van Doesburg Dutch, 1883–1931
Tree with Houses, 1916, oil on panel, 26 × 22 inches (66.0 × 55.8 cm)
Portland Art Museum, Portland, Oregon; gift of Mr. and Mrs. Jan de Graaff

60 Theo van Doesburg
Interior, 1919, oil on canvas, 26 × 21¾ inches (66.0 × 55.2 cm)
Baltimore Museum of Art; bequest of Saidie A. May

61 Vilmos Huszar Hungarian, 1884–1960
Figure of a Woman, c. 1918, oil on wood, 20¼ × 16½ inches (51.4 × 42.0 cm)
Sidney Janis Gallery, New York

62 Theo van Doesburg
Contracomposition, 1924, oil on canvas, 25¾ × 25 inches (65.4 × 63.5 cm) diagonal
Mr. and Mrs. Morton G. Neumann, Chicago

63 Theo van Doesburg
Contracomposition (Construction with Colors in the Fourth Dimension of Space and Time), 1924, gouache on paper, 22⅛ × 22 inches (56.3 × 56.0 cm) diagonal
Stedelijk Museum, Amsterdam

64 Vilmos Huszar
Figure Composition for a Mechanical Theater, c. 1920, gouache on paper mounted on paperboard, 48 × 31 inches (121.9 × 78.7 cm)
Herbert F. Johnson Museum of Art, Cornell University, Ithaca; gift of Silvia Pizitz

65 Vilmos Huszar
Composition, 1921, oil on wood, 31 × 23½ inches (78.8 × 59.7 cm)
Museum of Fine Arts, Houston; purchase with funds donated by Mr. and Mrs. Theodore N. Law

66 César Domela Dutch, b. 1900
Construction, 1929, glass, painted glass, painted metal, chrome-plated brass, and painted wood, 35⅜ × 29⅝ × 1¾ inches (89.8 × 75.2 × 4.2 cm)
Hirshhorn Museum and Sculpture Garden, Washington, D.C.

67 Theo van Doesburg
Project for a Ceiling: Café Aubette, 1928, gouache on paper mounted on paperboard, 13¼ × 9¼ inches (34.3 × 48.9 cm)
J. Barry Donahue, New York

68 Félix del Marle French, 1889–1952
Neoplastic Studio, 1928, gouache and ink on paper, 11 × 8¼ inches (27.9 × 21.0 cm)
Carus Gallery, New York

FRENCH PURISM AND LÉGER

69 Fernand Léger French, 1881–1955
Disks, 1918–19, oil on canvas, 51⅛ × 38¼
inches (129.9 × 97.0 cm)
Los Angeles County Museum of Art; David E.
Bright Bequest

70 Fernand Léger
Typographer, 1919, oil on canvas, 51 ×
38¼ inches (129.5 × 97.2 cm)
Philadelphia Museum of Art; Louise and Walter
Arensberg Collection

71 Fernand Léger
The Mechanic, 1918, oil on canvas, 18¼ ×
25¾ inches (46.3 × 65.4 cm)
Munson-Williams-Proctor Institute, Utica, New
York

72 Fernand Léger
Man with Dog, 1920, oil on canvas, 36 ×
25⅜ inches (91.4 × 64.5 cm)
Mr. and Mrs. Morton G. Neumann, Chicago

73 Fernand Léger
Figure of a Man (First State), 1920, oil on
burlap, 25⅝ × 19½ inches (65.0 ×
49.5 cm)
Philadelphia Museum of Art; Louise and Walter
Arensberg Collection

AMERICAN PRECISIONISM
AND ARCHITECTURE

74 Louis Lozowick American, b. Russia, 1892–
1973
Urban Geometry, 1925–27, oil on canvas, 30
× 22 inches (76.2 × 55.9 cm)
Farber Collection, New York

75 Louis Lozowick
Machine Ornament #2, c. 1927, brush and
ink on paperboard, 22⅙ × 15½6 inches
(55.9 × 38.2 cm)
Hirshhorn Museum and Sculpture Garden,
Washington, D.C.; purchase, 1975

76 Charles Sheeler American, 1883–1965
Ballet Mécanique, 1931, conté crayon on pa-
per, 10¼ × 10 inches (26.0 × 25.4 cm)
Memorial Art Gallery of the University of
Rochester; gift of Peter Iselin and his sister,
Emilie Iselin Wiggin, 1974

77 Charles Sheeler
Incantation, 1946, oil on canvas, 24 × 20
inches (60.9 × 50.7 cm)
Brooklyn Museum; John B. and Ella C. Wood-
ward Memorial Funds

78 Theodore Roszak American, b. Poland,
1907–81
Vertical Construction, 1943, plastic and
painted wood, 76 × 30 × 5 inches (193.0
× 76.2 × 12.7 cm)
Whitney Museum of American Art, New York;
gift of the artist

79 Hugh Ferriss American, 1889–1962
*The Metropolis of Tomorrow: Philosophy at
Night,* 1928, charcoal on paper, 38 × 22
inches (96.5 × 55.8 cm)
Drawings Collection, Avery Architectural and
Fine Arts Library, Columbia University, New
York

80 Hugh Ferriss
The Metropolis of Tomorrow: Aerial View,
1925, charcoal on paper, 13¼ × 17⅝
inches (33.7 × 44.8 cm)
Private collection

81 R. Buckminster Fuller American, 1895–
1983
4D Time Lock: Tower Garage, 1927, mimeo
drawing, 11 × 8½ inches (27.9 × 21.6 cm)
Janet Leszczynski, Chicago

82 R. Buckminster Fuller
*4D Time Lock: 100-Deck Office Building with
Bridge, A-1-9,* 1927, mimeo drawing, 11 ×
8½ inches (27.9 × 21.6 cm)
Museum of Modern Art, New York; purchase,
1983

83 R. Buckminster Fuller

*4D Time Lock: Modified 4D Twin Tower Office
Building, A-1-13,* 1927, mimeo drawing, 11
× 8½ inches (27.9 × 21.6 cm)
Carl Solway Gallery, Cincinnati

POST—WORLD WAR II

84 R. Buckminster Fuller

Geodesic Dome, 1952, aluminum model, 20⅝
inches (52.4 cm) high
Museum of Modern Art, New York; gift of the
architect

85 Frederick Kiesler American, b. Austria,
1896–1965

Space Division in Endless House, 1959, char-
coal on paper, 24 × 36 inches (61.0 × 91.4
cm)
Mrs. Frederick Kiesler, New York

86 Frederick Kiesler

Endless House, 1959–61, model, cement over
wire mesh, 38 × 96 × 42 inches (96.5 ×
243.1 × 106.2 cm)
Mrs. Frederick Kiesler, New York

87 Paolo Soleri American, b. Italy 1919

Arcosanti (Critical Mass), acrylic, wood, and
metal model, 1979, 12 × 72 × 45 inches
(30.5 × 182.9 × 114.3 cm)
Cosanti Foundation, Scottsdale, Arizona

88 Will Insley American, b. 1929

One City: Channel Space Reverse, 1968,
painted wood, 4 × 60 × 60 inches (10.2 ×
152.4 × 152.4 cm), intended to cover ground
area measuring 360 × 360 feet (110 × 110
m)
Max Protetch Gallery, New York

89 Will Insley

*One City: Volume Space Interior Wave, Iso-
metric X-Ray View through the Ground,* 1980–
81 (project 1973), ink on ragboard, 40 × 60
inches (101.6 × 152.4 cm)
Max Protetch Gallery, New York

DYSTOPIAN NIGHTMARES

EARLY PREMONITIONS

90 Ludwig Meidner German, 1884–1966

Apocalyptic City, 1913, oil on canvas, 35 ×
29½ inches (89 × 75 cm)
Private collection

91 Ludwig Meidner

The Uncertainty of Visions, 1914, ink on pa-
per, 18½ × 16¾ inches (47.0 × 42.5 cm)
Marvin and Janet Fishman, Milwaukee,
Wisconsin

92 Ludwig Meidner

Apocalyptic Scene, 1915, pen and ink and
pencil on paper, 21¼ × 27¾ inches (54.0
× 70.5 cm)
Marvin and Janet Fishman, Milwaukee, Wis-
consin

93 Frans Masereel Belgian, 1889–1972

The Prophet, 1937, woodcut, 11¹³⁄₁₆ × 15¾
inches (30 × 40 cm)
Clara and Walter Engel, Toronto

94 George Grosz American, b. Germany,
1893–1959

Untitled, 1920, oil on canvas, 32 × 24 inches
(81 × 61 cm)
Kunstsammlung Nordrhein-Westfalen, Düssel-
dorf, West Germany

95 Heinrich Hoerle German, 1895–1936

Mechanical Men, 1930, oil on wood, 40 ×
20 inches (100 × 50 cm)
Marvin and Janet Fishman, Milwaukee, Wis-
consin

96 George Grosz

The Pit, 1946, oil on canvas, 60¼ × 37¼
inches (15.3 × 94.6 cm)
Wichita Art Museum; Roland P. Murdock Col-
lection

97 George Grosz
Enemy of the Rainbow, 1946–48, watercolor on paper, 25½ × 19 inches (65 × 48 cm)
Peter M. Grosz Collection, Princeton, New Jersey

98 Peter Blume American, b. Russia 1906
Light of the World, 1932, oil on composition board, 18 × 20¼ inches (45.7 × 51.4 cm)
Whitney Museum of American Art, New York; purchase, 1933

POST–WORLD WAR II

99 Reg Butler British, b. 1913
Monument to the Unknown Political Prisoner, 1951–53, welded bronze, brass wire and sheet, 17⅜ inches (44 cm) high, on limestone base, 2¾ × 7½ × 7¼ inches (7.0 × 19.0 × 18.4 cm)
Museum of Modern Art, New York; Saidie A. May Fund, 1953

100 Luciano Minguzzi Italian, b. 1911
Monument to the Unknown Political Prisoner: Figure within Barbed Wire, 1952, bronze on wooden base, 24½ × 26 × 13 inches (62.2 × 66.0 × 33.0 cm)
Trustees of the Tate Gallery, London

101 Theodore Roszak American, b. Poland, 1907–81
Study for the Furies, 1950, ink on paper, 25 × 38¾ inches (63.5 × 98.4 cm) sight
Whitney Museum of American Art, New York; purchase, 1951

102 Theodore Roszak
Skylark, 1950–51, steel, 99 inches (251.5 cm) high
Mrs. Theodore Roszak, New York

103 Leonard Baskin American, b. 1922
Hydrogen Man, 1954, woodcut on Japanese paper, 61³⁄₁₆ × 24³⁄₁₆ inches (155.4 × 61.5 cm)

Smith College Museum of Art, Northampton, Massachusetts; gift of Priscilla Paine Van der Poel '28, 1977

104 Ben Shahn American, 1898–1969
The Fall, 1957, gouache on paper, 19¾ × 25¾ inches (50.2 × 65.2 cm)
Private collection

105 Ben Shahn
Lucky Dragon: We Did Not Know What Happened to Us, 1960, tempera on wood, 48 × 72⅛ inches (121.9 × 183.2 cm)
National Museum of American Art, Washington, D.C.; gift of S. C. Johnson & Son, Inc.

106 Joseph Hirsch American, 1910–81
The Watcher, 1950, lithograph, 8½ × 26½ inches (22.0 × 63.7 cm)
Genevieve Hirsch, New York

107 Joseph Hirsch
The Room, 1958, oil on canvas, 49¾ × 62¾ inches (126.4 × 159.4 cm)
Metropolitan Museum of Art, New York; Hugo Kastor Fund, 1958

108 Saul Steinberg American, b. Rumania 1914
Passport Photos, 1955, ink on paper, 9¾ × 14 inches (24.8 × 35.6 cm)
Pace Gallery, New York

109 George Tooker American, b. 1920
Government Bureau, 1956, egg tempera on gesso panel, 19⅝ × 29⅝ inches (49.8 × 75.2 cm)
Metropolitan Museum of Art, New York; George A. Hearn Fund, 1956

110 George Tooker
The Waiting Room, 1959, egg tempera on wood, 24 × 30 inches (61.0 × 76.2 cm)
National Museum of American Art, Washington, D.C.; gift of S. C. Johnson & Son, Inc.

111 George Tooker
Landscape with Figures, 1965–66, egg tempera on pressed wood board, 25½ × 29½ inches (64.7 × 75.0 cm)
Private collection

112 Jaap Mooy Dutch, b. 1915
Big Brother Is Watching You (McCarthy), 1963, photomontage, 14 × 19¼ inches (35.6 × 49.0 cm)
Haags Gemeentemuseum, The Hague, Holland

113 Jaap Mooy
Think, Think, Think, 1963, photomontage, 11 × 16 inches (28 × 41 cm)
Haags Gemeentemuseum, The Hague, Holland

114 Juan Genovés Spanish, b. 1930
The Prisoner, 1968, acrylic and oil on canvas, 78¾ × 59⅛ inches (200.0 × 150.2 cm)
Hirshhorn Museum and Sculpture Garden, Washington, D.C.

115 Juan Genovés
Man, 1968, acrylic and oil on canvas, 78⅞ × 59¼ inches (200.3 × 150.5 cm)
Estate of Joseph H. Hirshhorn, Washington, D.C.

116 Anzo (José Iranzo Almonacid) Spanish, b. 1931
Isolation 12, 1967, oil on linen, 58 × 45 inches (146 × 114 cm)
Anzo, Valencia, Spain

117 Anzo
Isolation 15, 1968, oil on panel, 39 × 39 inches (100 × 100 cm)
Anzo, Valencia, Spain

118 Ernest Trova American, b. 1927
Falling Man: Nickel-Wedge Landscape, c. 1966, nickeled metal, 11¼ × 21 × 18⅞ inches (28.4 × 53.2 × 47.9 cm)
Estate of Joseph H. Hirshhorn, Washington, D.C.

119 Ernest Trova
Falling Man: Two-Story Plexiglas Box, 1966, enamel, bronze, plexiglas, and mixed media, 26½ × 18 × 13 inches (67.3 × 45.7 × 33.0 cm)
Ernest Trova, Saint Louis, Missouri

120 Ernest Trova
Falling Man: Three-Box Landscape, 1966, plexiglas, plastic, and enameled bronze, 28 × 41 × 8¾ inches (71 × 104 × 23 cm)
Frank J. Moran, Grosse Pointe Shores, Michigan

121 Jacob Landau American, b. 1917
Holocaust: The Question, 1967, lithograph, 15 × 20½ inches (38.1 × 51.4 cm)
New Jersey State Museum, Trenton; extended loan

122 Jacob Landau
Holocaust: Man's End, 1967, lithograph, 15 × 20½ inches (38.1 × 51.0 cm)
New Jersey State Museum, Trenton; extended loan

123 Jacob Landau
Great Society, 1967, watercolor on paper, 21 × 26 inches (53.3 × 66.0 cm)
Mr. and Mrs. Irving Flicker, Trenton, New Jersey

124 Jacob Landau
Urbanology Triptych, 1969, watercolor on paper, three panels, 45 × 30 inches (114 × 78 cm) each
University of South Florida, Tampa

125 Nancy Grossman American, b. 1940
Figure, 1970, ink on paper, 45½ × 34½ inches (115.6 × 87.6 cm)
Private collection

126 Nancy Grossman
Double-Tethered Figure, 1976, collage painting, 48 × 35½ inches (121.9 × 90.2 cm)
Cordier & Ekstrom, New York

127 Gerhardt Liebmann American, b. 1928
The City, 1968, acrylic on masonite, 48 × 48 inches (122 × 122 cm)
Twining Gallery, New York

128 Gerhardt Liebmann
America, Monday, October 22, 1973, 1973, ink and chalk on paper, 24 × 19 inches (61.0 × 48.3 cm)
Norman Burwen, Fort Lauderdale, Florida

129 Thomas Bayrle German, b. 1937
Two Halls, 1982, photomontage on card-
board, 33½ × 26 inches (85 × 66 cm)
Thomas Bayrle, Frankfurt-am-Main,
West Germany

130 Thomas Bayrle
Call Me Jim, 1976, collotype, 43 × 29½
inches (109 × 75 cm)
Thomas Bayrle, Frankfurt-am-Main, West
Germany

131 Karl Hermann Kraus German, b. 1941
Freedom Object, 1971, mixed media construc-
tion, 24¾ × 24¾ × 5 inches (63 × 63 ×
13 cm)
Karl Hermann Kraus, Darmstadt, West
Germany

132 Karl Hermann Kraus
*The Economy: They Ought to Do What They
Have to Do,* 1973, montage, 67½ × 87⅜
inches (172 × 222 cm)
Karl Hermann Kraus, Darmstadt, West
Germany

133 Hans-Jürgen Diehl German, b. 1940
Manipulation, 1968, oil on canvas, 49¼ ×
38⅝ inches (125 × 98 cm)
Margrit Diehl, West Berlin

134 Alfred Hrdlicka Austrian, b. 1928
Roll over Mondrian: The All-New Testament,
1966, etching and drypoint, 29⅜ × 21½
inches (74 × 54 cm)
Galerie Hilger, Vienna

135 Robert Morris American, b. 1931
*Prelude (A.B.): A Tomb Garden outside the
City,* 1979–80, Italian onyx, silkscreened text,
light, metal, plastic, installed with black paint,
34 × 34 × 7 inches (86.4 × 86.4 × 17.8
cm)
Sonnabend Gallery and Leo Castelli Gallery,
New York

136 Hartmut Lerch German, b. 1949
Klaus Holtz German, b. 1946
Portrait, 1980–82, videotape
Ronald Feldman Fine Arts, New York

NOTES

Frequently cited sources are referred to by author's last name and short title of the work. Full references are in the bibliography.

1. Orwell, *Nineteen Eighty-four,* p. 74.

2. Cited in Hughes, *Shock of the New,* p. 9.

3. A partial list would include: the phonograph (1877) and lightbulb (1879), the first synthetic fiber (1883), the steam turbine (1884), electric motor and pneumatic tire (both in 1888), the diesel engine (1892), the Benz car in 1885, followed by the Ford car in 1893. In 1895 alone, Marconi invented the radio and the Lumière brothers the movie camera, while the principle of rocket propulsion was theorized. In 1903, radium was discovered, the first radio transmissions were sent, and the Wright brothers flew. Every year brought new developments in automobiles and aviation, and all Europe was thrilled by Blériot's Channel crossing in 1909. In addition to discoveries of a mechanical nature, there were investigations into the nonvisible universe, notably Roentgen's discovery of x-rays (1895), Becquerel's discovery of radioactivity (1896), Planck's quantum theory in physics (1900), and Einstein's theory of relativity (1905). These and other researches shook the increasingly fragile foundations of man's formerly secure view of his place in the world.

4. Cited by Norbert Lynton, "The New Age: Primal Work and Mystic Nights," in *Towards a New Art,* p. 10.

5. Robert Musil, *The Man without Qualities* (1930); cited in Levine, *The Apocalyptic Vision,* pp. 7–8.

6. Levine, *The Apocalyptic Vision,* p. 138. See pp. 6–7, 75–103, 138–69 for further discussion of Marc's and others' belief in the apocalypse as ushering in a new age.

7. "Program of l'Esprit Nouveau," *L'Esprit Nouveau* 1 (October 1920): 3.

8. Moholy-Nagy, *The New Vision,* p. 18.

9. Karl Otten, "Vom lebenden Geist" (1919); cited in Greenberg, *Artists and Revolution,* p. 80.

10. Kateb, *Utopia and Its Enemies,* p. 17.

11. Owen, "Declaration of Independence" (1826); cited in Tod and Wheeler, *Utopia,* p. 85.

12. Saint-Simon, *Opinions littéraires, philosophiques et industrielles,* 1825; cited in Egbert, *Social Radicalism and the Arts,* pp. 121–22.

13. Orwell, "Wells, Hitler and the World State" (1946); cited in Hillegas, *H. G. Wells and the Anti-Utopians,* p. 6.

14. Wells, *A Modern Utopia* (1905); cited in introduction by Hillegas to *A Modern Utopia* (Lincoln: University of Nebraska Press, 1967), pp. xvi–xvii.

15. "The Exhibitors to the Public" (1912); cited in Apollonio, *Futurist Manifestoes,* p. 49.

16. Wells, *Men Like Gods* (1923); cited in Hillegas, *H. G. Wells and the Anti-Utopians,* p. 80.

17. Kandinsky, *Concerning the Spiritual in Art;* cited in Lindsay

and Vergo, *Kandinsky*, vol. 1, p. 219 and *passim*.

18. Mondrian, "Neoplasticism in Painting" (1917); cited in Jaffé, *De Stijl*, p. 36.

19. Gropius, *Ja! Stimmen des Arbeitsrates in Berlin für Kunst* (1919); cited in Bletter, "Utopian Aspects of German Expressionist Architecture," p. 433.

20. *Aujourd'hui* (1931); cited in *Towards a New Art*, p. 26.

21. Moholy-Nagy, *Vision in Motion*, p. 7.

22. Annaliese Schmidt, *Der Bolschevismus und die deutschen Intellectuellen* (1920); cited in Greenberg, *Artists and Revolution*, p. 173.

23. Lissitzky, "Suprematism in World Reconstruction" (1920); cited in Lissitzky-Küppers, *El Lissitsky*, p. 330.

24. Hiller, "Ortsbestimmung des Aktivismus" (1918); cited in Whyte, *Bruno Taut*, p. 100.

25. Taut, "Die Erde eine gute Wohnung" (1919); cited in Whyte, *Bruno Taut*, p. 110.

26. Krayl to Walter Gropius, May 2, 1919; cited in Whyte, *Bruno Taut*, p. 189.

27. Luckhardt, letter, May 13, 1920; cited in Bletter, "Utopian Aspects of German Expressionist Architecture," p. 463.

28. "Manifesto III: Towards a Newly Shaped World" (1921); cited in Baljeu, *Theo van Doesburg*, p. 114.

29. Periodicals include *De Stijl* (Holland), *Esprit Nouveau* (Paris), *Mécano* (Holland), *Objet/Veshch/Gegenstand* (international), *Ma* (Budapest), *Zenith* (Belgrade), *Valori Plastici* (Italy), *Blast* (England), and *Little Review* (New York).

30. Lissitzky, "New Russian Art" (1922) and "The Blockade of Russia Moves Towards Its End" (1922); cited in Lissitzky-Küppers, *El Lissitsky*, pp. 332, 340.

31. "Manifesto III: Towards a Newly Shaped World" (1921); cited in Baljeu, *Theo van Doesburg*, p. 114.

32. Gropius, *Idee und Aufbau des Staatlichen Bauhauses Weimar* (1923); cited in Banham, *Theory and Design*, p. 279.

33. "Manifesto I" (1918); cited in Jaffé, *De Stijl*, pp. 172–73.

34. Mondrian, "Neoplasticism as Style" (1917); cited in Jaffé, *De Stijl*, p. 53.

35. Mondrian, "Neoplasticism in Painting" (1917–18); cited in Jaffé, *De Stijl*, p. 85.

36. Geddes, *Horizons*, p. 289.

37. Nietzsche, *Thus Spake Zarathustra* (1883–84); cited in John H. Randall, Jr., *The Making of the Modern Mind* (Cambridge, Mass.: Houghton Mifflin, 1940), pp. 609–10.

38. Apollinaire, "Poème 52" (1915), in *Ombre de mon amour* (Geneva: Pierre Caillier, 1948), p. 119.

39. Mondrian, "Natural Reality and Abstract Painting" (1919–20); cited in Seuphor, *Piet Mondrian*, p. 328.

40. Jane Heap, "Machine Age Exposition," *Little Review* 11 (Spring 1926): 36.

41. Moholy-Nagy, *Abstract of an Artist*, p. 76.

42. Ibid.

43. Gropius, "The Viability of the Bauhaus Idea" (1922); cited in Wingler, *Bauhaus*, p. 51. Kandinsky, *Concerning the Spiritual in Art*; cited in Lindsay and Vergo, *Kandinsky*, vol. 1, p. 197.

44. Scheerbart, aphorism for the Glass House (1914); cited in Sharp, *Glass Architecture*, p. 14.

45. Scheerbart, cited in Pehnt, *Expressionist Architecture*, p. 74.

46. Lissitzky, "New Russian Art" (1922); cited in Lissitzky-Küppers, *El Lissitzky*, p. 333.

47. Blok, "The Intelligentsia and the Revolution" (1918); cited in Mikhail Guerman, *Art of the October Revolution* (New York: Abrams, 1979), n.p.

48. Boccioni, Carrà, Russolo, Balla, Severini, "The Exhibitors to the Public" (1912); cited in Apollonio, *Futurist Manifestoes*, p. 48.

49. Lissitzky, "Exhibition Rooms" (1962); cited in Lissitzky-Küppers, *El Lissitzky*, p. 362.

50. Moholy-Nagy and Alfred Kemeny, "Dynamic-Constructive Energy System" (1922); cited in Kostelanetz, *Moholy-Nagy*, p. 29.

51. Moholy-Nagy, *Vision in Motion*, p. 359.

52. Kandinsky, *Concerning the Spiritual in Art*; cited in Lindsay and Vergo, *Kandinsky*, vol. 1, p. 131.

53. Moholy-Nagy, *Abstract of an Artist*, p. 76.

54. Ibid., p. 67.

55. Cited in Rainer Crone, "Malevich and Khlebnikov: Suprematism Reinterpreted," *Artforum* 17 (December 1978): 47.

56. Lissitzky, *An Architecture for World Revolution*, pp. 68–69.

57. Van Doesburg, "From Intuition towards Certitude" (1930); cited in Baljeu, *Theo van Doesburg*, p. 185.

58. Moholy-Nagy, *Painting, Photography, Film*, p. 16.

59. Van Doesburg, *De Stijl* 1 (1917); cited in Mansbach, *Visions of Totality*, p. 87. Mansbach provides a cogent and insightful analysis of the utopian aesthetics of Lissitzky, van Doesburg, and Moholy-Nagy.

60. Lissitzky, "New Russian Art" (1922); cited in Lissitzky-Küppers, *El Lissitzky*, p. 334.

61. Moholy-Nagy, *Abstract of an Artist*, p. 75.

62. Van Doesburg, "Comments on the Basis of Concrete Painting" (1930); cited in Baljeu, *Theo van Doesburg*, p. 182.

63. Léger, "The Machine Aesthetic" (1924); cited in Edward Fry, ed., *Functions of Painting* (New York: Viking, 1973), p. 52.

64. Moholy-Nagy, *Painting, Photography, Film*, p. 8.

65. Lissitzky, "Element and Invention" (1924); cited in Lissitzky-Küppers, *El Lissitzky*, p. 346.

66. Cited in Hughes, *Shock of the New*, p. 165.

67. Van Doesburg; cited in Jaffé, *De Stijl*, p. 161.

68. Lissitzky, "Proun" (1920–21); cited in *El Lissitzky*, exhibition catalog (Cologne: Galerie Gmurzynska, 1976), p. 71.

69. "Manifesto of the Futurist Painters" (1910); cited in Apollonio, *Futurist Manifestoes*, p. 25.

70. Ibid.

71. F. T. Marinetti, "Geometric and Mechanical Splendour and the Numerical Sensibility" (1914); cited in Apollonio, *Futurist Manifestoes*, p. 154.

72. Marinetti, "Electrical War: A Futurist Vision-Hypothesis" (1911–15); cited in Flint, *Marinetti*, p. 106.

73. Marinetti, "The Founding and Manifesto of Futurism" (1909); cited in Apollonio, *Futurist Manifestoes*, p. 22.

74. Marinetti, "Electrical War: A Futurist Vision-Hypothesis" (1911–15); cited in Flint, *Marinetti*, p. 104.

75. "Manifesto of the Futurist Painters" (1910); cited in Apollonio, *Futurist Manifestoes*, pp. 24, 26.

76. Marinetti, "Geometric and Mechanical Splendour and the Numerical Sensibility" (1914); cited in Apollonio, *Futurist Manifestoes*, pp. 154–55.

77. Marinetti, "The Futurist Sensibility" (1913); cited in Apollonio, *Futurist Manifestoes*, p. 96.

78. Marinetti, "Multiplied Man and the Reign of the Machine" (1911–15); cited in Flint, *Marinetti*, p. 91.

79. "Manifesto of the Futurist Painters" (1910); cited in Apollonio, *Futurist Manifestoes*, p. 25.

80. *Little Review* 12, no. 1 (May 1927): 10.

81. Russolo, "The Art of Noises (Extracts)" (1913); cited in Apollonio, *Futurist Manifestoes*, p. 85.

82. Ibid.

83. Marinetti, "The Founding and Manifesto of Futurism" (1909); cited in Apollonio, *Futurist Manifestoes*, p. 21.

84. Boccioni, "Technical Manifesto of Futurist Sculpture" (1912); cited in Apollonio, *Futurist Manifestoes*, p. 64.

85. Boccioni, "The Plastic Foundations of Futurist Sculpture and Painting" (1913); cited in Apollonio, *Futurist Manifestoes*, p. 88.

86. Boccioni, cited in Banham, *Theory and Design*, p. 102.

87. Boccioni, "Futurist Painting and Sculpture" (1914); cited in Apollonio, *Futurist Manifestoes*, p. 177.

88. Severini, "The Plastic Analogies of Dynamism" (1913); cited in Apollonio, *Futurist Manifestoes*, p. 118.

89. Carrà, "The Painting of Sounds, Noises, and Smells" (1913); cited in Apollonio, *Futurist Manifestoes*, p. 115.

90. Boccioni, "Technical Manifesto of Futurist Sculpture" (1912); cited in Apollonio, *Futurist Manifestoes*, p. 64.

91. Balla, "Futurist Reconstruction of the Universe" (1915); cited in Apollonio, *Futurist Manifestoes*, p. 200.

92. Balla's inscription on a velocity drawing (c. 1913) is cited in *Balla* (Rome: De Luca, 1972), p. 68.

93. Bruno Corrandini and Emilio Settimelli, "Weights, Mea-sures and Prices of Artistic Genius" (1913); cited in Apollonio, *Futurist Manifestoes*, p. 136.

94. Balla, "Futurist Reconstruction of the Universe" (1915); cited in Apollonio, *Futurist Manifestoes*, p. 197.

95. Balla, "First Manifesto of Men's Clothing" (1913); cited in Apollonio, *Futurist Manifestoes*, p. 132.

96. Balla, "Futurist Reconstruction of the Universe" (1915); cited in Apollonio, *Futurist Manifestoes*, pp. 199–200.

97. Ibid.

98. Sant'Elia, "Manifesto of Futurist Architecture" (1914); cited in Apollonio, *Futurist Manifestoes*, pp. 169–70.

99. Ibid., p. 172.

100. Ibid.

101. Wells, *When the Sleeper Awakes* (1897); cited in Hillegas, *H. G. Wells and the Anti-Utopians*, pp. 43–44.

102. Arnatov, "Materialized Utopia" (1923); cited in Stephen Bann, ed., *The Tradition of Constructivism* (New York: Viking, 1974), p. 87.

103. Ibid., p. 86.

104. Ibid., p. 88.

105. Malevich, "From Cubism and Futurism to Suprematism: The New Painterly Realism" (1916); cited in idem, *Essays on Art*, vol. 1, pp. 37–38.

106. Malevich, *The Non-Objective World*, p. 100.

107. Ibid., p. 68.

108. Ibid., p. 20; see also Baljeu, "The Problem of Reality," p. 106.

109. See Linda Henderson, "The Artist, the Fourth Dimension, and Non-Euclidean Geometry 1900–1930," Ph.D. diss., Yale University, 1975, especially the chapter entitled "The Mystical Side: Ouspensky, Russian Futurism, and Malevich's Suprematism."

110. Malevich, *Essays on Art*, vol. 1, p. 60.

111. Malevich, "From Cubism and Futurism to Suprematism: The New Painterly Realism" (1916); cited in idem, *Essays on Art*, vol. 1, p. 38.

112. Malevich, *The Non-Objective World*, p. 76.

113. Malevich, "Suprematism: Thirty-four Drawings," in idem, *Essays on Art*, vol. 1, p. 127.

114. Malevich, "Unovis" (1920); cited in *Ilya Grigorevich Chasnik*, p. 31 note.

115. Chasnik, "The Suprematist Method" (1922); in *Ilya Grigorevich Chasnik*, pp. 23–24.

116. Lissitzky, "Suprematism in World Reconstruction" (1920); cited in Lissitzky-Küppers, *El Lissitzky*, p. 327.

117. Ibid., pp. 327–28.

118. Ibid., p. 330.

119. Ibid., p. 327.

120. Ibid., p. 328.

121. "PROUN: Not World Visions, BUT—World Reality" (1920);

cited in Lissitzky-Küppers, *El Lissitzky,* pp. 343–44.

122. Lissitzky, "New Russian Art" (1922); cited in Lissitzky-Küppers, *El Lissitzky,* pp. 334–35.

123. Ibid., p. 334.

124. Lissitzky, "PROUN: Not World Visions, BUT—World Reality" (1920); cited in Lissitzky-Küppers, *El Lissitzky,* p. 344.

125. Lissitzky to Malevich, 1919; cited in Lissitzky-Küppers, *El Lissitzky,* p. 21.

126. Lissitzky, "The Film of El's Life" (1928); cited in Lissitzky-Küppers, *El Lissitzky,* p. 325.

127. Lissitzky, "The Plastic Form of the Electrical-Mechanical Peepshow Victory over the Sun" (1923); cited in Lissitzky-Küppers, *El Lissitzky,* p. 348.

128. Lissitzky, "Suprematism in World Reconstruction" (1920); cited in Lissitzky-Küppers, *El Lissitzky,* p. 328.

129. Malevich, "Unovis" (1920); cited in *Ilya Grigorevich Chasnik,* p. 28.

130. Chasnik, "A Department of Architecture and Technology" (1921); cited in Barron and Tuchman, *The Avant-Garde in Russia,* p. 141.

131. Malevich, "Suprematist Manifesto Unovis" (1924); cited in Conrads, *Programs and Manifestoes,* pp. 87–89.

132. Lissitzky, "The Catastrophe of Architecture" (1921); cited in Lissitzky-Küppers, *El Lissitzky,* p. 365.

133. Lissitzky, "Basic Premises," in idem, *An Architecture for World Revolution,* p. 27.

134. Lissitzky, "Ideological Superstructure" (1929), in idem, *An Architecture for World Revolution,* p. 68. See also Lissitzky's "The Future and Utopia," in idem, *An Architecture for World Revolution,* p. 66.

135. Tatlin, "The Work Ahead of Us" (1920); cited in Bowlt, *Russian Art of the Avant-Garde,* p. 206.

136. Punin (1922), cited in Birnholz, "On Meaning in Russian Avant-Garde Art," p. 103, and in Peter Coe and Malcolm Reading, *Lubetkin and Tecton: Architecture and Social Commitment* (London: Arts Council of Great Britain, 1981), p. 22.

137. This interpretation is drawn from Mansbach, *Visions of Totality,* p. 25.

138. Lissitzky, "PROUN: Not World Visions, BUT—World Reality" (1920); cited in Lissitzky-Küppers, *El Lissitzky,* p. 343.

139. Lissitzky, "Suprematism in World Reconstruction" (1920); cited in Lissitzky-Küppers, *El Lissitzky,* p. 330.

140. Ibid., p. 329.

141. Lissitzky, *An Architecture for World Revolution,* p. 28.

142. Lissitzky, "New Russian Art" (1922); cited in Lissitzky-Küppers, *El Lissitzky,* p. 333.

143. Lissitzky, "Nasci" (1924); cited in Lissitzky-Küppers, *El Lissitzky,* p. 347.

144. Lissitzky, "PROUN: Not World Visions, BUT—World Reality" (1920); cited in Lissitzky-Küppers, *El Lissitzky,* p. 344.

145. Hiller (1919), cited in Greenberg, *Artists and Revolution,* p. 24 note 2.

146. Kandinsky, *Concerning the Spiritual in Art;* cited in Lindsay and Vergo, *Kandinsky,* vol. 1, p. 141.

147. Blavatsky, cited by Kandinsky in Lindsay and Vergo, *Kandinsky,* vol. 1, p. 145; Kandinsky in ibid., p. 175.

148. Kandinsky, "The Great Utopia" (1920); cited in Lindsay and Vergo, *Kandinsky,* vol. 1, p. 444.

149. Kandinsky, *Concerning the Spiritual in Art;* cited in Lindsay and Vergo, *Kandinsky,* vol. 1, p. 197.

150. Ibid., p. 166.

151. Ibid., p. 165.

152. Ibid., pp. 156–57.

153. Ibid., p. 162.

154. Ibid., p. 185; see pp. 177–90 for analysis of colors.

155. Ibid., p. 176.

156. Ibid., p. 170.

157. Marc, "In War's Purifying Fire" (1914); cited in Levine, *The Apocalyptic Vision,* p. 102.

158. Ibid., p. 156.

159. Landauer, *Aufruf zum Sozialismus* (2d ed., 1919); cited in Pehnt, *Expressionist Architecture,* p. 23.

160. Taut, "An die sozialistische Regierung" (1918); cited in Whyte, *Bruno Taut,* p. 98.

161. Taut, "New Ideas on Architecture" (1919); cited in Conrads, *Programs and Manifestoes,* pp. 46–47.

162. Ibid., p. 47.

163. Taut, "Program for Architecture" (1918); cited in Conrads, *Programs and Manifestoes,* p. 41.

164. Ibid.

165. Taut, "New Ideas on Architecture" (1919); cited in Conrads, *Programs and Manifestoes,* p. 47.

166. Taut, *Frühlicht* (1921); cited in Conrads, *Programs and Manifestoes,* p. 63.

167. Gropius to Jefim Golyscheff, March 22, 1919; cited in Whyte, *Bruno Taut,* p. 137.

168. Scheerbart, *Glasarchitektur* (1914); cited in Conrads, *Programs and Manifestoes,* p. 32. Scheerbart's *Glasarchitektur* has been reprinted in full in a 1972 publication edited by Dennis Sharp; see bibliography.

169. Finsterlin, "Casa Nova: Architecture of the Future—Play of Forms and Subtle Construction" (1924); cited in Conrads, *Programs and Manifestoes,* p. 84.

170. Hablik, "Architectural Manifesto," in *Wem gehört die Welt?* (Berlin: Neue Gesellschaft für Bildende Kunst, 1977), p. 144 (translation by Gisela Cooke).

171. Ibid., p. 145.

172. Ibid.

173. Gropius, letter, December 1919, cited in Whyte, *Bruno Taut,* p. 177.

174. Gropius, "Program of the Staatliche Bauhaus in Weimar" (1919); cited in Wingler, *Bauhaus,* p. 31.

175. Gropius, "The Viability of the Bauhaus Idea" (1922); cited in Wingler, *Bauhaus,* p. 51.

176. Klee, December 1921, cited in Wingler, *Bauhaus*, p. 50.

177. Schlemmer, *The Theater of the Bauhaus* (1925; reprint, Middletown: Weslyan University Press, 1961), p. 29.

178. Gropius, *Idee und Aufbau des Staatlichen Bauhauses Weimar* (1923); cited in Banham, *Theory and Design*, p. 281.

179. Entry for June 1922 in Schlemmer, *The Letters and Diaries of Oskar Schlemmer*, edited by Tut Schlemmer (Middletown: Wesleyan University Press, 1972), p. 124.

180. Moholy-Nagy, "Constructivism and the Proletariat" (1922); cited in Kostelanetz, *Moholy-Nagy*, p. 185.

181. Schlemmer, *The Theater of the Bauhaus*, p. 17.

182. Schlemmer, "Design Principles for the Painting and Sculpture Decoration of the Workshop Building of the Staatliche Bauhaus" (1923); cited in Wingler, *Bauhaus*, pp. 64, 65.

183. Schlemmer to Otto Meyer, June 14, 1921, *The Letters and Diaries of Oskar Schlemmer*, p. 107.

184. Gropius, "Program of the Staatliche Bauhaus in Weimar" (1919); cited in Wingler, *Bauhaus*, p. 32.

185. Moholy-Nagy, *The New Vision*, p. 16.

186. Moholy-Nagy, "The Spiritual and Social Aspects of Constructivist Art" (1923); cited in Sibyl Moholy-Nagy, *Moholy-Nagy*, p. 197.

187. Moholy-Nagy, *The New Vision*, p. 18.

188. Ibid., p. 32.

189. Ibid., p. 38.

190. Moholy-Nagy, "Isms or Art" (1926); cited in Kostelanetz, *Moholy-Nagy*, p. 35.

191. Moholy-Nagy, *The New Vision*, p. 361.

192. Moholy-Nagy and Alfred Kemeny, "Dynamic-Constructive Energy-System" (1922); cited in Kostelanetz, *Moholy-Nagy*, p. 29.

193. Moholy-Nagy, *The New Vision*, p. 76.

194. Ibid., p. 79.

195. Ibid.

196. Ibid.

197. Albers, "Creative Education" (1928); cited in Wingler, *Bauhaus*, pp. 142–43.

198. Ibid., p. 143.

199. Ibid.

200. Mondrian, "From the Natural to the Abstract, or from the Indefinite to the Definite" (1918); cited in Jaffé, *De Stijl*, p. 75.

201. Mondrian, "Neoplasticism in Painting" (1917); cited in Jaffé, *De Stijl*, p. 38.

202. Ibid.

203. Mondrian, "From the Natural to the Abstract" (1918); cited in Jaffé, *De Stijl*, p. 75.

204. Ibid., p. 71.

205. Mondrian, "Neoplasticism in Painting" (1917); cited in Jaffé, *De Stijl*, p. 36.

206. Mondrian, "A Dialogue on Neoplasticism" (1919); cited in Jaffé, *De Stijl*, p. 122.

207. Mondrian, "Nature and Spirit as Male and Female Elements" (1918); cited in Jaffé, *De Stijl*, p. 89.

208. Mondrian, "Natural Reality and Abstract Reality" (1919–20); cited in Seuphor, *Piet Mondrian*, p. 306.

209. Van Doesburg and Cornelis van Eesteren, "Towards Collective Constructivism" (1923); cited in Baljeu, *Theo van Doesburg*, p. 147.

210. Van Doesburg, "The New Esthetics and Its Realization" (1922); cited in Baljeu, *Theo van Doesburg*, p. 129.

211. Van Doesburg, "Painting: From Composition to Counter-composition" (1926); cited in Baljeu, *Theo van Doesburg*, p. 153.

212. Mondrian, "The Realization of Neoplasticism in the Distant Future and in Architecture Today" (1922); cited in Jaffé, *De Stijl*, p. 168.

213. Kiesler, "Biography" (estate of the artist, New York), p. 4.

214. Kiesler, "Space-City Architecture" (1926); cited in Banham, *Theory and Design*, p. 198.

215. Apollinaire, "L'Esprit Nouveau et les Poètes" (1918); cited in Christopher Gray, *Cubist Aesthetic Theories* (Baltimore: Johns Hopkins University Press, 1953), pp. 110–12.

216. Léger, letter, 1922, in Christopher Green, *Léger and Purist Paris* (London: Tate Gallery, 1970), p. 86. My discussion of Léger's art and ideas is largely based on this source and Green's exhaustive *Léger and the Avant-Garde*.

217. Lissitzky, "'Americanism' in European Architecture" (1925); cited in Lissitzky-Küppers, *El Lissitzky*, p. 369.

218. H. G. Wells, *The Future in America* (1906); cited in Zabel, "Louis Lozowick and Technological Optimism of the 1920s," pp. 87–88.

219. Lozowick, "The Americanization of Art," *Machine Age Exposition* (New York: Little Review, 1927), p. 18.

220. Ibid.

221. Ibid.

222. Ibid.

223. Josef Gaer, "Louis Lozowick: An Artist Who Presents the Soul of America," *B'nai Brith* 41 (June 1927): 379.

224. Ames, cited in *Léger et L'Esprit Moderne*, p. 163.

225. Art galleries and several prominent private collections in New York, such as Albert Gallatin's Museum of Living Art (1927–43), made European abstract art increasingly visible. The *Machine Age Exposition* sponsored by *Little Review* (Steinway Hall, New York, 1927) and various pioneering exhibitions mounted at the Museum of Modern Art from 1929 on, especially *Machine Art* (1934) and *Bauhaus 1919–28* (1938), and a series of industrial art exhibitions at the Metropolitan Museum of Art in the late 1920s and '30s promoted the concepts of the "machine aesthetic."

226. Roszak, "Some Problems of Modern Sculpture," *Magazine of Art* 42 (February 1949): 56.

227. Ferriss, *Metropolis of Tomorrow*, p. 141.

228. Ibid., p. 142.

229. Ibid., p. 136.

230. Geddes, *Horizons* (Boston: Little, Brown, 1932), pp. 3–4.

231. Mumford, cited in Helen A. Harrison et al., *Dawn of a New Day: The New York World's Fair 1939/40* (New York: New York University Press, 1980), p. 4.

232. Teague, *Design This Day: The Technique of Order in the Machine Age* (New York: Harcourt, Brace, 1940), p. 240.

233. Ibid., p. 234. This idea survived World War I in the minds of some, such as architect Richard Neutra as expressed in his book *Survival through Design* (New York: Oxford University Press, 1954).

234. Eugene Santomasso, "The Design of Reason," in Harrison et al., *Dawn of a New Day,* p. 34; the architects were Wallace Harrison and André Foulihoux.

235. *Official Guidebook of the New York World's Fair* (New York: Exposition Publishers, 1939), p. 44.

236. Ibid., p. 45.

237. Fuller, *Utopia or Oblivion,* p. 3.

238. Fuller, cited in Paul Heyer, *Architects on Architecture* (London: Penguin, 1967), p. 387.

239. Martin Buber, *Paths in Utopia* (Boston: Beacon Press, 1960), p. 14.

240. Fuller, "Universal Architecture" (1932); cited in Conrads, *Programs and Manifestoes,* p. 129.

241. Kiesler and Thomas H. Creighton, "Kiesler's Pursuit of an Idea," *Progressive Architecture* 42 (July 1961): 123.

242. Ibid., p. 112.

243. Ibid.

244. Ibid., p. 121.

245. Kiesler, *Inside the Endless House,* p. 566.

246. Insley, "Onecity," p. 3.

247. Berdyaev, "Democracy, Socialism, and Theocracy"; cited in Huxley, *Brave New World,* p. ii.

248. Alexander Gray, *The Socialist Tradition: Moses to Lenin* (London: Longmans, Green, 1946), p. 62.

249. Koestler, cited in Eric Pace, "Arthur Koestler and Wife Suicides in London," *New York Times,* March 4, 1983, p. A20.

250. Cited in Walsh, *From Utopia to Nightmare,* pp. 78–79.

251. Zamyatin, *We,* pp. 182–87.

252. Huxley, *Brave New World,* p. 11.

253. Cited in Walsh, *From Utopia to Nightmare,* pp. 67–68.

254. Rand, *Anthem,* p. 11.

255. Ibid., p. 14.

256. Zamyatin, *We,* p. 5.

257. Huxley, "Progress: How the Achievements of Civilization Will Eventually Bankrupt the Entire World" (1928); cited in Hillegas, *H. G. Wells and the Anti-Utopians,* p. 114. Before *Brave New World,* Huxley wrote "On Making Things Too Easy: How Modern Inventions and Distractions May Assist in Inducing Mental Decay" (1926), "Progress:

How the Achievements of Civilization Will Eventually Bankrupt the Entire World" (1928), and "Boundaries of Utopia" (1932)—all attacks on the equation of real progress with technological innovations.

258. Huxley, cited in Hillegas, *H. G. Wells and the Anti-Utopians,* p. 115.

259. Huxley, *Brave New World,* p. 35.

260. Zamyatin, *We,* p. 83.

261. Ibid., pp. 3–5.

262. Ibid., p. 19.

263. Utopian artists themselves experienced a crisis of idealism. In 1930, van Doesburg abandoned the more utopian concerns of De Stijl for a new movement called Concrete Art, which emphasized objectivity and absolutely impersonal methods, purified of all "individualistic sentiment." Concrete Art and its offshoot, Abstraction-Création (1931–34), proposed a new art that appears to have such pure, universalized meaning as to have no meaning at all. Though van Doesburg asserted that this art would be "not without spirit . . . not empty" ("Art Concret," 1930, cited in Baljeu, *Theo van Doesburg,* pp. 181–82), self-reflexive formalist concerns appear to have replaced the earlier utopian goal.

264. Ernst Fisher, *The Necessity of Art: A Marxist Approach* (1968); cited in Schwartz, *The New Humanism,* p. 16. Schwartz's book is an invaluable pioneering study.

265. Meidner, *Neck of the Stormy Sea* (1916–18); cited in Michael Danoff, *Ludwig Meidner: Apocalyptic German Expressionist* (Milwaukee Art Center, 1976), p. 8.

266. Meidner, journal entry (1918); cited in Victor Miesel, *Ludwig Meidner: An Expressionist Master* (Ann Arbor: University of Michigan Press, 1978), p. 32.

267. Masereel, cited in *Partei ergreifen,* no. 180.

268. Grosz, "Zu meinen neuen Bildern" (1921); cited in Schneede, *George Grosz,* p. 66.

269. Čapek, *R.U.R.,* p. 25.

270. Grosz, in Lewis, *George Grosz,* p. 96.

271. Grosz, in Schneede, *George Grosz,* p. 78. This may have been an allusion to Leonhard Frank's book *Der Mensch ist gut* (1919), a collection of stories on the brotherhood of man and utopian hopes for a new world.

272. Grosz, in Lewis, *George Grosz,* p. 196.

273. Grosz, *Unter anderem ein Wort für Deutsche Tradition* (1931); cited in Schneede, *George Grosz,* p. 116.

274. Grosz to Weiland Herzfelde, June 6, 1933; cited in Hess, *George Grosz,* p. 181.

275. Ibid.

276. Ibid., p. 227.

277. Waldo Frank, *The Rediscovery of America* (1930); cited in Taylor, *America as Art,* p. 219.

278. *The Unknown Political Prisoner,* n.p.

279. Herbert Read and Hans Holthusen, "Gutachten der Akademie der Kunst zum Entwurf eines Denkmals des unbekann-

ten politischen Gefangenen"; cited in László Glozer, *Westkunst* (Cologne: Du Mont Buchverlag, 1981), p. 185.

280. Butler in ibid., p. 188.

281. Cited in Ronald Alley, *Catalog of the Tate Gallery's Collection of Modern Art* (London: Tate Gallery, 1981), p. 522.

282. Ibid., p. 654.

283. Roszak, "The New Sculpture," speech at Museum of Modern Art, New York, February 10, 1952; cited in Belle Krasne, "A Theodore Roszak Profile," *Art Digest* 27 (October 15, 1952): 18.

284. Ibid.

285. Roszak, cited in Dorothy Miller, *Fourteen Americans* (New York: Museum of Modern Art, 1946), p. 59.

286. Roszak, in Selz, *New Images of Man,* p. 134.

287. Roszak, cited in H. H. Arnason, *Theodore Roszak* (Minneapolis: Walker Art Center, 1956), p. 34.

288. Selz, *New Images of Man,* p. 15.

289. Tillich, in ibid., p. 9.

290. Baskin, *Baskin: Sculpture, Drawings and Prints* (New York: Braziller, 1970), p. 15.

291. Shahn, "If I Had to Begin My Art Career Today" (1949); cited in Morse, *Ben Shahn,* p. 106.

292. Shahn, *The Shape of Content* (1957); cited in James T. Soby, *Ben Shahn: Paintings* (New York: Braziller, 1957), p. 21.

293. Shahn, in McNulty and Shahn, *The Collected Prints of Ben Shahn,* p. 30.

294. Shahn, "In Defense of Chaos"; cited in Morse, *Ben Shahn,* pp. 184–85.

295. Shahn, *Paragraphs on Art* (New York: Spiral Press, 1952), p. 4.

296. Mooy, cited in *Partei ergreifen,* no. 198.

297. Ibid., no. 199.

298. Such as *Engagierte Kunst: Gesellschaftskritische Graphik seit Goya* (Vienna, 1966), *Kunst und Politik* (Karlsruhe, 1970), *Signale—Manifeste—Proteste in 20 Jahrhunderts* (Recklinghausen, 1965), *Partei ergreifen* (Recklinghausen, 1978), and others. Books appeared, like Jean Cassou's *Art and Confrontation* (1968), Mario De Michele's *Arte Contro 1945–70* (1970), and Barry Schwartz's *The New Humanism* (1974).

299. Zamyatin, *We,* pp. 78, 92, 104.

300. Trova, statement (1966); cited in Kultermann, *Trova,* p. 58.

301. Trova, "The Uses of Ingenuity" (1967); cited in Kultermann, *Trova,* p. 58.

302. Trova, statement in questionnaire, December 1972; cited in Kultermann, *Trova,* p. 59.

303. Landau, "Meditations," p. 8.

304. Ibid., p. 14.

305. Landau, "In Search of Heaven and Hell," p. 51.

306. Landau, "Art and the Future of a Dream," pp. 221–22.

307. Liebmann to author, March 1983.

308. Bayrle, in *Kunst und Politik,* no. 14.

309. Bayrle, interview with Walter Richartz, in *Partei ergreifen,* no. 33.

310. Kraus, "Der Mensch ist frei"; cited in *Karl Hermann Kraus* (Darmstadt: privately published, n.d.), p. 41 (translated by Gisela Cooke).

311. Lerch to author, April 20, 1983.

312. Wilde, cited in Walsh, *From Utopia to Nightmare,* p. 15.

313. Marinetti, "Destruction of Syntax—Imagination without Strings—Words-in-Freedom" (1913); cited in Apollonio, *Futurist Manifestoes,* p. 95.

BIBLIOGRAPHY

Adler, Bruno, ed. *Utopia: Dokumente der Wirklichkeit.* 2 vols. Weimar: Utopia Verlag, 1921.

Aftermath: France 1945–54: New Images of Man. Exhibition catalog. London: Barbican Centre for Arts and Conferences, 1982.

Alfred Hrdlicka. Exhibition catalog. Hannover: Kestner-Gesellschaft, 1974.

Amico, Alessandro d', and Danesi, Silvia. *Virgilio Marchi: Architetto, scenografo, futurista.* Exhibition catalog. Milan: Electa Editrice, 1977.

Andersen, Troels. *Malevitch.* Exhibition catalog. Amsterdam: Stedelijk Museum, 1970.

Apocalypse and Utopia: A View of Art in Germany 1910–1939. Exhibition catalog. London: Fischer Fine Art, 1977.

Apollonio, Umbro, ed. *Futurist Manifestoes.* Translated by Robert Brain, R. W. Flint, J. C. Higgitt, and Caroline Tisdall. New York: Viking Press, 1970.

Arbeitsrat für Kunst, Berlin. *Ruf zum Bauen.* Berlin: Ernst Wasmuth, 1920.

L'Art comme Utopie. Exhibition Catalog. Le Havre: Maison de la Culture du Havre, Bibliothèque Municipale, Musée des Beaux-Arts André Malraux, 1978.

Art in Western Europe: The Postwar Years, 1945–1955. Introduction by Lawrence Alloway. Exhibition catalog. Des Moines: Des Moines Art Center, 1978.

Baljeu, Joost. "The Problem of Reality with Suprematism, Constructivism, Proun, Neoplasticism, and Elementarism." *Lugano Review* 1 (1965): 105–28.

————. *Theo van Doesburg.* New York: Macmillan, 1974.

Banham, Reyner. *Theory and Design in the First Machine Age.* New York: Praeger, 1967.

Barron, Stephanie, and Tuchman, Maurice, eds. *The Avant-Garde in Russia 1910–1930: New Perspectives.* Exhibition catalog. Los Angeles: Los Angeles County Museum of Art, 1980.

Baur, John I. H. *George Grosz.* New York: Macmillan for the Whitney Museum of American Art, 1954.

Berlin, A Critical View: Ugly Realism 20s-70s. Exhibition catalog. London: Institute of Contemporary Arts, 1978.

Birnholz, Alan C. "Forms, Angles, and Corners: On Meaning in Russian Avant-Garde Art." *Arts Magazine* 51 (February 1977): 101–9.

————. "'For the New Art': El Lissitzky's Prouns, Part 1." *Artforum* 8 (October 1969): 65–70. "Part 2." *Artforum* 8 (November 1969): 68–73.

Bletter, Rosemarie Haag. "Bruno Taut and Paul Scheerbart's Vision: Utopian Aspects of German Expressionist

Architecture." Ph.D. dissertation, Columbia University, 1973.

Bloch, Ernst. *Geist der Utopie.* 1923. Frankfurt-am-Main: Suhrkamp Verlag, 1964.

Bowlt, John E. "The Failed Utopia: Russian Art 1917–32." *Art in America* 59 (July–August 1971): 40–51.

————, ed. and trans. *Russian Art of the Avant-Garde: Theory and Criticism 1902–1932.* New York: Viking Press, 1976.

Bruno Taut 1880–1938. Exhibition catalog. Berlin: Akademie der Künste, 1980.

Čapek, Karel. *R.U.R.* 1923. Translated by P. Selver. London: Oxford University Press, 1961.

Castillejo, José L. "Photographic Realism: On the Painting of Juan Genovés." *Art International* 10 (Summer 1966): 34–39.

Collins, George R. *Visionary Drawings of Architecture and Planning: Twentieth Century through the 1960s.* Cambridge: MIT Press for Smithsonian Institution Traveling Exhibition Service and the Drawing Center, 1979.

Compton, Susan P. "Malevich's Suprematism: The Higher Intuition." *Burlington Magazine* 118 (August 1976): 577–85.

Conrads, Ulrich, ed. *Programs and Manifestoes on 20th-Century Architecture.* 1964. Translated by Michael Bullock. Cambridge: MIT Press, 1975.

————, and Sperlich, Hans G. *The Architecture of Fantasy: Utopian Building and Planning in Modern Times.* 1960. Translated by Christiane Crasemann and George R. Collins. New York: Praeger, 1962.

Crispolti, Enrico. *Il mito della macchina e altri temi del Futurismo.* Trapani, Italy: Celebes Editore, 1969.

————. *Ricostruzione futurista dell'universo.* Exhibition catalog. Turin: Museo Civico, 1980.

Davis, Douglas. *Art and the Future.* New York: Praeger, 1973.

D'Harnoncourt, Anne, and Celant, Germano. *Futurism and the International Avant-Garde.* Exhibition catalog. Philadelphia: Philadelphia Museum of Art, 1981.

Doesburg, Theo van. *Principles of Neo-Plastic Art.* 1925. Translated by Janet Seligman. Greenwich, Conn.: New York Graphic Society, 1968.

Dorazio, Virginia Dortch. *Giacomo Balla: An Album of His Life and Work.* New York: Wittenborn, n.d.

Doty, Robert. *Human Concern, Personal Torment: The Grotesque in American Art.* Exhibition catalog. New York: Whitney Museum of American Art, 1969.

Drudi Gambillo, Maria, and Fiori, Teresa, eds. *Archivi del Futurismo.* 2 vols. Rome: De Luca Editore, 1958–62.

Egbert, Donald Drew. *Social Radicalism and the Arts: Western Europe.* New York: Knopf, 1970.

————, ed. *Socialism and American Art: In the Light of European Utopianism, Marxism and Anarchism.* Princeton, N.J.: Princeton University Press, 1967.

El Lissitzky 1890–1941. Exhibition catalog. Oxford: Museum of Modern Art, 1977.

Fagiolo dell'Arco, Maurizio. *Futur Balla.* Rome: Mario Bulzoni, 1968.

Ferriss, Hugh. *The Metropolis of Tomorrow.* New York: Ives Washburn Publishers, 1929.

Fishman, Robert. *Urban Utopias in the Twentieth Century: Ebenezer Howard, Frank Lloyd Wright, and Le Corbusier.* New York: Basic Books, 1977.

Flint, R. W., ed. *Marinetti: Selected Writings.* Translated by R. W. Flint and Arthur A. Coppotelli. New York: Farrar, Straus and Giroux, 1971.

Foresta, Merry A., and Tunkl, David. *George Tooker.* Los Angeles: David Tunkl, n.d.

Frederick Kiesler: Visionary Architecture, Drawings and Models, Galaxies and Paintings, Sculpture. Exhibition catalog. New York: André Emmerich Gallery, 1979.

Friedman, Martin. *Charles Sheeler.* New York: Watson-Guptill, 1975.

————; Hayes, Bartlett; and Millard, Charles. *Charles Sheeler.* Exhibition catalog. Washington, D.C.: National Collection of Fine Arts and Smithsonian Institution Press, 1968.

Friedman, Mildred, ed. *De Stijl: 1917–1931, Visions of Utopia.* Exhibition catalog. Minneapolis: Walker Art Center and New York: Abbeville, 1982.

Fuller, R. Buckminster. *Utopia or Oblivion: The Prospects for Humanity.* New York: Bantam, 1969.

Garver, Thomas H. *George Tooker: Paintings 1947–1973.* Exhibition catalog. San Francisco: Fine Arts Museums of San Francisco, 1974.

Geddes, Norman Bel. *Horizons.* Boston: Little, Brown, 1932.

Goodman, Cynthia. "The Current of Contemporary History: Frederick Kiesler's Endless Search." *Arts Magazine* 54 (September 1979): 118–23.

Green, Christopher. *Léger and the Avant-Garde.* New Haven: Yale University Press, 1976.

Greenberg, Allan C. *Artists and Revolution: Dada and the Bauhaus 1917–1925.* Ann Arbor: UMI Research Press, 1979.

Harrison, Helen A. *Dawn of a New Day: The New York World's Fair, 1939/40.* Exhibition catalog. New York: New York University Press and Queens Museum, 1980.

Hermann Finsterlin (1887–1973): Ideenarchitektur 1918– 1924. Exhibition catalog. Krefeld: Museum Haus Lange, 1976.

Hess, Hans. *George Grosz.* New York: Macmillan, 1974.

Hillegas, Mark R. *The Future as Nightmare: H. G. Wells and the Anti-Utopians.* New York: Oxford University Press, 1967.

Hughes, Robert. *The Shock of the New: Art and the Century of Change.* London: British Broadcasting Corporation, 1980.

Huxley, Aldous. *Brave New World* (1932) and *Brave New World Revisited* (1958). New York: Harper & Row, 1965.

Ilya Chasnik and the Russian Avant-Garde: Abstraction and Beyond. Exhibition catalog. Austin: Archer M. Huntington Art Gallery, University of Texas at Austin, 1981.

Ilya Grigorevich Chashnik: Lyucite 1902–Leningrad 1929: Watercolors, Drawings, Reliefs. Exhibition catalog. New York: Leonard Hutton Galleries, 1979.

Insley, Will. "The Greater Context." *Tracks* 1 (November 1974): 18–37.

———. "Onecity." Circa 1979. Library, Hirshhorn Museum and Sculpture Garden, Washington, D.C.

Jaffé, Hans L. C. *De Stijl.* New York: Abrams, 1971.

———. *De Stijl 1917–1931: The Dutch Contribution to Modern Art.* London: Alec Tiranti, 1956.

James, Martin. "The Realism behind Mondrian's Geometry." *Art News* 56 (December 1957): 34–37.

Jellicoe, Geoffrey A. *Motopia: A Study in the Evolution of Urban Landscape.* New York: Praeger, 1961.

Joseph Hirsch. Exhibition catalog. Athens, Ga.: Georgia Museum of Art, 1970.

Kateb, George. *Utopia and Its Enemies.* London: Free Press of Glencoe, 1963.

Kiesler, Frederick. *Inside the Endless House: Art, People, Architecture, A Journal.* New York: Simon and Schuster, 1966.

Kopp, Anatole. *Town and Revolution: Soviet Architecture and City Planning 1917–1935.* 1967. Translated by Thomas E. Burton. New York: Braziller, 1970.

Kostelanetz, Richard, ed. *Moholy-Nagy.* New York: Praeger, 1970.

Kultermann, Udo. *Trova.* New York: Abrams, 1978.

Kunst und Politik. Exhibition catalog. Karlsruhe: Badischer Kunstverein, 1970.

Kuspit, Donald B. "Utopian Protest in Early Abstract Art." *Art Journal* 29 (Summer 1970): 430–36.

L. Moholy-Nagy. Exhibition catalog. London: Arts Council of Great Britain, 1980.

Landau, Jacob. "Art and the Future of a Dream." In Pamela Pipines and Terence Ripmaster, eds. *The Arts Catalogue of New Jersey.* Wayne, N.J.: Avery Publishing Group, 1978, pp. 221–27.

———. "In Search of Heaven and Hell." *Print Review* 9 (1979): 49–56.

———. *Jacob Landau: Apocalyptic and Prophetic Works 1967–1976.* Exhibition catalog. New York: ACA Galleries, 1976.

———. "Meditations." 1978–81. Library, Hirshhorn Museum and Sculpture Garden, Washington, D.C.

———. "Yes—No, Art—Technology." *Wilson Library Bulletin* 41 (September 1966): 42–57.

László Moholoy-Nagy. Exhibition catalog. Chicago: Museum of Contemporary Art, 1969.

Léger and Purist Paris. Exhibition catalog. London: Tate Gallery, 1970.

Léger et L'Esprit Moderne: Une Alternative d'Avant-Garde à l'Art Non-Objectif 1918–31. Exhibition catalog. Paris: Musée d'Art Moderne de la Ville de Paris, 1982.

Leich, Jean Ferriss, et al. *Architectural Visions: The Drawings of Hugh Ferriss.* New York: Watson-Guptill, 1980.

Levin, Kim. "Kiesler and Mondrian: Art into Life." *Art News* 63 (May 1964): 39–41, 49–50.

Levine, Frederick. *The Apocalyptic Vision: The Art of Franz Marc as German Expressionist.* New York: Harper and Row, 1977.

Lewis, Beth Irwin. *George Grosz: Art and Politics in the Weimar Republic.* Madison: University of Wisconsin Press, 1971.

Lindsay, Kenneth, and Vergo, Peter. *Kandinsky: Complete Writings on Art.* 2 vols. Boston: G. K. Hall, 1982.

Lissitzky, El. *Russia: An Architecture for World Revolution.* 1930. Translated by Eric Dluhosch. Cambridge: MIT Press, 1970.

Lissitzky-Küppers, Sophie. *El Lissitsky: Life, Letters, Texts.* Translated by Helene Aldwinckle. Greenwich, Conn.: New York Graphic Society, 1968.

Lista, Giovanni. *Balla.* Modena: Edizioni Galleria Fonte d'Abisso, 1982.

Long, Rose-Carol Washton. "Kandinsky's Vision of Utopia as a Garden of Love." *Art Journal* 43 (Spring 1983): 50–60.

Ludwig Meidner: An Expressionist Master, Drawings and Prints from the D. Thomas Bergen Collection, Paintings from the Marvin and Janet Fishman Collection. Exhibition Catalog. Ann Arbor: University of Michigan Museum of Art, 1978.

McNulty, Kneeland, and Shahn, Ben. *The Collected Prints*

of Ben Shahn. Exhibition catalog. Philadelphia: Philadelphia Museum of Art, 1967.

Malevich, Kasimir S. *Essays on Art.* Vol. 1, *1915–1928.* Vol. 2, *1928–1933.* Edited by Troels Andersen. Translated by Xenia Glowacki-Prus and Arthur McMillin. 2 vols. Copenhagen: Borgen, 1968.

————. *The Non-Objective World.* 1927. Translated by Howard Dearstyne. Chicago: Theobald, 1959.

Mansbach, Stephen. *Visions of Totality: László Moholy-Nagy, Theo van Doesburg, and El Lissitzky.* Ann Arbor: UMI Press, 1980.

Martin, Jean-Hubert, and Pedersen, Poul. *Malévitch: Oeuvres de Casmir Severinovitch Malévitch (1878–1935).* Paris: Musée National d'Art Moderne, Centre National d'Art et de Culture Georges Pompidou, 1980.

Martin, Marianne W. *Futurist Art and Theory 1909–1915.* Oxford: Clarendon Press, 1968.

Maur, Karin V. *Oskar Schlemmer: Monographie.* 2 vols. Munich: Prestel Verlag, 1979.

Moholy-Nagy, László. *The New Vision* and *Abstract of an Artist.* 1928 and 1946. New York: Wittenborn, 1947.

————. *Painting, Photography, Film.* 1924–25. Cambridge: MIT Press, 1969.

————. *Vision in Motion.* 1947. Chicago: Theobald, 1969.

Moholy-Nagy, Sibyl. *Moholy-Nagy: Experiment in Totality.* 2d ed. Cambridge: MIT Press, 1969.

Molnar, Thomas. *Utopia: The Perennial Heresy.* New York: Sheed and Ward, 1967.

Morgan, George W. *The Human Predicament: Dissolution and Wholeness.* New York: Dell, 1970.

Morse, John D., ed. *Ben Shahn: An Interview.* New York: Praeger, 1972.

Mumford, Lewis. *The Myth of the Machine.* Vol. 1, *Technics and Human Development.* Vol. 2, *The Pentagon of Power.* New York: Harcourt Brace Jovanovich, 1967–70.

————. *The Story of Utopias.* 1922. Rev. ed. New York: Peter Smith, 1941.

Nicoletti, Manfredi. "Flash Gordon and the Twentieth Century Utopia." *Architectural Review* 140 (August 1966): 86–91.

Orwell, George. *Nineteen Eighty-four: A Novel.* New York: Harcourt, Brace and World, 1949.

Paris-Moscow 1900–1930. Exhibition catalog. Paris: Centre National d'Art et de Culture Georges Pompidou, 1979.

Partei ergreifen. Exhibition catalog. Recklinghausen, Germany: Städtische Kunsthalle, 1978.

Pehnt, Wolfgang. *Expressionist Architecture.* Translated by J. A. Underwood and Edith Kustner. New York: Praeger, 1973.

Piet Mondrian, 1872–1944: Centennial Exhibition. Exhibition catalog. New York: Solomon R. Guggenheim Museum, 1971.

The Precisionist View in American Art. Exhibition catalog. Minneapolis: Walker Art Center, 1960.

Rand, Ayn. *Anthem.* 1937. New York: New American Library, 1946.

Rembert, Virginia Pitts. "Mondrian's Aesthetics, as Interpreted through His Statements." *Arts* 54 (June 1980): 170–76.

Ringbom, Sixten. "Art in the 'Epoch of the Great Spiritual': Occult Elements in the Early Theory of Abstract Painting." *Journal of the Warburg and Courtauld Institutes* 29 (1966): 386–418.

Rowe, Colin, and Koetter, Fred. "Collage City." *Architectural Review* 158 (August 1975): 66–91.

Rudenstine, Angelica Zander, ed. *The George Costakis Collection: Russian Avant-Garde Art.* New York: Abrams, 1981.

Schneede, Uwe M. *George Grosz: His Life and Work.* Translated by Susanne Flatauer. New York: Universe, 1979.

Schuyt, Michael; Collins, George R.; and Elffers, Joost. *Fantastic Architecture: Personal and Eccentric Visions.* New York: Abrams, 1980.

Schwartz, Barry. *The New Humanism: Art in a Time of Change.* New York: Praeger, 1974.

Selz, Peter. *New Images of Man.* Exhibition catalog. New York: Museum of Modern Art, 1959.

Seuphor, Michel. *Piet Mondrian: Life and Work.* New York: Abrams, n.d.

Shahn, Ben. *The Shape of Content.* New York: Random House, 1957.

Shapiro, David, ed. *Social Realism: Art as a Weapon.* New York: Ungar, 1973.

Sharp, Dennis. "Hablik's Crystal Dream." *Art and Artists* 15 (July 1980): 20–21.

————, ed. *Glass Architecture* by Paul Scheerbart. 1914. Translated by James Palmes. *Alpine Architecture* by Bruno Taut. 1919. Translated by Shirley Palmer. New York: Praeger, 1972.

Shikes, Ralph E. *The Indignant Eye: The Artist as Social Critic in Prints and Drawings from the Fifteenth Century to Picasso.* Boston: Beacon Press, 1969.

Sibley, Mulford Q. *Technology and Utopian Thought.* Minneapolis: Burgess Publishing, 1971.

Sky, Alison, and Stone, Michelle. *Unbuilt America.* New York: McGraw-Hill, 1976.

Taut, Bruno. *Der Weltbaumeister: Architektur-Schauspiel für symphonische Musik.* Hagen, Germany: Folkwang-Verlag, 1920.

Taylor, Joshua C. *America as Art.* Exhibition catalog. Washington, D.C.: National Collection of Fine Arts and Smithsonian Institution Press, 1976.

Teague, William D. *Design This Day: The Technique of Order in the Machine Age.* New York: Harcourt, Brace, 1940.

Tod, Ian, and Wheeler, Michael. *Utopia.* London: Orbis Publishing, 1978.

Towards a New Art: Essays on the Background to Abstract Art 1910–20. Exhibition catalog. London: Tate Gallery, 1980.

The Unknown Political Prisoner. Exhibition catalog. London: Tate Gallery, 1953.

Utopies et Réalités en U.R.S.S. 1917–1934: Agit-Prop, Design, Architecture. Paris: Centre de Création Industrielle, 1980.

Vance, Mary. *Utopias: Concept and Design, A Selected Bibliography.* Monticello, Ill.: Vance Bibliographies, 1979.

Von Blum, Paul. *The Art of Social Conscience.* New York: Universe, 1976.

Wall, Donald. "Will Insley: Buildings/Fragments." *Arts Magazine* 50 (November 1975): 70–74.

Walsh, Chad. *From Utopia to Nightmare.* New York: Harper & Row, 1962.

Wells, H. G. *A Modern Utopia.* New York: Charles Scribner's Sons, 1905.

Welsh, Robert P. "The Birth of De Stijl, Part 1: Piet Mondrian—The Subject Matter of Abstraction." *Artforum* 11 (April 1973): 50–53.

Whyte, Iain Boyd. *Bruno Taut and the Architecture of Activism.* New York: Cambridge University Press, 1982.

Willett, John. *Art and Politics in the Weimar Period: The New Sobriety, 1917–1933.* New York: Pantheon, 1978.

Will Insley. Exhibition catalog. Chicago: Museum of Contemporary Art, 1976.

Will Insley: Plane für eine andere Welt. Exhibition catalog. Krefeld: Museum Haus Lange, 1973.

Wingler, Hans Maria. *Bauhaus: Weimar, Dessau, Berlin, Chicago.* Translated by Wolfgang Jabs and Basil Gilbert. Cambridge: MIT Press, 1969.

Wolfe, Tom. *From Bauhaus to Our House.* New York: Farrar, Straus and Giroux, 1981.

Zabel, Barbara Beth. "Louis Lozowick and Technological Optimism of the 1920s." Ph.D. dissertation, University of Virginia, 1978.

———. "The Precisionist-Constructivist Nexus: Louis Lozowick in Berlin." *Arts* 56 (October 1981): 123–27.

Zamyatin, Evgeny. *We.* 1924. Translated by Mirra Ginsburg. New York: Viking Press, 1972.

Zeugnisse der Angst in der Modernen Kunst. Exhibition catalog. Darmstadt, Germany: Mathildehohe, 1963.

INDEX OF ARTISTS